Bruce,

I hope this book will remind you of the GAA grounds you played in.

Harry + Briege Mc Cabe

Key club is on page 212

A PLACE
TO PLAY

*This book is dedicated to my wife Claire,
children Tony, Eamon and Susan, and
grandchildren Oisin, Aaron, Kate,
Alex, Anna, Lucy and Paul*

A PLACE TO PLAY

The people and stories behind
101 GAA grounds

Humphrey Kelleher

CONTRIBUTING EDITOR
DR DÓNAL McANALLEN

MERRION
PRESS

FIRST PUBLISHED IN 2023 BY

Merrion Press
10 George's Street
Newbridge
Co Kildare
Ireland
www.merrionpress.ie

9781785374807 (hardback)
9781785374814 (ebook)

A CIP catalogue record for this book is available from
the British Library.

Developed for the author and publishers by
Peadar Staunton at the Design Gang, Tralee,
and Peter Malone Editing, Dingle, Co. Kerry

Typeset in Georgia, Univers

Printed in Dubai

Front cover image: Páirc Lachtain, Freshford, Co. Kilkenny
Back cover image: Parnell Park, Donnycarney, Dublin

All drone photography © Humphrey Kelleher

The author and publisher wish to thank the GAA clubs
and family members of people featured in this book who
provided photos and permission to reproduce them

Other images courtesy of:

Sportsfile, Croke Park Archives, iStock by Getty Images, Liam Lyons
Collection, RTÉ Archives, National Library of Ireland, National
Museum of Ireland, Library of Congress, Dublin City Libraries and
Archive, Dublin County Board, Alamy, Carlow County Museum,
Conradh na Gaeilge, Kennelly Archive, Waterford County Museum,
Columban Missionary Society, Kilkenny City Council Chamber,
Cardinal Ó Fiaich Library, NYC Municipal Archives, New York Public
Library, Dutch National Archives, Hugh Lane Gallery, Mirrorpix,
Kieran Galvin Photography, Catholic Publication Society, Delany
Archive, Gerry Cassidy Collection, *Irish News, Anglo-Celt, Clonmel
Nationalist, Leinster Leader, The Irish Times, Donegal News,
Galway Advertiser, The Tuam Herald, Leitrim Observer*

Merrion Press is a member of Publishing Ireland

Contents

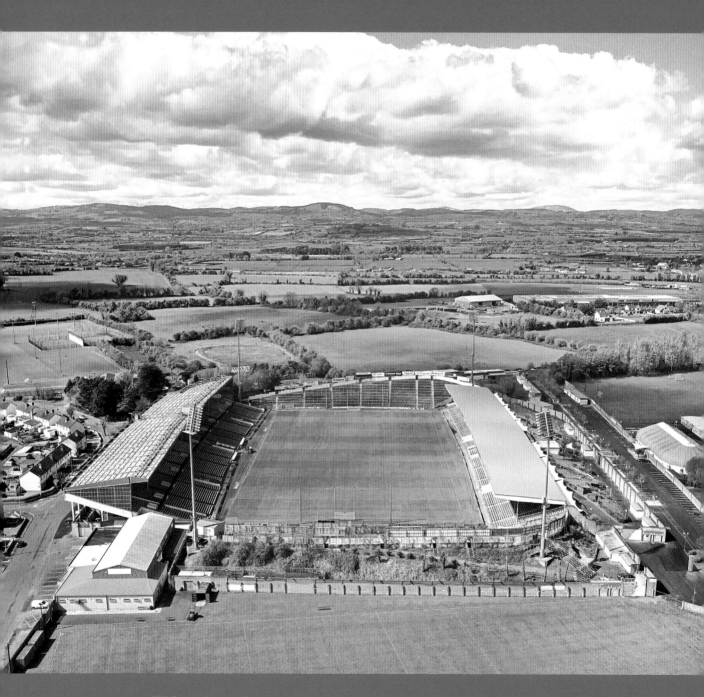

FBD Semple Stadium, Thurles – one of the GAA's most historic and celebrated grounds is an important landmark not just in Tipperary but as part of our national sports infrastructure

A debt of gratitude

IT WAS A HAPPY coincidence when Humphrey Kelleher first spoke to me about his ambitious project to record the stories of more than 100 GAA grounds the length and breadth of the island. Our conversation happened at a time when Tipperary GAA were about to announce that FBD Insurance had secured the naming rights for Semple Stadium so the important role such an iconic ground, along with GAA parks everywhere, plays in the lives of people was very much on my mind. Humphrey spoke passionately about how the research for *A Place to Play* was progressing (he had the title before anything else), the way his skills as a drone photographer were developing (no major air incidents to report as yet) and the warm reaction he was receiving from ground custodians everywhere.

As we swapped stories about grounds we had been to and characters we had encountered in our many years as enthusiasts of Gaelic games, it became clear that he and I were on the same wavelength about the importance of recognising and paying tribute to the generations of Gaels who first created these venues. Selfless people who raised funds to purchase plots of land and invested their time and toil in the task of creating playing spaces for their clubs and communities. We both agreed that they would be proud of the way that from humble beginnings many fine modern stadiums have emerged. Some more grand than others but all with the ability to energise players, enthral spectators and inspire kids to dare to dream.

I wished Humphrey well with his project and would occasionally hear from him as he criss-crossed the country on his herculean task. All his endeavours have handsomely paid off. *A Place to Play* is a book to be treasured, an engaging, insightful and often amusing compendium that pays homage to the national treasure that these grounds really are.

Enjoy.

[signature: Michael Berkery]

Michael Berkery
FBD TRUST CHAIRMAN

FBD Trust was established in 1974 by the founding farmer shareholders of FBD Insurance Company. Its mandate is to provide funding for education, research, sponsorships, publications and other initiatives that advance the interests of Ireland's farming and rural communities. Through the Trust's philanthropic disbursements, FBD Insurance reciprocates the loyalty of its customers. The author gratefully acknowledges the generous financial support of the FBD Trust, which helped so much to bring the research and writing of this work to fruition.

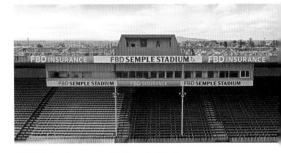

FBD joining its name with Semple Stadium is a prime example of the company's ongoing commitment to the GAA

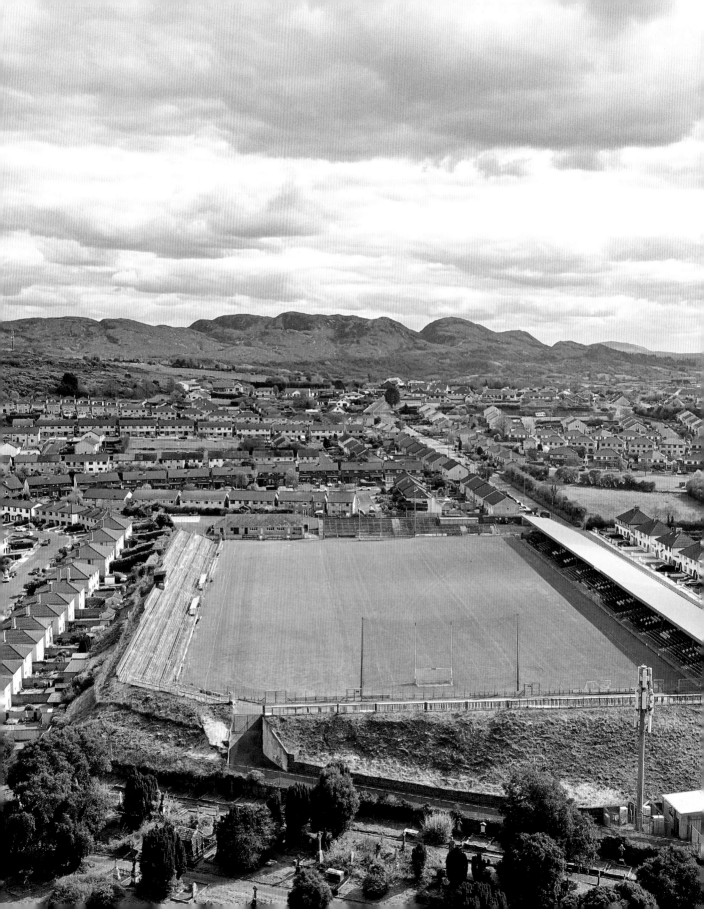

A celebration of Gaelic grounds

I WELCOME THE PUBLICATION of this book. It is another significant addition to the library of the GAA by Humphrey Kelleher. He is a man who has already made a lifelong contribution to the promotion and development of Gaelic games, not least in his nurturing of hurling, in particular, at club and county level.

His previous work on the prestigious silverware that adorns our competitions produced a wealth of information about 101 of our prized cups and trophies. We are indebted that he has gone back to the coalface and excelled himself once more in the production of this work, which chronicles 101 county grounds in the GAA – featuring venues well known and others not so well known across the 32 counties, as well as grounds in London and New York.

Larry McCarthy
UACHTARÁN CUMANN
LÚTHCHLEAS GAEL

It is good to take time out from the ongoing drive for progress so as to appreciate what has been achieved, and the truly magnificent collection of grounds that has been left to us. Humphrey's research, and his wonderful photographs also, are a lasting record of how much has been accomplished. No other sport in Ireland has invested as much in their grounds as the GAA. As rightly proud as we are of the great sports that we play, we put enormous emphasis on those places where we play them.

Clubs and communities work tirelessly to maintain venues that are the envy of many, and a credit to the volunteer effort involved. The best of them are chosen to host our biggest games as county grounds, and here, in this book, are the stories behind them.

Thar ceann Cumann Lúthchleas Gael, comhghairdeas, Humphrey, agus míle buíochas.

Markievicz Park, Sligo

A great mingling

Trips to hallowed grounds in high summer

MICHAEL FOLEY

TWENTY-FOUR YEARS ago the writer Simon Inglis came to Croke Park for the All-Ireland hurling final between Cork and Kilkenny. Sports stadia were among his great passions and Croke Park among those experiences he was gathering for a book that eventually became *Sightlines*, a journey across five continents to capture the essential charm and importance of the world's great venues.

His interest in these places was so deep and abiding that when his wife once asked him where they were as they flew over a city in middle Europe, from his window seat and with a clear sky below him he could see a football stadium and tell her that, from its contours and angles, they were cruising at 30,000 feet over the home ground of Eintracht Frankfurt.

His essay on the meaning of Croke Park beyond its bricks and mortar sprouted from the joys of an All-Ireland final day. He called it 'A Great Mingling.' No expression for a big match anywhere across the country in high summer seems more appropriate.

These grounds of ours are the scene for that great mingling, from all corners of a vast and varied community, drawn to these small, medium and gigantic grounds simply to watch a game.

The ones we have known since we were children are knitted into our memories. We know the route there without even thinking of the journey. We know the smell of the place, the best places on the bank to watch the match, the old trees to sit in or the hills and balconies that overlook the pitch.

We know the pitches – a split-second scan of the grass or a study of one patch will tell us if the place is in good order for the time of year. We know the parking spaces and the bars and the restaurants and the picnic spots and the rat-runs out of town to dodge the traffic clogged up by day-trippers to the place. We know the good tickets and the bad tickets. We also know the days when there's no such thing as a bad ticket.

But there is much we didn't know about these places too. Sometimes the name of the ground meant nothing to us. The stories of the men and women who gathered money and took risks to buy these fields were usually, outside their own families, lost to history. The stories of how these grounds, often built in the quietest, most unlikely parts of the country, became such places of pilgrimage got balled up and tossed away over time.

Which is no one's fault either. The very point of buying these plots of land over the years was a direct expression of the GAA's core ethos to preserve and promote the games and bequeath a legacy to the generations that followed. Those early founders succeeded on all counts.

This collection of grounds was built as the canvas upon which masterpieces could be created by the players and where communities

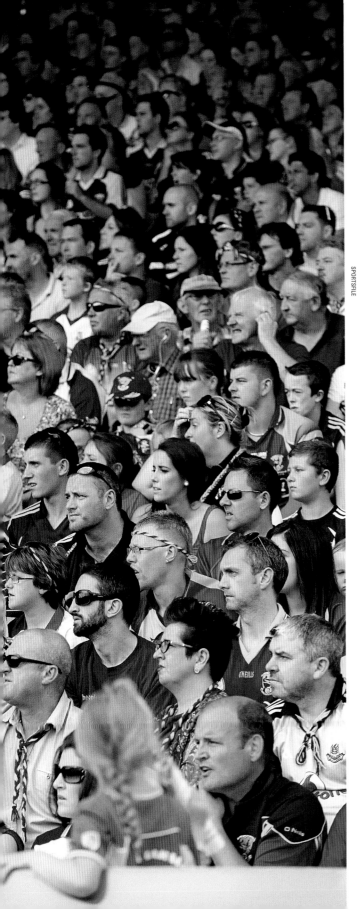

could be built and sustained. Their never-ending gift to us is the epic games and days out and memories that cement entire lives together, match by match.

Being remembered was never the point, but the need to recognise the sacrifice and enterprise of these pioneering groups of people across the country and beyond is why *A Place to Play* has come about. Their stories are often remarkable and courageous. The new photographs of every ground here also provide a set of important social documents about how each venue lives within its own community. Some are stitched into the fabric of a town or city; others are surrounded by fields. Some are hemmed in by cemeteries, factories, railway lines, supermarkets, rivers, beaches and canals.

All of them have their own stories, bound together by those who raised the first posts on these fields, marked out the first pitches, dug the first foundations and laid the first bricks. With this book Humphrey Kelleher has paid them all due tribute and done the GAA an enormous service.

Collective experience – young and old pack Ardán Ó Riain in Semple Stadium for an All-Ireland hurling quarter-final in 2014

...

Michael Foley is a sportswriter with the *Sunday Times* and author of a number of GAA-themed books, including *The Bloodied Field: Croke Park. Sunday 21 November 1920* and *Kings of September*

A decade-long odyssey

Mining through records and soaring through skies

When I had decided on the grounds to feature in the book, the final selection was marked on my trusty road map and pinned to the wall of my study. It acted as an inspiration to finish the work, recording what was done, the places visited, and where was left to go

IN 2013 I COMPLETED *GAA Family Silver*, the people and stories behind 101 cups and trophies, which proved to be a useful reference book for commentators and sportswriters, and for followers of Gaelic games. Now that I had been bitten by the bug, I started on researching this book. My initial idea was to write only about the people after whom GAA grounds were named, similar in many ways to the previous work.

But within months I realised that there was a far bigger story behind these playing fields. As I progressed, I found that very little had been written about the origins and development of club or county grounds. Though some club histories did allude to their pitch's background, they focused primarily on matches played and county championships won. Published works that focused on grounds, such as *The GAA – A People's History* by Mike Cronin, Mark Duncan and Paul Rouse, *Croke Park – A History* by Tim Carey, and *The Struggle for Páirc Tailteann* by Michael O'Brien were few and far between. I decided to select 101 Gaelic grounds and dig deeper into how they came about. As part of the criteria for selection, the parks chosen had to be an existing or former county ground, taking about three of these per county.

I wasn't to know at the outset that this journey would take me ten years to complete. The depth of history in every place, the tales of people coming together to create playing fields in every part of Ireland, and how these fields have progressed to become the GAA grounds we know today – this is a monumental story. Some of it is kept alive in local memory, some in official and other published records; more of it is beyond our knowing. This book is not, and could not be a definitive or complete history of each ground. It is

Some time after starting my research, it became apparent that if I wanted a good photo of each ground, the only practical option was to photograph them myself, using a drone. From where I was starting, neither a photographer nor a fan of gadgets, I faced quite the learning curve. There were cross-country trips when I'd find on return that an incorrect setting meant the images were unusable or even non-existent. Still, it is never too late to learn new skills, and with practice and repeated visits I began to plan the best time of day for a shot, watch how the light might illuminate a ground's features or its dramatic setting, and returning home sometimes brought delight and pride in having captured a particular picture

Having mapped out a route of grounds to be photographed, I realised that I needed another pair of eyes to act as a lookout, so I commandeered the services of my good friend, Ballymun Kickhams club man and former Dublin footballer, Eoin Kelly. Feeling confident of not crashing our aerial device, we set off. Meeting people on the ground was a great experience as we traversed the country on our mission. They welcomed us with open arms and were ever helpful in offering information about their cherished piece of land. Often, we met groundsmen as they worked away diligently on preparing the pitch for the next match. All these people, who go about their work without fuss or favour, are true stars of the GAA. They are proud of what they do and rightly so. One was adamant we should have told him we were coming, as he would have cut the grass!

Despite a mishap or two (beware of flocks of seagulls) we managed to compile this portfolio of grounds, which we hope does them and their custodians justice

a concise account that tries to capture something of the essentials, from the first purchasing of these fields to their growth and the character they took on over time.

I was aware from previous research that the GAA had set up a Grounds Committee in 1963 and that there had to be relevant files in their possession, so I set about looking for them. Despite several leads, I had no luck and was even advised that they had probably been destroyed when Croke Park was redeveloped in the 1990s. Undeterred, I continued my research, using the library in Croke Park as well as other sources. Then – a real stroke of luck – I met Kathy Slattery, who was Head of the GAA Finance Unit in Croke Park. She had files on every GAA club, she told me. I had struck gold.

The archive was a treasure trove. There were details on the purchase and cost of land, who the trustees were and documentation of the vesting process. There were letters from clubs setting out their plans to have the best ground in the GAA and how their young people would benefit from it. The quality of applications varied but all pleaded for funding. Sometimes they got it, but there were also letters of refusal when the administration itself lacked resources or allocated them elsewhere.

I began to discover more and more the contribution that county and club grounds committees made in putting these pitches in place. For me, among the real heroes of the GAA are the people who bought the land the first day and oversaw its initial development. They were supported by local communities, who dug deep to fund and oftentimes build these projects. Engineers, architects, building contractors and many others added their expertise, and none of this could have been completed without the input and advice of the legal fraternity. Further support came by way of grants from the GAA, individual donations, and, later on, lottery funding and sports grants from the Irish and Northern Ireland governments.

In all of this, the real kudos must go to the grassroots of the GAA, past and present, the people who have laid out an array of playing fields and community hubs all around the country, giving so much to the wellbeing of our society and our national culture of sport.

HUMPHREY KELLEHER
Autumn 2023

MISCELLANEOUS NOTES

CHOICE OF GROUNDS

All the parks are an existing or former county ground. That is to say, they hosted senior inter-county games at some stage in their history. As a result an average of three grounds per county are featured.

ORDER SEQUENCE

The counties are, in the main, presented alphabetically except in the Leinster and Munster sections, where Dublin and Cork jump to the head of the queue. Each province opens with a large dramatic photograph so Croke Park and Páirc Uí Chaoimh appearing first is as much a reflection on how photogenic they are as their importance within the GAA story.

London and New York are included in the Connacht section because they play in the Connacht Football Championship.

Within each county the grounds are ranked by capacity, the largest appearing first.

RESEARCH AND RESOURCES

As a primary source, the files in the GAA Finance Unit in Croke Park were invaluable while the Croke Park Library holds hoards of match programmes, year books and other printed matter about Gaelic Games.

Cotemporary sources came via the Irish Newspaper Archives' website and its British equivalent. Public libraries played a major role in my research as did the many authors, local historians and club members who generously shared their knowledge. Last but not least was the network of friends, colleagues and former players I made throughout my life in the GAA.

CAPACITIES AND GROUND SIZES

Ever-changing health and safety criteria along with ground redevelopments mean that capacities are constantly being revised, both upwards and down. The figures listed are the most up-to-date received from GAA authorities at the time of printing.

Ground dimensions can also change and the sizes listed are the result of information received from county boards, ground staff, club members and measurements drawn from satellite images on Google Maps.

LAND MEASUREMENTS

The acre is the unit of land measurement used throughout the book.

30.25	square yards	=	1 perch
40	perches	=	1 rood
4	roods	=	1 acre
2.4	acres	=	1 hectare

It is interesting to note that the average size of a GAA pitch is circa three acres or 12,000 square metres.

PRE-DECIMAL CURRENCY

When giving the cost of land purchases, building projects etc. that occurred before 1971, the money amounts appear in pre-decimal, imperial sterling pounds. 'f.s.d.' was used when writing a figure for pounds, shillings and pence, as older readers will remember. This is how they are displayed throughout:

£526. 14s. 6d.

POUNDS

SHILLINGS
(20 shillings in a pound)

PENCE
(12 pence in a shilling)

CONVERTING MONEY VALUES

There is no single 'correct' measure to calculate the relative values of money over time, and economic historians use different indicators depending on the context. In the handful of cases in this book where modern values are provided, the retail price index for a commodity from the website *measuringworth.com* was used.

Using this measure, £100 in 1900 is worth approximately €13,371 today, and in 1920 the same amount is worth €4,964.

GLOSSARY OF ABBREVIATIONS

SHC: Senior Hurling Championship
SFC: Senior Football Championship
JHC: Junior Hurling Championship
JFC: Junior Football Championship
IHC: Intermediate Hurling Championship
IFC: Intermediate Football Championship
NHL: National Hurling League
NFL: National Football League

From stony sod to pristine park

How the GAA held its ground

Dónal McAnallen

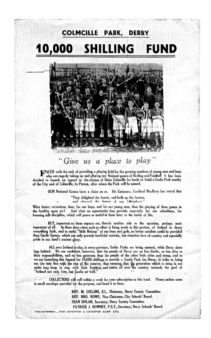

All avenues were explored when it came to fundraising in the early years of the GAA. Door-to-door collections like the one advertised above were common, as were livestock and motor-car raffles, carnivals, bazaars, dances, firewood sales, bingo nights and greyhound racing

'Give us a place to play!'

THIS HEADLINE ON a pamphlet promoting the Derry City GAA Board's '10,000 Shilling Fund' in 1939 – which was intended to buy and develop 'Colmcille Park' – could have been repeated in every Irish county for the first half-century and more of the association. More than any other large sporting organisation in Ireland, the GAA had struggled to secure regular playing fields, homes for their games.

The new association had hardly any wealth or resources at its disposal in the 1880s. The bulk of members were agricultural labourers and landless lower classes. Those small businessmen who favoured it had few pastures to their names. Colleges that played sport did not engage with Gaelic games. And the GAA's alignment with Home Rule and agrarian causes, plus IRB infiltration, ruined most chances of patronage from the ascendancy and gentry who still dominated the land; their fields were given to other sports.

Finding urban spaces was especially difficult. Cricket, soccer and even polo had the edge in public parks. The pioneer hurlers at Dublin's Phoenix Park complained of discrimination and obstruction. Belfast Corporation and city fathers elsewhere forbade games in their parks on Sundays. Local objections to Sunday play brought an end to the GAA's lease of an All-Ireland venue at Terenure, Dublin, in the early 1900s. Meanwhile, urbanisation ate up green spaces, bricks and mortar replacing some early Gaelic fields.

It was with assistance from sympathetic farmers and land-

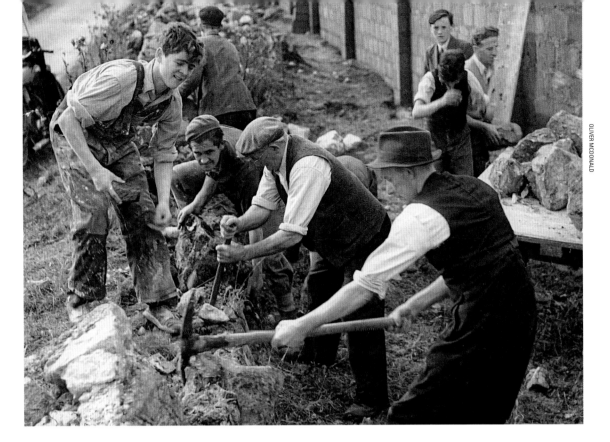

owners that the GAA's initial 'prairie fire' spread from Munster to the Sligo–Dundalk line, as described by Michael Cusack. Typically, though, clubs could only obtain short leases, which militated against them investing in ground improvements. And though shared access between Gaelic games and other sports was a frequent phenomenon in the early decades, it was seldom a happy arrangement. For one thing, hurling and Gaelic football required a much bigger field (140 x 84 yards minimum) than those of rugby, soccer and hockey. Gaelic teams were also bigger in number – 21-a- side at first, and then 17-a-side until 1913. Tampering with another code's pitch markings or churning up the soil caused many rows.

In some large towns, GAA units and other recreational clubs became joint tenants and shareholders of sports grounds from the 1900s on. At least these grounds were central and equipped to host the swelling Gaelic crowds; and, being enclosed, they enabled collection of gate-money (which could be invested in facilities) and reduced the spectator encroachments that had disturbed so many early games and caused so many boardroom objections.

The spirit of the age emboldened the GAA to go solo. The advent of county councils from 1899 raised nationalist voices to a

The GAA's voluntary heyday in the 1950s. Locals set to work in Killeavy, Co. Armagh, with picks, shovels and bare hands, their own tractors and the odd borrowed bulldozer. Hedges were razed, hills flattened and rivers redirected to build a pitch in every parish

…

Early playing fields were far from ideal. A club match at Strandhill, Sligo, in 1893, took place on a small pitch with a large rock at its centre, with a man sitting on the rock like a sentinel to prevent players from 'dashing out their brains against it.' Lines were marked irregularly, sometimes with players' clothes, and wooden goalposts were often erected on match-day with drooping ropes as crossbars. The work of developing these sloped, bumpy or often marshy grounds continued for years

This photo, taken in Doohoma, Co. Mayo, shows how rudimentary pitch facilities often were, even as late as 1970. The goals here were fashioned from rough timber and fishing nets, and fought against the winds blowing in off the Atlantic

...

For decades, many clubs struggled to develop facilities as they did not own their playing fields, and were often forced to move out. Hence the fields and posts they used on any given Sunday were very poor relations to the developed county grounds. A columnist in Newry's Frontier Sentinel *remarked in 1944: 'One season they are in Farmer Rafferty's field, but the following season they are told to get out as Farmer Rafferty wishes to plant corn. They carry their posts to Farmer MacFetteridge's field and play a season or two there, but then along comes Farmer McFetteridge with a request that they remove their posts in order to allow him to plant his potatoes. And so they move from pillar to post while the officials of Croke Park rack their brains for the best method of spending another forty or fifty thousand pounds on the further equipment of the National Stadium.'*

higher pitch and nurtured county consciousness; and the Land Purchase (Ireland) Act of 1903 opened up peasant proprietorship, through which small farmers could lease fields – subject to crop rotation – without landlord veto. GAA members began to follow their county team as well as their local clubs, and began to dream also of having a place of their own.

Munster struck first. Cork Athletic Grounds was reserved for Gaelic sports alone from 1906, after two years of sharing with soccer and hockey. As tensions between the GAA and rival bodies over one another's lease terms caused many sports grounds governed by limited companies to collapse, news that Dublin's City and Suburban Racecourse ground would be devoted solely to GAA sports prompted 'Vigilant' in the *Kilkenny Journal* to remark in February 1911 that 'the motto of "Gaelic fields for Gaelic players" is winning all along the line, and Jones Road has followed the lead of Dungarvan, Cork, Thurles and other places that can distinguish between a hawk and a hand-saw'.

After the Croke Park purchase in 1913, GAA officials in the counties awaited their opportunity to secure Gaelic grounds for the long run.

Independence for the Free State moved the goalposts. The new climate south of the border was pronouncedly *pro* Gaelic culture and sports. In 1922, a government grant to prepare Croke Park for the Tailteann Games conferred on it the de facto status of 'national stadium'. The reconstituted Irish Land Commission, in executing the division of old estates, received ever more approaches from GAA officials, and often offered fair terms that led to purchases.

The 'county ground' model took hold swiftly. This term meant that a field was bought and developed by a county board as a playing centre to stage club championship finals and inter-county matches. Boards were now taking charge of their county teams and running more regular competitions. Leix County Board's purchase of its Maryborough pitch in 1919 was perhaps the pilot county ground, aptly prefiguring the birth of a new Laois identity with Portlaoise as its centre. Breffni Park set a new landmark in 1923. Even as the embers of the Civil War glowed, the Cavan board moved rapidly to buy and develop this ground as a way for the county – all counties – to reunite and play together again.

The succession of new county grounds over the next decade and a half embodied and hastened the GAA's exceptional growth. More national competitions and publicity stirred excitement and elevated Gaelic games to mass spectatorship. This steady rise in popularity proved profitable, but also challenged the GAA to extend and improve venues to host them. The executive policy pursued by Pádraig Ó Caoimh as *Ard Rúnaí* from 1929 (when the GAA owned just 16 fields) was to 'plough back into grounds and pitches any surplus income'. The projects were equally driven at county level by a common purpose, as local acts of nation-building. Meanwhile, the vesting process entailed transferring the title deeds to the GAA, in the names of trustees from the county or club, provincial council and *Ard Rúnaí*. The result was that the association advanced from being all but unpropertied to owning and launching impressive grounds in most counties. They proved remarkably durable: about half of the principal county grounds of today (2023) were opened during this GAA boom between 1923 and 1938.

The naming of Gaelic grounds after historic figures, places and events sets the GAA apart in world sport. During the 1940s–50s era there was a profusion of parks memorialising republican martyrs, yet a clear majority of all grounds over time were dedicated to non-political persons – saints, former GAA players and officials – and local features. Besides, on big match-days people spoke of Thurles, Killarney, Tuam, Clones and so on; patron names fade away.

Most clubs, however, had little home comfort at this time. Hardly any owned a ground, and in various parts of the country some were still surviving peripatetically, hingeing on local farmers' whims. Such hand-to-mouth struggles often soured rank-and-file views of the enlargement of county arenas. Nonetheless, from the early 1950s more funds percolated down through the GAA's hierarchical structure to the grassroots. Central Council and provincial councils disbursed annual grants to county boards to distribute to clubs that had purchased and vested their own grounds. This was bolstered locally by fundraising ventures of all kinds, 'GAA weeks', carnivals and tournaments aplenty. Club-owned pitches multiplied perhaps tenfold within a decade until there were over 250 by 1962, when a total of 325 vested grounds were counted and mapped by the GAA. Pádraig Ó

Archbishop of Tuam, Rev. Dr Joseph Walsh, officiating at the opening of St Jarlath's Park, Tuam, 1950

...

The formal opening ceremonies were big occasions, featuring oratory by special guests, blessing by a Catholic clergyman, parading and musical renditions, and a game between leading county teams if not also local clubs in contest. These rituals were both a celebration of accomplishment and a statement of the GAA's permanent presence in every corner of the land

Caoimh explained the significance of this achievement:

'These fields represent more than a place to play, they stand for the unchanging loyalty of parish and club and county to the ideal of the nation's games for the nation's children.'

Newly appointed committees at each level also undertook audits of facilities. Bord na bPáirc(eanna), installed in 1963, produced a 'grounds plan' to award grants on a phased basis, starting with provincial (final) grounds. Deeming there to be ample county grounds now, they shifted focus towards refurbishing them for spectators' safety and comfort, and for players' benefit. The inauguration of the national Grounds Tournament in 1961 topped up central funds for these developments.

While new club grounds continued to open, pre-existing club facilities required much work. Clubs heeded urgings from Croke Park to upgrade pitches to include amenities such as dressing rooms with running water and showers for players, and to regularise playing fields to standard dimensions with clear markings, fixed goalposts and nets.

Building community centres became the 1970s mantra. The numerous GAA-owned halls in these years catered for concerts, dances and Scór competitions, plus sundry indoor sports. Many Gaelic branches opened social clubs with drinks licences. These lured old and new members in through the doors, generated buzz, and yielded some tidy profits.

The goal that every parish would have its own pitch was re-emphasised throughout centenary year, 1984. A year later, the 1,000-mark was breached.

With this progress came problems. Some clubs overspent and overborrowed. Running a club bar brought the same headaches as a pub in town, and serving pints could absorb more effort than scoring points. Consequently, some Gaelic social clubs called time. For county grounds, too, harsh realities mounted. There were decreased crowds, commentary about stadia as 'white elephants',

DERRY JOURNAL

Few matters caused as much division and politicking at provincial council level as the allocation of major fixtures to county grounds. The crowds came anyway, surging through the gates, packing the stands, sitting on the sidelines, and often swelling far beyond the ground's actual capacity. The health and safety rules of recent years have improved conditions, though people who recall those earlier times will always remember the excitement of big match-days, like this 1946 Ulster camogie semi-final replay at Celtic Park

and grass-bank terraces and creaking concrete imperilling safety, at Croke Park especially. However, lessons were learned and new safety standards were imposed on all grounds in the country.

The Celtic Tiger era spawned bigger designs to cater for the ever-increasing use of resources, for males and females, from six-year-olds to past masters. Government and lottery funding multiplied. County grounds of the new millennium became greater, floodlit and even colour-coordinated, with spacious changing rooms, media areas and manicured pitches. Naming rights for several venues have been sold to sponsors to recover costs. (Grounds are not referred to by sponsored names in this book, as these change over time.) Key venues became flagship stadiums, and along with several other grounds diversified into hosting concerts and other commercial events. Though GAA officials locally may be wary that their volunteer-built club facilities could be exploited unduly, Gaelic grounds have at the same time become ever more the hub of communities. These premises, of course, come with big costs and clubs and communities are constantly stretched to fundraise for their upkeep – but that is what they do.

The GAA-owned grounds in Ireland alone total 1,745 in the year 2023: 247 in Connacht; 395 in Ulster; 517 in Munster; and 586 in Leinster. Finally we can say, we have a place to play.

Dr Dónal McAnallen is Library and Archives Manager for National Museums NI, and a historian whose published works include The Evolution of the GAA: Ulaidh, Éire & Eile; The Cups that Cheered: A History of the Sigerson, Fitzgibbon and Higher Education Gaelic Games; *and* Forgotten Gaelic Volunteers: Ulster GAA Members who fought in World War I.

Today county boards are investing in creating county training centres, like the Connacht GAA Centre of Excellence in Bekan, Co. Mayo, with its innovative and striking dome that accommodates a full-size pitch
...
Modern facilties, with multiple pitches, all mod-cons to cater for county teams, and administrative headquarters, have come a long way from their origins. For many clubs, meanwhile, the local pitch is often augmented with a practice area, perhaps a second pitch, even a third; a stand, seats, a scoreboard and floodlights; carparks; a pavilion with four dressing-rooms, a kitchen, perhaps a gym, and much else

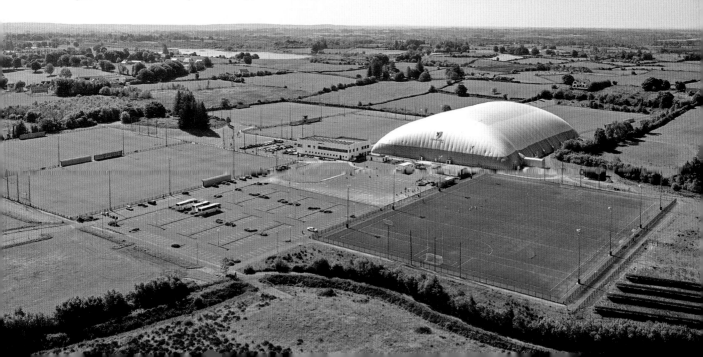

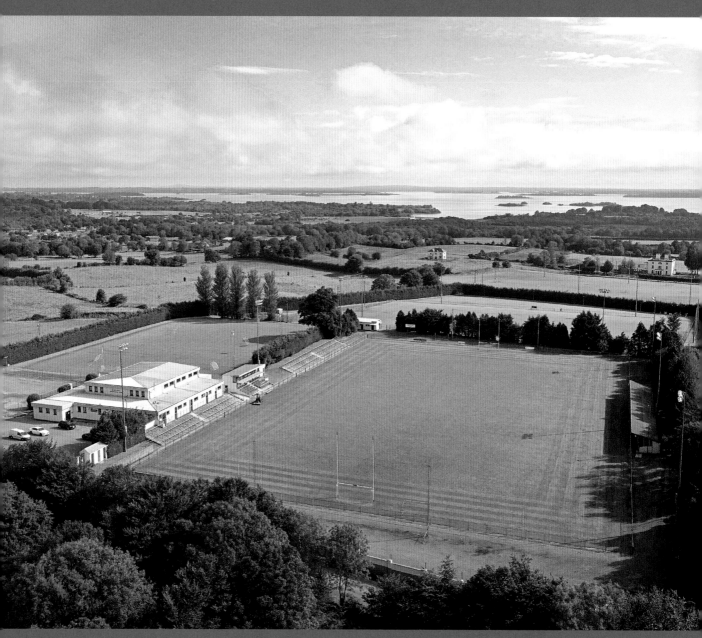

St Brigid's Park, Kiltoom, Co. Roscommon

CONNACHT

Pearse Stadium

LOCATION
Dr Mannix Road, Salthill, Galway

NAMED AFTER
Pádraig Pearse (1879–1916)
1916 Rising leader

OPENED
1957

CAPACITY
26,200

PITCH DIMENSIONS
145 x 81 m

COVERED ACCOMMODATION
Yes

FLOODLIGHTS
No

CLUB
No

Galway Bay and Salthill provide a glorious setting for Pearse Stadium. The seaside location also gives rise to the wind for which the ground is famed

WASHED OUT OF THE SWAMP

By 1887, just three years after the founding of the GAA, Co. Galway had 45 registered clubs, and all of 78 by 1888. In Galway city Gaelic games were played at Renmore in the early 1900s, on land owned by Major T. Wilson Lynch, who was very supportive of the fledgling sports.

In 1903 the GAA began discussions with Galway Urban District Council about acquiring a ground in the South Park area of the Claddagh, on land known locally as 'the Swamp,' and ten years later secured a lease on part of it. From then until the 1950s games were played either in South Park or at the Sportsground – now home to Connacht Rugby.

There were ongoing objections to the games in South Park, however: the Harbour Commissioners felt the land should be used for industrial development. Mother Nature intervened in the end. At Christmas 1951 gales and high tides combined to wreak havoc and flood the park. A new location for a GAA stadium was plainly needed.

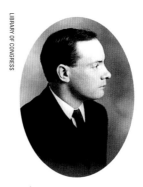

LIBRARY OF CONGRESS

PÁDRAIG PEARSE (1879–1916)

Pádraig Pearse was a teacher, barrister, poet, writer, nationalist and political activist. Leader of the 1916 Rising, Pearse developed his love of the Irish language by spending summers in Rosmuc between 1903 and 1915.

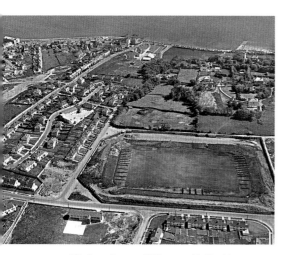

Work on the new GAA ground in Rockbarton was well under way when this aerial shot was taken over Salthill in 1956/57

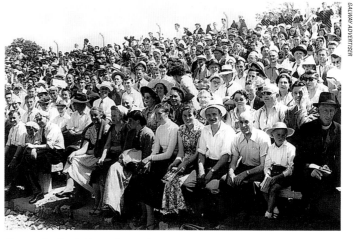

GALWAY ADVERTISER

'A great day for the bog' – Pearse Stadium was inaugurated on 16 June 1957 on a blistering hot day. The large crowd sweltered in the heat as they watched Galway defeat Tipperary in hurling and Kerry in football in a double-header

KEY DATES

1900
Major Wilson Lynch offers the GAA a field. He also provides land to host the first Galway Races

1903
GAA begins negotiations with Galway Urban Council and Harbour Commissioners

1913
GAA finally leases South Park in the Claddagh

1952
Galway Corporation and Chamber of Commerce join with county board members Rev. James O'Dea, John Cotter, William Keane, Patrick Ruane, Paddy Taylor and Edward Walsh to source a ground

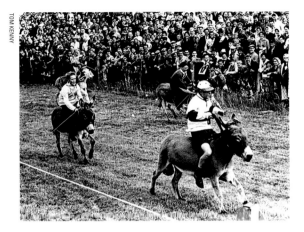

TOM KENNY

Champion Ryder – local boy Christy O'Connor Junior gallops to glory in a Donkey Derby run on the hallowed turf of Pearse Stadium circa 1965. The Knocknacarra lad would grow up to experience many more sporting highs as one of Ireland's golfing greats

OUT OF THE SWAMP AND INTO THE BOG

In April 1953 Galway Corporation granted the GAA a lease on a 17.5-acre site on land in Salthill which was known locally as 'the Boggers' because it was so wet and boggy. Undeterred, the GAA launched an appeal for funds and quickly raised the considerable sum of £15,000. Work on a new stadium – to include a pitch and athletics track surrounded by terracing – began in 1955 by Messrs James Stewart Ltd in the sum of £34,337. 3s. 9d. Additional monies were to come from America, from tournaments, the GAA and bodies sympathetic to the project. Pearse Stadium was opened on 16 June 1957 by GAA President Seamus McFerran in front of a reported crowd of 16,000 people, who paid two shillings admission and two shillings extra for a sideline seat.

RESTORING PRIDE

In 1972 Fr Griffin's GAA Club agreed to take over the management of the stadium and pay off the £10,000 debt incurred by the Galway County Board. In exchange, the club was allowed to use the facility as their home ground. The club also bought out the freehold of the ground for £3,000 from Galway

Corporation. However, following a row with the county board, Fr Griffin's ceased managing the park in 1984 and by the early 1990s it had fallen into disrepair.

A redevelopment committee under the chairmanship of Salthill GAA Club's Tom Leonard faced a derelict site, a broken-down stand and an overgrown, weed-infested pitch and terracing when they began refurbishing Pearse Stadium in 1996. The work involved removing 2,000 lorry loads of boggy soil, sometimes to a depth of 20 feet. Bolstered by a FÁS employment scheme and later a £650,000 government grant, a new pitch, terracing, and in 2001 a new stand to accommodate 8,000 spectators were constructed. The stadium was reopened on 25 May 2003 by GAA President Seán Kelly in the presence of Taoiseach Bertie Ahern.

SINGING IN THE RAIN

Bob Dylan, Bryan Adams, Andrea Bocelli and more have all helped to fund Pearse Stadium's growth by performing at the Salthill venue. Westlife generated huge excitement when they arrived in June 2008, but the boggy origins of Galway's GAA grounds, first in the Swamp and then the Boggers, put a dampener on things. Though it was held on midsummer's day, the concert was played in a downpour.

Some years later, in August 2021, as Covid pandemic restrictions began to ease, the stadium celebrated the return to normal life with a four-night festival of music at which capacity was limited to 500 people, gathered in socially distanced pods of four.

1957 Galway defeat Leitrim in the first Connacht SFC final played at Pearse Stadium

1970 The stadium hosts the first Connacht football final to be broadcast live by RTÉ television. Galway and Roscommon played over 80 minutes as part of a rules experiment

1995 Galway County Board launch a new initiative to redevelop the ground

2003 Connacht SFC final returns to re-vamped stadium, and six more times up to 2022

2011 Stadium capacity reduced to 26,197 following health and safety survey

Kenny Park

LOCATION
Swan Gate, Athenry

NAMED AFTER
Tom Kenny (1877–1947)
Blacksmith, political radical, hurler, GAA administrator

OPENED
1955

CAPACITY
6,500

PITCH DIMENSIONS
145 x 85m

COVERED ACCOMMODATION
Yes

FLOODLIGHTS
No

CLUB
No, but has a historic connection with St Mary's

St Mary's Athenry is a dual club, but hurling is its real strength. The senior hurlers have won eight county titles and the All-Ireland club crown on three occasions, 1997, 2000 and 2001. The club has produced many fine players for Galway county teams, including household names like Joe Rabbitte, Paul Hardiman and Eugene Cloonan.

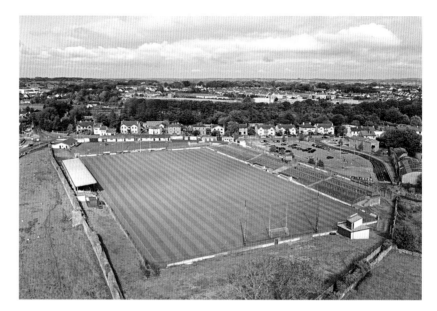

Kenny Park lies within Athenry's original town walls, constructed in the 1300s by the de Burgh family. They remain among the best preserved medieval walls in Ireland. The land on the South Moat side of the town was the site of a hospital which included a leper compound in the 14th and 15th centuries. When the hospital ceased operation the area was left to the people of Athenry as a park, and became known locally as the Back Lawn. Athenry GAA Club, founded in the spring of 1885, played their games there, and it was a popular venue for club and county games because of the town's central location.

At the turn of the 20th century the lease on the Back Lawn was held by a Mrs Barrett, subject to football being played there and the holding of the annual show. After the Land Commission purchased the land from the estate of Lady Edith Drummond, townspeople felt that the Back Lawn should continue as a park, and it was vested in five men to hold in trust for the town. In 1912 the trustees gave the GAA the right to use the field on Sundays and Church holidays for sports and pastimes, and indeed for some 20 years many Galway county finals were also played there.

Kenny Park is widely regarded by players as having one of the best summer hurling surfaces in the country and by fans as a favourite venue to enjoy a game

KEY DATES

1885
Less than a year after the founding of the GAA, Athenry affiliates to the new association

1902
Many Galway county finals are played at the Back Lawn between now and 1922

1932
Athenry GAA Club resolves that: 'We, the Gaels of Athenry, protest against the sale of the Back Lawn to any individual'

1947–49
Loughrea, Craughwell and Athenry are deemed suitable for a Kenny Memorial Park, but Athenry is finally preferred

1952
As Sheehy Brothers, Limerick, tender £1,200 to develop the ground, the bank refuses request for £1,000 loan

TOM KENNY

Born in Craughwell on 5 November 1877, Tom Kenny left school at 14 years of age and went to work as a blacksmith with his father. A keen hurler, he and Michael Conway reorganised Craughwell GAA Club in 1904. From 1909 to 1916 he was chairman of the Connacht Council and a member of GAA Central Council. He was at the GAA Congress in Dublin when the Rising broke out, and as organiser of the IRB and Sinn Féin in East Galway returned home to take part in the rebellion. Afterwards he fled to the USA, where he remained politically active to the point that a British MP asked the Chief Secretary, 'was Ireland to be ruled by a Galway blacksmith?'

Returning to Craughwell in 1922, he was chairman of the Galway County Board when Galway won the 1923 All-Ireland SHC title, played in 1924. It was the county's first triumph at this level. Tom Kenny died aged 70 on 29 March 1947.

CRAUGHWELL NATIONAL SCHOOL

Kenny saw himself as a socialist and led an agrarian secret society that aimed to redistribute the land of the big estates. His radical ideas and actions made him many enemies and generated a lot of turbulence locally. In one notorious incident in 1911 his hurling team were shot at in Craughwell

JUDGE DECIDES FOR GAA

The last remaining trustee, John F. Kelly, died in 1928 and title to the Back Lawn passed to his nephew, Patrick M. Kelly, who decided to sell the land. A contract for sale was agreed with Mrs Annie Fox of Athenry, but Athenry GAA Club protested. In 1933 District Court judge Wyse Power reaffirmed that the Back Lawn must be held in trust for the people of Athenry and any profit made should be for the good of the poor. Judge Wyse Power was a son of John Wyse Power, one of the founders of the GAA.

MEMORIAL COMMITTEE OPENS GROUND

New trustees were appointed in the '30s, including James Ruane, Stephen Jordan, Michael Walsh, James Barrett, Michael Kilkelly and John Cleary, but gradually GAA officials' influence grew as the Back Field ran into financial difficulties. Finally in 1952 the trustees sold the Back Lawn for £500 to the Kenny Memorial Committee, who aimed to develop a new stadium on the site. Athenry, one of the most important railway junctions in the West of Ireland, was an ideal centre, and on 3 July 1955 the Tom Kenny Memorial Park, the first enclosed grounds west of the Shannon, was formally opened.

CLUBS UNITE AS ST MARY'S

In 1956 Athenry GAA Club attempted to unite clubs in the town under the name St Mary's. Two years later the Kenny Memorial Committee and the local trustees agreed to vest the property in the GAA as a county ground. A deed was drawn up that prescribed that the grounds be held in trust for Galway County Board. No provision was made with regard to St Mary's use or ownership of the park. This had repercussions some years later.

DISPUTE FINALLY RESOLVED

In 1982 Galway County Board set up the Kenny Park Committee to manage the park development. Just a few days after the park's reopening on 3 June 1985, a major conflict broke out between St Mary's club and the county board. The board insisted that the grounds were the board's property and that the club could only use it at their behest. The club and county board eventually came to an agreement on St Mary's access to the ground.

1955
Tom Kenny Memorial Park is opened on 3 July by Dan O'Rourke, Chairman of the Connacht Council and a former GAA president

1984–85
Kenny Park undergoes a £145,000 facelift

2002
GAA President-elect Seán Kelly opens St Mary's new grounds and clubhouse on 17 August at an eight-acre site at Carnaun, about 7km north of Kenny Park

2007–16
Kenny Park gets new dressing rooms and in 2010 a designated area for the disabled. Improvements continue through 2014 and 2016, and further plans are in place to develop the Swan Gate end

Duggan Park

LOCATION
Harris Road, Ballinasloe

NAMED AFTER
Dr Patrick Duggan (1813–1896)
Bishop of Clonfert, nationalist,
tenants rights supporter

OPENED
1934

CAPACITY
3,000

PITCH DIMENSIONS
141 x 84m

COVERED ACCOMMODATION
John Dunne Stand

FLOODLIGHTS
Yes

CLUB
**No, but had a historic
connection with St Grellan's
football club and Ballinasloe
hurling club before they
merged in 2005 and moved
to Brackenragh**

Ballinasloe GAA Club continues
to add to the town's long and
illustrious Gaelic games history,
winning an All-Ireland junior
football title in 2013. Many of its
players have worn the maroon
and white of Galway.

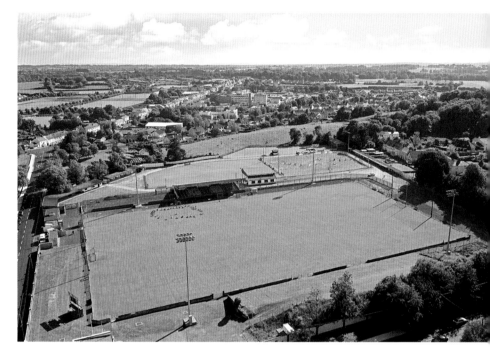

The rules of hurling were first sketched out in Ballinasloe on Easter Monday 1884 when the East Galway hurling champions Killimor played a challenge match with Michael Cusack's Dublin Metropolitan Hurling team on the Fair Green. However, confusion reigned once the ball was thrown in because the teams were playing to different rules. The match was stopped and Cusack's side gave an exhibition so that Killimor could note their style. Killimor then gave a display of their own. Cusack refused to continue the match and Killimor were declared the winners, but afterwards he and Frank Lynch, the Killimor captain, met in Hayden's Hotel to discuss the rules. The clash of styles between the teams convinced Cusack that the rules of Gaelic games needed to be standardised and that a body must be established to govern the sports. In the meantime, when Killimor played Meelick on the Fair Green on 12 June – a match that lasted three hours and ended in a draw – the game was played under Cusack's rules.

Sleeping giant – throughout its history Duggan Park has been plagued by stop-start development schemes. Locals feel its potential has not been properly exploited

KEY DATES

1889
Ballinasloe football club
is founded; changes
name to St Grellan's
Gaelic Club in 1913

1893
Creagh overcome Ballinasloe 2–1
to 0–1 in first football match in
Ballinasloe, played in Pollboy

1924
Galway beat Roscommon
in a Connacht SFC match
played in the Mental
Hospital's grounds

1934
Duggan Park opens on
8 July; becomes a popular
venue for Railway Cup
games from 1938 on

DR PATRICK DUGGAN

Born in Cummer near Tuam, the eldest of four children, Patrick Duggan was brought up in the house of his uncle, the parish priest of Cummer. Ordained in 1841, he saw at first hand the horrors of the Famine, which deeply influenced his political views. Consecrated Bishop of Clonfert in 1872, Dr Duggan lived a frugal lifestyle and was wary of the influence the wealthier farming class was having on the Church. To remedy this growing worldliness, he told a meeting of the hierarchy: 'I would put the priests – and perhaps ourselves – on a diet of Indian meal stirabout for twelve months.' Michael Cusack invited the bishop to become a patron of the GAA but he declined due to ill health and suggested Archbishop Croke in his place.

BALLINASLOE HERITAGE

FINDING A PERMANENT HOME

In the early years football in Ballinasloe was played at a field in Pollboy and in the grounds of the Mental Hospital, where most hurling matches also took place. In 1932 Fr Hughes, Dr Rossiter, T. J. McGrath, W. O'Rourke and E. Kilduff set up the Town's Sporting and Development Association to lease part of the Fair Green from the Earl of Clancarty. The Agricultural Show Society and the GAA procured part of the green for £450 on a 20-year lease at a rent of £20 a year. The society paid £270 and the GAA £180, plus a further £10 for additional ground. The area was just over four acres, small for an inter-county pitch. Nonetheless £600 was spent on levelling and enclosing the field, £200 of which was contributed by the town's traders.

INVESTING AND INVESTITURE

A development committee chaired by Fr Hughes and with John 'Tull' Dunne as secretary, supported by St Grellan's football club, built an embankment on the Sarsfield Road end of the ground using cinders from St Brigid's Hospital, and installed five rows of seating catering for 5,000 spectators. The committee's first big challenge came when they were asked to host the Connacht SFC final on 19 July 1942, when Galway defeated Roscommon. The game came just a few weeks after Duggan Park became the first ground in Galway to be vested in the GAA.

As a young priest during the Famine, Duggan worked hard on behalf of his starving parishioners, tending to their physical and pastoral needs and writing letters to the press seeking aid. Later his own father was evicted from his house at Carrownageeha. As bishop his sympathies were entirely with the aims of the Land League

TREADING WATER

In the 1970s seating for 8,000 was installed and the John Dunne Stand was built in 1978 in co-operation with the Agricultural Show Society, who used the ground on show days. Capacity increased to 17,000 but expectations of regular inter-county fixtures were disappointed as the ground hosted only occasional NFL and NHL games up to the mid-2000s, and little improvement work was done.

A major upgrade of the park was sanctioned in 2014. Floodlights – the first in a Galway county ground – were erected and the terracing dug up to facilitate further redevelopment. But then, suddenly, the work came to a halt.

Club games continued at Duggan Park but the ground remained undeveloped. The first inter-county game played there since 2011 was held in January 2022 when Galway's hurlers entertained Offaly in the Walsh Cup.

1941
Galway County Board offer £355. 10s. 7d. for Duggan Park and take ownership in June 1942

1945
John Joe Barry, the 'Ballincurry Hare,' wins the mile event at the National Athletics Championship in Duggan Park. He represents Ireland in the 1,500 and 5,000 metres at the 1948 London Olympics

1977
Galway defeat London in the last Connacht SFC match played at the park

2023
Park Development Programme deferred. Instead, adds its support to county board's fundraising for the park

St Jarlath's Park

LOCATION
Vicarschoraland, Tuam

NAMED AFTER
Saint Jarlath (d. 550 AD)
Medieval priest, scholar

OPENED
1950

CAPACITY
6,700

PITCH DIMENSIONS
140 x 84m

COVERED ACCOMMODATION
Yes

FLOODLIGHTS
No

CLUB
No, but has a historic
connection with Tuam Stars

Tuams Stars are a powerhouse in Galway football, regularly winning honours at all grades. The opening of St Jarlath's Park helped drive the club to its greatest spell of success, winning a remarkable seven senior county titles in a row, with the 'Terrible Twins,' Seán Purcell and Frank Stockwell, to the fore.

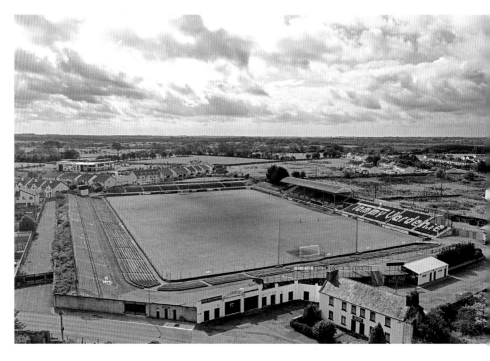

In December 1887 Tuam's first football club was formed as an association football team and played its first match against Ballyhaunis the following month. That April the club's honorary secretary, William Silk, resigned from his position because, being a member of the GAA also, he helped to set up a new Gaelic club in the town. The club, Tuam Stars, played their first game on St Patrick's Day 1889 against Cortoon Shamrocks on a pitch owned by a Mrs Ormsby. 'They have not yet mastered the game,' the *Tuam Herald* reported on the match, 'and the habit with a good many of them is to rush for the ball chest forward as if they were afraid to touch it with their hands.'

The Gaelic code took hold, however, and matches were played at the Parkmore complex outside the town. Parkmore, which included a racecourse, athletics track and a GAA pitch, was enclosed and had a grandstand for spectators – though unfortunately it was 100 metres away from the field of play.

The once grand old lady of Galway football, St Jarlath's Park (more generally called Tuam Stadium) has seen better days but retains a special place in the hearts of Galway fans

KEY DATES

1906
Parkmore hosts its first Connacht SFC final, Roscommon vs Mayo, on 27 May

1928
Sligo overcome Mayo at Parkmore to win their first Connacht SFC title

1946
Tuam Stars buy land near the railway station at Vicarschoraland for a reported £1,000

1950
Cinders from Tuam sugar factory provide a bed for the new ground's playing pitch

ANDREAS F BORCHERT

SAINT JARLATH

Jarlath was born in the Tuam district and founded a monastery that became a renowned centre of learning a short distance from the present town. He is the patron saint of the Archdiocese of Tuam.

A window in St Benin's Church, Kilbennan, north of Tuam, depicting the local saint

BANGING THE DRUM FOR MUSICIAN'S RIGHTS

Parkmore became one of the leading grounds in the West of Ireland, hosting 11 Connacht SFC finals between 1906 and 1944. At the time Connacht Council had a policy of making the bands who provided music on the day pay into the match. The Tuam Fife and Drum band took exception to this at the 1908 Connacht final, played on 31 January 1909. They attacked the stewards at the gates, and with spectators joining in made their way into the ground. The council gave marching bands free admission after that.

Parkmore hosted the All-Ireland SFC semi-final between Kerry and Mayo the following year and again in 1931. The ground's stewards were overwhelmed once more, however, when the 1934 semi-final between Galway and Cavan drew a full 30,000 spectators. The game was nearly abandoned but despite disruptions – and the fact that many spectators 'only got glimpses of the ball when it was in the air' – it eventually came to a conclusion two hours after it started.

A BOLD MOVE

In 1946 Galway County Board offered their support to Tuam Stars' bid to purchase a new ground nearer Tuam town. Following an appeal from club chairman Joe Mooney for co-operation from town traders, the stadium development committee proposed that the new venue would have a semi-autonomous ownership model – i.e. it would be vested in the GAA jointly with representatives of local businesses.

Tuam Stars purchased a field at Vicarschoraland from Galway businessman Martin McDonogh in 1946 and development began in August 1948. The aim was to provide seating for 15,000 spectators and embankments for 25,000 more at a total cost of £10,000. Fundraising efforts were strongly supported by the *Tuam Herald*, which ran a banner front-page headline on 4 March 1950 calling for 'Voluntary Labour for New Stadium' to help complete the work.

St Jarlath's was blessed and officially opened by the Archbishop of Tuam, Rev. Dr Walsh, on 21 May.

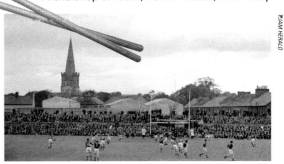

TUAM HERALD

In August 1950 the All-Ireland SHC semi-final between Galway and Tipperary brought 27,000 to the new ground

REVERSING THE DECLINE

In its heyday Tuam Stadium could accommodate around 30,000 supporters and Connacht championship games involving Galway and Mayo often filled the venue. This was drastically reduced to 6,700 for safety reasons.

The fate of St Jarlath's changed in the 1990s when Galway County Board moved the county ground to Pearse Stadium. The former home of Galway football began to fall into disrepair.

The Development Advocates for Tuam Stadium was set up in 2015 to reverse the situation, and improved player and spectator facilities in 2018–19. Plans to upgrade the stand facilities continue.

1950
Cavan take on Mayo and Galway play Dublin at the opening of St Jarlath's Park

1964
A record 30,230 see Galway defeat Mayo in the Connacht SFC final; 2,000 more gain free admission. The Tribesmen go on to lift Sam Maguire, the first of a three in a row

1998
26,000 fill the park as Galway, with local lad Ja Fallon playing a pivotal role, beat Roscommon en route to a first All-Ireland title in 32 years

2019
Upgraded dressing rooms opened at a cost of €372,000

Páirc Seán Mac Diarmada

LOCATION
Attyfinlay, Carrick-on-Shannon

NAMED AFTER
**Seán Mac Diarmada
(1883–1916)**
IRB organiser, newspaper
man, signatory of the 1916
Proclamation

OPENED
1964

CAPACITY
9,000

PITCH DIMENSIONS
143 x 88m

COVERED ACCOMMODATION
Ardán Mhic Shamhráin

FLOODLIGHTS
No

CLUB
No

Leitrim's premier ground sits snugly in the landscape with the river and town providing a picturesque backdrop

For many years the GAA lacked a club or a proper ground in Leitrim's capital town. In the early 1900s games were played in the Bull Field, owned by Charles B. Whyte of Hatley Manor. Leitrim played Sligo there in 1910, a game organised by the local Temperance Society as there was no GAA club in Carrick at the time. Matches moved to Laird's Field in the 1920s, though when Leitrim defeated Roscommon there en route to winning the county's first provincial title in 1927 Roscommon objected that the pitch was too small and were awarded a replay, which they lost by 1–0 to 0–7 in Ballinamore. At this point the county board began looking for a new ground.

When New Park, some 11 acres on the Boyle Road owned by a number of local businesspeople, opened in 1936 it was made available to the GAA and the people of the town. It had sheds and seating and held 15,000 spectators, and hosted the Railway Cup semi-final between Connacht and Ulster in 1937.

KEY DATES

1889
County board set up on 14 April, two months after first match under GAA rules played in Leitrim

1907
Leitrim play their first ever game in the Connacht football championship

1936
Leitrim defeat Fermanagh in football as Archdeacon Donohoe, PP Carrick, opens New Park on 3 May

1964
GAA President Alf Murray opens Páirc Seán Mac Diarmada on 24 May

SEÁN Mac DIARMADA

Born near Kiltyclogher in Co. Leitrim, Seán Mac Diarmada was a member of the IRB's Supreme Council and manager of the newspaper *Irish Freedom*. He was stricken with polio, and due to this disability took little part in the fighting during Easter Week, though he was stationed in the GPO. Executed subsequently, his house in Kiltyclogher is today a national monument.

LEITRIM OBSERVER

Páirc Seán Mac Diarmada, with a capacity of 17,000, 3,000 seated, opened in 1964. Carrick's link with the defunct Leitrim–Donegal railway was maintained when the old railway tracks were transformed into silver-painted girders that acted as stays for the wire fencing surrounding the pitch. The park hosted its first Connacht championship match that June, a contest between Leitrim and Roscommon that went to two replays which Roscommon eventually won.

A SCRAMBLE FOR LAND AND FUNDS

The Presentation Brothers and local clergy were the driving force in setting up St Mary's GAA Club in 1944. Fr Bernie Keville was chairman, Brother Gabriel secretary, and Brother Patrick treasurer. They rented the New Park for £15 a year, sharing it with Shannon Gaels. Fairs were also held in the ground occasionally.

In October 1954 a car-load of club members on their way home from a funeral stopped on the edge of Carrick-on-Shannon and after scrambling through bushes and brambles came to a piece of land that they agreed would be ideal for a GAA pitch. St Mary's chairman George O'Toole, and later Fr Pat Claffey, promoted the idea, not least because Leitrim often had to play their home games in Roscommon in those years.

When the land came on the market in 1961 the GAA hesitated to buy it because it was more than they needed. While they delayed the land was purchased by another party. However, negotiations followed that culminated in the GAA acquiring 6.5 acres for £1,200. A further £14,000 was spent on developing the ground.

MAUREEN DIFFLEY – ST MARY'S

George O'Toole, Leitrim GAA stalwart, was instrumental in securing Páirc Mac Diarmada for the GAA

FROM STRENGTH TO STRENGTH

Connacht Council granted Páirc Seán Mac Diarmada county ground status in 1980. Development work waited until the new millennium, however, when the terracing was upgraded and capacity fixed at 13,500.

A 3,000-seat covered stand was constructed in 2006–07. Costing approximately €3m, the work was funded by Central Council grants, government funding and a 'Get on the Team' initiative which raised funds from the local community. The stand was opened by GAA President Nicky Brennan on 24 June 2007 and named Ardán Mhic Shamhráin in recognition of Leitrim-born businessman Tony McGovern. Tony, renowned for his generous sponsorship of Gaelic games, had London's GAA stadium, McGovern Park, named in his honour a decade later.

Following a review of GAA stadiums in 2011 the ground's crowd capacity was reduced to 9,331. Remedial work was carried out two years later and in 2013 Páirc Seán Mac Diarmada hosted the All-Ireland Ladies Senior Club Football final for the first time.

1968
Mayo vs Tyrone junior football final is Leitrim's first All-Ireland final in any grade

1975
Ulster beat Connacht as the ground hosts the Railway Cup football semi-final

1982–83
Ground hosts All-Ireland U21 football finals in consecutive years

2022
Tyrone defeat Kildare in the All-Ireland U20 football final in the park on 14 May

Páirc Sheáin Uí Eislin

LOCATION
Railway Road, Ballinamore

NAMED AFTER
Seán O'Heslin (1887–1942)
Teacher, footballer, handballer, GAA administrator

OPENED
1952

CAPACITY
2,300

PITCH DIMENSIONS
143 x 81 m

COVERED ACCOMMODATION
Yes

FLOODLIGHTS
No

CLUB
Seán O'Heslins

Over its long history Seán O'Heslins has enjoyed success in every grade of football and amassed 21 senior county titles. They have contested the Connacht senior final on four occasions (1968, 1973, 1986, 1990) and five O'Heslin's men were part of the famous Leitrim squad that captured the Nestor Cup in 1994.

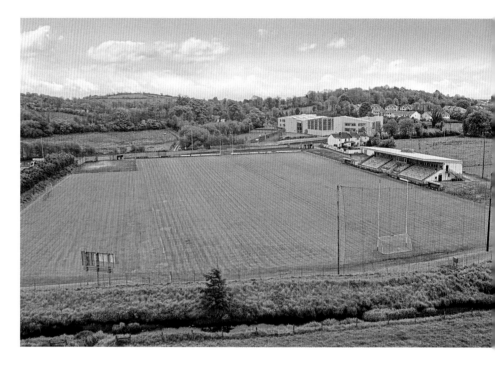

Ballinamore GAA Club – initially called Ballinamore William O'Brien's after the leading Home Rule MP – was founded in 1889 at a meeting in McGauran's Railway Hotel. They played at Ardrum Rock about two kilometres south of Ballinamore until finally in March 1946 the club purchased some fields from James Delahoide in Lahard which were more convenient to the town and set about developing a pitch there. The cost of the land was £395 plus £32. 4s. 7d. to redeem the annuity.

The fine playing surface of O'Heslin Park is the result of a hard fought, decades long campaign against the flood waters of the River Foghera

Ballinamore thus became the first club in Leitrim to own its own ground. When it opened in 1948 the park was seen as a boon for the town's commerce and the club was pressed to put on as many games as possible. However, the decision to move to Lahard was often regretted when the pitch became unplayable in wet weather. Despite drainage the ground was boggy and subject to flooding from the nearby Foghera River. Some of the older members bemoaned leaving Ardrum Rock, which was at least dry all year round.

KEY DATES

1890
Ballinamore lose to Mohill in the first Leitrim SFC final; they win the title in 1913

1927
Leitrim defeat Roscommon in the Connacht SFC semi-final played at Ardrum Rock

1952
Dr Austin Quinn, Bishop of Kilmore, officially opens Seán O'Heslin Park on 5 May

1952
Leitrim beat Tipperary 2–5 to 0–5 in the All-Ireland JFC semi-final at the park

SEÁN O'HESLIN

SEÁN O SUILLEABHÁIN – SEÁN O'HESLINS

Seán O'Heslin was born in Drumcommaun, Ballinamore, where his father Johnny was a well-known horse dealer and his mother Catherine was a teacher. Seán became a teacher too, and after teaching for a while in the Industrial School in Killybegs took up an appointment with Ballinamore Boys NS in 1924. He married Margaret Kelly of Kiltyclogher the following year.

Seán played football in Cavan and also for Ballinamore, usually in goal. He was also a fine handballer but it was as an administrator that he excelled. From the late 1920s on he was often described as 'Mr Football' around Ballinamore. He provided leadership for young players and under his stewardship the club won the Leitrim SFC five times between 1930 and 1939. He was county board secretary, 1932–33, and Connacht Council delegate in 1934.

Seán was well respected as a teacher and mathematician. He submitted a correct solution to the Saturday puzzle in the *Irish Press* every week from 1932–42 under the pen-name 'Mr Ballinamore.'

NAME CHANGES

In 1952 the club decided to name the ground Páirc Sheáin Uí Eislin and the club itself was renamed Seán O'Heslins GFC the following year. From its official opening O'Heslin Park was the main county ground and the centre for inter-county fixtures. However, the park's status changed when Páirc Seán Mac Diarmada opened in Carrick-on-Shannon in 1964.

CONTAINING THE FOGHERA

The club opened new dressing rooms with modern showers in 1972 and due to the voluntary labour of members the cost was kept to just over £1,000. People turned out again to tackle the ground's drainage problems in 1975 and further improvements followed in 1980.

Flooding, however, continued and when the 1986 Connacht club football final between O'Heslins and Clan na nGael had to be moved to Cloone as a result, the writing was on the wall. O'Heslins had to decide whether to move or to update the ground. They decided to stay put. As the new millennium dawned a development committee was set up to raise funds and in 2002 a Sports Capital grant of €144,000 helped to build an embankment along the Foghera River and to pump excess water from the ground into an underground tank and then back into the river. These works finally solved the problem. The club now purchased adjacent land and developed a second pitch.

The sheds and workshops of the Midland Great Western Railway Company were located in Ballinamore up until 1959, when the Leitrim–Cavan narrow gauge railway closed. One of the line's first-class carriages was transported to O'Heslin Park to take up station as the ground's changing rooms.

Work continued in 2008 when a new 750-spectator stand replaced the old shed, and dressing rooms, club rooms and other facilities were built at a cost of €1.8m. Plans to floodlight the main pitch and to construct a new multipurpose playing area were launched in 2018.

Now boasting the best playing surface in the county, O'Heslin Park continues as the second county ground in Leitrim.

1961
Galway defeat Leitrim in the only Connacht Championship match to be played at the ground

1984
Seán O'Heslins are selected as Leitrim Club of the Century

2003
Ladies football starts in club and major drainage scheme revives the ground's fortunes

2009
GAA President Christy Cooney opens O'Heslin Park's stand and other new facilities

2021
Club win their 21st county senior football title, their first since 1990

St Mary's Park

LOCATION
Drumharkan Glebe, Cloone

NAMED AFTER
Mary, patron saint of Cloone parish

OPENED
1980

CAPACITY
2,500

PITCH DIMENSIONS
126 x 91 m

COVERED ACCOMMODATION
Yes

FLOODLIGHTS
Yes

CLUB
Cloone

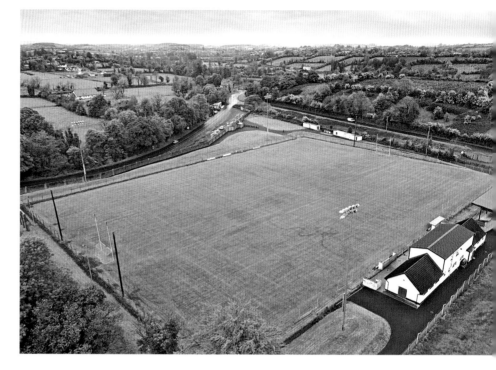

Cloone GAA Club has enjoyed a lot of success on the field of play, winning the Leitrim senior football championship 11 times between 1911 and 1980.

Off the field the club is at the hub of social life in the parish and a unifying force within the community. It continues to contribute enormously to local pride and sense of identity.

Gaelic football began to be played in Cloone in 1898 and a GAA club, Cloone O'Connell's, was eventually set up in 1906, largely on the initiative of local priest Fr O'Connell, and became affiliated to the Leitrim County Board.

Games were played in several fields around the parish, including Béal an Leachtain and Pat Doyle's Field. Cloone O'Connell's amalgamated with the other parish team, Corduff, in 1925–26. Another team, Riverstown, sprang up as rivals, but eventually came together to form the new Cloone GAA Club in 1931–32.

From the 1950s they played at The Grange, formerly the residence of the parish curate. Its owner, local farmer John McGovern, made this flat field available to Cloone GAA for more than 25 years. In the days before football pitches were fully developed, this was one of the finest in the county. Ground facilities were fairly simple, though: players changed in the shelter of an ash tree which stood at one corner of the ground.

St Mary's Park's setting, facilities and standard of maintenance has won it many admirers

KEY DATES

1898
The first attempts to organise Gaelic games locally are credited to a Mr Fitzsimons

1911
Cloone O'Connell's beat Ballinamore by a point to win their first Leitrim SFC title

1934
Cloone GAA Club win their second title

1980
Artane Boys Band plays at the opening as Bishop Cahal Daly blesses St Mary's Park

VIRGIN MARY, MOTHER OF JESUS

Mary has been venerated since early Christian times and is considered by many to be the holiest of all saints.

UNITED EFFORT REAPS REWARDS

In 1976 the club decided that John McGovern's generosity could not last forever and began looking for a new venue. In January 1977 they found what they wanted, 5.3 acres owned by a local farmer, Charles Mitchell. A price of £11,000 was agreed, and though it was somewhat above what the club had set for themselves and the field was located more than a kilometre south of Cloone village, the ground was purchased that March. A park committee was established under the chairmanship of Damian Brennan and set themselves a target of clearing the purchase price within a year.

Teams of ticket sellers were designated a town each for selling raffle tickets. Fundraising activities in fact spread to Tipperary, Kildare, Donegal and Westmeath as club members piled into mini-buses to sell even more, offering a pure-bred Hereford heifer as first prize. Local bazaars, sponsored walks and other events all helped to haul in funds.

In 1978 the club purchased an adjacent 1.36 acres from John O'Loughlin for £1,400, and during 1978 and '79 began building dressing rooms, toilets, press facilities and fencing with the aid of a Youth Employment grant. In 1979 the Leitrim County Board designated the Cloone venue as a secondary county ground, which entitled it to extra funding.

Under the guidance of people like Seamus Shortt, Damian Brennan and Gerry McGovern club members gave long hours of personal commitment to ensure that the ground was constructed to the highest standards. Tons of earth were transported from a factory site in Mohill to form an embankment along one side of the pitch. When St Mary's Park was officially opened by GAA President Paddy Mac Flynn on 25 May 1980, £65,000 had been spent on developing this natural amphitheatre, with up to £45,000 of that money raised locally.

COMMITTED TO EXCELLENCE

While St Mary's Park was described by one sports-writer as 'a lovely, almost quaint ground,' the club was conscious of maintaining its standard. In 1994 Cloone GAA built a new stand and scoreboard and rewired the pitch enclosure. At the turn of the millennium they added an all-weather pitch, electronic scoreboard and disabled access to the stand, and the grounds were re-drained in 2002. That year Cloone was voted Leitrim GAA Club of the Year for their success on the field of play and their development of St Mary's. The park became fully floodlit in February 2006 and was the first ground in Connacht to host an NFL match under lights, played between Leitrim and London.

In 2010 new developments brought an extension to the dressing rooms, a spacious first-aid room, increased viewing area and a function room with catering facilities. This work was partially funded through Sports Capital grants of €80,000 with the balance made up from local fundraising. Cloone's refurbished and extended club rooms were officially opened on 5 August 2012 by GAA President Liam O'Neill.

Cloone GAA Club regularly hosts top matches including fixtures in the Leitrim SFC.

DONEGAL NEWS

In 1972 Cloone club member Jim Sheridan became the first senior League of Ireland soccer player to win a county championship medal after the removal of the ban the previous year. He went on to captain Finn Harps to success in the 1974 FAI Cup final

1994	2010	2020	2022
A new stand adds to the natural shelter of the trees surrounding the ground	New development includes a function room which adds to the GAA park's central role in the community	While ground is closed due to Covid pandemic, silage is saved from the overgrown pitch to sell as 'top quality feed for winter'	Club receives Sports Capital and Equipment grant of €4,583

MacHale Park

LOCATION
Drumconlan, Castlebar

NAMED AFTER
Dr John MacHale (1791–1881)
Catholic Archbishop of Tuam, scholar and author

OPENED
1931

CAPACITY
31,235

PITCH DIMENSIONS
140 x 83m

COVERED ACCOMMODATION
Yes

FLOODLIGHTS
Yes

CLUB
Castlebar Mitchels

Castlebar Mitchels have a list of successes to match their long and illustrious history. In the senior ranks alone they have notched up 30 county and four Connacht titles, going all the way to the All-Ireland final on three occasions (1994, 2014, 2016).

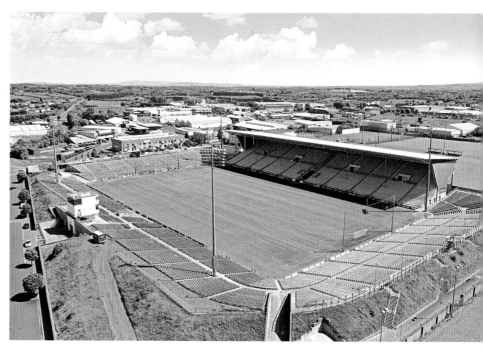

Castlebar Mitchels was the first GAA club set up in Mayo, following a meeting in the Town Hall's Reading Room on 11 December 1885. Their first games were held at the Hat Factory Field and subsequently they played in the Old Pound Field, Pigeon Park (also known as the Fair Green) and the Asylum Grounds until they finally found a home of their own in 1929.

MacHale Park is the only all-seater ground in the country thanks to the refurbishment works undertaken over recent decades

Nine private individuals each paid £50 and the Castlebar club put up £245. 5s. 6d. to purchase the land, known locally as the Racecourse, from Charlotte Beckett and Jane Mary Keegan Beckett. These co-owners then leased the 17½ acre field to Castlebar Mitchels GAA Club in 1930 with a covenant for perpetual renewal.

Developing the ground cost £1,700. It was drained and levelled and three tiers of timber seats were built along the sidelines. Thousands of tons of material were carted in to build terraces. At the official opening of MacHale Park in May 1931, 4,000 spectators watched Mayo and Kildare play to a draw.

KEY DATES

1888
Castlebar Mitchels GAA Club win their first senior football championship title

1914
Roscommon defeat Galway in the first Connacht SFC match played in Castlebar at the Asylum Grounds

1932
20,000 spectators, the largest crowd yet to attend a football match in the county, turn out for Mayo vs a United States team at MacHale Park

1934
MacHale Park hosts the NFL final between Mayo and Dublin; Mayo win the replay

1940
The proceeds of a carnival help pay for a new pavilion

DR JOHN MacHALE

Born in Tubbernavine, Co. Mayo, as a boy John MacHale saw General Humbert's French soldiers marching by after landing in Killala during the 1798 rebellion. John was educated in a hedge school and Patrick Staunton's school in Castlebar, where he learned Latin, Greek and English. He distinguished himself at Maynooth College and was offered the Chair of Dogmatic Theology before he had even graduated.

In 1834 Dr MacHale became Archbishop of Tuam, despite the British authorities' efforts to prevent his appointment. He worked with Daniel O'Connell to repeal the Act of Union and on behalf of his parishioners during the Famine. In later years he supported the Tenant League and the Irish Party and was a pioneer of the Irish language revival. 'The Lion of the West,' as Daniel O'Connell called him, died in 1881 at the age of 91.

CATHOLIC PUBLICATION SOCIETY

STRUGGLING TO PAY THE RENT

Between 1930 and 1935 an annual rent of £22. 10s. was due on the lease. This was never paid and by 1936 the total outstanding came to £135. Mayo County Board had offered a grant of £100 in 1933 on condition that the title of the grounds be transferred to them. In the meantime, the club had spent over £3,000 on MacHale Park and in August 1935 requested a grant of £250–£300 to make further improvements. However, no monies were forthcoming and without funds for maintenance the timber seating deteriorated, the fencing was broken down and its galvanised sheeting taken away. The county board took on a caretaker at 10 shillings a week to look after the park but a more long-term arrangement was needed.

Finally, on 20 May 1938, an agreement was made between the owners of MacHale Park, on the one hand, and the club trustees, county board trustee and a trustee from Central Council guaranteeing a payment of 5% per annum for ten years on the £450 subscribed by the nine owners. The capital sum was to be repaid thereafter.

GRIPES ABOUT GARDENS

The Irish government and local authorities encouraged extra tillage during the war years to ensure that the country was self-sufficient in food. Castlebar's urban council set up allotments alongside MacHale Park where people could grow vegetables but went a bit too far and dug up part of the pitch while they were at it. Castlebar Mitchels were forced to protest in April 1942.

MIXED MESSAGE

A major redevelopment in 1950–52 raised the ground's capacity to 40,000, with seating for 18,000. It reopened in June 1952 with a game between reigning All-Ireland champions Mayo and Meath that ended in a draw.

The Connacht SFC final that year was the first to take place in MacHale Park and the first big game there since its refurbishment. However, because of a strike there were no reporters at the game. The result was sent by telegram to Radio Éireann, which decided that a mistake must have been made because Mayo, who were coming off the back of two consecutive All-Irelands and four Connacht titles in a row, couldn't possibly have been beaten by an unfancied Roscommon. The result was announced as Mayo 3–5 to Roscommon 0–6 when in fact it was the reverse.

1963
Central Council selects MacHale Park as one of the four provincial grounds

1978
New sports complex provides squash, basketball, racquetball, volleyball, handball and badminton courts

1981
Construction of Gerry MacDonald Stand begins and takes ten years to complete

2011
New 10,000 seat stand opens

2022
Resurfaced and extended pitch reopens for Connacht SFC match between Galway and Mayo on 24 April

THEM'S THE BREAKS

Galway were well ahead in the 1962 Connacht SFC final when eight minutes into the second half Roscommon goalkeeper Aidan Brady clung to the crossbar in MacHale Park and it broke in two pieces. The game was delayed for 24 minutes while repairs were made, and when it resumed Roscommon turned things around to snatch a famous win, 3–7 to 2–9. Thirty years later Roscommon broke a crossbar in the Connacht final for the second time. Mayo were on top on this occasion when corner-back Enon Gavin swung from the bar and brought it down. However, there was to be no turnaround for Roscommon on this occasion and Mayo went on to comfortably regain the title by 1–14 to 0–10.

RETURN TO SENDER

Throughout the 1960s and '70s Castlebar Mitchels embarked on several fundraising ventures. The club and the MacHale Park Development Committee became separate bodies in 1967 and the committee took over the club's debt of some £4,000. Committee member Gerry MacDonald proved to be an extraordinary fundraiser. Knowing that the Mayo diaspora would be keen to support MacHale Park, he enlisted the help of schoolboys in De La Salle College to collect the addresses of their relations living abroad – with a prize for the boy who gathered the most. Gerry then sent a letter to each person on these lists, enclosing raffle tickets for them to buy and a sprig of heather from Croagh Patrick blessed on Reek Sunday.

The project proved to be a great success and a lucrative source of funds, though many of the winning schoolboy's letters were returned stamped 'not known at this address.' One can only speculate if this was because he used creative licence rather than diligent research to compile his impressive list.

RISING TO THE CHALLENGE

In 1990 Connacht Council decided to grant aid Dr Hyde Park, Co. Roscommon, with a view to making it the main venue in the province. Castlebar Mitchels reacted by launching an ambitious plan for MacHale Park. Over the next 12 years the ground was converted into a 32,000 all-seater stadium and new dressing rooms, improved press facilities, dugouts and a wheelchair area were constructed. Their efforts were rewarded when the ground hosted the 2001 All-Ireland SFC quarter-final between Roscommon and Galway, the first All-Ireland series match to be played in Castlebar.

However, the club had built up an unsustainable debt of £870,000 on their sports complex (An Spórtlann), which had opened some years earlier in 1978. In 2005 Mayo County Board agreed to clear the Spórtlann debt and took control of MacHale Park on a 50-year lease with a view to upgrading the stadium. They also agreed to pay Castlebar Mitchels €600,000 over ten years to develop one of their own pitches adjacent to the park.

Bearing witness – RTÉ broadcaster Micheál O'Hehir was just one of the many media people packed into MacHale Park's viewing tower ahead of the 1966 Connacht football decider. Back-to-back All-Ireland champions Galway were in town and their hosts were particularly keen to take them down. A classic contest unfolded in which Mayo scored a wonder goal but the Tribesmen prevailed by a single point, 0–12 to 1–08, the winning score coming deep in injury time

Too close to the action – Mayo corner-back Séamus O'Connor not only had to deal with his side conceding a goal to arch rivals Galway in the 1968 Connacht SFC final, he also had to contend with fans dancing in delight around his goal area. In an era when health and safety standards were rudimentary compared to today, it wasn't unusual for fans to be allowed to situate themselves behind the goals and along the sidelines on big match days. Some even took advantage of their close proximity to the players to give them advice and suggestions

MacHale Park Development Committee,
Castlebar, Co. Mayo, Ireland.

RETURN TO SENDER
For Better Address

Mr. Buck S. Galore,
1 Gold Tower,
Wall Street,
New York,
USA.

LIAM LYONS COLLECTION

BIG BILLS FOR BIG AMBITIONS

In 2008 construction work began on further renovation, to include the construction of a new 10,000-seater stand to replace the Gerry MacDonald Stand as well as an extension to the seated area to the south (Albany) end. The aim was to raise the seated capacity of the stadium to 42,000, making it one of the largest all-seater venues in Ireland. This redevelopment also included improved facilities for spectators, underground training areas, county board offices, new dressing rooms and a museum. New floodlights were turned on at the ground for a match between Mayo and GMIT in the FBD League on 15 January 2011.

SPORTSFILE

The impressive stand was completed in 2011 and can accommodate 10,000 spectators

These redevelopments left Mayo County Board with a debt of about €10m. In 2015 GAA Central Council agreed to take over the board's bank loan of €5m and allow Mayo pay the outstanding money to Croke Park at a lower interest rate. It was understood that the new deal would save the Mayo board €200,000 a year.

In April 2021 the county board launched a new initiative to help raise funds to extend and resurface the MacHale Park pitch. Described as 'the biggest project undertaken by the Mayo County Board since the stadium was redeveloped,' the works were finished in time for the start of the 2022 Connacht Championship.

LIAM LYONS COLLECTION

James Stephens Park

LOCATION
Carrowcushlaun West, Ballina

NAMED AFTER
James Stephens (1825–1901)
Fenian, IRB leader

OPENED
1933

CAPACITY
6,000

PITCH DIMENSIONS
144 x 82m

COVERED ACCOMMODATION
Yes

FLOODLIGHTS
No

CLUB
Ballina Stephenites

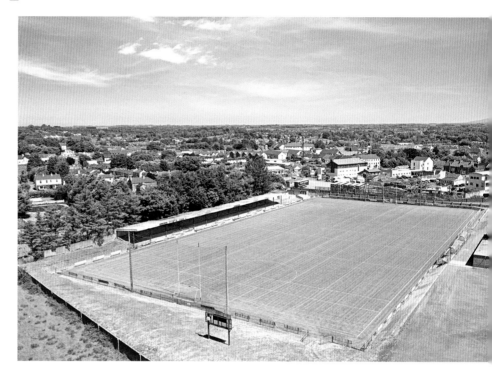

Ballina Stephenites are the kingpins of Mayo football clubs, boasting a whopping 36 senior county titles, three Connacht triumphs (1998, 2004, 2007) along with an All-Ireland senior club victory in 2005. Five All Stars have worn the club colours – Kevin McStay, Jimmy Browne, Liam McHale, Ger Cafferkey and David Clarke.

The Ballina Stephenites Club led a peripatetic life in their early years – wandering from Jones' Field in Ardnaree to a field near the Killala Road donated to them by James Carroll and Sir Charles Gore, and on to Bourke's Field on Castle Road and then the Show Grounds. The Show Grounds and the Camp Field – so called because British military camped there during the summer – were owned by Col. Saunders Knox Gore. The Ballina Show Committee leased the field for their annual show and later sublet it to Ballina RFC, but transferred their interest in the ground to Ballina Stephenites in 1933. At this point the club took a 25-year lease on the Camp Field and the Show Grounds and fenced off their area of ground.

Ballina-born Minister for Justice P. J. Rutledge opened James Stephens Park on 4 June 1933. In fact he cut the ribbon again the following year when the club celebrated the GAA's jubilee year with a second opening.

James Stephens Park boasts a fine playing surface and clubhouse. The ambition is to continue upgrading facilities

KEY DATES

1886
Ballina Stephenites founded by James Wallace Melvin, known locally as the town's poet laureate

1904
Club wins the Mayo SFC each year until 1916

1934
James Stephens Park enjoys a second opening, though Mayo lose out to Louth on the day

1936
Club celebrates 50th anniversary by buying the ground, clearing liabilities of £380. 18s. 2d.

1948
Connacht Council designate the park as one of three provincial grounds

JAMES STEPHENS

Kilkenny born James Stephens took part in the ill-fated Young Ireland rebellion of 1848, escaping to France subsequently. After returning to Ireland he founded the Irish Republican Brotherhood (IRB) in 1858. Though Stephens' revolutionary career was chequered, the IRB became deeply embedded in the GAA and played an influential and often controversial role in the struggle for independence.

The pallbearers at Stephens' funeral in 1901 included Mayo's land reform champion Michael Davitt

THE NUTS AND BOLTS OF IT

The club spent £1,000 installing sideline seating in 1935 but the workmanship stirred debate at a county board meeting. The nuts and bolts holding the seats in place stuck out, much to the discomfort of the people sitting on them. By way of explanation the board heard that it would have cost too much to have counter-sunk the nuts and bolts into the timber.

STOPPING THEM IN THEIR TRACKS

The GAA purchased the freehold to the tract of land that included the GAA pitch and the former Show Grounds outright in 1936. That year Mullingar Greyhound Racing Company enquired if the park might be used as a racetrack but Central Council would not allow it. Mayo's United Coursing Clubs asked to lease part of the Show Grounds site in 1945, but Central Council again refused permission. Greyhound racing in GAA grounds was being stamped out all around the country.

However, when a revived Show Committee asked to use the site once more Ballina Stephenites granted them a 99-year lease in December 1943, though there was an informal agreement that the club would use part of the area for training and occasional matches.

MODERNISATION PROCEEDS APACE

James Stephens Park saw ongoing development from the mid-1960s. Terraced seating accommodating 3,000 spectators was installed in 1969 and a sports complex that included dressing rooms, a squash court and a member's bar was opened four years later. Fresh development in 1980 provided an assembly hall and gym, improved clubhouse and four modern dressings rooms. The stand was also refurbished. The club opened a €300,000 expansion to its facilities that included new dressing rooms and a gymnasium in 2003.

In 2005 the Tesco Group expressed an interest in purchasing the park, redeveloping the site leased by the Show Committee as a complex with three pitches and a 3,000-seater stand. The club agreed to enter into negotiations but the proposal was later withdrawn by Tesco. This turn of events also marked a change in the fortunes of James Stephens Park.

A FINE SOD FOR MAYO HURLERS

A major development plan in 2009–2010 envisioned a second stand and floodlights. Though they were not constructed, work on the clubhouse was completed and the pitch was vastly improved. Ballina, however, was losing out to a redeveloped MacHale Park, which hosted all county games. In 2013 the Stephenites boycotted Mayo GAA's development draw because they felt their park had been overlooked for county matches and important senior club fixtures. Even when MacHale Park was out of action in 2022, Mayo played their home League games outside the county. While the sod in Ballina is good, the ground does not have the capacity for inter-county football. However, Mayo hurlers use it as their main home venue.

1984–85 The club hosts the GAA Congress two years in a row

1988 The park is the venue for the semi-finals and final of the Railway Cup

1990 Croke Park overturns club decision to allow Ballina Town play FAI Cup match at the ground

2005 Ballina Stephenites beat Portlaoise to win their first All-Ireland club football championship

2020 Club included in the GAA Green Club programme as part of the UN's Sustainable Development Goals

Fr O'Hara Park

LOCATION
Lowpark, Charlestown

NAMED AFTER
Fr Edward O'Hara (1888–1950)
GAA organiser, administrator

OPENED
1951

CAPACITY
3,000

PITCH DIMENSIONS
146 x 86 m

COVERED ACCOMMODATION
Yes

FLOODLIGHTS
No

CLUB
Charlestown Sarsfields

The footballers of Charlestown Sarsfields have consistently contended for top honours, the highlight of which are the three county senior championships won in 1902, 2001 and 2009. Their 2001 triumph was also the springboard for the club's successful tilt at the Connacht crown. Sarfields is also very proud of its vibrant and active ladies wing.

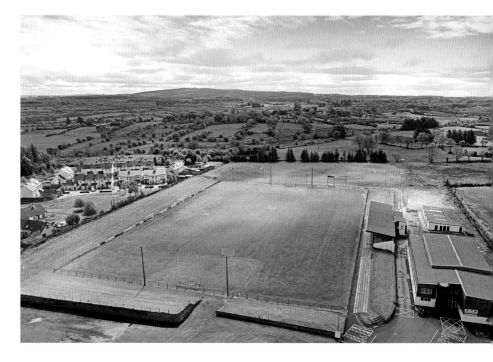

Fr McNicholas was one of many priests to take a lead in the formation of local GAA clubs, as he did with Charlestown Sarsfields in 1888. That year also saw the birth of Fr Edward O'Hara, who would become Fr McNicholas's successor in Charlestown and play a significant role in the GAA there 60 years later.

The beautifully maintained facilities and playing surface at Fr O'Hara Memorial Park are the grounds for Charlestown's footballing success

Sarsfields opted for a maroon and black strip but it took some time before they could actually get hold of any jerseys at all. At one tournament in Swinford, Ballina Commercials obligingly lent Sarsfields their jerseys so they could play a match. Later, when the club was finally clad in maroon and black, the team captain would continue to turn out in the green of Ballina. Sarsfields eventually adopted the colour as their own.

Sarsfields played their games in the park in Charlestown, located on the Ballaghaderreen Road. The first ever Connacht SFC match was played there on 11 November 1888, a game between Mayo and Sligo that ended in a draw.

KEY DATES

1902
Charlestown defeat Ballina Stephenites to win the first of their three Mayo SFC titles

1948
Fr O'Hara purchases a field for £800 saying, 'It is my wish and desire to have it vested in the GAA'

1951
Most Rev. Dr James Fergus, Bishop of Achonry, opens Fr O'Hara Park

1952
All-Ireland and Connacht champions Mayo defeat Sligo in the first Connacht SFC match to be held in the park

FR EDWARD O'HARA

Edward O'Hara was born in Attymachugh near Foxford, Co. Mayo, one of six children. Ordained in 1913, he served in six parishes during his 37 years as a priest, becoming parish priest of Charlestown in 1948.
Fr O'Hara's great passion was the GAA. As curate in Bonniconlon in 1935 he was instrumental in securing a playing pitch for the community. Today it is named after him, as are the club facilities, the O'Hara Grove Complex. He made an equally valuable contribution to the GAA in other parishes, including the GAA field in Keash near Culfadda in the Ballymote area of Co. Sligo.

CHARLESTOWN SARSFIELDS

Fr O'Hara was elected President of the Mayo County Board in 1932 and remained in that position until he died unexpectedly on 7 November 1950 at the age of 62.

SARSFIELDS' NEW HOME

In December 1948 Fr Edward O'Hara, parish priest of Charlestown and Chairman of Mayo County Board, announced that he had purchased eight acres of land for £800 for the Charlestown Sarsfields club. The land, known as Bernie Moffit's Field, was on the main Ballina–Dublin road a convenient distance from the town. The club set up a committee to raise funds to develop the ground, and fundraising committees were also formed in London, New York and Philadelphia. Though plans to have a cycle track were dropped, some £3,500 was spent in 1949–50 ploughing and levelling the pitch, installing seating and railing off the ground. It was officially opened on 3 June 1951 during Charlestown's Carnival Week.

A YEAR OF INTENSIVE WORK

In 1968 the ground was closed for almost 12 months as a maintenance programme was implemented. The pitch was ploughed, harrowed, rotovated and re-seeded. New dressing rooms and players' dugouts were built, the embankment on the Charlestown/Swinford side of the ground was completed and a new press box installed. Much of the work was done by volunteers after their own day's work.

❛ *The purchase price was £800, considered cheap for such a fine field which is almost square… I trust there will be no obstacle in getting it vested in the GAA, although Ballina and Castlebar will probably be jealous …*❜

Edward O'Hara in a letter to the Mayo County Board

GROWING AND DEVELOPING

The years from 1985 saw ongoing improvements to the ground's facilities, including a covered stand for 1,500 spectators which opened in 1992. Development continued from the start of the new millennium.
In 2003 the club leased 3.24 acres from Mayo County Council to lay out a training ground. A new sand-based training area came to fruition in 2010, and lights were installed around the new pitch. Four years later the club leased a further seven acres of land at Parkview from Mayo County Council to lay out another pitch.
In that year, too, Charlestown Sarsfields' senior women's side won the County Junior Championship and Intermediate League titles. Now fielding teams from U8 up to senior level, the women's side of the club grew enormously on the back of these achievements.

PLAN TO HONOUR COLM

In December 2020 the club announced plans to develop a new all-weather pitch to be named the Colm Horkan Memorial Pitch. Garda Colm Horkan, a prominent member of the club, was tragically killed while on duty on 17 June 2020.

1974
Pitch closed temporarily when the goalposts are knocked in January storm

1993
The club plays host to the Mayo–Sligo Special Olympic Games

2001
Sarsfields defeat Annaghdown (Galway) to win their first Connacht SF club championship

2019
Charlestown Sarsfields win Mayo Club of the Year award

Dr Hyde Park

LOCATION
Athlone Road, Roscommon

NAMED AFTER
Douglas Hyde (1860–1949)
*President of Ireland, scholar
academic, linguist*

OPENED
1971

CAPACITY
18,870

PITCH DIMENSIONS
142 x 90m

COVERED ACCOMMODATION
Yes

FLOODLIGHTS
No

CLUB
**No, but has a historic
connection with
Roscommon Gaels**

*Since their foundation
Roscommon Gaels have been
the driving force behind the
development of Gaelic games
in the Roscommon town area.
The club to date has won 18
senior football titles and 23
senior hurling titles.*

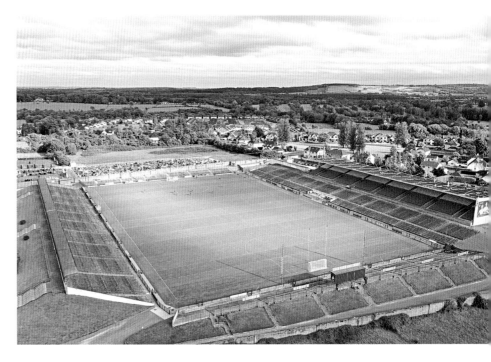

St Coman's, founded in 1889, was the first GAA club in Roscommon town. It became known as L. P. Hayden's in 1891 and changed name again to the Roscommon Football Club in 1897. The club underwent another alteration four years later when it became a hurling and football club and adopted a new name, Roscommon Gaels Hurling, Football and Literary Club. By the time they won their first senior hurling title in 1902 the team was popularly known as The Blues.

Hyde Park is Roscommon's premier ground and a fitting host for Connacht's big footballing days

The club found a home at The Lough, which a group of townspeople purchased from the Land Commission in 1926. Named St Coman's Park, it was developed through the 1930s by Roscommon County Board and officially opened on 14 June 1936. That August the ground hosted the All-Ireland SFC semi-final, when Mayo defeated Kerry by 1–5 to 0–6. However, the new pitch was susceptible to flooding on a regular basis, which caused huge problems for both club and county board.

KEY DATES

1889
St Coman's GAA Club, named after Roscommon's patron saint, is founded

1930
12,000 watch Kerry defeat Mayo in the All-Ireland SFC semi-final at Raftery's Field

1954
Eoghan Ruadh's Club formed. The two town clubs unite as Roscommon Gaels in 1959

1971
Roscommon Gaels U14 Greg McGrann records the first score on the new pitch on opening day

DOUGLAS HYDE

Douglas Hyde, *nom de plume* An Craoibhín Aoibhinn, was born in Castlerea in 1860 and grew up in Frenchpark, Co. Roscommon. He was co-founder and first president of the Gaelic League, the national movement for the revival of the Irish language. He was elected Ireland's first president in 1938 and served until 1945.

Douglas Hyde as he appeared on the pre-Euro Irish £50 banknote

STONES PICKED AND BANS LIFTED

When St Coman's Park defied all attempts to drain it, Roscommon County Board purchased Raftery's Field, a 15-acre site on the Athlone Road, for £3,000 in 1962. It was named New Park and became Roscommon Gaels' new home.

The county board nominated the park as the county's main football ground. The pitch was ploughed, levelled and re-seeded, embankments constructed, sideline seating installed and a boundary wall built. Brother Dwyer and Brother Coffey, both of whom were heavily involved in the GAA, brought the CBS boys out regularly to pick stones from the pitch.

The ground, renamed Dr Hyde Park, hosted its first championship match on its official opening in 1971, when Roscommon lost to Sligo for the first time in a football championship since 1937. Two prominent Sligo Rovers soccer players, David Pugh and Gerry Mitchell, played for Sligo on the day, following the lifting of the infamous 'ban' in Belfast earlier that year. Ironically, Douglas Hyde had been expelled from the GAA in 1938 for attending a soccer match in Dalymount Park.

ROSSIES COME THROUGH AT THE HYDE

The development of 'the Hyde' continued every decade from the 1970s on. A community centre encompassing a hall, meeting rooms, kitchen, lounge and dressing rooms was completed in 1972 at a cost of *circa* £30,000. Players' dugouts were constructed in 1980 as were new men's and ladies' toilets. A covered stand with a capacity of 2,500 was built in 1983 at a cost of £50,000, along with facilities for press, radio and TV. In 1992 the grassy embankments that surrounded the ground on three sides gave way to modern terracing and stadium capacity reached 30,000.

From 1077 Dr Hyde Park hosted numerous Connacht SFC finals, most memorably Roscommon's victory over Galway that year to take the county's first Connacht SFC title played at the park, and the double in 1990 and '91 when they overcame Galway and Mayo respectively.

A NEW LEASE OF LIFE

Following long-running negotiations between the county board and Roscommon Gaels, in 2014 the club moved to a new ground in Lisnamult which they had bought in 2010. They maintained a 999-year lease on the Hyde Park Social Centre and a 150-year lease on the park's training pitch.

This arrangement allowed the board to draft new plans for Dr Hyde Park. The need for improvements was highlighted in 2016 when the Roscommon football team had to cancel four National League games there due to waterlogging on the pitch. Following renovation, the stadium reopened with a new, well-drained pitch in February 2017.

Roscommon County Board plan further extensive improvements to the ground and the creation of a Dermot Earley centre of excellence, named after the late Roscommon footballer and Chief of Staff of the Irish Defence Forces.

1978	1998–2002	2003	2014	2022
Hyde Park hosts its first All-Ireland final when Roscommon's U21 footballers defeat Kerry	Dressing-room complex completed and the stand upgraded to seat 3,500 people	Concert by legendary acts The Beach Boys and Don McLean help to raise funds	Roscommon County Board take over the park and invest in ground improvements	Planning permission granted for major upgrade of facilities

St Brigid's Park

LOCATION
Newpark, Kiltoom

NAMED AFTER
Saint Brigid (c. 450–525 AD)
Abbess, patron saint of Ireland

OPENED
1962

CAPACITY
3,500

PITCH DIMENSIONS
136 x 84 m

COVERED ACCOMMODATION
Yes

FLOODLIGHTS
Yes

CLUB
St Brigid's

In 2013 St Brigid's became the first Roscommon club to win an All-Ireland Club senior football title. They won ten county SFC titles between 2005 and 2017 and three Connacht SFC club titles in a row between 2010 and 2012. One of the all-time football greats, Gerry O'Malley, won four county SFC titles with the club.

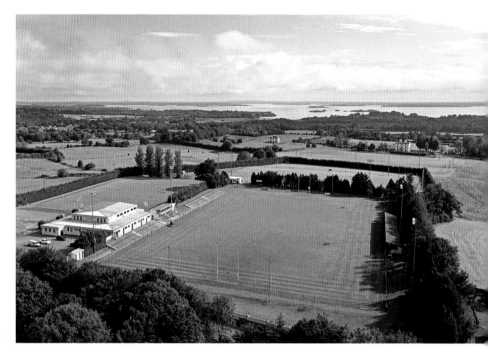

Football, hurling and handball were played in the parishes of Kiltoom and Cam since the turn of the last century. Teams from Brideswell, Curraghboy and Kiltoom played at junior football level, while the hurling team was Kiltoom Rovers. They played in various fields, among them Willie Donnelly's, Batty Leonard's, Frank Donnelly's and most often in Leo Monahan's. Games were also played in the Curraghboy region, frequently in Michael John Fallon's Field at Carrick. This became the main GAA ground locally, with players togging out under a whitethorn hedge at the side of the pitch.

With its modern clubhouse, dressing rooms and three floodlit pitches, the ground by the shores of Lough Ree is one of the finest GAA complexes in Connacht

Local junior clubs amalgamated in 1944 to form St Brigid's. They played in blue and white jerseys until 1953, when they decided to purchase a new set. They called on Miss Sue Docherty, who owned a woollen shop in Athleague, to make them. However, the only yarns she had available were red and green, so the club went with what she had and these have been the club's colours ever since.

KEY DATES

1899
The earliest record of football locally is from a Kiltoom team in January

1960
Tenders invited for building of dressing rooms and boundary wall as new ground takes shape

1962
Cypress trees planted as a shelter from the cold winds blowing in from nearby Lough Ree

1975
St Brigid's fields its first female Gaelic football team

SAINT BRIGID

One of the patron saints of Ireland along with St Patrick and St Columcille, St Brigid's continued renown was honoured in 2023 with the introduction of a national holiday on her feast day in February, the first woman to be celebrated in this way.

THOMAS HUMMEL

A HOME FIT FOR CHAMPIONS

1953 proved to be an exceptional year for St Brigid's. They won their first SFC title and acquired a playing field in Kiltoom consisting of over five acres for the sum of £115. This land was formally part of the Levinge Estate, Newpark, in the townland of Carrowmurragh prior to it coming under the control of the Land Commission.

The estate contained a man-made underground drainage system made of flag-covered cross drains that had been installed to prepare the land for growing flax. The club benefitted from this drainage system later when the playing pitch transpired to be one of the finest winter surfaces in the county.

With the help of local contractor Paddy Donnelly the new grounds began to take shape and, complete with two small dressing rooms, were opened on 21 October 1962 by Dr Donal Keenan, Chairman of Roscommon County Board.

LEVELLING AND UPGRADING

In 1966 the club embarked on a development programme that included levelling the pitch and erecting a fence around it. The dressing rooms were upgraded in 1973 to include showers and toilets. Training floodlights and dugouts were also installed.

Work began on a new spectator stand and press box in 1979 which were completed two years later, and seating was installed in the stand in 1984. In February 1987 the club purchased another 3.4 acres adjoining the ground. A new Community Centre Complex that included a hall, training pitch, tennis courts and car parking was completed in 1988 at a cost of £350,000.

SUCCESS ON AND OFF THE PITCH

A further purchase of six acres in 2002 gave space for a second full-sized pitch, while floodlights were erected on the main pitch.

Ten years later the club added another 18.44 acres adjacent to their existing facilities for £172,500, which allowed them to develop one more playing pitch and add new terracing with steps and barriers.

Progress on the grounds was matched by success on the pitch. On 25 November 2012 St Brigid's achieved a three-in-a-row of Connacht club SFC titles, becoming only the second team in the province ever to achieve this feat.

BUILDING FOR THE FUTURE

St Brigid's set about further improving facilities in 2021. The project was granted government funding of €356,849, while the club also launched its own 'Buy A Brick' fundraising campaign, with subscribers' names inscribed on a commemorative wall. The upgraded complex, complete with a new gym, meeting rooms and store room, was opened in July 2023.

SHORT BACK AND SIDES

St Brigid's hosted the All-Ireland and All-Nations Sheep Shearing and Wool Handling Championships in 1997. The weekend-long event was held in conjunction with the Irish Sheep Shearers Association and 200 competitors from as far afield as New Zealand, Norway, France and England took part. The club proved to be fine hosts and the championships returned to Kiltoom in 2017

1988
GAA President John Dowling opens new community sports complex on 26 August

2005–20
Club wins 11 Roscommon SFC titles in a period of 16 years

2013
St Brigid's defeat Ballymun Kickhams to win the All-Ireland Club SFC title

2017
Roscommon county teams allowed to use Kiltoom as their training ground

2020
Club hosts its first NHL game since 1990 when Roscommon play Warwickshire

Waldron Park

LOCATION
Cloonykelly, Athleague

NAMED AFTER
James Waldron (1909–1981)
Publican, hurler, GAA club
administrator

OPENED
1961

CAPACITY
2,500

PITCH DIMENSIONS
137 x 89m

COVERED ACCOMMODATION
Yes

FLOODLIGHTS
Yes

CLUB
Athleague

Athleague GAA Club is a hotbed for hurling with 19 county senior titles so far to its name. At underage level, the club has been amalgamated with Tremane since 1975, winning numerous county titles at all grades. Many joint initiatives take place each year to support the continued development of this local underage nursery.

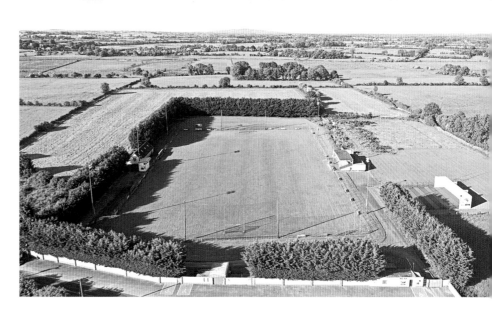

Athleague GAA club – known initially as the Athleague Liberators Football, Hurling and Literary Club – was founded in 1901 and affiliated to the GAA in 1902. In its early years the players trained on the Fair Green, while matches were held in farmers' fields around the village. The principals involved in founding the club were Dan Haughey and John Murray, who also offered the club a field. By 1905 the club was known as Athleague Ireland's Own. They won their first Roscommon SHC title in 1909 and reached another milestone in 1913 when they represented Roscommon and defeated Galway in the semi-final of the Connacht SHC.

Athleague won 12 Roscommon SHC titles between 1909 and 1959, the year they went in search of a ground of their own. Club members approached local farmer Michael Heneghan to see if he would sell them land at Cloonykelly. Michael eventually agreed, and seven acres changed hands for the sum of £991.

Waldron Park has won many admirers and plaudits for the clever way in which it has been planned and developed

KEY DATES

1909–10
Athleague win consecutive Roscommon SHC titles

1913
Camogie club founded and named Athleague Caitlín Ní Houlihan

1959
Johnny Haughey, Paddy Hennigan, Mattie Keane and Michael Finneran negotiate the purchase of land

1971
£500 grant from Roscommon County Board helps towards building boundary wall and car park

JAMES WALDRON

James Waldron was born in Athleague to Ralph and Annie Waldron. His father was a farmer and publican in the village. When James took over the business in later years the pub was often used for club meetings and as a venue for club celebrations.

WALDRON FAMILY

James played hurling with Athleague from an early age until he retired in 1945 at the age of 36, having played most of his career in goal and winning three Roscommon SHC medals in 1928, 1929 and 1937.

He married Bridget Mary O'Reilly from Ballyjamesduff in October 1945. Bridget was a nurse and often tended to injured players during club hurling games. James, for his part, was honorary secretary of Athleague GAA Club in the 1950s.

FROM HUMBLE START TO AWARD WINNER

Farmer and reclamation contractor Peter Killian was engaged to level the ground, which he did over a period of three years. The new park had no official opening but from the early 1960s began to host county hurling and football finals.

The Athleague club embarked on an ambitious programme of development through the 1980s. It was one of the first GAA clubs to adopt a new concept in stand design, a low-cost modular stand to cater for 600 spectators which was built in the summer of 1981. The stand contained dressing rooms, referees' rooms and toilets. In 1988 the club built a new front wall with four entrance gates and another car park, as well as players' dugouts and a press box. The venue became

Roscommon's designated county hurling ground in 1983 and hosted many Connacht club hurling championship semi-finals and finals. The ground was named Waldron Park in 1984 in memory of former club secretary James Waldron.

Five acres of land adjacent to the main ground was purchased in 1996 and converted into a training facility, which alleviated the pressure on the main pitch, while new dressing rooms were added in 2002 and floodlights in May 2005. The club sold 0.75 acres of land to near neighbours Kepak Ltd in 2007, with the proceeds of the sale to be used for advancing club facilities. Much of the development work was spearheaded by executive club members, including Basil Jones, Padraic Moran, Tommy Connaughton and Anthony Flaherty.

Waldron Park was named Roscommon's Club Ground of the Year in 2010 in recognition of its ongoing progress. A decade later a new hurling wall offered improved training facilities that bore fruit the following year when Athleague won the Roscommon senior and junior hurling championships. Athleague and fellow parishioners Tremane hurling clubs come together to represent Fuerty in football.

BIG CHEESE IN THE BIG APPLE

Terry Connaughton, who played hurling for his native Athleague as well as Roscommon's 1951–52 senior teams, won a Lifetime Achievement Award in 2020 for his contribution to Gaelic games in New York. Terry served as vice president of New York GAA from 1971–73, and president in 1974, 1988 and 1989. Under his leadership the New York Board affiliated to GAA headquarters in Croke Park, a move which led to New York being entered in the Connacht SFC.

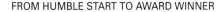

1984
Waldron Park is the venue for Roscommon's historic victories over Wexford in the Centenary Cup tournament in April and Waterford in the NHL in October

1997
The ground hosts its one and only senior inter-county final, when Galway beat Roscommon in the short-lived Connacht Hurling Championship

2002–05
Sports Capital grants totalling €168,000 allocated to club to aid ground improvements

2022
Community Recreation for all Abilities and Ages programme grant of €81,000 supports an inclusive, diverse and welcoming environment for all

Markievicz Park

LOCATION
Cairn's Road, Sligo

NAMED AFTER
**Constance Markievicz
(1868–1927)**
*Revolutionary, suffragette,
labour activist, MP and TD*

OPENED
1955

CAPACITY
18,558

PITCH DIMENSIONS
141 x 81 m

COVERED ACCOMMODATION
Yes

FLOODLIGHTS
No

CLUB
No

*'Land of heart's desire,'
Sligo's county motto, seems
particularly apt looking south
towards the Ox Mountains.
The splendid Markievicz
Park is the result of decades
of voluntary work carried out
by many selfless people*

Markievicz Park is the most prominent county ground named in memory of a woman. It is sited on one of the earliest venues for Gaelic games in Sligo, Thomas Ward's Field, which became Markievicz Park 70 years later.

Sligo boasted one of the first clubs in Connacht to affiliate to the GAA, when Collooney led the way for the county in May 1885, but by 1895 the *Sligo Champion* worried that the association was 'quietly dying out.' A revival took place at the turn of the century, particularly with the formation of Sligo Wanderers hurling club in 1902, which commanded the support of the population and former GAA personnel.

When the County Sligo Agricultural Society opened the show grounds on the west side of Sligo town in July 1908 the GAA quickly rented part of it, and held their first match there on 9 August, the minor football final between Coolera and Keash. Sligo played Mayo there the following month in the 1908 Connacht SFC semi-final.

KEY DATES

1930s
Many GAA matches take place in grounds attached to Sligo Mental Hospital

1940
New Park hosts its final major game, a Connacht SFC clash between Sligo and Mayo

1955
The first match played at Sligo's new GAA venue was an intervarsity match between Connacht and Ulster played on 26 March

1955
GAA President Séamus McFerran officially opens Markievicz Park on 22 May

1970
Sligo vs Galway game called off when new seating fails to arrive due to a cement strike

CONSTANCE MARKIEVICZ

Constance Markievicz, née Gore-Booth, was brought up at the family estate in Lissadell, Co. Sligo. Active in the 1916 Rising, in 1918 she became the first woman elected to the House of Commons. She was also the only woman to serve in the first Dáil Éireann, when she acted as Minister of Labour. Imprisoned during the Civil War, Markievicz later joined Fianna Fáil and was elected to the Dáil in 1927, but died a month later without having taken her seat.

A NEW PARK, BUT NOT FOR LONG

The GAA shared the show grounds with local soccer clubs St Mary's and Ballina AFC, and Sligo Rovers from 1928 to 1934. In December 1932 Alderman John Lynch convened a meeting with the aim of providing Sligo with a county playing pitch. In August 1933 a 14-acre site was purchased at Finisklin, lying between Farmhill and the seashore at Alma Cottage. However, by the time New Park opened in September 1934 costs had reached £6,000. The ground hosted provincial and county games up until 1940, but shortly afterwards it was taken over by the bank and sold to clear its debts.

THE DRIVE FOR MARKIEVICZ PARK

Without a home ground, matches were played at different locations, but finally in January 1950 a meeting was held in Sligo Town Hall to spearhead a new ground project. In April 1952 an area of seven acres previously used by Sligo Rugby Club was bought from Miss Connolly on Albert Line (now Pearse Road).

Two other pieces of land were purchased from Tom Smith and Tony Jones to square up the area, bringing the cost to *circa* £1,500.

Development got underway immediately. Materials were drawn by horse and cart from St Columba's mental hospital two miles away as the pitch was drained and levelled. A number of patients helped with the work as did children from the Marist Brothers NS, who picked stones before the ground was seeded. Bank manager Seán Forde led a fundraising committee whose raffles offered prizes ranging from a Kerry cow to a Ford Anglia car. Seats supplied by Hanley's timber merchants were installed by voluntary labour while James Kiernan, manager of Gowna Wood Industries, donated two timber dressing rooms with showers.

10,000 turned out for opening day, 22 May 1955, when Galway defeated All-Ireland champions Cork in hurling and Mayo overcame Sligo in football.

ONGOING IMPROVEMENTS

The 1960s brought extra seating, fencing and a new press box, and the pace of development quickened in the 1980s and '90s with the laying of a top-quality playing surface, new dressing rooms and a covered stand, along with new terracing on three sides of the ground. The park was redeveloped in a ten-year project costing €2.4m which was completed in 2009 with the opening of the extended covered stand on the Cairns Road side.

The venue was closed in 2018 when the pitch was taken up, levelled, rolled and re-seeded. History was made in Markievicz Park on 20 April 2022 when Sligo defeated Mayo to claim their first ever Connacht football title at the new U20 grade.

1975
Markievicz Park hosts the Connacht SFC final for the fourth time when Sligo and Mayo play out a pulsating draw. The Yeats county would prevail by a point in the replay to capture their second provisional title

2002
IT Sligo hosts its first Sigerson Cup weekend and beat UCC in the final to claim the title at Markievicz Park

2003
Pop group Westlife celebrate their Sligo roots with a gig at the venue on 25 July

2022
Press box upgraded and facilities provided for team statisticians

Kilcoyne Park

LOCATION
Carrowntober, Tubbercurry

NAMED AFTER
Michael Kilcoyne (1900–1963)
Veterinarian, footballer, athlete

OPENED
1964

CAPACITY
3,000

PITCH DIMENSIONS
140 x 86 m

COVERED ACCOMMODATION
Yes

FLOODLIGHTS
No

CLUB
Tubbercurry

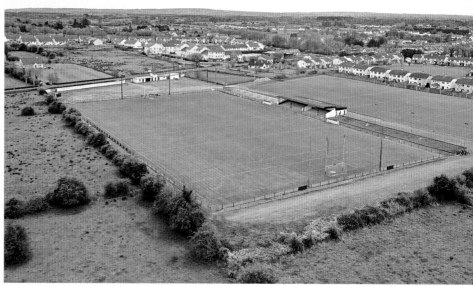

Tubbercurry GAA Club fields teams in both football and hurling and has enjoyed success in both codes, having won 20 senior county titles in football and 14 in hurling. Its underage teams are also very active and competitive.

Tubbercurry GAA Club, founded in 1888, had no pitch of its own for its first 70 years. A player from those days could recall being chased out of several fields where they tried to play – all in one evening.

High and dry – Kilcoyne Park has undergone extensive remedial work to combat recurring flooding

In 1913 they rented from Mr J. Allen, and later O'Connor's Park on Ballymote Road became the town's main GAA park. But despite this lack of a home ground, Tubbercurry nonetheless won 16 senior county titles between 1890 and 1957.

In 1959 a committee was charged with finally finding a site and the following year 9 acres and 5 perches at Carrowntober was bought from James and Annie Mulvaney for £900. Twelve members of the committee agreed to guarantee a loan from the Hibernian Bank to complete the purchase. More than a decade later it was announced at the 1971 AGM that the ground was now free from debt and the original guarantors were also free from their responsibilities.

KEY DATES

1888
Tubbercurry GAA Club is founded under the name St Patrick's

1917
Mayo beat Sligo at the first Connacht SFC match played at Tubbercurry on 5 August

1935
Sligo win their first Connacht SFC match played in Tubbercurry; it is also the last Connacht SFC game to be played there

1964
Mayo beat Sligo by a point at the opening of Kilcoyne Park

MICHAEL KILCOYNE

Michael Kilcoyne was born in the townland of Oghambaun, Tubbercurry, to Luke and Brigid Kilcoyne, who were farmers. One of a family of nine children, he went on to study veterinary science at UCD. The young student was in Croke Park on Bloody Sunday, 21 November 1920.

Michael was a key member of the Sligo team that defeated Galway in the 1922 Connacht final (played in 1923) and then beat Tipperary in the All-Ireland semi-final. However Galway had a list of grievances, including two disputed Sligo goals, and lodged a successful objection. Galway won the replayed match and replaced Sligo in the All-Ireland final.

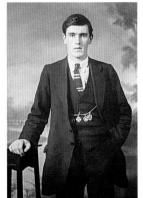

KILCOYNE FAMILY

Michael won a Sigerson Cup medal with UCD and was on the first Sligo team to win a Connacht SFC title in 1928. He won eight Sligo senior football medals, four with Tubbercurry and four with Curry, and represented Connacht in the Railway Cup. An all-round athlete, he also won Connacht championship medals in the long jump, 100 yards and hurdles all through the '20s.

Appointed veterinary inspector for the Tubbercurry area in 1929, he was a staunch member of the Western Agricultural Show Society until his sudden death in 1963. His brother Tommy was secretary of the Connacht GAA Council and Sligo County Board for many years.

THE UPS AND DOWNS OF FUNDRAISING

When the club began developing Carrowntober in 1961 they received advice on levelling and draining the ground from agricultural advisor Peadar MacCanna, school headmaster Seán O'Dowd and engineer Gerry Flood, with club secretary Michael Brett being the key figure in driving things forward. Many activities were organised to raise funds; some were more successful than others. A dance in the Marine Ballroom, Enniscrone, made a loss of £25. A carnival ran into difficulties when the marquee was blown down in a gale. On the other hand, weekly bingo in the local hall provided a steady stream of income, while the club also let the grazing rights to the pitch. With grants from Connacht and Central Council and a donation of goalposts and nets from local TD James Gallagher, all was set for the official opening of Kilcoyne Park on 2 August 1964.

OVERCOMING STORM AND FLOOD

A new stand was completed in 1980 and in 1986 the club purchased an adjoining field to provide more training and playing facilities. However, the main pitch had a recurring problem. Though the ground, situated on a rock plateau, was naturally dry, it was subject to continual flooding due to poor drainage locally. The pitch was re-seeded, sanded and rolled in 1995 but extensive flooding in 2008 and 2009 showed that the entire Carrowntober area had to be drawn into the scheme.

Storm Desmond caused yet more flooding in December 2015. In response the main pitch was sanded and verti-drained in 2019 while work began on converting the second pitch into a new all-weather sand-based pitch. This pitch was also verti-drained in 2021. The club set about installing a lighted walking track around the ground in 2022 to add to the amenity and open it out even more to the community.

1970
The park is the first in Sligo to be completely fenced off from the public

1977
Work begins on a new stand, completed in 1980 at a cost of £4,000

1982
Showers are installed in the dressing rooms and a third one is built

1984
Tubbercurry become Sligo and Connacht GAA Club of the Year in the GAA's centenary year

2021
Former Tubbercurry club chairman John Murphy elected president of the Connacht Council

Corran Park

LOCATION
Stoneparks, Ballymote

NAMED AFTER
Corran, mythical harper

OPENED
1949

CAPACITY
2,500

PITCH DIMENSIONS
137 x 77m

COVERED ACCOMMODATION
Yes

FLOODLIGHTS
No

CLUB
Ballymote Round Towers

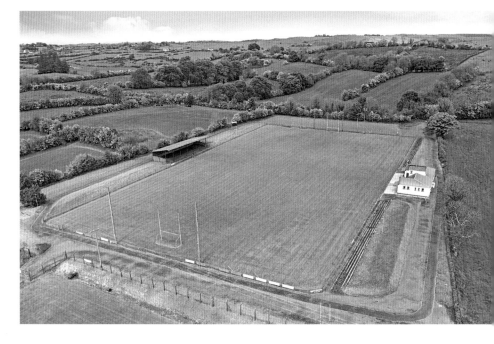

Ballymote Round Towers GAA Club play at Junior A championship level and contested the Connacht JFC final in 2017. Their roll-call of honours also includes five Sligo SFC titles, the most recent in 1948, and an intermediate championship in 1993. Club players like Neal Farry (1960s) and Pat Dockry (1990s) have represented Sligo with distinction.

The first GAA football club in Ballymote was founded on 19 January 1886 and played initially in the Castle Meadow on the Earlsfield Estate, at Cloonacurra and at Carrigans about half a mile outside the town. Sir Henry Gore-Booth, father of Constance Markievicz and a noted Arctic explorer of the day, gave the use of a field at Carrownanty, now the local cemetery, for the opening rounds of the 1888 Sligo championship. The playing area was measured out carefully and the goals and point posts decorated with green flags for the games.

Gaelic football thrived in Ballymote even after Sligo County Board disbanded in 1892. The town's football teams gathered under many names, among them Fr Matthew's, Commercials, Mechanics, Round Towers, Emeralds, Young Ireland's and the Liberators. Ballymote won their first Sligo SFC title in 1892 under the name of Round Towers. In the 1920s the club played in Stone Park, a field adjacent to today's Corran Park. Cricket and rugby were also played there, mainly by the staff of the three banks in town.

Corran Park has a great relationship with its neighbours in Ballymote Town Park, and together they provide facilities for a range of sports

KEY DATES

1886
Michael J. Flannery is elected as Ballymote GAA Club's first president

1946
Derroon and Keash play the first match in the new Town Park on 28 April

1947
Ballymote's Town Park hosts the horse show and gymkhana, as well as athletics meetings and feiseanna

1949
Bishop of Anchory Dr James Fergus opens GAA ground and surprisingly names it Corran Park – the park committee had agreed to name it Canon Quinn Memorial Park

CORRAN

CONRADH NA GAEILGE

Corran was the famed harper of the mythical Tuatha Dé Danann. As a reward for his excellent music, the Tuatha bestowed on him the district that bears his name, today's barony of Corran, with Ballymote as its capital.

TIED UP IN LEGAL KNOTS

The Ballymote Town Park Committee was formed in April 1946. Shortly afterwards, when 11 acres of the late Canon Thomas Quinn's estate at Earlsfield, owned by Batty Cawley, came on the market, they bought it for £800. Over the next year or so very little was done with the newly named Town Park until the arrival of Fr Denis O'Hara to the town in 1947. He organised a group of willing volunteers to set about improving the ground, which was described as being like a ship with a list – one side up and the other down. In 1947 the Minister for Finance offered a grant of £690 on condition that the park's trustees execute a Deed of Trust declaring that they held the property for the people of Ballymote's use, which they did.

Fr O'Hara succeeded in getting 40 members of the town park committee to each sign a promissory note for £25 to secure a bank loan of £1,000 to help develop the ground. In March 1948 the GAA Central Council offered a grant of £300 on condition that the ground was vested in the GAA, and the committee agreed to that too.

In the event, the Deed of Trust and subsequent Deed of Transfer dated 30 December 1948, which the park trustees sent to the GAA's solicitors, were never lodged in the Land Registry. In any case, the committee's transferring the title to the GAA was in breach of the Deed of Trust they had executed with the Minister for Finance.

NEWLY NAMED PARK OPENS

Corran Park opened on 1 May 1949, and as Kilcoyne and Markievicz parks had not yet come on stream it became Sligo's leading county ground, hosting its first Connacht SFC match between Mayo and Roscommon that June. The park's facilities were upgraded through the 1950s and '60s and in 1972 a new development committee was formed to continue the work. Under the guidance of people like Neal Farry and Alfie Banks funding was organised throughout the 1980s to build another pitch. However, the main ground was still not vested in the GAA, and when the Connacht SFC

NEAL FARRY – GERRY CASSIDY COLLECTION

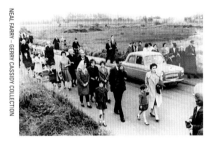

'Build it and they will come' – crowds make their way to the opening of Ballymote's field of dreams in 1949

match between Sligo and Leitrim was fixed for Corran Park in 1989, Connacht Council faced a dilemma. As a goodwill gesture they allowed the match to go ahead but insisted no further championship games be played there until Corran Park was vested in the association.

SHARING FACILITIES

Ballymote Community Park continues as home to both the GAA in Corran Park and Ballymote Celtic at Brother Walfrid Park, named after the renowned Ballymote man (Andrew Kerins) who founded Glasgow Celtic FC. Gaelic and soccer players share dressing rooms and the new all-weather pitch which opened in 2009. In 2020 an additional 14 acres were purchased to expand facilities for all the clubs that use the park.

A fine sculpture in Ballymote honours its famous son

THE Q

BROTHER WALFRID

1951 & '53	1975	1980	1985
Corran Park hosts the Connacht SFC semi-finals	*Four new dressing rooms are built for the GAA and soccer clubs*	*Novel 'baronial election' raises over £8,000 after being featured on BBC's Nationwide*	*New covered stand built at a cost of £4,500*

McGovern Park

LOCATION
West End Road, South Ruislip

NAMED AFTER
Tony McGovern
Businessman, philanthropist

OPENED
1979 and 2017

CAPACITY
3,000

PITCH DIMENSIONS
145 x 83m

COVERED ACCOMMODATION
Yes

FLOODLIGHTS
No

CLUB
No

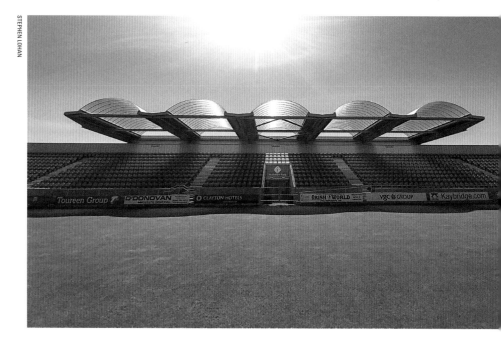

STEPHEN LOHAN

STEPHEN LOHAN

Rainwater that falls on the pitch runs into drains and is stored in a well and attenuation tanks. It is then reused to keep the playing surface in magnificent condition

At the heart of the GAA in London, this stadium reopened in May 2017 after a redevelopment costing more than £4m. Its social as well as playing facilities draw the Irish community together in their shared love of Gaelic games.

There's some corner of a foreign field that is forever Ireland – a resplendent McGovern Park following its €4.3m upgrade

Decades of emigration meant that GAA clubs in the city had an abundance of players but no permanent home until 1947, when the London County Board purchased Elliott's Cricket Ground in New Eltham. It served as the GAA's centre until 1992. The GAA bought another pitch in Ruislip in 1978, formerly QPR's training ground, on a site of 7.5 acres. Thirty years later they launched an ambitious three-phase plan to improve it. Progress depended on selling New Eltham for housing development, which took all of 15 years.

Work finally began in 2016. GAA teams played at the London Irish rugby grounds in Sunbury until Ruislip was reopened under its new name, McGovern Park. The park is the largest development undertaken by any GAA branch outside of Ireland.

KEY DATES

1896
London GAA is founded and is admitted to the All-Ireland Championships in 1900

1903
London (Selection) defeat Cork (Redmonds) to win the All-Ireland SHC 1901 title

1928
Dublin and Cork hurlers play for the inaugural Monaghan Cup in Herne Hill Athletics Ground

1978
GAA purchase the Ruislip ground for £100,000

TONY McGOVERN

Tony McGovern was born in Aughavas, Co. Leitrim, in 1945, the youngest of nine children. He emigrated at the age of 17 and worked as a barman at the famed Crown pub in Cricklewood. In 1967 he started a haulage business and with his brother Peter built it into a thriving company.

Tony and his wife Bernadette have given much back to the communities they came from, in both Ireland and England. They have contributed to numerous causes, among them the Church, charities, the homeless and those in need of care. The Leitrim GAA and Tony's native Aughavas have long benefited from their generosity, in sponsorship, ground developments and more, as has the London GAA.

Tony and James McGovern's support for the redevelopment of Páirc Mac Diarmada in Carrick-on-Shannon saw the Ardán Mhic Shamhrain (McGovern Stand) given their name in 2009. Ten years later GAA President John Horan opened the Leitrim McGovern Aughavas Centre of Excellence, which was supported by Tony and Bernadette. The couple's contribution to London GAA's central facility was also honoured in the ground's name.

A champion of Gaelic games, Tony indulges one individual passion of his own – his abiding love of vintage tractors.

GAELIC GAMES MOST FAMOUS NAMES

London's place in GAA annals has long been secured due the contribution of two of the association's most notable figures, Liam MacCarthy and Sam Maguire.

MacCarthy served on London's very first county committee and became president in 1898. In 1922 he commissioned a trophy for the winners of the All-Ireland SHC which was subsequently named in his honour.

Maguire, who served alongside MacCarthy, was also an outstanding player and captained London against All-Ireland champions Kerry in the 1903 final, played in November 1905. The Sam Maguire Cup is named in his honour.

IRELAND'S FIFTH PROVINCE

The origins of the GAA in London can be traced back to 1896. That year, leading Irish players played Gaelic exhibition matches at Stamford Bridge. In 1900 England was constituted as a province, with the winner of the All-Ireland (Home) Championships playing off against the English champions for the 'All-Ireland' titles. London represented England from then until 1913, when they played their final match against Louth in Kensal Rise. London's participation in the All-Ireland championships stopped at this point.

London GAA re-entered the All-Ireland SFC in 1975. They played all their matches away in the Connacht Championship until 1981, when they played Mayo in their first home match in Ruislip. Since then, all of London's first round championship games have been played there.

A HOME FROM HOME

McGovern Park boasts a modern pitch and new artificial 3G floodlit training area, a 1,950-capacity stand, four dressing rooms, referee's room, a medical treatment room, along with meeting rooms and media newsroom. The centre streams GAA matches and offers social facilities to the Irish community. A sporting and cultural centre for many, GAA President Larry McCarthy unveiled a tribute to Liam MacCarthy and Sam Maguire when London celebrated its 125th anniversary in 2021 with a display of hurling, football and shinty matches at McGovern Park.

2009
Munster play Ulster in the Railway Cup football final at Ruislip, then called the Emerald GAA grounds

2013
London beat Sligo and Leitrim to reach the Connacht final for the first time

2017
Leitrim defeat London in the Connacht SFC as the upgraded ground is officially opened

2018
McGovern Park is runner-up to Nowlan Park for the GAA County Pitch of the Year award

Gaelic Park

LOCATION
The Bronx, New York

OPENED
1928

CAPACITY
2,000

PITCH DIMENSIONS
139 x 78 m

COVERED ACCOMMODATION
No

FLOODLIGHTS
Yes

CLUB
New York

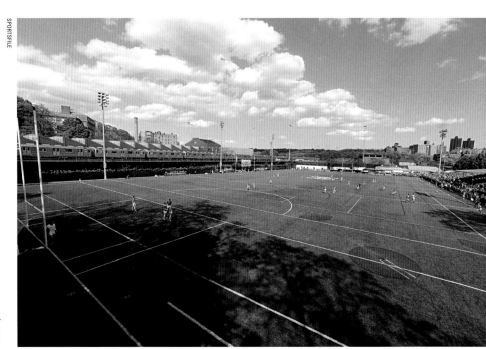

A familiar sign to the thousands of immigrants making a new life in the Big Apple. The banquet hall was a popular venue for socialising, though management wasn't keen on new fashion fads judging by this poster from the 1960s

New York's GAA emerged in 1914 at a time when the Irish community was one of the largest ethnic groups in the city. From the very first championship in 1915 the association grew steadily despite WWI and the Great Depression of 1929–39.

Generations of Irish people have anchored their life in New York around the weekly pilgrimages to 'The Park' to see and play matches

P. J. Grimes and Billy Snow, of the Gaelic Athletic Association of Greater New York, leased a park from the Metropolitan Transport Association (MTA) in the North Bronx in 1926; it opened as Innisfail Park two years later. Since the 1950s it has gone by its current name, Gaelic Park.

The ground, bound by the 240th Street train yard facility on one side and railway tracks on another, was rough – at the height of summer it turned into a dustbowl – but it served for hurling and football. Gaelic Park was also an important social centre. Weddings, dances, meetings and political rallies were hosted in the ground's banquet hall, and it was also a place where newly arrived immigrants could go to learn about the availability of jobs.

KEY DATES

1898
Celtic Park opens. It hosts Gaelic games but also becomes famous as a training ground for Olympic athletes under the auspices of the Irish-American Athletic Club

1936
40,000 fans watch Limerick beat New York at hurling in Yankee Stadium

1985–90
Renewed Irish immigration produces bumper crowds at Gaelic Park

THE BRONX BLOODPIT

The MTA took the lease back after the GAA fell into financial difficulties and in 1944 leased the park to John 'Kerry' O'Donnell. O'Donnell had played for New York's Kerry football club and would be the city's GAA president seven times up until the 1970s.

Post-war immigration produced a boom in Gaelic games. The city soon boasted 65 clubs, while Gaelic Park typically hosted four matches every Sunday with 4,000 spectators in the stands. The ground, leased at a nominal rent from the Irish-dominated transit authority, was also used gratis for fundraising events on behalf of local political and trade union allies, among them William O'Dwyer, who as Mayor of New York did much to facilitate the 1947 All-Ireland final in the Polo Grounds, and Transport Workers Union leader, Kerryman Michael Quill, popularly known as 'Red Mike.'

O'Donnell was instrumental in starting Irish GAA teams' tours to New York, and vice versa, from 1950. The transatlantic relationship grew despite constant wrangling with Central Council. O'Donnell regularly bypassed council, while the American fixtures periodically disrupted the GAA calendar by enticing clubs and county teams to New York. There were fractious encounters on the pitch, too. The New York teams' tough physical style and the ground's hostile atmosphere prompted a New York sports columnist to dub Gaelic Park the 'Bloodpit of the Bronx.'

STAYING BETWEEN THE LINES

Manhattan College took a lease on the ground in 1991 and sublet it to New York GAA under its official name, the Gaelic Park Sports Centre. The park continued to host Gaelic games but was also used by the college's sports club, Jaspers. The college lacrosse, soccer and softball teams played their home games at Gaelic Park and the surface suffered heavy wear and tear from the amount of sport being played there.

After New York was admitted to the Connacht championship in 1999, Connacht counties began travelling to Gaelic Park on a rota basis for championship games.

The groundskeepers had to cover the earthen area used in softball with sods before every match and take them up again afterwards. However, in early 2007 a $3m renovation of Gaelic Park began and a durable synthetic turf was laid to replace the natural grass. The markings for the different sports, Irish and American, were painted on the playing surface, which made for a colourful though perhaps sometimes confusing pitch.

Three men with close ties to Gaelic Park: (1) New York GAA President John 'Kerry' O'Donnell, (2) NYC Mayor Bill O'Dwyer and (3) the founder of the Transport Workers Union of America, 'Red Mike' Quill

NEW LEASE SPARKS REVAMP

In 2018 New York GAA secured a long-term lease from the MTA and permission to replace the ground's dilapidated buildings, which had stood since the 1930s. The security of the lease paved the way for long-awaited renovations. In April 2019 Gaelic Park's banquet hall – a feature of Irish life in New York for decades – was torn down and work began on a new two-storey facility. The $4.5m (€4.2m) project included a function room, bar, medical office, changing rooms and administrative offices. In New York a fundraising event at Rosie O'Grady's restaurant, Manhattan, raised $500,000 in one evening. After many delays work finally began on the new development in July 2022. It is planned that the New York GAA administration will relocate to the new premises.

2000s
Possibility of developing new GAA ground in Randall's Island NY is mooted but comes to nought

2019
Irish government pledges $1m and Croke Park $2m (€1.79m) to support modernisation plan

2021
Cork man Larry McCarthy, former secretary and chairman of the New York GAA Board, becomes first overseas official elected President of the GAA

2023
Gaelic Park sees New York win their first Connacht SFC game when they beat Leitrim 2–0 on penalties after a period of extra time couldn't separate the sides

St Brigid's Park, Dundalk, Co. Louth

L E I N S T E R

Páirc an Chrócaigh

LOCATION
Jones Road, Drumcondra

NAMED AFTER
Dr Thomas Croke (1823–1902)
*Archbishop of Cashel & Emly,
first patron of the GAA*

OPENED
1892

CAPACITY
82,300

PITCH DIMENSIONS
144 x 86m

COVERED ACCOMMODATION
**Hogan, Cusack and
Davin stands**

FLOODLIGHTS
Yes

*The headquarters of Gaelic
games has gone through
several manifestations in its
lifetime. With a capacity among
the top five stadiums in Europe,
Croke Park is a cathedral of
sport, one that has opened its
doors to rock stars and royalty,
international conferences and
local school tours, and played
host to many memorable
moments in Irish life for
over a century*

MAURICE BUTTERLY'S FIELD

In the 1860s Maurice Butterly of Albert Villas, a farmer, market gardener and city alderman, leased two tracts of adjoining ground, separately owned by Love's Charity and Mrs Marie McGrane, for a period of 500 years. Nestled between the banks of the Royal Canal, Jones Road and Clonliffe Road in Drumcondra, Butterly had an ambition to create a race-course, sporting and amuse-ment centre there, and a wide variety of sports, from athletics to whippet racing, did come to use 'Butterly's Field.'

After the GAA was formed in Dublin, several grounds were used to hold matches. There was Donnybrook; Elm Park, Clonturk Park in Drumcondra; Terenure; the Abattoir Field, North Circular Road; Mount Drummond, Harold's Cross; the Phoenix Park; and Goldenbridge in Inchicore. The GAA held its first athletics meeting in Butterly's Field on Thursday 10 September 1891. The first major match held there was the 1895 Leinster football semi-final played on 16 February 1896, when Dublin defeated Kildare by 3–7 to 0–4.

1913 map of the ground showing the plot Frank Dineen sold to Belvedere College in 1910

One of the oldest known photographs of Jones Road was taken in 1909 at the start of the first marathon staged in Ireland. Runners had to complete 60 laps of the ground and were led home by Tom Hynes of Galway in under three hours. The winner was rewarded with £30

KEY DATES

1893–94
The City and Suburban Grounds is home to Bohemians' soccer club and other sports

1897
Dublin County Board signs agreement to use the venue for Dublin Championship

1890s
Site reduced as a result of compulsory purchase to create Drumcondra & North Dublin Railway Link

1901
Cliftonville, Belfast, beat Freebooters, Sandymount 1–0 in soccer's Irish Cup final

BUTTERLY REALISES HIS AMBITION

Barrister J. McInerney BL opened Butterly's City and Suburban Racecourse and General Amusement Grounds officially on 20 August 1892. Two years later the City and Suburban Racecourse and General Amusement Grounds Company Ltd was formed and purchased the lease from Maurice Butterly for £13,500. Butterly was the principal shareholder and managing director and to raise funds to develop the site he mortgaged the land to the Munster & Leinster Bank in March 1895. The GAA continued to rent the venue and held the 1895 All-Ireland finals there in March 1896. Tipperary were the winners in both codes, beating Kilkenny in the hurling final and Meath in football.

FORMER GAA PRESIDENT BUYS LEASE

Maurice Butterly died suddenly on 25 April 1905. His company had been in financial difficulty and had gone into voluntary liquidation on 7 December 1900. On 27 February 1906 the ground was put up for auction; in August it was to be sold by private treaty, and it was put up for auction again on 16 April 1907. It didn't sell. It became known that Butterly had purported to assign the property on Jones Road to the company by an agreement dated 16 April 1896, but the conveyance had never been executed. This situation would have compromised ownership for any future purchaser as the liquidator did not have clear title, hence the reason for no sale.

However, former GAA president and general secretary Frank Dineen, now working as a journalist in Limerick, stepped in at this point. On 17 December 1908 he bought the lease from the liquidators, in agreement with the executors, for £3,250. Dineen intended this purchase to be a short-term matter and that in time the GAA would buy the grounds from him. In the meantime he made substantial improvements in the spring of 1909, re-laying the pitch and erecting terracing.

Born in Ballylanders, Co. Limerick, in 1862, and a founding member of his local GAA club, Frank Dineen secured Jones Road for the GAA

DR THOMAS CROKE

Born in in Castlecor, Co. Cork, Thomas's father, William, was Catholic and his mother, Isabella, Protestant. Thomas went to a local hedge school and at the age of 16 won a bursary to the Irish College in Paris, graduating as a Doctor of Divinity.

He later served as a curate in Co. Cork and lectured as Professor of Rhetoric at Carlow College and Professor of Dogmatic Theology in Paris. Personally well off after inheriting some £19,000 in 1857 from his uncle, James, Dr Croke was known for his generosity towards the poor.

For Dr Croke, being patron of the GAA was not just a title – he was actively involved in the issues which defined the association's place in Irish sport. His importance was recognised by the Irish Independent *when it featured him on the cover of a special Golden Jubilee supplement published in 1934*

Dr Croke became Bishop of Auckland in 1870 and five years later was appointed Archbishop of Cashel & Emly. He was perhaps the most outspoken Irish prelate at a time when the land issue and Home Rule were paramount, and he encouraged his clergy to play an active political role also. His famous letter of support to Michael Cusack in 1884 led to his appointment as a founding patron of the GAA.

1903	1913	1923	1924	1928
London defeat Cork 1–5 to 0–4 in the delayed 1901 All-Ireland SHC final	*Croke Memorial Tournament raises funds for the GAA to purchase the ground*	*Liam MacCarthy Cup is presented for the first time as Limerick take the delayed 1921 All-Ireland SHC title*	*GAA revive the ancient Tailteann Games, combining sporting and cultural activities*	*All-Ireland SFC winners Kildare receive Sam Maguire Cup, the trophy's first appearance in Croke Park*

CROKE PARK ARCHIVES

Rodeo extravaganza – No one had ever seen anything like Tex Austin's rodeo in August 1924, with its galloping horses and bucking broncos, lassoing, trick riding, steer wrestling and calf roping. Playing two shows a day to over 100,000 spectators in all, it sparked off a Wild West mania that spread to cinema, books and kids playing cowboys in the street

Doing the sums – Clare builders McInerney & Company test the load-bearing capacity of the upper tier of the 'new' Hogan Stand during construction in 1959

Finishing touch – A plaque saved from the old Hogan honouring the player killed on Bloody Sunday was fixed to the new stand by Jimmy Curran. Looking on are (1) Seán Ó Síocháin, (2) Bríd Ní Mhuircheartaigh, (3) Eileen McDonald and (4) Pádraig Ó Caoimh. The five made up the full complement of Croke Park staff at the time, which nowadays numbers around 150

GAA OPTS FOR JONES ROAD

The first big matches after Frank Dineen purchased the grounds were played on 21 February 1909 when Dublin and Cavan met in the 1908 All-Ireland hurling semi-final final and Dublin played Antrim in the 1908 All-Ireland football semi-final.

However, the improvements carried out by Dineen placed him under massive financial strain. He was a successful journalist but not wealthy and had borrowed money to buy the grounds, and by 1910 he was forced to sell off four acres to the Jesuits of Belvedere College for £1,090.

Central Council, for their part, had decided to look for a ground of their own. The minutes of their 17 August 1913 meeting reveal that a delegation had inspected several grounds around Dublin, though only two were identified as suitable: Jones Road and Elm Park near Donnybrook. The land at Jones Road, under lease, consisted of 9¼ acres including two houses on site and was being offered to the GAA for £4,000. Elm Park, freehold, consisting of 15 acres, was on offer for

£5,000. The meeting agreed that council would revisit Elm Park. The minutes for Central Council's next meeting on 7 September record that Frank Dineen had reduced his asking price to £3,625.

At a special meeting held on 4 October it was proposed that Central Council offer £3,500 to Dineen for the Jones Road Sports Ground. An amendment was put that the question be postponed until the 1914 Convention, but the decision to go ahead was carried by eight votes to seven. It may be as well that they did. It was subsequently reported that the GAA had a competitor, the Archbishop of Dublin, who had reputedly been negotiating with Dineen to buy the land as the site for a new cathedral.

RENAMED GROUND TAKES CENTRE STAGE

Once the purchase was agreed, the ground was renamed Croke Memorial Park and was ready for its first All-Ireland football final on 14 December 1913, when Kerry defeated Wexford 2–2 to 0–3. Indeed, the stadium quickly became the centrepiece of Gaelic

KEY DATES

1953
Croke Park hosts American football match in aid of the Red Cross

1962
RTÉ broadcast Gaelic games live on TV for first time, the Railway Cup finals on 17 March

1970
World Handball Championships held in Croke Park handball alley

1984
32,000 watch Australia win the first ever Compromise Rules Series

1985
Hometown band U2 play their first concert in Croke Park

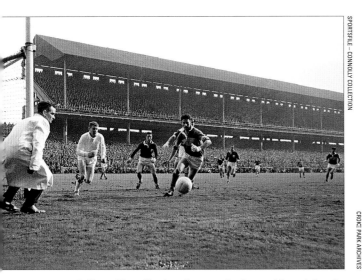

Ball watching – Umpire, players and a thronged Cusack Stand are focused on the action during the 1965 All-Ireland football final. Defending champions Galway defeated Kerry to complete the second leg of a famous three-in-a-row of titles

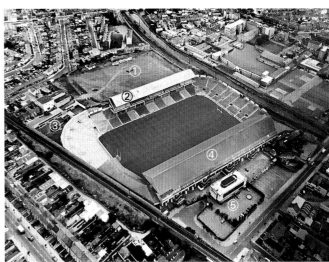

Once-familiar landmarks are indicated in this 1980s view of Croke Park and its surroundings before the ground was radically transformed: (1) Belvedere College pitch, (2–3) Cusack Stand and entrance, (4) Hogan Stand and (5) Ceannáras

games, so much so that the GAA had to issue an appeal to the media to stop calling it 'the National Stadium' and refer to it as Croke Park. Decisions were also made to move the association's offices from 68 Upper O'Connell Street to the ground and to establish a new company – the Gaelic Athletic Association Limited – on 19 December 1914 as the purchase of Jones Road had shown that the GAA, as constituted, had no power to borrow money.

TAKING THE HILL

In 1914 work began on building an embankment at the north end of Croke Park. It was named Hill 60 after a hill near Gallipoli where a brutal battle was fought during the 1914–18 war. However, exception was taken to the title at a meeting of Central Council in September 1931. *This was sacred ground which commemorated our fight for freedom*, Munster Council chairman Mr McCarthy

said, *and not a fight in a foreign country*. It became Hill 16, commemorating 1916, in the years after that.

CROKE PARK'S DARKEST DAY

Early on the morning of 21 November 1920, 14 British intelligence officers were assassinated in Dublin. British troops targeted Croke Park in reprisal, opening fire inside the ground during a challenge match between Dublin and Tipperary. Thirteen spectators and Tipperary footballer Michael Hogan were killed on a day that went down in history as Bloody Sunday.

NEW STANDS AND RECORD CROWDS

Accommodation for spectators at Croke Park was very basic to begin with. Two stands existed along the Jones Road side, one known as the Long Stand and

1986
Kerry defeat Wexford in the first All-Ireland Ladies Football final played in Croke Park

1998
Taoiseach Bertie Ahern opens the GAA Museum

2002
New Desso pitch is laid, combining synthetic fibres and grass

2006
Canal End Stand is renamed the Davin Stand and Hill 16 becomes Dineen Hill 16

2007
81,678 fans watch Tyrone defeat Dublin in the first floodlit match in the stadium

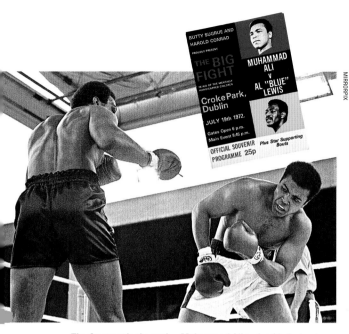

MIRRORPIX

The Greatest in the park – Muhammad Ali arrived in Ireland on a mission to revive his career after the controversies that dogged him since his refusal to fight in the Vietnam War. The match against Al 'Blue' Lewis on 19 July 1972 was co-promoted by publican, entrepreneur and former circus strongman Butty Sugrue from Killorglin, Co. Kerry. When Ali won by a technical knockout in the 11th round, the crowd swarmed the ring in celebration

Special Olympics – Croke Park proudly held a colourful opening ceremony for the Special Olympics on 20 June 2003, with Nelson Mandela as guest of honour. It was the first time the games were held outside the USA since they were founded by Eunice Kennedy Shriver, sister of President John F. Kennedy. Towns, villages and cities all around Ireland hosted the 7,000 athletes representing countries from all over the world. By the 2023 games held in Berlin, participation in the Special Olympics had grown exponentially

the other simply called 'The Stand.'

Setting out to increase Croke Park's capacity, the Hogan Stand was built in 1924. Named after Michael Hogan, it was opened by GAA President Patrick Breen on 17 March 1926. The two-tier Cusack Stand, the largest of its kind in Europe at that time, was opened by GAA President Pádraig McNamee on 21 August 1938. The stand's terrace area was later replaced with seating for 9,000 spectators in 1966. In 1949 General Secretary Pádraig Ó Caoimh launched fresh plans to cater for the park's attendances, beginning with new terracing at the Canal End; the Nally Stand followed in 1952. After the 'old' Hogan Stand was dismantled and shipped to the Gaelic Grounds in Limerick it was

replaced in 1959 with a two-tier structure seating 16,000. A record 90,556 crowd filled the revived stadium to watch Down beat Offaly in the 1961 All-Ireland SFC final.

A BOLD VISION FOR A NEW CENTURY

In the 1980s, under the stewardship of Ard Stiúrthóir Liam Mulvihill, a grand plan to entirely redevelop Croke Park with all the facilities of a 21st-century stadium was set in train. In 1991 the GAA bought back the land sold by Frank Dineen to Belvedere College. The project was staged in four phases, including the realignment of the pitch. The old Cusack Stand was

KEY DATES

2011
GAA President Christy Cooney tells Queen Elizabeth II, 'Your presence does honour to our association,' as the British monarch visits Croke Park

2012
Skyline Tour is launched offering exhilarating views across Dublin from the roof of the stadium

2012
Kilkenny's Henry Shefflin carries the Olympic torch into the park ahead of the games in London

2012
80,000 pilgrims pack Croke Park for closing Mass of 50th International Eucharistic Congress

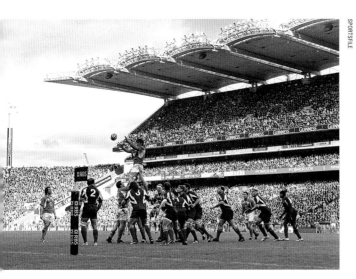

SPORTSFILE

The end of Rule 42 – In 2005 GAA Congress voted to abolish Rule 42 and open Croke Park to other games. The motion gave Central Council the power to rent the park for events beyond Gaelic games. History was made on 11 February 2007 when the first rugby international was played at the ground, a Six Nations clash between Ireland and France. On 24 March soccer returned to Jones Road for the first time since the early 1900s, when over 72,000 spectators watched the Republic of Ireland beat Wales in a Euro 2008 tie

Festival of Eid – Ireland's Muslim community first celebrated the holy festival of Eid in Croke Park in 2020. Because of Covid restrictions, they needed a large open space to worship safely, and the GAA obliged. Eid was repeated in 2021. The 2022 service was led by Shaykh Dr Umar Al-Qadri from Blanchardstown Mosque, who opened his sermon by thanking Croke Park for hosting the event. 'Three in a row,' he quipped. 'It seems Dublin's Muslims are as lucky as Dublin's footballers'

demolished after the 1993 All-Ireland football final and rebuilt by May 1995, completing phase one. Work began on the next phase in 1998, when the Canal End terrace was replaced by the Canal End Stand. The Hogan Stand was demolished in 1999 and rebuilt in 2002, its four-tier design holding a main concourse with a museum and library, and a premium level incorporating hospitality and conference facilities. The corporate box level contained administrative offices, restaurants and bars and an upper concourse. The project culminated in 2005 when a new Nally Terrace and Hill 16 Terrace were opened officially. The redevelopment was completed two years ahead of schedule and without disrupting an All-Ireland final.

The jewel in the crown of Gaelic games, in 2009 architects Gilroy McMahon were awarded the Royal Institute of Architects of Ireland's gold medal for the quality of the stadium's design. The ground's ongoing innovation and outreach has been acknowledged in many awards since, becoming one of the first net-carbon neutral stadiums in the world in 2009, declared Best Stadium Venue in the UK and Ireland in 2017 ahead of prestigious locations like the Emirates Stadium, London, and the Etihad Stadium, Manchester, and winning the Community Integration award at the World Stadium Congress in Amsterdam in 2018 for the wide programme of community projects and events that surround the ground at Jones Road.

2013
Hawk-Eye point detection technology makes its debut

2014
Country superstar Garth Brooks runs foul of planning authorities in his attempt to stage five sell-out concerts on consecutive nights, prompting near meltdown among his devoted fans

2015
After 102 years in legal limbo GAA finally secures the freehold title to Croke Park

2018
82,000 people enjoy World Meeting of Families concert in the company of Pope Francis

Parnell Park

LOCATION
Donnycarney, Dublin

NAMED AFTER
**Charles Stewart Parnell
(1846–1891)**
*The 'uncrowned king of Ireland,'
leader of Home Rule movement*

OPENED
1901

CAPACITY
8,500

PITCH DIMENSIONS
144 x 80m

COVERED ACCOMMODATION
Yes

FLOODLIGHTS
Yes

CLUB
No

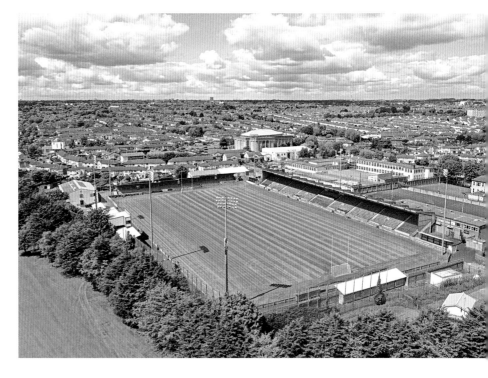

**'The Nell,' HQ of the Dublin
County Board, is a homely
and atmospheric ground**

TRUE BLUE THOROUGHBRED

*The St John's Ground was a
favourite venue for athletics.
International athlete Charlie
Harris from Santry, who later
trained the Dublin football
team, won the two-mile race
there in 1907. He also had the
distinction of racing against
a horse in Jones Road (now
Croke Park) on 19 November
1911. He came second.*

Parnell Park sits in a part of Donnycarney, north Dublin, which was known as St John's Ground in the 19th century. The playing pitch there, Victoria Park, was leased to Richmond Rovers AFC and Civil Service Rugby Club and was mainly used by civil servants in Dublin Castle for playing rugby and soccer. It was also a venue for athletics.

In 1901 Celtic Hurling Club leased Victoria Park from Dubliner Tom Byrne, a town commissioner, nationalist politician and ardent Gaelic League supporter. Now known as the Celtic Club grounds, it was 'The most northern outpost of hurling territory on the east coast of Ireland' according to one of the Dublin dailies. The first Dublin GAA championship games there took place on 12 May between Erin's Hope and John Mitchels in football, and Celtics and Grocers (who morphed into Young Ireland's Hurling Club in 1923) in hurling. Louth thrashed Offaly 6–14 to 0–1 in the first inter-county match at the ground – a 1900 Leinster SFC tie played on 18 August 1901.

KEY DATES

1901
*Celtic Hurling Club
beat Rapparees in the
first game at the
venue on 10 March*

1932
*Leinster Council invests £150
in ground improvements
after the county board takes
over the lease*

1940s & '50s
*St Vincent's Athletics Club revive
athletics meetings at the park,
with Olympians John Joe Barry
and Dave Guiney taking part*

1969
*Victories for O'Toole's
(hurling) and Na Fianna
(football) as park hosts its
first senior county finals*

CHARLES STEWART PARNELL

LIBRARY OF CONGRESS

Charles Stewart Parnell, leader of the Irish Parliamentary Party, led Ireland to the brink of self-government; then, at the high point of his political career, fell foul of a personal scandal that lost him political and popular support. Like other groups of the time, the GAA were also divided on the Parnell issue, with clubs, players and county boards often at odds. Parnell's GAA Club, originally known as Parnell's Volunteers, were clear on where they stood.

CHANGING NAME AND MOVING A BUILDING

The Dublin Senior Hurling League took over the lease of Victoria Park from the Celtic Club in 1902, and ten years later Parnell's GAA Club took up residence there. One of the first things they did was to change the name to Parnell Park. They also transported a corrugated-iron canteen structure from Collinstown airfield (now Dublin airport), which had been vacated by the British Army, to the park to be used as dressing rooms and a meeting room. It was subsequently used as a community centre and became the venue for many concerts and céilís throughout the 1920s.

DUBLIN COUNTY BOARD

The corrugated-iron dressing rooms may have started out as army surplus but provided decades of great service

SAVING THE PARK FROM THE CORPO

Dublin County Board took over the lease from Parnell's in 1929, recouping some of the £50 annual rent by selling grazing rights. The board moved to improve the ground so it could host inter-county matches and £400 was spent on developing it in 1932–33.

Due to the gradual expansion of the city the GAA began losing grounds to Dublin Corporation, who were actively seeking land for housing. Mount Drummond Avenue in Harold's Cross, Terenure, The Thatch in Drumcondra and several others were taken over. In 1937 the corporation issued a compulsory purchase order on Parnell Park with a view to building houses there.

However, the corporation and the GAA came to an alternative arrangement in the end: Dublin GAA released their interest in nearby Killester Park for a fee of £320 on condition that they would maintain their lease on Parnell Park. In 1939 the corporation granted a 99-year lease dated from 1937 to Dublin County Board, and this is still the existing lease on the ground.

HEFFO MAGIC PRECEDES MAJOR OVERHAUL

The park was a hub of excitement in the early 1970s when Kevin Heffernan trained his breakthrough Dublin football team there. The first phase of a refurbishment plan was completed in 1988 when new dressing rooms and toilets finally replaced the old corrugated-iron building from 1922. Redevelopment took off in 1993: a new stand seating 3,040, dressing rooms, toilets, administrative offices and press-box were built, and three sides of the ground terraced and partially covered at a cost just under £4m. Floodlights were installed in 2004–05. The Dublin senior hurling team play most of their home games in Parnell Park, a fine compact ground known locally as 'The Nell.'

1979
Portion of the ground ceded to the local Craobh Chiaráin Club to build a clubhouse

1996
First inter-county game in redeveloped ground sees Dublin defeat Cavan in the NFL on 11 March

2005
Dublin defeat Mayo 2–13 to 1–15 in the first competitive match under floodlights on 5 February

2018
A new players' gym is constructed at the ground

Lorcan O'Toole Park

LOCATION
Crumlin, Dublin

NAMED AFTER
Lorcan O'Toole (1882–1951)
Businessman, councillor,
GAA administrator

OPENED
1957

CAPACITY
1,500

PITCH DIMENSIONS
136 x 90m

COVERED ACCOMMODATION
No

FLOODLIGHTS
No

CLUB
No, but has a long-standing
tenancy with Crumlin

Crumlin GAA Club field teams at all age levels and in all codes, including ladies football. Under past names the club has won an All-Ireland senior camogie title in 1985, two senior hurling county titles, 1978 and 1979, along with the Leinster title in '79.

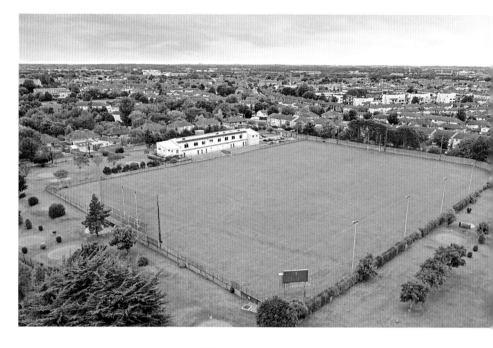

Finding pitches in Dublin was difficult because of the intense competition for land in the city. Moreover, grounds that Dublin County Board held on lease were often

The only development that has been allowed in O'Toole Park is the fine clubhouse built by Crumlin GAA Club on the western side of the pitch

taken over by Dublin Corporation for housing development. In 1949 the board held discussions with the corporation and the Land Commission about two potential playing areas. One at Bremore Park, Balbriggan, they bought for £122 in 1951; the land on Captain's Road, Crumlin, they leased from the corporation.

The county board purchased another site at Stannaway Park, Crumlin, on 29 October 1952. It was part of a deal with the corporation, which agreed to pay the board £1,900 in compensation for taking the Captain's Road ground back by compulsory purchase in 1949.

The board now had three county grounds – Bremore Park, Parnell Park in Donnycarney and the new ground in Crumlin – as well as the regular use of Croke Park. In October 1955 they decided that Crumlin would become Dublin's principal ground and set about developing it.

KEY DATES

1952
Dublin County Board buys 10 acres 3 roods of land in Crumlin for £6,500

1957
Pearse Park, Boland Park and Fr Flanagan Park are proposed as names but county board settles on Lorcan O'Toole Memorial Park

1957
Park officially opened by Minister for Defence Kevin Boland on 27 October

1961
Following a ratepayers' plebiscite Stannaway Park was renamed Lorcan O'Toole Park

LORCAN O'TOOLE

Wicklow-born Lorcan O'Toole moved to Dublin in 1900 when he was 18 and became a member of the Dublin County Board the following year. Always active in public life, he was elected to Dublin Corporation in 1908 and held office until 1933. Throughout his working life he was prominent in the insurance business in the city.

JIM BROPHY, THE LEATHER'S ECHO

Appointed secretary of Dublin County Board in 1917, he was summoned for the recovery of Amusement Tax that year after two Excise officials visited a match in Croke Park to see if the 2 pence tax had been charged at admission. The summons against him was withdrawn, though the board's chairman was convicted.

Regarded as one of Dublin's outstanding GAA officials, O'Toole acted as the county board's secretary, treasurer and registrar from 1916 until 1940, when he stepped down at the annual convention.

GAA STAR WINS CONTRACT

The £36,000 investment plan for the stadium involved building a stand for 2,000 spectators and sideline seating for 4,200 more, along with new dressing rooms, offices and other amenities. Two of Dublin's most prominent players, Norman Allen and Des Ferguson, both members of the famed St Vincent's club, worked in construction at the time but because of the bleak economic outlook were on the point of emigrating to New York. County board chairman Denis

Mahony, also a St Vincent's man and fully aware of the loss to Dublin hurling and football if the two left the country, offered them the contract to build the park's infrastructure. Norman decided to carry on to the USA.

Des, however, took on the work, though the stand was never built.

PARK FIGHTS TO PROGRESS

Dublin County Board arranged most of their club championship matches for the new O'Toole Park as well as many inter-county league and cup matches. Over the next ten years the perimeter of the park fell into disrepair and with money in short supply part of the ground was leased to the Old County Pitch and Putt club in 1966 to generate some income. In 1970 St Agnes' Club and St Columba's Club amalgamated as Crumlin GAA Club and became tenants at O'Toole Park.

During the 1970s the county board was heavily in debt and to raise finance decided to apply for planning permission to build 33 houses on 2.8 acres at the north end of the park that had fallen into neglect. The land was finally sold to a developer in 1977 for £57,875. Soon afterwards the Crumlin club was granted permission to build a clubhouse in the ground, which was opened in 1983.

STUCK IN THE ROUGH

In 1994 Dublin County Board decided to build a stand on the eastern side of the park but these plans had to be shelved when the pitch and putt club objected. The Dublin Circuit Court found in their favour in 1996 and granted them a 99-year sporting lease. This, together with the expensive redevelopment of Parnell Park, effectively put a stop to any further development at O'Toole Park. The park continued to host Dublin club matches and inter-county camogie matches, but with little or no expectation of major development.

1980
Crumlin becomes the first Dublin club to win the Leinster SH club championship

1983
Pavilion and new dressing rooms are constructed

1985
Crumlin (Cuchulainn) win the All-Ireland Senior Camogie title

2001
County board receives an offer of £1.175m for the ground but no sale materialises

Dr Cullen Park

LOCATION
Dr Cullen Road, Carlow

NAMED AFTER
Dr Matthew Cullen
(1864–1936)
Bishop, GAA enthusiast

OPENED
1936

CAPACITY
21,000

PITCH DIMENSIONS
146 x 83 m

COVERED ACCOMMODATION
Tommy Lennon Stand

FLOODLIGHTS
Yes

CLUB
No

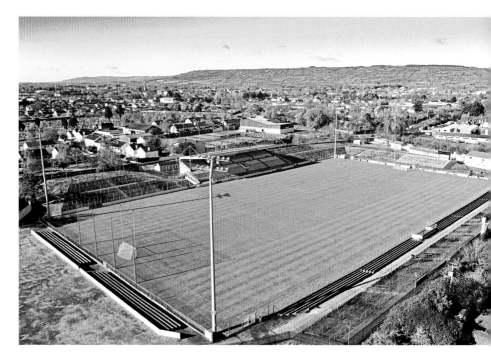

CARLOW COUNTY MUSEUM

Two years after it opened Gaelic Park was renamed in honour of Dr Matthew Cullen

Though Carlow GAA dated back to 1887, the county waited until 1935 for its first county ground. A few sites were considered, including Doyle's Field, known as the Shamrock, and Maher's Field, nicknamed the Birdhouse. Finally in January 1935, on the recommendation of Leinster GAA chairman Bob O'Keeffe, Leinster Council secretary Martin O'Neill and Rev. W. Miller bought eight acres from Captain H. A. Bruen on behalf of the GAA for £530. 16s. 7d. Leinster Council contributed £300. The site included a house occupied by Tommy Lennon, an employee of the Bruen estate. Lennon became the ground's caretaker, bringing his great expertise in land management with him. Local contractors Thompsons levelled the field and built a perimeter wall at cost price, but even so total expenditure came to £3,590. 15s.

Gaelic Park, as it was known, was officially opened on 9 August 1936 by Ulster Council chairman Padraig McNamee and renamed Dr Cullen Park in honour of 'a great churchman, a true-hearted Gael and a patriotic Irishman.'

The vibrant atmosphere created in Dr Cullen Park is fostered by its character and history

KEY DATES

1898
The Croppy Boy's ground at Granby Road hosts the first Leinster SFC match played in Carlow

1933
The Irish Sugar Co. subscribes £25 to a fundraising committee headed by Rev. Millar

1936
Kildare play Wicklow in the Leinster JFC final on 2 August, a week prior to the official opening

1950
Timber sideline seats are replaced by concrete benches

DR MATTHEW CULLEN

Matthew Cullen began his clerical studies at Carlow College in 1881 and later served as parish priest of Tinryland and Bagenalstown before being ordained Bishop of Kildare and Leighlin in 1927. A keen Gaelic games supporter, he threw in the ball at a number of All-Ireland finals in Croke Park, including the historic 1928 All-Ireland when the Sam Maguire cup was first presented.

DOGS ARE ON THE BALL, JUDGES AREN'T

Dr Cullen Park hosted its first Leinster SFC match on 9 May 1937, when Kildare defeated Wicklow by 5–11 to 1–7. That year also saw a major effort to raise much-needed funds. A carnival was held in the ground, with a bar set up in the dressing rooms. The perimeter of the pitch was adapted for greyhound racing and a rugby ball was pulled around the track in lieu of a hare. The dogs were kitted out in different colours and a matching flag was raised to signal the winner, but after one much-wagered race the wrong-coloured flag was hoisted, causing consternation among the crowd and much dispute with the bookies.

FOOT AND MOUTH STALLS MOMENTUM

After three drawn semi-finals against Wexford, Carlow finally came through to reach their first ever Leinster SFC final in 1941. However, at this point the Minister for Agriculture declared that they could not travel outside the county due to the Foot and Mouth

epidemic that year. The game was finally played on 9 November after Dublin agreed to travel to Dr Cullen Park, though the fixture had originally been scheduled for Athy. Unfortunately, Carlow, who had played well during the summer, had been idle for almost three months and proved no match for the visitors, losing 1–4 to 4–6. Carlow lost to Dublin again the following year but overcame them finally to claim their first Leinster crown in 1944. Ironically, that game was played in Athy.

CARLOW'S SWIRLY GATES

Dr Cullen Park spruced up its image in the summer of 1967. A tarmac apron was laid around the main entrance and wrought-iron gates, inscribed Páirc an Cullainaigh, were built by Joseph Bennett Steel Contractors of Stradbally, Co. Laois. They were also the builders of the entrance gates to Fr Maher Park in Graiguecullen on the Laois side of Carlow town.

A STAND FOR TOMMY'S GARDEN

Dr Cullen Park was a favourite Leinster venue, with a fine playing pitch, good dressing rooms for players and referees as well as boardrooms for officials, but it still lacked a stand. One was finally built in 1981–82. Catering for 1,300 spectators, it was named in memory of the ground's first caretaker, Tommy Lennon, who served there from 1935 to 1976. Indeed, for some the park was fondly known as 'Tommy's garden.'

Between 1986 and 1996 further major works were carried out. The pitch was re-sodded, electronic scoreboard installed, dressing rooms improved and new terracing completed. A grant of €150,000 from Croke Park helped build a modern new stand that opened in 2005. Floodlights followed and were officially switched on in September 2016 to mark the ground's 80th anniversary.

1954
Dressing rooms with hot and cold showers, a referee's room and boardrooms constructed

1960
2,000 fans storm past the new turnstiles to watch Carlow play Down in the All-Ireland JHC

1989
County board sells plot of land adjacent to the park to O'Hanrahan's GAA Club

2013
Carlow lose to Laois as the park hosts the first Friday night game ever in the Leinster SFC

McGrath Park

LOCATION
**Dunleckney, Muine Bheag /
Bagenalstown**

NAMED AFTER
Daniel McGrath (1866–1941)
Tea merchant, philanthropist

OPENED
1950

CAPACITY
2,500

PITCH DIMENSIONS
149 x 87m

COVERED ACCOMMODATION
No

FLOODLIGHTS
No

CLUB
Bagenalstown Gaels

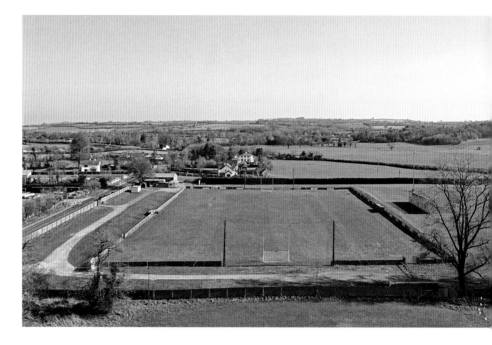

NATIONAL LIBRARY OF IRELAND

DUNLECKNEY MANOR (c.1890)

*The heir to the Bagenal estate,
Walter Newton, renovated
the house in around 1850,
incorporating parts of the
original structure dating back
to the 16th century.*

The sporting facilities at Dunleckney are an extraordinary legacy. Gifted to the town by Bagenalstown native Daniel McGrath, they include two GAA pitches, a soccer pitch, tennis court, pitch and putt course and a cricket ground.

McGrath Park is the fine legacy of a Bagenalstown businessman – and Dublin's tea drinkers

McGrath bequeathed £48,316 – over €2.5m in today's value – to the people of Bagenalstown when he died in 1941. A portion of this was to be used to purchase a recreational ground for the town under the jurisdiction of the McGrath Memorial Trust. In 1944 the Trust bought 23 acres from the Dunleckney estate, which had been the home of the Bagenal family for centuries – Sir Nicholas Bagenal had built the original manor there between 1585 and 1610. The following year government enacted the Daniel McGrath Foundation Act, extinguishing a right of way from the manor to the Carlow road so that development of the sportsfield could go ahead.

The Trust allocated £6,039 to the sportsfield. The GAA moved to the new ground in 1950 and it became home to Erin's Own hurling club, and Erin's Own and Bagenalstown football clubs until the two amalgamated in 1952 as St Andrew's.

KEY DATES

1887
Bagenalstown's first hurling club is formed and after an uncertain start is relaunched in 1895

1928
Games are played at the Bog Field, made available to the GAA by Messrs Brown and Crosthwait, owners of the local flour mill

1944
The McGrath Memorial Trust purchases 23 acres of the Dunleckney estate. Some of it was on land formerly owned by Bagenalstown Golf Club

1949
Work begins on developing the pitch and boundary wall, and the ground opens in 1950

1966
The club builds four dressing rooms at a cost of £600

DANIEL McGRATH

Daniel McGrath was born on 12 August 1866, the son of Pierce and Alicia McGrath, who were grocers in Bagenalstown. Daniel and his brothers established the first Catholic-owned firm of tea merchants in Dublin, a business that made his fortune. When McGrath died in 1941 he left £93,016 in his will and set some £48,000 aside for his native town. The money was used to build a town hall, which opened in 1946, and a sportsfield. Daniel had been a keen sportsman. Seen quite often at race meetings, he was also a member of Portmarnock and Milltown golf clubs and of the United Services Club in Dublin. The bequest also offered marriage portions of £25 to 'poor deserving Catholic girls' born and baptised in the parish. The first bride to receive this gift was Kathleen Dwyer, who was married in January 1943.

Daniel worked as a commercial traveller for tea merchants Messrs Baker & Wardell Co. Ltd for a number of years before setting up McGrath Brothers at No. 3 Bachelors Walk and then on Abbey Street. They were the first and only Catholic tea merchants in Dublin at that time

❝ *And whereas by Clause 10 of the said Scheme The Will Trustees were directed, subject to the approval of the Court, and after consultation with the McGrath Memorial Trustees, to purchase, inter alia, a Sports Field for the use of the people of Muine Bheag to be known as The McGrath Memorial Sports Field; and a sum of £6,039. 12s. 3d. was allocated for the purchase and equipment of the Sports Field.* ❞

Extract from the Daniel McGrath Foundation Act, 1945

A DECLARATION OF TRUST

Because the grounds were under the control of the McGrath Memorial Trust, the club could not vest the land in the GAA, and as a result could not secure funding from GAA Central Council.

Despite some development carried out in the 1960s, by the 1970s the ground had fallen into disrepair. In 1979 a management and development committee came together to rectify the situation. They set out a seven-point plan that included the appointment of a permanent caretaker. Their work transformed the area to the extent that the GAA commended McGrath Park as the best ground in Carlow in recognition of the excellence of the development.

In 1992 St Andrew's purchased a further 3.35 acres of land, which was used to develop a second pitch. A Declaration of Trust was now agreed between the GAA and the club and as a result the club became eligible for grants from Central Council. Development over the next few years reached a cost of £90,000. Over £50,000 was raised locally within a year of the development being launched.

ONE TRUE IDENTITY

On 27 January 2019 history was re-written for the GAA in Bagenalstown when St Andrew's Football Club, Erin's Own Hurling Club and juvenile club Muine Bheag amalgamated under the name of Bagenalstown Gaels. 'Maybe a bit like Brexit, there were difficulties,' county board secretary Michael Doran admitted, 'but members of all three clubs worked well together and persevered.' The new club aimed to 'give the people of Bagenalstown one true identity from five years of age to adulthood.'

1979	1981	1992	2008	2020
A new development plan sees the pitch relayed and fencing erected around the playing area	The ground is officially reopened on 19 April by Chairman of Carlow County Board Dan Harnedy	Park committee purchase 3.35 acres adjacent to the main pitch. Redeveloped ground opened by GAA President Peter Quinn on 21 August	New dressing rooms are built for the club's young players	Plans launched to improve the entrance to the park and build a spectator stand

Brother Leo Park

LOCATION
Ballymurphy Road, Tullow

NAMED AFTER
**Brother Leo Slattery
(1878–1951)**
*Teacher, Gaelic games
enthusiast*

OPENED
1966

CAPACITY
5,000

PITCH DIMENSIONS
143 x 89 m

COVERED ACCOMMODATION
No

FLOODLIGHTS
Yes

CLUB
St Patrick's

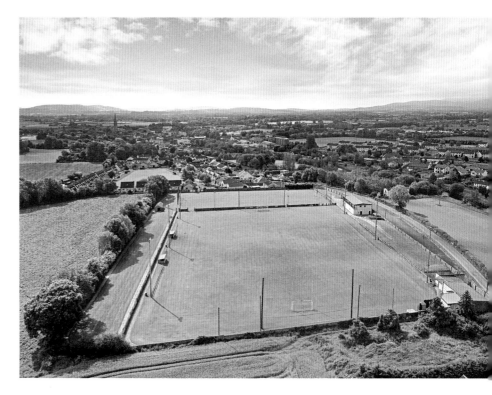

Three Tullow club men, Jim Archibold, Johnny Darcy and Chris Maher, won Leinster senior football medals with Carlow in 1944 in the county's only win at that level. While Tullow men's hurlers and footballers attempt to get back to senior level, the ladies footballers are making real progress since their foundation as St Anne's in 2006.

'The Stars and Stripes' was a bold departure from most GAA clubs' titles, though Tullow's Gaelic football club, founded in Lennon's Hotel on 20 May 1888, would go through several name changes over the years. The club became C. J. Kickham's in 1902 and St Patrick's GFC in 1905. The new title was in honour of the Patrician Brothers (officially the Brothers of St Patrick), founded in Tullow in 1808. Tasked with educating the poor, the Brothers also did a lot to promote Gaelic games in their schools.

St Patrick's have developed impressive club facilities at Brother Leo Park on the banks of the River Slaney

Brother Leo Slattery, who trained youth teams locally, was a key figure in the club moving from a field on the farm of Peter Doyle in Loughmartin to a pitch of their own. In late 1930 they bought land on the Ballymurphy Road from the Soldiers and Sailors Trust Fund for £140. The new ground, known as Tullow Gaelic Park or sometimes as Norse's Field, has been their home ever since.

KEY DATES

1888
Stars and Stripes play in a field at the foot of Tullowhill offered by club vice-president Garret Moore of Wastegrass

1940
Club's green and white colours changed to blue and gold to echo Br Leo's Tipperary ties

1966
Carlow's footballers draw with Wexford at the opening of Brother Leo Park

1980s
Park hosts the Tullow Vintage Festival, locals sports days and athletics meetings to raise funds

BROTHER LEO SLATTERY

Born in Ballymackey, Nenagh, Co. Tipperary, Leo joined the Patrician Brothers at the age of 16 and began his teaching career at the Patrician National School in Fethard, Co. Tipperary. He was transferred to Galway in 1912, where he encouraged his pupils to take up woodwork and toy-making, an initiative that eventually led to a toy-making factory being opened in the city. He moved to Tullow in 1919 and taught at the Monastery National School for the next 12 years, during which time he was keenly involved in the local community. In August 1931 he was appointed Superior in Fethard. His last appointment brought him to Carrickmacross, Co. Monaghan, before his retirement in 1942.

SETTING THE GROUND RULES

On the 7 May 1931 Thomas Hayden, James Kirwan and John Monaghan, acting as trustees of the Tullow Gaelic Park Committee, signed a set of 16 rules governing the ownership and use of the park. Though Carlow County Board had the use of the pitch, the ground was not vested in the GAA. Opened officially on 10 June 1934 in front of 3,000 spectators, development was minimal beyond erecting galvanised sheeting around the boundary. St Patrick's amalgamated with Grange in early 1940 to form the new St Patrick's GAA Club.

Gaelic Park was the venue for the Tullow Young Farmers annual agricultural show from 1946 to 1954, and the park in fact had cattle and horses grazing on it when a ground's subcommittee under Jim Murphy was formed in 1957. Work now began on levelling the playing surface and building two dressing rooms in 1958 and a sideline wall the following year. St Patrick's bought two acres of adjacent land from the Church of Ireland for £325 in 1962 to use as a practice area while the main pitch was being developed, and an embankment and finally a roadside boundary wall were also constructed.

NO DELAY FOR THE REOPENING

Work was not fully complete when the park reopened on 24 April 1966, but the club acceded to a request from the county board to go ahead. The ground was blessed by club president Rev. Seán Kelly and formally opened and named Brother Leo Park by the Superior General of the Patrician Brothers, Tullow, Brother Francis. Just over ten years later the club purchased and upgraded the former Patrician College Recreation Centre, which they made available to the people of Tullow for meetings and dances.

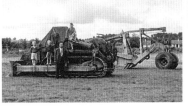

Small (and not so small) boys love big machines – the impressive earth-moving equipment used during the ground redevelopment in 1959 had many admirers

LET THERE BE LIGHTS

Brother Leo Park was vested in the GAA in 2008 and became eligible for grants from Croke Park. Improvements followed. In 2009 new floodlights were installed on the main pitch atop six pylons recycled from the M50 in Dublin. The old floodlights were transferred to the juvenile pitch.

A Texaco Sports Bursary helped to provide a hurling wall in 2010 and the club also extended the dressing rooms. New ball-stop netting was added around the goals and the electronic scoreboard was upgraded. The clubhouse was refurbished from 2018 with improved meeting rooms and a gym on the second floor, and in May 2023 new ball-stop nets were installed behind the the ground's goalposts.

1995
Ground receives a facelift, including new goalposts and improved dressing rooms

2006
Current clubhouse finally completed after much work

2012
Club takes part in the popular Celebrity Bainisteoir with Micheál Ó Muircheartaigh

2013
Walking track laid out for the local community

2022
Main dressing rooms are refurbished, extended and opened

St Conleth's Park

LOCATION
Liffey View, Newbridge

NAMED AFTER
St Conleth (d. 519 AD)
Metalworker, illuminator, first Bishop of Kildare

OPENED
1931

CAPACITY
8,500

PITCH DIMENSIONS
136 x 86 m

COVERED ACCOMMODATION
Yes

FLOODLIGHTS
No

CLUB
No

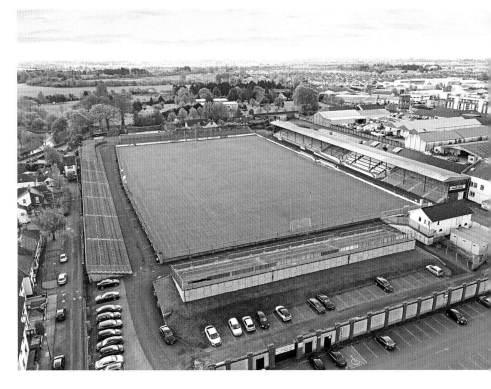

Ready for a makeover – St Conleth's Park pictured in 2022 before it was due to undergo a €17.5m redevelopment. When completed the ground will have a 15,000 capacity with a new stand, dressing rooms, multipurpose rooms and shops. A stylish entrance plaza is also in the plans

Newbridge grew in tandem with the Cavalry Barracks, which from 1819 was home to several regiments and at one point the largest overseas military base in the British empire. Many of the troops and horses used in the Crimean War and the historic 'Charge of the Light Brigade' came from the plains of Kildare.

After the British Army evacuated the barracks in 1922 the Irish government used it as an internment camp for republicans during the Civil War. The Board of Works took charge in 1925 and in the following years most of the buildings were demolished or repurposed to make way for new factories such as Irish Ropes and Newbridge Cutlery.

Kildare County Board met the Board of Works in January 1928 seeking part of the area as a GAA ground. After three years of negotiation, they finally secured a 20-year lease on the sports ground attached to the old military barracks, dating from 25 December 1930 at a rent of £20 per annum.

KEY DATES

1900s
Kildare play at McGuinness's Field, Newbridge College grounds, and Naas Racecourse

1930
GAA lease the barrack's sports ground, consisting of 7 acres 2 roods and 25 perches

1931
Kildare's footballers beat Cavan as General Secretary Pádraig Ó Caoimh opens St Conleth's Park on 10 May – in place of Bishop Cullen, who had a confirmation that day

1954
County board secures another 20-year lease on the ground from December 1950

SAINT CONLETH

Patron saint of Newbridge, he became the first Bishop of Kildare in 490 AD and governed the diocese along with St Brigid.

The saint appears in a fine stained-glass window in the local church named in his honour

DOGFIGHT OVER GREYHOUNDS

St Conleth's Park opened in 1931. Managed by Kildare County Secretary Tim Clarke, his and local GAA clubs' plans to improve the venue were put on hold during WWII, when turf production was stepped up and many workers who came to Kildare to work on the local bogs, at a wage of 32 shillings for a 48-hour week, were housed in the old barracks area.

Opening night race card, 30 April 1948

In December 1946 Newbridge Greyhound Racing Committee submitted a proposal to the county board to use the ground for greyhound racing. Despite disapproval from Leinster Council in 1947 together with ferocious opposition from county board official Fintan Brennan, the proposal was carried by 26 votes to 6. A greyhound track was laid 15 feet outside the pitch and racing started in 1948. Kildare also refused to comply with a Central Council ruling banning greyhound racing from all GAA fields and were suspended from the association.

A row erupted between Kildare County Board and Leinster Council, who demanded that the monies they had granted to improve the ground should be repaid. Kildare County Board refused. They said the money was spent for the purpose for which it was granted and they had no legal or moral duty to refund it.

Central Council and the county board finally agreed in 1953 that racing would be allowed until 1960. In fact, despite a court ruling in 1966, greyhound racing continued at St Conleth's until 1968.

NOWHERE LOSES OUT

Following improvements in 1985–88 the ground reached a capacity of 13,000, but after a health and safety audit in 2011 this was halved. The upshot was that some of Kildare's major games were moved to venues outside the county, sometimes even at the county board's request. The loss of home advantage came to a head in June 2018 when the GAA announced that Kildare's SFC qualifier against Mayo would be moved to Croke Park. A stand-off ensued. Kildare insisted that it was 'Newbridge or Nowhere.' Central Council relented and Kildare went on to enjoy a famous victory over Mayo.

Rallying flag – in the run up to the disputed game, a mural with this defiant message appeared on a gable outside the ground

DEFLATED BY INFLATION

Kildare County Board set out to bring St Conleth's up to modern standards with a plan to construct a new 2,600-capacity stand, dressing rooms, offices and conference rooms, and a plaza at the main entrance. Ground capacity would increase to 15,000. Work was to begin in 2019 but just as funding was secured the Covid pandemic forced the country into lockdown in early 2020. The county board revived the project the following year and planned to start work in summer 2022, but by now another calamity had arrived: soaring construction costs. The board was forced to announce that 'the impact of inflation on our proposed development in St Conleth's Park is of the order of 30% to 40%. In these circumstances it is not possible to proceed as planned.' Newbridge, it seemed, would have to wait for a while.

1959	**1965**	**1988**	**2018**	**2023**
Work starts on building a small galvanised stand	*Kildare GAA purchases the ground outright for £1,600*	*Stand is extended the length of the pitch, albeit with seating only in the centre*	*Kildare County Board granted planning permission for a €10m modernisation plan*	*St Conleth's closes to undergo a major two-year renovation*

Fr Brennan Park

LOCATION
Fishery Lane, Naas

NAMED AFTER
Fr Owen Brennan (1886–1932)
Naas club mentor, president

OPENED
1933

CAPACITY
Not known

PITCH DIMENSIONS
Not known

COVERED ACCOMMODATION
No

FLOODLIGHTS
No

CLUB
Naas

With some 2,800 members and catering for more than 90 teams across football, hurling and camogie, Naas has recently come to dominate county senior hurling and football champion-ships and in 2022 became the first Kildare club to win the county senior camogie, football and hurling titles in the same year. Leading inter-county stars include Johnny McDonald in the 1990s and Eamon O'Callaghan in the 2000s.

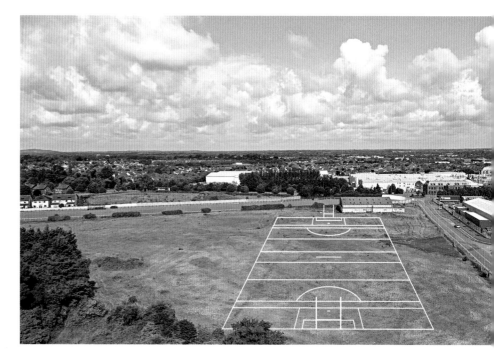

A vacant lot is all that remains today of Fr Brennan Park. Since Naas GAA Club's move in 2004 their old home has slipped into a development limbo

Over 20 people attended the inaugural meeting of the Naas John Dillons GAA Club, chaired by Rev. E. Walsh in the Town Hall ballroom on 16 October 1887. The club minutes of that year and the next are the oldest in the GAA's archives. The ballroom was adopted as John Dillons' clubroom. They also used it as a gymnasium and the venue for the club's debating society, which gathered to discuss current political and social topics on Sunday nights.

Following a period of uncertainty and turmoil in the association locally at the turn of the century a new club called Naas GAA superseded John Dillons in 1902. The club leased a sportsfield from Naas UDC in 1913. The entrance to this field was from the Tipper Road along what was known locally as 'Spooner's Lane.' Naas became the first club in Kildare to cordon off the playing area when they set up a fence around the pitch for the 1916 county final between Maynooth and Roseberry.

KEY DATES

1877
John Dillons play their first ever game against Clane in Jigginstown on 27 November

1930
Kildare vs Kerry NFL match on 16 November is abandoned due to waterlogged sportsfield

1935
Fr Brennan Park is the venue for the 1935 All-Ireland junior football final on 20 October, when Sligo defeat London

1936
Park hosts Leinster SHC games, Kildare vs Offaly and Meath vs Wexford, on 26 April

1938
Park holds its only Leinster SFC match, a replay between Carlow and Wicklow on 5 June

FR OWEN BRENNAN

Born in Turra near St Mullins in Co. Carlow, Owen attended Maynooth College and was ordained in 1911. He became curate in Naas in 1924 and soon formed a juvenile hurling club. He was elected president of Naas GAA Club in 1926 and was involved in organising the club's first minor football team in 1928 and introducing camogie in 1931. He died in Celbridge on 13 November 1932 at the age of 45.

HEMMED-IN CLUB MOVES TO FISHERY LANE

In the early 1920s Naas racecourse was developed around the GAA ground. As a result, players and spectators had to cross the racetrack to get to the ground, which led to many disagreements between the GAA and the racecourse people over the years. Another problem was that the low-lying pitch was susceptible to flooding. In the end, club chairman Joe McDonald and president Fr Owen Brennan found a new location on Fishery Lane near the Dublin Road. When it opened on Sunday 20 August 1933 it was named in memory of Fr Brennan, who had died the previous year.

Naas ran several events to fund improvements and build dressing rooms, without support from the GAA at provincial or national level as the ground was not vested. Fr Owen Brennan Memorial Park hosted a number of Leinster championship matches nonetheless.

COUNTY STATUS BRINGS IMPROVEMENTS

After Fr Brennan Park was finally vested in the GAA in 1948 and became a county ground, a finance committee was appointed in April 1950 to finance and implement development plans for the park. Two new dressing rooms were built at a cost of £211. 10s., but when Naas was selected as the venue for the 1952 SFC final between Sarsfields and Carbury planks had to be borrowed from

the Athy ground and laid on cement blocks as sideline seating, and more seats were borrowed from Newbridge.

In 1972 work began on building a social centre, a project led by Philip Hanrahan and Barney McPoland. Costing £28,000, the club received a loan from Croke Park for the project because their members had invested £3,400 in the GAA's club development scheme. The centre was completed in 1973 and opened by former GAA President Pat Fanning.

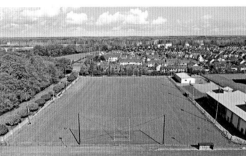

Naas GAA's modern ground on the Sallins Road superseded the club's historic Fr Brennan Park, which was the club's home from 1933 to 2005

PARK FALLS SILENT AS CLUB MOVES ON

Hampered by debt, the club spent many years reducing it through constant fundraising, but even so the ground's facilities were also improved through the 1980s and extra land purchased to develop the small pitch to full size.

In 1999 discussions were held with a developer regarding the club relocating to a site in Oldtown. Naas would receive 16.7 acres and a payment of £1.623m in exchange for the ground on Fishery Lane. The expanding club needed extra pitches and so in 2004 they moved to the larger venue on the Sallins Road, which now boasts three full-sized pitches, a juvenile pitch, a training pitch and an excellent clubhouse. Fr Brennan Park remains a vacant lot, with the social centre still standing. The new ground does not bear Fr Brennan's name nor has it the status of a county ground.

1947	1982	1991	2021	2022
Club members Ger Grehan and the Marum brothers organise an indoor carnival to clear club debt	New squash courts prove to be a great success in raising funds	Club upgrades clubhouse, develops a new pitch and resurfaces car park	Naas win the All-Ireland Club intermediate hurling title	Naas win their tenth Kildare SFC and SHC titles

Geraldine Park

LOCATION
Dublin Road, Athy

NAMED AFTER
The Geraldines of Kildare
Anglo-Norman dynasty

OPENED
1931

CAPACITY
3,500

PITCH DIMENSIONS
136 x 86 m

COVERED ACCOMMODATION
Fintan Brennan Stand

FLOODLIGHTS
Yes

CLUB
Athy

Athy GAA Club has a long proud history, enjoying success in both football and hurling at all levels. Highlights are the seven senior football county championships won, including the 2020 title, along with three senior hurling county titles.

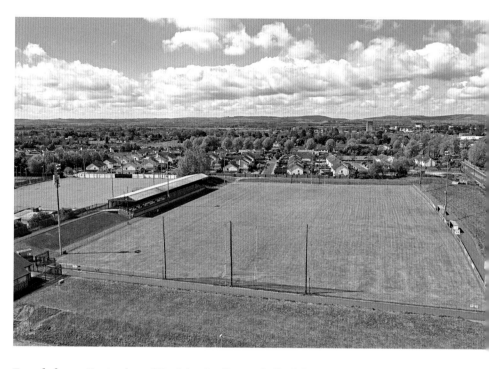

The modern, well-equipped facilities at Geraldine Park rank among the best in the county

Founded on 1 September 1887 Athy Gaelic Football Club played their games in a number of places locally up to 1904, when they rented the Athy Agricultural Grounds on one day a week from the South Kildare Agricultural Society.

One of the club's first actions was to erect a fence around the ground. They were the first club in Leinster to do so and this simple initiative was a major factor in the ground being selected as the venue for inter-county matches. Its first big match was the 1904 Leinster Championship game between Wexford and Meath on 25 March 1906. The club also hosted the 1906 All-Ireland SFC final, played in October 1907, when Dublin defeated Cork by five points to four.

The Leinster SFC finals of 1907 and 1908 followed, and in June 1909 the 1908 All-Ireland hurling final replay between Tipperary and Dublin took place there. Tipperary captain Tom Semple remarked afterwards that the 'Athy ground is perhaps the very finest in Ireland.'

KEY DATES

1887
Originally called Athy Wolfe Tone Club, Athy plays at Bellview, Anthony's Barn and Ardreigh

1904
The club rents the agricultural grounds for the sum of £12 per annum

1929
Fintan Brennan becomes secretary and sets about expanding the club

1933
Athy win the club's first Kildare senior football championship title

THE GERALDINES

The Geraldines became one of Ireland's great family dynasties following the Anglo-Norman conquest of the 12th and 13th centuries. Among them was the Earl of Kildare, whose coat of arms can still be seen on the White Castle, Athy.

MIS-HIT AT THE OPENING

The Kildare County Board bought the ground from the agricultural society in September 1931 for £250 and it was formally opened and named Geraldine Park on 18 October. The parish priest, Fr Patrick McDonnell, presided over the opening, which was followed by the All-Ireland JFC 'Home' final between Kildare and Galway. Kildare were declared the winners on the day but due to an error by the referee – he disallowed Galway's penalty goal because the goalkeeper touched the ball before it hit the net – the result was overturned by Central Council and Galway were awarded the title.

SLEEPERS FOR SALE

In October 1949 the club's auctioneer placed an advertisement in the *Irish Press* selling the innovative paling surrounding the pitch. The haul contained such items as 184 sleepers, 184 lengths of angle iron, 3,360 feet of timber stretchers, 16,000 feet of barbed wire and 1,120 feet of fencing wire.

BLESSED AGAIN

The pitch was closed in 1949 for major developments, with most of the work done by voluntary labour. The pitch was levelled and dressing rooms, a new perimeter fence and front boundary wall were constructed. An open stand, built in 1950, provided accommodation for up to 8,000 spectators and new embankments had standing room for 25,000. Athy also became the first ground to allow only players and officials on the pitch.

The ground was formally reopened on 10 June 1951 before a crowd of 3,000 by the same man who opened the ground in 1931, Canon Patrick McDonnell. To raise funds the club ran an annual draw for several years during the 1950s. The first prize of a Hillman car and caravan aroused great interest. In fact, the draw spread far and wide as ticket sellers went from town to town during the summer months.

A FINAL PRAYER

New dressing rooms built in 1964 had a holy water font positioned near the exit for the players to use before they ran onto the pitch

CLUB LEADER HONOURED

The first phase of a new stand was completed in 1979 at a cost of £9,300. The second phase costing £22,000 followed in 1983. The club did not officially open the stand until it was fully paid for in the centenary year of the GAA. GAA President Paddy Buggy did the honours for the Fintan Brennan Stand on 11 November 1984. Fintan Brennan was a former state solicitor and one of the most dominant and often controversial figures in Kildare GAA. Chairman of the Leinster Council from 1945 to 1947, he was a key figure in the acquisition and development of Geraldine Park.

Three years later, in 1987, the club's centenary year, Athy opened a new clubhouse, which included a squash court, kitchen, bar and dressing rooms. The centenary was crowned when they defeated Johnstownbridge by 2–9 to 0–9 to win their first senior title in 45 years.

1951
Kildare plays Louth as Geraldine Park re-opens after two years' redevelopment

1975
The ground hosts the All-Ireland Ladies SFC final between Tipperary and Offaly

1991
The Kildare juvenile boxing championship is held in the club's pavilion

2011
Ireland take on Scotland in the shinty/hurling international series at the park

2021
Work begins on laying two new pitches on 13 acres purchased for €750,000

Nowlan Park

LOCATION
Hebron Road, Kilkenny

NAMED AFTER
James Nowlan (1864–1924)
Cooper, alderman, GAA
president

OPENED
1928

CAPACITY
27,000

PITCH DIMENSIONS
145 x 83 m

COVERED ACCOMMODATION
Ardán Breathnach
Ardán de Grás
Ardán Ó Cearbhaill

FLOODLIGHTS
No

CLUB
No

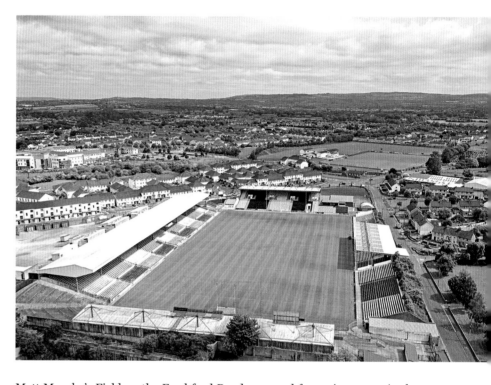

The largest ground in Leinster (apart from Croke Park) Nowlan Park is loved by players for its immaculate, award-winning playing surface, and its raucous match-day atmosphere confirms its status as the hurling capital of Leinster

Matt Murphy's Field on the Freshford Road was used for major games in the first decade of Kilkenny GAA, but in 1896 the association approached the Kilkenny Agricultural Society for the use of St James's Park, Granges Road. They were given permission to play on Sundays but just 12 months later there were heated exchanges when the landlords raised the rent by a full 50%. The GAA left and turned to pitches at Kilcreene and on Asylum Lane (now Larchfield/James Stephens' club grounds). The 1902 All-Ireland football Home final between Dublin and Tipperary was played at Asylum Lane in July 1904.

Peace was eventually restored between the agricultural society and the GAA, who returned to St James's Park in 1906. But despite hosting big games that year and the next, relations between the two were never the best. At a Town Tenants' meeting in March 1911 county board chairman J. F. Hackett lambasted the society for 'boycotting the Gaels of Kilkenny' by refusing to lease the park at a reasonable price.

KEY DATES

1906
St James's Park hosts the Kilkenny SHC final of 1905 between Erin's Own and Tullaroan

1907
Tipperary and Dublin contest the only All-Ireland SHC final (1906) staged in Kilkenny

1928
Cork defeat Dublin in the All-Ireland SHC semi-final at the official opening of Nowlan Park

1950
A record 36,000 crowd watch Kilkenny defeat Wexford in the Leinster SHC final on 16 July

JAMES NOWLAN

James Nowlan was born in Monasterevin, Co. Kildare, in 1864. He was a cooper by trade and worked in Sullivan's Brewery, Smithwick's and Guinness's.

A member of the Gaelic League and Sinn Féin, as well as the IRB, in 1899 James was elected to Kilkenny Corporation and was successful in every election he contested until he retired in 1919. A popular figure locally, he was familiarly known as Alderman Nowlan, and was a founding member of St Patrick's Brass and Reed Band in Kilkenny.

Nowlan became the first chairman of the Leinster Council on 4 November 1900. He was elected president of the GAA in 1901, and served during a turbulent time in Irish and world history. He himself was arrested following the Easter Rising in 1916 and spent some time in detention in Frongoch in Wales.

During the early days of his presidency, along with men like Luke O'Toole and Maurice Crowe, Nowlan greatly contributed to the reform and expansion of the association. He held the position of president for a full 20 years, making him the organisation's longest-serving president. When he retired, he was appointed honorary life president of the association, the only person to be given this honour.

James Nowlan died in June 1924. He was buried in Glasnevin Cemetery, where a Celtic cross was erected in his honour in 2013. His memory is also preserved in the James Nowlan Cup, unveiled in 2016 as the All-Ireland U21 hurling championship trophy.

James Nowlan was further memorialised in 2016 when the All-Ireland Under 21 hurling trophy was named in his honour

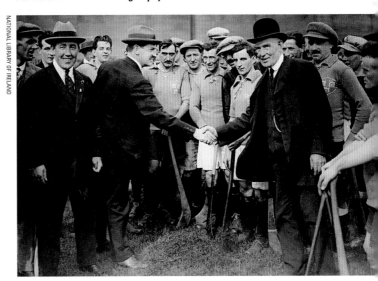

11 September 1921 – The ceasefire may have been holding between the Provisional Government and the Crown Forces but there was no truce between the hurlers of Kilkenny and Dublin in Croke Park. James Nowlan shakes hands with Michael Collins at the Leinster final while Harry Boland grins at the camera. It proved to be a great day for the Dubs as they successfully defended their title

1963
Nowlan Park hosts the NHL final between Waterford and New York on 3 November

1996
Leinster Council's Jim Berry reopens the upgraded ground on 19 May after £1.7m investment

2001
The park becomes a concert venue, featuring Elvis Costello, Shania Twain, Dolly Parton and more

2014
Sky Sports broadcast a championship game live to a UK audience for the first time

2018
Nowlan Park wins the County Pitch of the Year award and again in 2019

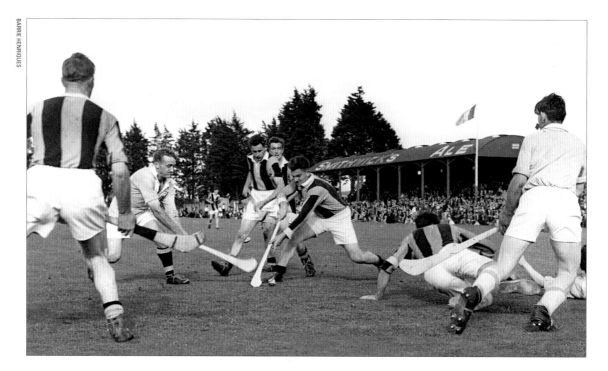

BARRIE HENRIQUES

A PERMANENT HOME FOR 'THE GAELS OF KILKENNY'

In 1927 the county board acquired almost eight acres of a site on Hebron Road known as Pennefather's Lot from Peter Corcoran for £700. The board imposed a levy of £1 on affiliated clubs to help pay for the ground, which was opened by GAA President Seán Ryan on 26 August 1928.

Nowlan Park's first stand, built in the 1930s, offered seating on the upper tiers. Curiously, the stand had a timber floor with small openings that afforded a view of the dressing rooms beneath.

As the park began to establish itself as the principal venue for Leinster hurling finals in the 1930s and '40s, an embankment was constructed around the pitch using cinders brought by horse and cart from the Gas House in Barrack Street and the city's bakeries. The embankment was extended in 1948 with rubble and stone from the old Kilkenny jail, which had been demolished. In 1949 plans were put in place to spend £7,000 on replacing the early stand with a new one, which would become known locally as the Smithwick stand due to the famous brewery's name emblazoned on the roof.

Brewing up a storm – Kilkenny and Dublin battle it out in front of a packed 'Smithwick stand' in 1961. The rudimentary structure was typical of stands of the era and the barrel top, replete with the local beer's branding, was a familiar sight to patrons of Nowlan Park in the 1950s and '60s. The ale that it advertised dates back to 1710 when John Smithwick founded Ireland's first large commercial brewery on the site of a Franciscan abbey which had brewed ale since the 14th century

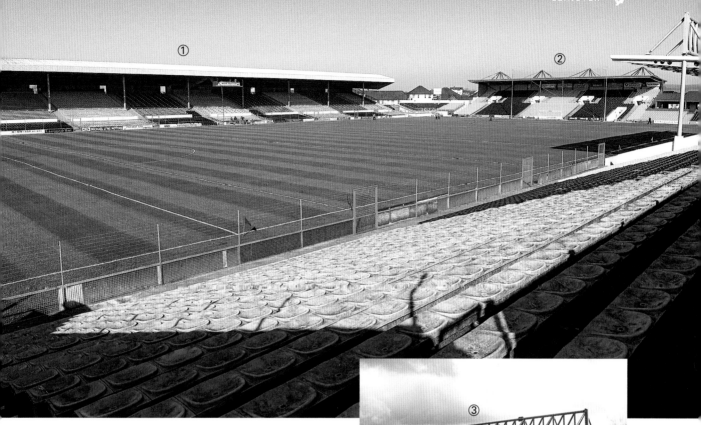

EVER IMPROVING

The 1960s saw continuous improvements under the watchful eye of county secretary Paddy Grace. Nowlan Park was designated a provincial ground in November 1963, making it eligible for extra funding, and it played host to the NHL final in 1963, the first two U21 All-Ireland hurling finals in 1964 and '65, and other big games. The Smithwick stand was taken down in 1965 and transported to Kilkenny Golf Club to be used as a machinery shed, where it remains today. A modern stand with dressing rooms, meeting rooms and toilets took its place in 1966.

By the mid-'80s, however, the wear and tear on the pitch was beginning to show and the park had to be closed for renovations. In 1993 the county board embarked on a major redevelopment plan, which saw all facilities including wheelchair access improved over the next three years.

OUTSTANDING ACCOMMODATION

A new 9,183-seat stand, Ardán de Grás, named after Paddy Grace, was opened in 1996 and the existing one, now named Ardán Breathnach in honour of

The three amigos – the Paddy Grace (1), Ted Carroll (2) and Ollie Walsh (3) stands have won a lot of praise for their functionality and stylish architecture

Kilkenny goalkeeper Ollie Walsh, was improved. Part of the roof of Ardán Breathnach was ripped off during the height of Storm Darwin in 2014. Rebuilt the following year, it housed a modern media centre with a fully equipped TV studio and facilities for journalists on match days. Ardán Ó Cearbhaill, originally opened in 2010 and named in honour of hurler and county secretary Ted Carroll, was extended and refurbished in 2017 to incorporate the Kilkenny County Board administration centre.

The largest GAA ground in Leinster outside of Croke Park, Nowlan Park continued to host the All-Ireland U21 hurling finals, as well as interprovincial hurling and two NHL finals in 2013 and 2018.

John Locke Park

LOCATION
Fair Green, Callan

NAMED AFTER
John Locke (1847–1889)
Teacher, writer, Fenian activist

OPENED
1983

CAPACITY
3,500

PITCH DIMENSIONS
145 x 84 m

COVERED ACCOMMODATION
Yes

FLOODLIGHTS
No

CLUB
John Lockes

John Lockes GAA Club have spent most of their existence in either the junior or intermediate ranks of Kilkenny hurling but did win a senior county title in 1957. They've also won the intermediate title on three occasions, most recently in 1999. The club's most famous player is former intercountry star John Power.

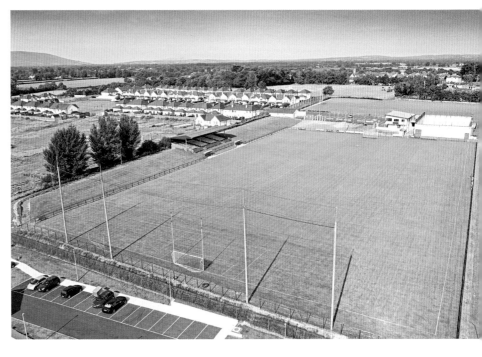

It is generally accepted that the first football match ever played under the auspices of the GAA took place on 15 February 1885 when Callan held Kilkenny to a scoreless draw on the Fair Green in Callan. The green had been willed to the people of the town by the Annely Estate and became home also to Callan GAA Club.

The fine facilities and clubrooms at John Locke Park are a result of the club's vision and planning

The club continued to play at the Fair Green down through the decades, until in 1977 they decided to purchase a ground of their own. Spearheaded by Canon John Kennedy and Wicklow native Fr Liam Dunne, the club bought land at Bolton Woods, adjacent to the green, at a cost of £44,000, and then started the task of raising funds. The goal was to have the development work completed by 1984, the GAA's centenary year.

The pitch was opened a full year ahead of schedule on 5 June 1983, when some 4,000 spectators watched Kilkenny outplay Tipperary 1–17 to 1–3 in a senior hurling challenge match.

KEY DATES

1889
Callan GAA Club is founded and takes part in the Kilkenny SHC

1957
Callan win their first and so far only senior county title

1977
The club purchases 11.7 acres from Billy Fennelly at Bolton Woods

1981
John Lockes and Callan CBS, who are free to use the club's ground, form a joint fundraising committee

JOHN LOCKE

Callan's John Locke had his first poem published at the age of 16. He began writing for the Fenian newspaper *The Irish People*, which earned him a six-month term in Kilkenny jail when he was all of 18. Locke subsequently emigrated to New York where he wrote for the literary journal *The Emerald*. He wrote short stories, novels and poetry, much of it about Ireland. He is remembered in Callan for the poem 'The Calm Avonree,' or King's River, which flows through the town. His most famous poem was 'Dawn on the Irish Coast,' also known as 'The Emigrant's Anthem,' which was later set to music. When US President Ronald Reagan visited Ireland in 1984 he recited the first verse to rousing applause. Said to have been a stylish hurler in his schooldays, Callan GAA Club adopted the poet's name in his honour.

HURLING ON THE FAIR GREEN

Renamed John Lockes in 1902, the club won their first county title in 1911 when they took junior hurling honours. The team included Edward Roche, the local postman, harness-maker John Walsh, Paddy Walsh, a gaffer with the county council, Jim Lavelle, a small man handicapped with a short leg but 'a terror' in front of goal, and carpenter Dick Finn, who made many of the club's camáns.

The team also had four Fitzgerald brothers. The four spent most of their Sundays hurling on the Fair Green and were so dedicated in preparing for important games that their dinner was brought in from Bauntha in a basket so that their training would not be interrupted.

MULTI-INSTRUMENTALISTS

When John Lockes minor hurling team played in the county final in 1950 they were marched into the ground in Mullinavat by the Callan Fife and Drum band. A huge crowd from Callan cycled to the game, parked their bikes along the road and joined the band and the team as they approached the pitch. The Callan Fife and Drum was 20 strong but as they went through the gate one official remarked to another, 'That must be the biggest band in Ireland. I gave up counting after 85!' Too late they realised that many Callan supporters had taken the pumps off their bikes, put them to their lips, played along *mar dhea* with the band and got in for nothing.

CALLAN
FIFE, DRUM &
BICYCLE PUMP
BAND

SITES SOLD IN ATTRACTIVE NEIGHBOURHOOD

John Lockes has been highly innovative in raising and using resources. Most of the initial debt on ground development was cleared by 1980 through a series of fundraising initiatives, which included selling a one-eight acre site that significantly helped finances. When the club decided to upgrade its facilities again in 2003 they applied for outline planning permission for 12 houses at Bolton, adjacent to their pitch. When permission was granted the club sold the site to developers for a considerable sum, which was then invested in the grounds.

INVESTING IN THE FUTURE

Always looking to their base, in 2013 John Lockes invested over € 1m in their facilities, including the construction of a new clubhouse, changing rooms, referee's room, meeting rooms, kitchens, gymnasium and a hurling wall with an astro-turf surface for practice. The pitch was also extended by 15 metres.

1983
Former GAA President Con Murphy opens John Locke Park on 5 June

1999
Juvenile pitch created with support from GAA and National Lottery

2007
Club hosts the annual Féile na nGael hurling competition

2008
New John Lockes ladies football team play their first competitive game

Páirc Lachtain

LOCATION
Moat, Freshford

NAMED AFTER
Saint Lachtain (c. 550–622 AD)
Patron saint of Freshford

OPENED
1994

CAPACITY
2,500

PITCH DIMENSIONS
143 x 81 m

COVERED ACCOMMODATION
Yes

FLOODLIGHTS
No

CLUB
St Lachtain's

St Lachtain's is a hurling and camogie club which has enjoyed success in both codes. In the early sixties they won two senior hurling county tiles (1961, 1963) and in 2010 they swept the board at intermediate level and captured an All-Ireland title. The women won three-in-a-row senior camogie county championships, 2004–2006.

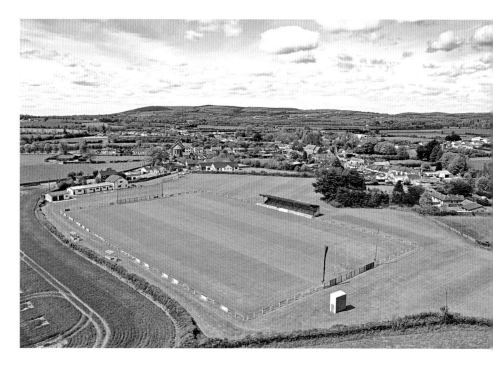

Picture perfect – the beautifully maintained pitch and facilities at Páirc Lachtain on a summer's day

Because of its position in north Kilkenny, Freshford has long been a central venue for hurling. In the early part of the 1900s Gaelic games were played by clubs in Lodgepark, Sart and Threecastles, while in Freshford itself matches were played in a field on the Moat Road and in the Culteens near the Market Square. 'Culteens' is derived from *cúl tithe,* meaning 'back of the houses.'

In the 1920s local landowner Nicholas Harrison of Crowhill made a field on the Clintstown Road about a mile outside the village freely available for sports, including pony-racing, athletics, coursing and even hot-rod racing, but mainly of course for hurling and football. The pitch had the name of being the driest in Kilkenny. There was a sandy base under the sod and even the heaviest rainfall had no effect on the firm surface. The field was used by several nearby clubs and was so popular that when fixtures were announced the venue was simply called 'Harrison's.'

KEY DATES

1920s
Harrison's Field becomes the regular ground for the hurlers of Galmoy, Johnstown, Crosspatrick, Clomantagh, Urlingford, Ballyouskill, Conahy, Ballyragget, Freshford, Lisdowney, Three Castles and Tullaroan

1961
St Lachtain's win their first Kilkenny SHC beating Near South 4–5 to 0–12 on 17 September

1986
St Lachtain's school offers a portion of land to facilitate an entrance for new pitch

1994
Páirc Lachtain is opened by former GAA President Jack Boothman

SAINT LACHTAIN

In the late 6th century, Lachtain, who would became the third Bishop of Ossory, founded a church at Achadh Úr, literally 'fresh field' but mistranslated later as Freshford.

The Shrine of Saint Lachtain's Arm is an arm-shaped reliquary crafted in the early 10th century to house a bone fragment of the saint. Noteworthy for its fine decoration and defiant clenched fist, it appears on the crest of the local GAA club

NATIONAL MUSEUM OF IRELAND

CHANGE OF NAME AND LOCATION

Freshford GAA Club changed its name to St Lachtain's in 1951. The club continued to use Harrison's until an unexpected opportunity arose to purchase a field just 300 metres from Freshford village.

Club chairman Pa Dillon received the unanimous backing of a committee meeting on 8 October 1985 to investigate the possibility of acquiring the 5.5 acre site beside St Lachtain's NS, which had been advertised for sale by the Walsh family. Some reservations were raised about the difficulty of fundraising at this time, but veteran club member Patsy Brennan allayed these fears when he confidently proclaimed: 'Buy it anyway, lads, someone will pay for it!'

JOB DONE IN SHORT ORDER

Following the purchase of the ground at a cost of £10,127, a development committee was formed in 1986 to raise funds to pay for it. Cars set forth from the village every night for a month, touring the county and beyond with raffle tickets. First prize was a trip to the Holy Land with a group led by broadcasting personality Donncha Ó Dulaing. The fundraising efforts brought in £14,355 – enough to pay for the new ground – in just eight weeks.

FIREWOOD FUELS DEVELOPMENT

In October 1987 landowner Jack Staunton offered the club an adjoining field at a cost of £11,900. In short order the club had secured an area of 12 acres in total, enough to provide pitches for their senior, juvenile and camogie teams.

Local people set to raising money once again, heading to the surrounding forests armed with chainsaws and axes to fell timber which was auctioned as firewood on the village green at Christmas. Between 1987 and the final auction in 1990 the club raised more than £20,000 in all.

Work began on building two dressing rooms and a meeting room in 1991 as St Lachtain's moved into their new ground. By the end of 1993, £50,000 had been spent on buying and developing it. The official opening took place on 25 May 1994. On a very wet day in Freshford, Kilkenny beat Dublin by 2–12 to 0–12 in a senior hurling challenge match.

CLUB'S EFFORTS REAP REWARDS

Improvements continued and in 1996 a stand was built at a cost of £22,000. From then Páirc Lachtain hosted club games, including county finals in hurling and camogie, and inter-county games at NFL, O'Byrne Cup and Walsh Cup level.

Further development was supported by €175,000 from the Sports Capital grant scheme and the sale of half an acre of land to Kilkenny County Council for €190,000 in 2006. The funds went on extending the clubhouse to include new dressing rooms, a meeting room, storage, toilets and a gymnasium. The upgraded facilities helped Páirc Lachtain secure the status of Designated Second County Ground in 2007, and three years later the club won the Irish Institute of Sports Surfaces' Leinster GAA Club playing surface of the year award.

2004
Club's camogie team win the All-Ireland senior club title for the first time

2010
St Lachtain's defeat St Gall's, Antrim, to win the All-Ireland intermediate club hurling title

2017
Lights installed around the training pitch along with new dugouts on the main pitch

2022
Plans made to create community children's playground and walkway

O'Moore Park

LOCATION
Clonminam, Portlaoise

NAMED AFTER
Laois's historic O'Moore sept

OPENED
1888

CAPACITY
21,500

PITCH DIMENSIONS
143 x 85m

COVERED ACCOMMODATION
Yes

FLOODLIGHTS
Yes

CLUB
No

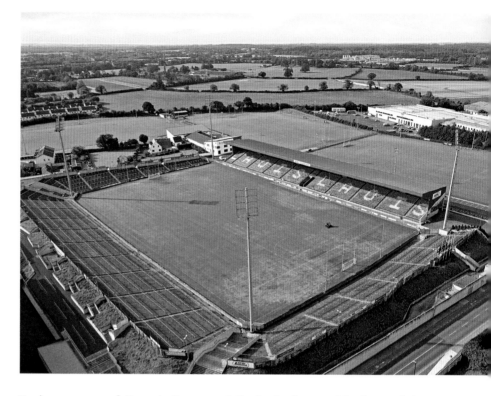

O'Moore Park has one of the best all-weather pitches in the country and is frequently used as a neutral venue for inter-county matches not involving Laois. The bowl effect created by the large stand and surrounding terraces offer unimpeded views and create a great atmosphere

Laois was renamed Queen's County and Portlaoise became Maryborough in honour of the English queen, Mary Tudor, in the 16th century. For all the Anglicisation that followed, the land where O'Moore Park is situated was one of the earliest GAA grounds in the association's history. The first Queen's County football final was played at Maryborough on 20 May 1888, when Ballinakill defeated Knock by 0–7 to 0–0. On 10 June, Queen's County took on Kilkenny in the Leinster championships, hurling and football, at the venue.

Maryborough GAA Club, under the guidance and direction of local curate Rev. J. J. Kearney, took over the management of the grounds in 1908. Fr Kearney became county chairman in 1910 and during his time in office negotiated the outright purchase of six acres of the grounds on behalf of the county board. In November 1919 possession of the newly purchased grounds, which later became known as the County Grounds, was taken over by the trustees.

KEY DATES

1888
Kilkenny beat Dublin by 0–7 to 0–3 on 15 July in the first ever Leinster SHC final at the Maryborough venue

1925
The Nationalist *reports that the 'bank balance has been reduced' as the ground makes progress*

1930s
O'Moore Park hosts Railway Cup and National League games and several Leinster finals

1934
County board treasurer Bob O'Keeffe proposes building a new covered stand

O'MOORE

The O'Moores were the leading clan of the Seven Septs of Laois who ruled the area in Gaelic times.

SETTING THE STANDARD

When Laois and the county capital regained their Gaelic names following independence, the first Leinster SFC match played in the Portlaoise ground was on 15 April 1923, when Kilkenny defeated Kildare by 2–3 to 2–1.

The field committee managing the ground improved it through the 1920s to the extent that it was pointed to as a model for other counties to follow. At a ceremony held in conjunction with the Laois County Feis held at the venue on 15 June 1930, the ground was renamed O'Moore Park by President of Laois GAA, Lar Brady.

This development inaugurated a glorious period for Laois football, with the emergence of one of the great footballers of all time, the 'Boy Wonder' Tommy Murphy, as well as the famous Delaney brothers, all of whom later had GAA cups named in their honour. With players like these Laois won three Leinster SFC titles in a row in 1936, '37 and '38.

REBIRTH IN THE 1980s

An open 7,000-seat stand and improved sideline development brought the venue's capacity to 30,000 in the late 1950s but despite some additional works in the

CROKE PARK ARCHIVES

Tommy the 'Boy Wonder' Murphy was named at midfield on the Team of the Millennium, the only player from a county which had not won an All-Ireland title

'60s O'Moore Park began to deteriorate. By the '70s the pitch and other facilities, county board chairman Seán Ramsbottom noted, were 'very primitive.'

Laois' clubs and county board came together in 1980 in support of a redevelopment plan which also had the backing of Leinster Council and Croke Park. The ground closed for a three-year-long reconstruction estimated to cost £200,000, with clubs and councils pitching in to provide funds. A new pitch was laid, terracing was provided on three sides of the ground and the stand and dressing rooms were renovated. The final price ran beyond the original estimate, but when O'Moore Park reopened for the county finals of 1984 players had a new pitch under them and spectators enjoyed much better facilities. Two years later NFL champions Laois outplayed Kerry at the official opening.

BUILDING ON EXCELLENCE

The bulldozers moved into O'Moore Park in December 2000 to demolish the stand, which was replaced by a new one opened on 12 May 2002. The 5,280-seater stand cost € 1.75m and this addition helped O'Moore Park host a total of six championship games that year. Much of the cost was recouped when Laois County Board sold a portion of the ground on the Abbeyleix Road side of the park to a local developer for over € 1m in 2003.

New floodlights costing € 1m came on stream in 2007 and in 2008 the Leinster Council commissioned a feasibility study on the potential further development of O'Moore Park. Ten years later Laois County Board launched a three-year strategic plan which included upgrading media facilities in the park. In 2022 the broadband connection was improved, floodlights were upgraded and new seats were installed in the stand. History was made in the same year when O'Moore Park hosted a Munster Ladies SFC game between Cork and Waterford to facilitate a television broadcast.

1972
The dressing rooms get showers and toilets – but the ground's facilities are falling behind

1983
Fundraising committee chaired by former Laois football star Bobby Miller elected to keep modernisation project on track

1986
GAA President Paddy Buggy formally opens the upgraded ground on 18 May

2022
O'Moore Park listed in top six county grounds by the GAA's National Pitch Workgroup

Fr Breen Park

LOCATION
Tullyroe, Abbeyleix

NAMED AFTER
Fr John Breen (1864–1949)
Parish priest, community leader, sports enthusiast

OPENED
1926

CAPACITY
2,500

PITCH DIMENSIONS
137 x 85 m

COVERED ACCOMMODATION
No

FLOODLIGHTS
No

CLUB
St Lazerian's

Abbeyleix St Lazerian's are mainly a hurling club and play at intermediate level. They have won eight Laois senior hurling titles, the last of which came in 1949. In 2006, a number of the club's footballers were part of the Ballyroan Gaels squad (an amalgamation with their neighbours) that won the Laois Senior Football Championship.

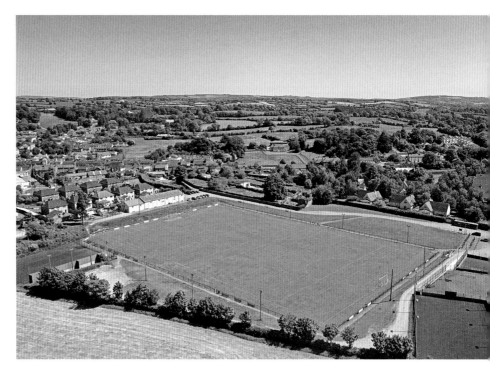

Abbeyleix GAA Club played their first ever game at Coyle's Field, Ballymaddock, in 1888. There were four clubs in the parish – Abbeyleix, Ballyroan, Raheenabrogue and Brandra – and they also competed at hurling and football in Hollow, near the Catholic church, and Muldowney's Field at Brandra. From 1907 to 1914 Abbeyleix rented Wiley's Field on the Ballyroan Road for £20 a year, and then moved to Leigh's Field in Oldtown, which they also rented. Their next move would be inspired by a peculiar source: the Black and Tans.

A large sand and gravel pit, known as Jelly's Pit after the family of builders who worked it, had closed down in 1906. During the War of Independence the Black and Tans, who were stationed in the Old Hospital, took it over and made a soccer pitch for themselves. After the Truce was signed in 1921 the GAA assumed control of the ground and began to play hurling and football games there.

Fr Breen Park has had a remarkable history, catering for a variety of sports, but Gaelic games above all

KEY DATES

1907
St Lazerian's emerge as Abbeyleix's premier GAA club

1909
Abbeyleix Lawn Tennis Club formed; lays out grass courts at Jelly's Pit

1924
Rail tracks and trolleys borrowed from Castlecomer Colliery help work on the ground

1926
New Park opens on 22 August, Abbeyleix CYMS sports day

BILLY PHELAN

FR JOHN BREEN

Fr John Breen was born in St Mullins, Co. Carlow. He was ordained in 1898 and served as a curate before being appointed parish priest of Abbeyleix in 1919. Fr Breen involved himself in many local projects. He was prominent in the SVDP, an active member of the town council, and founded a local branch of the CYMS, but his greatest achievement was his contribution to the development of Abbeyleix Town Park.

ABBEYLEIX ANSWERS THE CALL

£1,500 was spent on improving Jelly's Pit over the next three years. In late 1923 the local community led by parish priest Fr John Breen made representations to Lord de Vesci, whose family held a 1,500 acre estate in the area, to lease the sandpit and some other ground as a park and recreation area. The park committee launched the 'Big Push' to move things forward. In April 1924 all businesses in Abbeyleix and the surrounding area closed and some 200 men armed with picks, barrows and shovels put their weight behind the project. They were joined by almost 80 farmers who brought their horses and carts, while the ladies' committee provided refreshments for all in the town hall. A month later another effort – the 'Final Push' – brought the work to completion.

In December 1925 Lord de Vesci granted the park trustees a 91-year lease, dated from 1 May 1924, at a rent of five shillings per annum. The trustees – Fr Breen, Fintan Phelan, Patrick Ryan and Michael Maher, who was later replaced by Edward McEvoy – granted licences to several sports bodies, including

An army of volunteers, inspired by Fr Breen, make the big push on a fine April day in 1924

St Lazerian's hurling and football club. Laois's Rathdowney played Dicksboro, Kilkenny, in hurling at the New Park's official opening in August 1926.

GAA AT ODDS WITH PARK TRUSTEES

The New Park or Town Park was used for the Maytime festival, the agricultural show, show jumping and community games as well as local and inter-county GAA matches. Circuses performed there each summer. Though St Lazerian's was granted an irrevocable licence to use the park in July 1948 other sports played there too, so it could not be vested in the GAA. As a result developments such as a 1960 proposal to lengthen the pitch did not go ahead.

BILLY PHELAN

In 1975 the club and the park trustees found themselves in the High Court, at odds over fencing off the pitch, which could have prevented it being used by the local soccer club. The trustees were granted an injunction restraining St Lazerian's, which also had its licence to use the ground revoked for a year.

COOPERATION FOR THE COMMON GOOD

St Lazerian's came to an agreement with other sports clubs in 1982 to develop Fr Breen Park, but Laois County Board could not support this as the local soccer club was party to the agreement. Work on improving the ground did start in 1983 nonetheless, and three years later the GAA pitch was extended.

The club finally got the trustees' permission to erect a fence around it in 1999. In 2012 a hurling wall was erected, the fencing was replaced and the dressing rooms renovated. A small all-weather pitch was also built and is hired out by the park committee.

1935
Tennis court and pavilion built in the park

1949
Park renamed in honour of Fr Breen, while St Lazerian's win their 8th Laois SHC title

1962
Abbeyleix Athletic Football Club moves to Fr Breen Park

1999
St Lazerian's install training lights at a cost of €13,000

2022
Club wins the Laois Junior Hurling Championship

Kelly Daly Park

LOCATION
Rathdowney

NAMED AFTER
Ker Kelly (1887–1963)
Businessman, hurler, GAA
administrator
Peter Daly (1876–1946)
Carpenter, hurler, referee, GAA
administrator, county councillor

OPENED
1914

CAPACITY
2,000

PITCH DIMENSIONS
144 x 88 m

COVERED ACCOMMODATION
No

FLOODLIGHTS
No

CLUB
Rathdowney–Errill

Even in its relatively short
history, Rathdowney–Errill
Hurling Club has enjoyed great
success, winning the Laois
senior county championship
on five occasions, the most
recent in 2019.

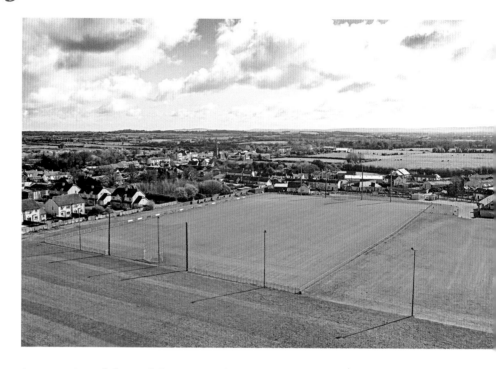

At a meeting of the Rathdowney Trade and Labour Union in 1914, Very Rev. Canon Brennan announced that the directors of Perry's Brewery were offering Rathdowney GAA Club a large field, Adamson's Meadow, at a nominal rent. The Perry family, renowned Quakers, also reduced the working week at the brewery, changing the day's finishing time from 7pm to 6pm, which may well have given some men more time to practise their hurling. Part of the land was also made available to the brewery workers as allotments during WWI.

Steady as she goes: the prudent and considered development of Kelly Daly Park is an example to many

The ground was known as the Sports Field but following Pete Daly's death in 1946 it was renamed in his honour. Pete captained the Rathdowney senior hurling team from 1899 to 1914, when they won eight county titles playing on fields around the village. In 1954 a major fundraising effort took place to finance the enclosure of the playing area at a cost of £200. The improvement led to the park hosting the county hurling semi-finals the following year.

KEY DATES

1886
Rathdowney GAA Club
established, wins its
first county SHC in 1888

1927
Adamson's Meadow
hosts the Gaelic
League's Aeríocht
festival, and does so
through to the 1950s

1951
Rathdowney Athletics Club
allowed use of the ground,
an arrangement that lasts
until the early '70s

1955
Park hosts the county hurling minor and senior
semi-finals. Loudspeakers keep supporters up
to date with the All-Ireland football semi-final
between Dublin and Mayo being played in
Croke Park at the same time

KIERAN (KER) KELLY

Kieran (Ker) was born to Charlie and Mary Kelly in Ballybuggy in 1887. The eldest of seven children, he became a successful businessman and owner of the Durrow Mills Stores, and was a great supporter of the farming community. He gave a lifetime of service to Rathdowney, first as a member of the hurling championship winning teams of 1911 and 1912 and then as a club administrator, acting as treasurer, chairman and county board delegate over the years. One of his key goals was to encourage young talent, and under his administration the club became one of the strongest sports organisations in the county.

ALEX STENSON

Peter Daly (1) and Ker Kelly (2) with the 1911 Rathdowney county champions team

PETER DALY

Peter Paul Daly was born in Rathdowney in 1876 to Peter and Anne Daly. After leaving school he went to work with Perry's Brewery where he trained as a carpenter. He captained the Rathdowney senior hurling team and led the Laois senior hurling team to many successes, including the Croke Cup in 1908.

A referee of note, he was president or chairman of Rathdowney Club for many years and represented the club at county board level. He was also the Laois representative on the Leinster Council for over 40 years, and represented the Leinster Council at Central Council level.

A life-long Gaelic speaker, Peter was actively involved in the Gaelic League and was for some time its president. He was also committed to serving working people and was the Labour Party representative on Laois County Council for 24 years.

GENEROSITY, GOODWILL AND A GROUNDED APPROACH TO DEVELOPMENT

Ker Kelly, one of the most successful businessmen in Laois, who had been involved with the club for more than half a century, purchased the ground as well as the local mill, Hare's Pond and Nanny Kelly's cottage from Perry's Brewery in 1959. He generously handed the playing ground to Rathdowney GAA Club in 1960. A small portion at the end of the GAA pitch was put aside for the local tennis club.

Ker Kelly's name was added to the ground, which became Páirc Uí Cheallaigh Uí Dhálaigh, or Kelly Daly Park in 1978. The new clubhouse, with changing rooms, showers, meeting room and kitchen, was opened by Leinster Council Chairman Paddy Buggy to coincide with the occasion. Built at a cost in the region of £6,000, the figure would have been far higher

except that the work was done on a voluntary basis. The local community showed the same enthusiasm five years later when they funded work on the embankments surrounding the pitch and a new entrance to the ground.

The new Rathdowney–Errill Club was founded in 2005 through an amalgamation of neighbouring clubs. The club embarked on a plan to modernise the park in 2016. Careful to keep the development within their means, the clubhouse and players' facilities were refurbished in Phase 1. Phase 2 started in 2017 when the club purchased an area of land to extend the pitch and create an additional playing pitch/training ground. Work was completed in 2021. Phase 3 is intended to provide floodlighting and a small spectator stand.

1978
Park is renamed on 21 May to honour Ker Kelly alongside Pete Daly

1992
Laois play NHL fixtures against Tipperary and Cork in Kelly Daly Park despite opponents appealing to have the venue switched to O'Moore Park

2005
Neighbours amalgamate to form Rathdowney–Errill Hurling Club. The clubs remain separate for football

2006
Rathdowney–Errill win Laois SHC title for first time

Pearse Park

LOCATION
Battery Road, Longford

NAMED AFTER
Patrick Pearse (1879–1916)
1916 Rising leader

OPENED
1937

CAPACITY
5,500

PITCH DIMENSIONS
145 x 84 m

COVERED ACCOMMODATION
Yes

FLOODLIGHTS
No

CLUB
No

Renovate or relocate? After an expert report highlighted structural problems, the future of Pearse Park is uncertain as Longford County Board weighs up its options for the future of the county's flagship stadium

Longford GAA can trace its roots back to September 1888 when the county's first club, Granard Healy's, was formed. The first club in Longford town, Longford Davitt's, was founded a few months later. The county finally saw a club football final on 8 June 1890, played in Peter McLoughlin's Field on Abbeycartron Lane, but the GAA in Longford collapsed the following year and was not formally revived until 1904. Longford played in the Leinster SFC that year, eventually going out to neighbours Westmeath.

In the early 1900s Gaelic games in the town were played at Longford Park, owned by the Longford Park Company. It was also a venue for cricket and hockey, as well as being home to Longford Town soccer club.

While soccer made headway in town, the GAA club scene remained weak up to the 1920s, and clubs were often indifferent to fixtures. The GAA also lacked a ground of its own. This changed in 1929 when the county board set about securing a Gaelic playing field.

KEY DATES

1929
Committee of Fr Michael McLoughlin, Joe Kelly, Fr Andy Lynch, Kit Halpin and John Ralph locate county ground site

1937
GAA Secretary Pádraig Ó Caoimh and Rev. P. Kelly officially open Pearse Park

1955–56
Pitch is drained, timber seating installed for spectators and hot showers for players

1963
Covered terrace completed

1966
Longford win the NFL and in 1968 the Leinster SFC for first and only times

PATRICK PEARSE

Patrick Pearse was the first President of the Provisional Government of the Irish Republic proclaimed in Dublin on 24 April 1916, and commander in chief of the Easter Rising that began that day.

WORK CREW ROLL UP THEIR SLEEVES AND PIN BACK THEIR EARS

The committee tasked with finding a site secured a lease from the Board of Works on ten acres of land at the derelict British Artillery barracks – renamed Kelleher Barracks – at Lisbrack, complete with stables and stalls. The ground was bought in 1930 and development commenced in 1931. The first task was to demolish the buildings located on part of the present-day pitch.

Teams of voluntary labour were drawn from GAA clubs throughout the county and, using borrowed box-barrows and Frank Gaffney's jennet, work began under the watchful eye of Paddy Hourican each evening at eight o'clock and went on until dark. Longford County Board took possession of the ground in 1933 and negotiated with the Land Commission to buy an extra portion of land to create the main entrance through Kelleher Square.

Some club games were played at the venue even as it was being developed. Ironically there was no football team in the town just then as Longford Wanderers had disbanded after going into debt to the tune of £85.

Known simply as the Gaelic Grounds, Sunday 25 April 1937 was set for the official opening when the ground was renamed Pearse Park. Seats were borrowed from Cusack Park, Mullingar, to facilitate the 7,500 spectators who saw Longford's footballers defeat Roscommon and Munster champions Kerry defeat All-Ireland champions Mayo.

OPERATING BEHIND ENEMY LINES

Improvements were made in the 1950s and '60s, but as Central Council delegate Fr Pilib Mac Aodha (Fr Phil McGee) wrote to General Secretary Pádraig Ó Caoimh in 1963, 'Our indebtedness, when the present scheme is complete, will be in the region of £6,000 … a very formidable one for us. As you know, our only town, Longford, is still largely "enemy" territory. Our rural clubs are not in any position to help as they are badly hit by emigration.'

GROUND'S PROGRESS UNDERMINED

During the 1990s the ground's boundary wall was replaced, seats installed in the stand and the embankment converted to terracing. The new pavilion included four new dressing rooms, meeting rooms and a referee's room. The stands were refashioned in the new millennium at a cost of €750,000 and reopened in time for the 2006 Longford–Dublin Leinster quarter-final. Further improvements costing some €375,000 followed in 2007.

However, in 2014 the entire West Stand was closed due to subsidence at one corner. As a result important games like the 2015 qualifier against Kildare was played in Mullingar and the 2016 Leinster SFC match against Offaly was moved to Tullamore. Refurbishment involved rebuilding parts of the stand and terraces and was completed in time for the Leinster SFC match against Meath in May 2018. But in 2022 further issues arose regarding the safety of the stand, which created a dilemma for Longford County Board: take on the major cost of rebuilding it, or move to a new site altogether.

2000	2008	2011	2018
County board considers move to a greenfield site, but €15m cost is prohibitive	Park hosts the All-Ireland minor final replay between Tyrone and Mayo	Ground's 18,000 capacity cut to 8,000	West Stand rebuilt at an estimated cost of €2.5m

Leo Casey Park

LOCATION
Edgeworthstown Road, Ballymahon

NAMED AFTER
Leo Casey (1846–1870)
Poet, writer, orator, Fenian

OPENED
1972

CAPACITY
2,500

PITCH DIMENSIONS
144 x 89 m

COVERED ACCOMMODATION
Yes

FLOODLIGHTS
No

CLUB
Ballymahon

Senior League winners in 1960, the club won one Longford SFC title in 2002 and were winners of the intermediate championship in 2022. John Heneghan, Trevor Smullen and Joe McCabe represented Ballymahon on the county team with distinction, as did Liam Mulvihill and Albert Fallon at administrative level in the GAA.

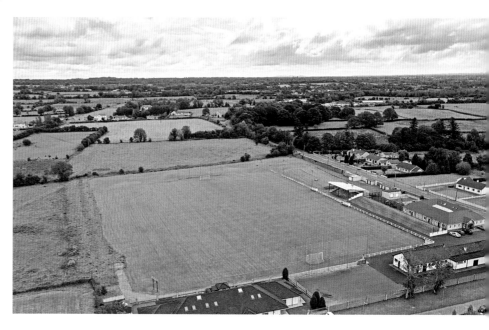

Ballymahon GAA and the local community is well served by the fine facilities at the club's headquarters in Leo Casey Park

Cricket was the popular game in Ballymahon before a GAA club was founded there in 1889. The first GAA match in the village, between Ballymahon and Longford Davitts, was contested on the Fair Green on 24 February that year. Before the game started Longford objected to the fact that the Ballymahon players were wearing hobnailed boots that would give them an advantage on the slippery ground.

The Ballymahon club changed its name five times between 1893 and 1907. Ballymahon O'Briens became Ballymahon Emmets in 1896, then Ballymahon Shamrocks, Ballymahon Leaguers and Ballymahon Goldsmith Gaels in honour of the local, world-renowned literary figure, Oliver Goldsmith.

The club also had a multiplicity of venues. Between 1889 and 1972 they played at a field in Terlicken owned by GAA Ard Stiúrthóir Liam Mulvihill's grandfather, Hugh; Kelly's Field, Moigh; Ward's Field in Ballymulvey; fields at Castlecor; Garrahan's Meadow, Cartronboy; Shaw's Field in Antley; Larry Feeney's Field in Moigh until 1953; and from then until 1971 James Delaney's Field in Drinan.

KEY DATES

1891
GAA as an organisation collapses in Longford and is not formally revived until 1904

1905
Ballymahon GAA Club is formally established and affiliated to Longford County Board

1911
One of the GAA's founding members, Thomas St George McCarthy, serves in the RIC in Ballymahon

1940s
Ballymahon club progresses under chairmanship of local curate Fr Patrick McKeown

1972
First official game in new ground is a county SFC match between Mostrim and Rathcline on 16 July

LEO CASEY

John Keegan Casey was born at Mount Dalton, near Mullingar in Co. Westmeath. In the mid-1850s the family moved to Gurteen, west of Ballymahon, where his father became principal of the local national school. John began writing poetry in his teens, when he is said to have written his most famous composition, 'The Rising of the Moon,' which commemorates the heroic failure of the 1798 Rebellion.

He joined the Irish Republican Brotherhood in Ballymahon in the 1860s and wrote regularly for the nationalist newspaper, *The Nation*, under the pen-name 'Leo.' He was imprisoned for his part in the Fenian rebellion of 1867 and held in Mountjoy Jail, where he was treated brutally.

Casey was a noted public speaker and continued campaigning after his release. However, his health was weakened and following an accident in 1870 he died on St Patrick's Day at the age of 24. Many walked from Longford to Dublin for his funeral, which was attended by tens of thousands.

COUNTY BOARD AND CLUB WORK TOGETHER

In October 1966 Longford County Board purchased ten acres on the Edgeworthstown Road from local butcher George Vance on behalf of the club. The grounds cost £2,669 including fees and in 1969 the club handed the county board a cheque for £430 as their contribution. The pitch was developed from then until it opened in the summer of '72 and was named Leo Casey Park. County board and club jointly improved the ground

'The Rising of the Moon' was chosen as the title of the Clancy Brothers first album, recorded in 1956, and featured a striking cover by renowned Irish painter Louis le Brocquy

through the 1970s and '80s, re-seeding the pitch, adding dressing rooms and a scoreboard, and enclosing the area with a boundary wall. Then in 1982 Longford County Board agreed to sell the park to the club for £7,000, the amount the board had invested. Ballymahon paid the first instalment in 1984.

CLUB TAKES OVER

Ballymahon GAA Club launched a monster draw in 1987 to fund improved facilities. A grandstand with a capacity of 600 followed, as did a new clubhouse, and dugouts for players and an embankment for spectators were completed in 1988. The new facilities were officially opened by GAA President John Dowling as part of the club's centenary celebrations on 24 September 1989.

Further improvements followed in the new millennium when the dressing rooms and shower areas were modernised, public toilets and toilets for the disabled were constructed, and a new PA system was installed as well as ball stops behind the two goalmouths.

DAYCARE FACILITATED, STALWART HONOURED

The club agreed in 2010 to sell one-third of an acre to a local charity who wished to build a daycare facility. The funds were used to develop an additional playing pitch adjacent to the existing one.

On 10 May 2014 the club's meeting room was renamed in memory of Paddy Kenny, who had played at every level for the club and remained a keen supporter up until his death on 5 July 2010.

Leo Casey Park hosted the Longford Community Games track and field events on 4 June 2017, when up to 700 young athletes competed in celebration of the Community Games's golden jubilee.

2002	2003	2011	2021	2023
Ballymahon win a maiden SFC title, and Casey Park hosts the club's Leinster SFC debut, resulting in defeat to Rathnew	Longford beat Derry, 1–12 to 0–10, in an NFL game at the park on 6 April, securing promotion to Division 1	Casey Park hosts the All-Ireland Ladies' Club Football Championship final, Carnacon beating Na Fianna on 27 November	Club history is made as Melissa Walshe is elected club's first female chairperson	Club granted planning permission to upgrade existing floodlighting system

Gaelic Athletic Grounds

LOCATION
Moneymore, Drogheda

OPENED
1926

CAPACITY
3,800

PITCH DIMENSIONS
145 x 81 m

COVERED ACCOMMODATION
Yes

FLOODLIGHTS
No

CLUB
O'Raghallaighs

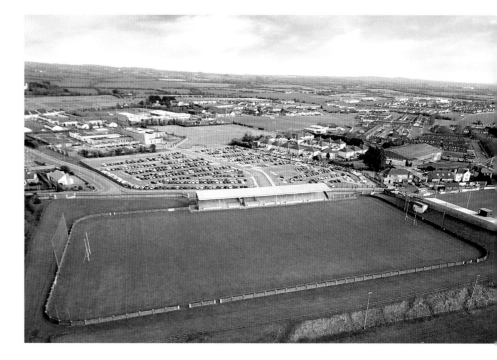

The club's sole Louth SFC title came in 1965. The county team was captained by club man Michael 'Muckle' McKeown the following year; his team-mate, Mick Leech, was also a prominent county player at the time. The club won the Division Two league in 2022 and plays at intermediate championship level at present.

The Drogheda branch of the GAA was founded on 30 May 1885 at a meeting in the Sheriff's Rooms in the town's Tholsel. The High Sheriff, James A. Clarke, was elected president. There were seven football clubs in Drogheda by 1888, when Dundalk Young Irelands represented Louth in the first ever All-Ireland SFC final, losing out to Limerick Commercials by 0–3 to 1–4.

Almost a century on, Drogheda remains a county ground, albeit rarely prominent. Its future as such may be jeopardised if Louth County Board's plans for Dundalk come to pass

When the playing pitch at Shamrock Lodge, Louth's main ground from 1917, became unsuitable for games, the Drogheda Athletic Grounds Committee was formed in 1925 to search for a new site. With the aid of a loan of £250 from Leinster Council and £550 collected from the people of Drogheda they purchased 11 acres on the North Road that year at a cost of £775. The Drogheda Gaelic Athletic Grounds were opened on Easter Sunday 1926 by Lord Mayor Luke Elcock in front of a crowd of 4,000 spectators. To crown the occasion, Louth beat Dublin in a senior football match on the day.

KEY DATES

1926
Drogheda Gaelic Athletic Grounds becomes the venue for Louth's home games

1927
B. C. Fay, secretary of the Ulster Council, unveils the new stand

1957
O'Raghallaighs GAA Club formed from Drogheda's Boyle O'Reilly, Beechgrove and Hardman's Gardens areas

1988–90
Four dressing rooms, a press box, scoreboard, ball stops, entrance gates, fencing and toilets completed at a cost of £105,000

COMMITTEE FORMED BUT PROGRESS IS SLOW

In July 1931 the Drogheda committee formed the Drogheda Gaelic Athletic Grounds Company Ltd, with the Leinster Council, Central Council and Louth County Board as shareholders. Further progress in the 1930s was stymied, however, when financial assistance from Central Council was refused because GAA funds were committed to building the Cusack Stand in Croke Park at that time.

CLONTEAD PARISH

AHEAD OF ITS TIME

Maurice Bogue, who lived in St Mary's Villas, Drogheda, invented the famous Bogue Clock which was first used in May 1938 when Louth played Mayo at the Gaelic Grounds. The clock was in effect a giant stopwatch – it could be stopped when there was a break in play and restarted when play resumed. Players and spectators could also see the time.

Bogue was invited to demonstrate his device at various matches around the country, and though a number of counties proposed that the clock should be used in inter-county, provincial and All-Ireland finals, Congress refused to back the motion.

Maurice Bogue was mystified by the 'official hostility' to his device when it was rejected by Congress. Decades later a countdown clock would prove a great success in ladies football

SUSPENDED PLAYERS CRY FOUL

Members of the now defunct St Dominic's junior football club picketed the ground on 30 June 1970, protesting at what they saw as discrimination by Louth County Board in its administration of Rule 27. It seemed that two members of the club were suspended when they were reported for playing soccer, while another three, who played minor football for the county team, were not.

O'RAGHALLAIGHS MOVE IN

In 1974 Louth County Board embarked on building a community centre at the ground. Pressed for funds, the GAA made an arrangement with the Drogheda Horse Show Committee allowing them to use a piece of land adjacent to the pitch for equestrian events between 1974 and 1976.

In 1974 also the O'Raghallaighs club, who played at Forest Grange on the Ballymakenny Road, sold their own field and agreed with the county board and the Gaelic Athletic Grounds Company to maintain and develop the ground on North Road. When the community centre opened in 1976 it became known as the O'Raghallaigh GAA Sports and Social Centre. The club's contribution to the park was acknowledged in 1994 when a lease was created in their favour for a term of 150 years, from 1 March 1976, at a nominal rent. However, despite improving facilities even more in the 1990s, further plans would run into difficulties.

NEW YORK PUBLIC LIBRARY

BOLD FENIAN MAN

O'Raghallaighs GAA Club was named after John Boyle O'Reilly, who, as a young man, was transported to Australia for his Fenian activities. He escaped to the USA and led an extraordinary life as a journalist, writer, poet and civil rights activist of international renown.

NEW GROUND WINS OUT OVER REVAMP

In 2011 Louth was forced to play a match against Meath in Breffni Park, Cavan, when the Gaelic Athletic Grounds was deemed unsuitable. Plans were subsequently launched for a new 12,000 capacity floodlit stadium at Dundalk Institute of Technology, but these were shelved when costs spiralled far beyond the original €6m estimate. Redevelopment was now back on the agenda and the old venue was earmarked for a €3.7m facelift, doubling capacity to 7,000. However, in 2018 Louth County Board changed tack and decided instead to build a new stadium in Dundalk. Nonetheless, the Gaelic Athletic Grounds remains a Louth county ground. It is a valuable piece of real estate that could potentially become a 'Moneymore Moneymaker' for the county board and the O'Raghallaighs club when the stadium in Dundalk is built.

1996
A new stand is completed at a cost of almost £345,000, along with other improvements

2005
Louth GAA, Drogheda United soccer club and Athletics Ireland discuss building a common sports campus for the town

2017
The Drogheda grounds hosts the O'Byrne Cup final, when Louth lose to All-Ireland champions Dublin

2022
Club wins Division 2 title and major work begins on developing the Moneymore pitch

St Brigid's Park

LOCATION
Newry Road, Dundalk

NAMED AFTER
Saint Brigid (c. 450–525 AD)
Abbess, patron saint of Ireland

OPENED
1959

CAPACITY
3,000

PITCH DIMENSIONS
137 x 81 m

COVERED ACCOMMODATION
Yes

FLOODLIGHTS
No

CLUB
Dowdallshill

Dowdallshill GAA, known locally as 'the Dowdallers,' is one of the strongest clubs in Louth junior football, having won the county title on five occasions.

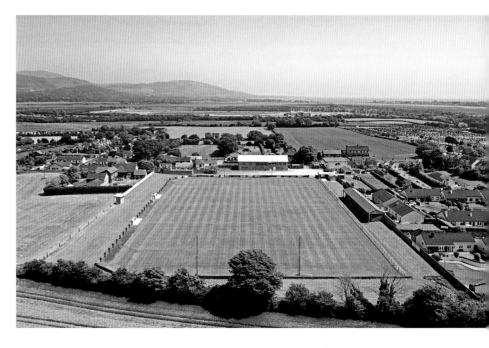

Dundalk was an early nerve centre of the GAA. On the northern outskirts of town, Dowdallshill Gaelic Football and Athletic Club, founded in 1886, played their first official game that May against the famed Dundalk Young Ireland's. The teams met again in the Louth SFC final the following year, a game played in McGeough's Field on the Dublin Road. Young Ireland's won in a replay and went on to represent Louth in the first All-Ireland football final in 1888.

St Brigid's Park has hosted the Louth senior football county final on 20 occasions

Dowdallshill, for their part, split in 1904 and disbanded altogether in 1908. They revived 18 years later and entered a team in the Louth football championship, playing their home games in a field on the Racecourse Road that was provided by the Carroll family. Known locally as Curlew Park, the land was very wet and when it was unplayable the players crossed the road to Dundalk Racecourse and played there instead. The club built dressing rooms on a site on Racecourse Road known as The Quarry, given to them for free by local landowner Nicholas O'Rourke. This galvanised-iron shed was affectionately christened 'Shack One.'

KEY DATES

1886
Dowdallshill Gaelic Football and Athletic Club is the third GAA club founded in Co. Louth

1904
Players leave to join other clubs when Dowdallshill lose the county finals of 1902 and '03

1923
Dundalk Athletic Grounds, a multi-sports venue, hosts its third All-Ireland SFC semi-final, Dublin vs Monaghan

1926
Club mentors Patsy Hearty, Con Colbert, Paddy McCourt and Willie O'Hanlon are key to club's revival

1953
Rev. Fr Shields blesses the new clubrooms on 18 October

SAINT BRIGID

Born at Faughart, Co. Louth, in *c.* 450 AD, St Brigid founded the first monastery in Co. Kildare, where she was abbess. She is one of the patron saints of Ireland, along with St Patrick and St Columcille. St Brigid died *c.* 525 AD at the age of 75.

TRACK STARS AT HOME AND ABROAD

Dowdallshill maintained its athletics tradition in its name and on the track. This side of the club came to the fore after WWII and with great success. In the late 1950s and early '60s the club's Gerry McShane was the top sprinter in the country, winning county, Leinster and national titles. Unfortunately, because of the split in Irish athletics at the time, he was unable to test his ability on the international stage. Peter McArdle, who won 12 national titles between 1951 and '56, emigrated to America and took out citizenship there. He won gold in the 10,000 metres for his adopted country at the Pan American Games held in Sao Paulo, Brazil, in 1963 and went on to run in the marathon at the Olympic Games in Tokyo the following year.

SUCCESS ON AND OFF THE FIELD

With new management leading the club, in 1949 they set about making a comeback on the GAA pitch. They got a taste of success in 1951, beating Oliver Plunkett's in a replay to win the JFC. Two years later the old dressing rooms on Racecourse Road were replaced with new clubrooms and the club also began to search for a new ground. In late 1955 they bought a field of 6 acres 2 roods and 4 perches from Paddy O'Rourke, brother of Nicholas, for about £1,500.

A weekly sixpenny draw defrayed the £7,000 it cost to develop the 16,000-capacity ground, St Brigid's Park, which opened on 13 September 1959. The following year the park hosted its first senior football county final, played between St Mary's, Ardee, and Naomh Muire from Drogheda.

DEALING WITH CHANGE

Following the closure of the Dundalk Athletic Grounds in 1959, Dowdallshill accommodated the county board by hosting many club and inter-county matches. St Brigid's also became home to the local Clan na nGael club until 1966.

In the ten years between 1956 and 1966 the club carried out several developments in keeping with the ground's status, and the pitch was enlarged in 1971. A covered stand for 600 spectators followed in 1978 and facilities were further improved through the 1980s. St Brigid's Park was the official Louth county ground up until 1990, but now Drogheda Athletic Grounds was preferred and GAA funds were diverted there. Dowdallshill's facilities deteriorated drastically as a result.

In 2003, with new population growth planned for the area, the club responded with a €550,000 investment plan. They sold the clubhouse on Racecourse Road and with the aid of Sports Capital grants and local fundraising built new dressing rooms, a referee's room and first-aid room for their members, and a hall, kitchen and meeting rooms for the broader community.

DOWDALLSHILL GAA

One final check – club stalwarts Ownie Rogers (left) and Paddy McCourt closely inspect the quality of the sward ahead of the opening of St Brigid's Park in 1959. For Rogers, in particular, that Sunday was the culmination of years of hard work

1959
Louth overcome Cavan as Leinster Council chairman Hugh Byrne opens St Brigid's Park on 13 September

1973
St Brigid's Park stages its first Leinster SFC match, when Louth defeat Carlow by 0–14 to 1–3

1987
5,000 watch Kilkenny beat Antrim as the ground hosts its only All-Ireland SHC semi-final

2008
GAA President Nickey Brennan opens the new clubrooms on 16 August

2022
Club hosts All-Ireland U16 C and D camogie semi-finals on 31 July

St Mary's Park

LOCATION
Drogheda Road, Ardee

NAMED AFTER
Saint Mary

OPENED
1952

CAPACITY
2,500

PITCH DIMENSIONS
138 x 87m

COVERED ACCOMMODATION
Yes

FLOODLIGHTS
No

CLUB
St Mary's

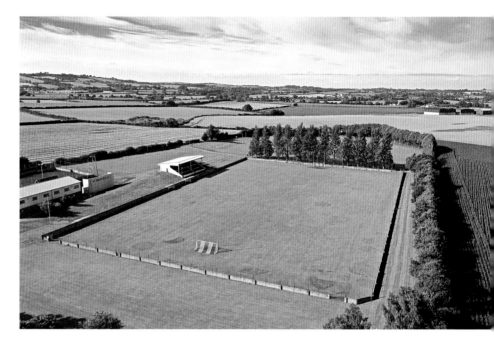

St Mary's GAA are a dynamic club on and off the field. They are justifiably proud of their impressive facilities and record of 11 Louth senior football championships, the most recent in 2022. St Mary's has produced many great players down through the years, including six on the Louth All-Ireland winning panel of 1957.

From 1886, when the Ardee Defenders were formed, this Co. Louth town boasted several clubs such as Ardee Volunteers, Ardee St Mochta's, Eamon Ceannt's, Independents and Gaels. Independents and Gaels came together as a new club, St Mary's, in 1928, playing at the Fair Green and then at Broadlough before finding a field of their own in Dawson's Demesne alongside the River Dee. The land was held from the Land Commission by Joe Dolan, who agreed to transfer it to the club if they paid the £250 rates that had accumulated.

Football tournaments in Drogheda and Dundalk helped raise the money. A local collection realised £237. Voluntary labour did the rest. When a ditch and drain had to be filled with rubble to create the playing area the work was done by hand, while the De la Salle Brothers and their pupils spent weeks clearing stones and weeds. The ground was named Ferdia Park after the warrior who died at the hands of Cuchulainn in the ford that gave the town its name, Áth Fhirdhia, or Ardee.

The resplendent Páirc Mhuire plays a huge part in the life of the local community, not just for club members but for those who use the facilities on a recreational basis as well

KEY DATES

1930
Louth footballers play Meath at Ferdia Park's official opening on 9 November

1930s–40s
As St Mary's star wanes, local soccer club Bohemians bid to lease the ground

1952
County board chairman J.J. Mathews opens St Mary's Park as Armagh footballers beat Louth

1957
St Mary's contribute six players to Louth's All-Ireland SFC-winning panel including captain Dermot O'Brien who goes on to become one of Ireland's leading entertainers

ST MARY, MOTHER OF JESUS

Mary has long been the focus of the Christian heritage of Ardee, commemorated in St Mary's Abbey and other local centres for many hundreds of years.

MERGER PAYS DIVIDENDS

St Mary's amalgamated once more, in 1945, with local club St Dominick's, keeping the St Mary's name and playing in the blue and white of Dominick's. The merger worked from the start. In 1946 they won the county SFC for the first time and would add ten more over the years. Their success led to them being called on to represent the county in 1948 when Louth couldn't field a team against Kildare. County board secretary Paddy Duffy arrived in Ardee, gave the players a set of Louth jerseys and said he hoped they would give a good account of themselves. In the event they beat a strong Kildare side, who gave their St Mary's opponents a standing ovation after the match.

CLUB WASHES UP IN NEW HOME

Ferdia Park suffered from poor drainage and was sold eventually as the club set about finding a new pitch. A farm belonging to Tom McNello came up for auction in 1945. It was beyond the club's budget or needs, but a farmer, James Roe, offered to purchase the McNello farm and give the club an option on the ground they needed. St Mary's bought this portion for £750, but unfortunately the site was also found to be wet. James Roe generously released the club from its commitments, which allowed them to buy a ten-acre field on the Drogheda Road from Mrs E. Casey for £1,000, with a further £160 paid to the Land Commission. The new ground, St Mary's Park, opened on 29 June 1952.

CLEVER CAMPAIGNS YIELD RESULTS

From the early 1950s the club took to organising carnivals and marquee dances to fund the ground's development. New dressing rooms in 1967, named after Tom McKenna, were followed by a 500-spectator stand in 1979. St Mary's clubrooms in Bridge Street were renovated and became a sports centre, opened by President Hillery in June 1985. The pitch was improved in 1991 and a second full-size pitch was added.

Selling the sports centre in 1995 helped fund a new centre in St Mary's Park, with four dressing rooms, treatment rooms, referee's room, dining facilities and a large function hall with separate meeting rooms. Trees were planted around the grounds and later a sensory garden was created to add to the atmosphere.

Facilities for the women's teams were added along with a new Prunty pitch solely for juvenile use. Progress continued into the new millennium. In 2017 the club received €115,000 in Capital Sports funding to go towards realising its Vision 2020 Development Plan, which included a gym, floodlit walking/running track, kick football area, hurling wall and more. The club launched a spectacular draw in 2021 to fund the plan, with a holiday home as first prize. Irish soccer legend Paul McGrath offered his support, recording a hilarious video of himself singing the iconic 'Ooh, ah, Paul McGrath' chant to promote the venture.

FIONE CARROLL

MISTAKEN FOR A CHANCER

The day in 1957 when St Mary's most famous club man, Dermot O'Brien, captained Louth to an All-Ireland victory didn't get off to the best of starts. Travelling alone to Croke Park, the Ardee man arrived some time after his teammates and was stopped at the gate. His desperate pleas to be let in fell on deaf ears. It was only when a call came over the tannoy for 'Dermot O'Brien to report to the Louth dressing room' that the steward relented.

1979
New stand completed at a cost of £9,900

1985
Clubrooms renovated to add squash court, billiards room, table tennis and meeting room

2022
St Mary's win the Louth SFC title for the first time in 27 years, defeating Newtown Blues in a replay

2023
Louth plays all four of its home games in NFL Division 2 at Ardee, and wins three to bring them to their highest league position in decades

Páirc Tailteann

LOCATION
Brews Hill, Navan

NAMED AFTER
Mythological goddess Tailtiu, and the Tailteann Games

OPENED
1935

CAPACITY
10,500

PITCH DIMENSIONS
139 x 89 m

COVERED ACCOMMODATION
Yes

FLOODLIGHTS
No

CLUB
No

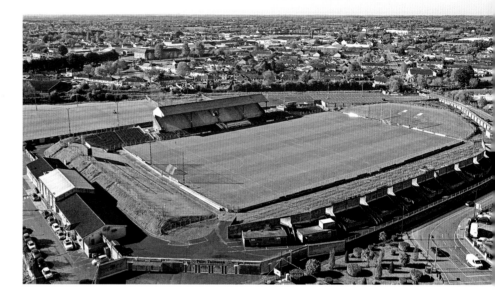

DUTCH NATIONAL ARCHIVES

Nobel Laureate Bertrand Russell (1872–1970) was the last of his family to own land in Navan. Although he was the grandson of John Russell, Prime Minister during the Famine, as a teenager he befriended Land League champion Michael Davitt and became a great supporter of the 'Irish cause'

The land on which Tailteann Park sits is steeped in history. The earliest recorded ownership goes back to the Cromwellian Wars, when the Nangles' lands were confiscated and passed to John Preston, then to the Earl of Ludlow and subsequently the Duke of Bedford. The duke granted the land to John Russell, Prime Minister of Britain from 1846 to 1852. The philosopher Bertrand Russell was the last of that family to own the estate.

An impressive plan for the redevelopment of a careworn Páirc Tailteann awaits a more favourable economy

At the turn of the century the Royal Meath Agricultural Society took a 100-year lease on the land at Brews Hill; this would last until 1998. They laid out two main arenas – the show grounds, which were also used for cricket and GAA, and the jumping enclosure. The society also provided facilities for hockey and lawn tennis as well as a cycle track.

The GAA played their county and Leinster championship matches in the show grounds, the first on 6 December 1903 when Dublin defeated Louth in the 1902 Leinster SFC.

KEY DATES

1909
GAA rents the jumping enclosure for £5 a year plus 20% of match receipts

1913
The Gaelic League hold an Aeríocht in the show grounds; Gaelic games quickly follow

1932
Meath County Board leases the show grounds from the agricultural society

1935
GAA President Bob O'Keeffe opens Páirc Tailteann on 8 September

TAILTEANN

The mythic Aonach Tailteann, held at Teltown in modern Co. Meath, dates back to the Iron Age. The GAA held modern revivals in Dublin between 1924 and '32.

A programme and medal from the modern Tailteann Games. The games were presented as a Celtic Olympics, a revival of an ancient Irish custom whose origins are associated with the ancient Queen Tailtiu and can be traced back to 632 BC

OPENING DAY OVERSIGHT

Relations between the GAA and the agricultural society, however, were often strained, while the GAA and the cricket club were frequently at loggerheads over who had first rights to play on the bowling area, the cricket crease.

The fortunes of the agricultural society began to wane in the 1930s and in 1932 the owner of the grounds, James McCann, sold the freehold of the jumping enclosure to the GAA for £616. The agricultural society also sublet their interest in the show grounds to the GAA for £1,400 plus an annual rent of £16. The GAA began work straight away on their newly acquired ground and purchased the car park for £150. As the pitch was levelled and lengthened, at a cost of £247. 8s. 6d., the old show grounds gave way to the new Páirc Tailteann. Over 5,000 people attended the formal opening in 1935.

None of the speakers at the event made any reference to the agricultural society nor was any member of the society present on the platform. 'The Meath Agricultural Society, and it would be ungracious not to acknowledge it,' the *Meath Chronicle* wrote, 'made a playing pitch, as near to perfection as it was possible to attain. It was turfed and re-turfed, drained and cared for. When Meath County Committee of the GAA acquired the grounds, they had little expenditure to face.'

FAITHFUL PACK NEW STAND

In 1938 Meath County Committee decided to erect a new stand, but the project was delayed due to the lack of steel during WWII. The covered stand was completed in 1951 together with the construction of new dressing rooms and drainage at a cost close to £11,000. A new uncovered stand opened in 1953.

The stands were full a year later when, despite heavy rain, 15,000 people gathered in Páirc Tailteann to hear 'the rosary priest,' Fr Patrick Peyton. The Mayo-born priest is said to have addressed over 26 million people worldwide during his decades-long prayer crusade. 'His presence was like a refreshing breeze even on this Island of St Patrick,' the *Irish Independent* reported.

MAJOR OVERHAUL PUT ON ICE

Navan O'Mahony's bought the old jumping enclosure part of the ground from Meath County Board in 1967 and with additional purchases of land in 1970 and 1993 created a club pitch of their own.

Páirc Tailteann itself was closed from 1986–88 as a new Prunty pitch was laid, the stand refurbished and the grass bank converted into a terraced area. The redevelopment cost £475,479.

The ground had a capacity of circa 40,000 but following a safety audit in 2011 the GAA reduced this to 10,500. Looking ahead, Meath GAA put forward plans for a 21,000-capacity stadium which was granted planning permission in 2018. The first phase – including a new stand – was set to cost around €12m. Unfortunately, in 2022 the project was put on hold indefinitely due to a huge increase in construction costs.

1968	1988	2006	2020
Meath play an Australian Rules team to a draw in Páirc Tailteann on 26 October	*All-Ireland champions Meath draw with Kerry at the park's reopening on 19 June*	*Floodlights installed but are dismantled for safety reasons in 2015*	*€6.2m Large Scale Sports Infrastructure grant approved for stadium upgrade*

St Loman's Park

LOCATION
Newhaggard Road, Trim

NAMED AFTER
Saint Loman
5th-century Bishop of Trim

OPENED
1950

CAPACITY
2,500

PITCH DIMENSIONS
140 x 91 m

COVERED ACCOMMODATION
No

FLOODLIGHTS
No

CLUB
Trim

Trim's hurling and camogie teams have enjoyed considerable success at club level and can also boast several All-Ireland winners. Peter Darby captained the Meath All-Ireland winning football team of 1967. Brothers Kevin and Frank Foley won All-Ireland medals in 1987 and 1988, while in hurling Ollie Reilly and Sonny Kelly won 21 county senior hurling titles between them. Darren Fay won All-Ireland SFC medals in 1996 and '99.

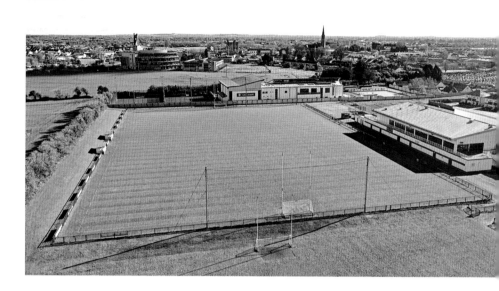

Hurling was strong in the Trim and south Meath area in the 1890s, with clubs such as Newtown Round Towers, Trim John Mitchels, Kilmessan, Breemount Inisfails and Galtim Downes leading the way. Newtown Park, on the eastern side of the town, owned by W. J. Wilkinson, was the home of Newtown Round Towers. Trim John Mitchels also played some of their games there, as did local hockey players. Meanwhile, the Shanlothe pitch, which also hosted cricket matches, was located at Canty's farm on the Summerhill Road, near Knightsbrook.

John Mitchels and Newtown Round Towers amalgamated in 1906 as Trim Clan na Gael. This club lasted for just four years and in 1910 was replaced by Trim Abbey Harps. The new club soon became known as Trim and moved to the Fair Green in the centre of town in 1914. Owned by the urban council, who leased it to the GAA, the green was also the location for the town's markets and livestock fairs.

Trim GAA Club has kept pace with the demands of an ever growing urban population with its impressive sporting facilities

KEY DATES

1915
Trim win the Meath SHC title for the first time and win it again in 1916

1936
Trim play their final game on the Trim Fair Green after 22 years playing there

1952
St Loman's Park gets two new dressing rooms costing £400

1962
Trim GAA Club wins its first and only Meath SFC title

1965
Park hosts American trotting races as a fundraising event in July

SAINT LOMAN

St Loman of Trim was a nephew of St Patrick and evangelised with his uncle in Ireland from 433 AD. He converted Fortchern, prince of Trim and grandson of Laeghaire, king of Meath. Loman for his part became the first Bishop of Trim.

The saint appears on a window in the local Catholic church which is named in honour of his uncle Pat

CLUB MOVES TO OLD RACECOURSE

Trim acquired a temporary lease on Egan's field in the Friarspark / St John's area on the Dublin Road in 1937 and remained there until 1940. In 1938, thanks to club members including Paddy Yore and Mick Leonard, the club secured a new pitch on the Newhaggard Road from the Land Commission, initially for a period of 11 months. The ground had served as Trim Racecourse from 1753 to 1915.

Making clever use of government grants, the club planted trees brought in from Wexford to act as a wind barrier in 1939. Meath County Board purchased the freehold of this land, consisting of ten acres, from the Land Commission on 12 May 1949 for £240. The venue, initially known as Trim Sportsfield, was nominated as a county ground and renamed St Loman's Park when it was officially opened on 21 May 1950.

SÉ-MUS BRENNAN

Racegoers pack the stand at the track on Newhaggard Road in 1915

ACQUIRING ROOM TO IMPROVE

Over the following 40 years various improvements were carried out, but by the mid-1990s St Loman's needed to be upgraded. Most other grounds in Meath had more up-to-date facilities even though Trim was the county ground and was hosting the majority of Meath's inter-county hurling games and county hurling finals. However, 17 acres adjoining the park were purchased for £150,000 from James and Mary Howley in January 1997 and work began on two new pitches in 1999; they were opened in 2001.

THE BIG BUILD

In 2005 an arrangement was made between the club and Meath County Council whereby three acres of GAA land were transferred to the local authority in 2006 and in exchange the club received planning permission for up to 50 houses and a new clubhouse. Work began on the clubhouse in April 2007 and was completed in December 2009. The new clubhouse included a sports hall and meeting rooms on the ground floor with a conference hall, function room and lounge bar upstairs. Six large dressing rooms were sited facing the pitch.

The main pitch reopened in May 2010 and further upgrades followed, including astro-turf goals and ball-stop netting on the main pitch and gated fencing surrounding the grounds. The refurbished park was opened on 12 May 2013 by Leinster Council chairman Martin Skelly. It was estimated that a total of €6m was spent on developing the ground, clubhouse and facilities since its purchase.

In 2018 Trim GAA Club added a 70 x 35m 4G astro pitch to their impressive range of facilities and made this valuable playing area available to other sports clubs in Co. Meath. St Loman's fine complex isn't only built of bricks and mortar. Trim GAA underlined their commitment to the future with the launch of their five-year Coaching and Development Plan 2023–28, with play starting at *naíonra* level and graduating from there to U6 and onwards.

1987
Trim hurlers win the first of their three-in-a-row Meath SHC titles

2007
Floodlights are erected on one of the two new pitches

2014
Ground hosts inter-provincial hurling semi-final between Leinster and Ulster

2022
Trim reaches the Leinster IHC final but lose out to Bray Emmets

St Colmcille Park

LOCATION
Gardenrath, Kells

NAMED AFTER
Saint Colmcille (521–597 AD)
One of the three patron saints of Ireland, missionary evangelist

OPENED
1934

CAPACITY
2,500

PITCH DIMENSIONS
141 x 89m

COVERED ACCOMMODATION
No

FLOODLIGHTS
No

CLUB
Gaeil Cholmcille

Gaeil Cholmcille was founded in 1964 and made an immediate impact in Meath senior football by making the final that year. Two years later they captured the title and again in 1968. Their third and most recent success came in 1991. The club has also won the Meath Intermediate Hurling Championship on four occasions, most recently in 2008.

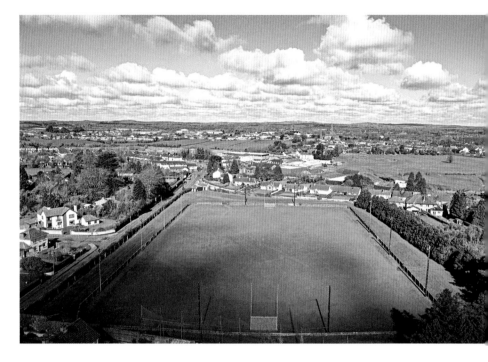

Kells Park was leased to Kells Town Council by the Marquess of Headfort, Geoffrey Thomas Headfort, who in 1901 scandalised Edwardian society by marrying a Catholic-born music-hall star, Rose Boote. The couple lived in Headfort House and the marquess later became a senator in the Irish Free State.

Gaeil Cholmcille continues to develop its spiritual home, St Colmcille's Park, along with its new facilities at Grangegodden

The park was used as a recreation area for the townspeople and also by Kells Harps GAA Club as their home ground. A Park Improvement Committee formed in 1931 set about raising funds to develop the area and the ground was closed in 1933 while the pitch was levelled and railings installed. The park could hold up to 25,000 spectators though only around 2,000 attended when it hosted its first Leinster SFC match on 3 June 1934, when Dublin defeated Westmeath by 2–10 to 1–4. The ground at Gardenrath was officially opened the following month by local curate Rev. Fr P. J. Murphy and named St Colmcille Park. It hosted Leinster SFC games that year and in 1935 and '37.

KEY DATES

1887
The first Meath county football final sees Kells Campaigners lose to Dowdstown

1934
Louth play Kildare and Meath play Wexford at the opening of St Colmcille Park

1964
Gaeil Cholmcille reach the Meath SFC final but lose to Kilbride 0–6 to 0–8

1966
Club wins the Meath SFC for the first time, beating Kilbride in a second replay

SAINT COLMCILLE

Colmcille, one of the great missionaries of the 6th century, established a religious settlement in Kells in 550 AD. His monks from Iona took refuge there in 806 and it was here that they completed their illuminated manuscript, the Book of Kells.

THE BIRTH OF GAEIL CHOLMCILLE

A delegation from the GAA clubs in Kells met the urban district council in July 1951 to talk about buying St Colmcille Park. A figure of £2,500 was mentioned for the 4.5 acres. The council eventually agreed to sell and it was finally acquired by Meath County Board in 1954 by way of a 99-year lease costing £2,600.

Ten years later Kells Harps, Drumbaragh Emmets and Kilmainham combined to form the Gaeil Cholmcille GAA club. Kilmainham and Drumbaragh later left the amalgamation while Gaeil Cholmcille continued at Gardenrath, maintaining the pitch and facilities and contributing to its upkeep. One of the founding members of Gaeil Cholmcille was the great Dublin footballer and hurler Des Ferguson, who had moved to the town as a teacher.

The club began raising funds to develop their facilities in 1969. To this end the ground hosted the National Sheep Shearing competition that June and in September a football match between the renowned Jimmy Magee All-Stars and a Meath selection.

On 6 March 1970 the club purchased four acres of land adjacent to the playing pitch for £2,600 and set about building a social centre that included dressing rooms and a recreation hall at a cost of £35,000. The building was opened by GAA President Pat Fanning on 23 February 1973.

To celebrate the 1,500 anniversary of the birth of Colmcille in 2021, six important buildings and monuments in Kells were illuminated with a series of wonderful illustrations describing the saint's life

Dual star Des 'Snitchy' Ferguson was a legend with both Dublin and Gaeil Cholmcille, the club he helped found

HAVE BOOTS, WILL TRAVEL

On 5 March 1995 the club held a unique fundraising event when their footballers played in each of the four provinces in one day. The first game was at 8 am against J. K. Brackens in Templemore, Co. Tipperary, the second against Clan na nGael in Roscommon before travelling to Virginia, Co. Cavan, to play Ramor Utd, and then finishing off in Navan with a match against Navan O'Mahony's.

A TALE OF TWO GROUNDS

Needing extra facilities to cater for their ever-expanding numbers, in 2005 the club set about purchasing 26 acres of agricultural land at Grangegodden Glebe, 1.5 kilometres from St Colmcille Park, from local landowner Michael Reilly. The intention was to apply for planning permission for housing at Gardenrath, which was valued at circa €4m at the time, and to offer it for sale to developers, using the balance of funds to create new sports facilities at Grangegodden, including one juvenile and three full-sized pitches, with dressing rooms, a clubhouse, car park and pitch and putt course. However, the downturn in the economy in 2008 put these plans on hold. The club continued to develop Grangegodden nonetheless, and in 2009 opened three new Prunty pitches there.

The development of the new grounds was partly financed by sponsorship from local businesses and a €60,000 grant from the Leinster Council. In 2018 the club renewed its efforts to sell four acres of their Gardenrath property and in the meantime continue to use the pitch there.

1974	1980s	2007	2023
Pitch and putt course opened primarily for retired players and to attract new members	Meath senior team play some of their NHL games in St Colmcille's	Club buys 26 acres at Grangegodden Glebe for €1m	Clubhouse and pitch & putt course at Gardenrath finally sold

Donnelly Loughran Park

LOCATION
Ringlestown, Kilmessan

NAMED AFTER
Tony Donnelly (1915–1955)
Joey Loughran (1907–1960)
Club and county dual stars

OPENED
1969

CAPACITY
3,000

PITCH DIMENSIONS
149 x 77m

COVERED ACCOMMODATION
No

FLOODLIGHTS
No

CLUB
Kilmessan

Kilmessan hurling and camogie teams are among the most successful in Meath GAA, with the Donnelly and Horan families to the fore. The hurlers have won 29 senior county titles. The club hosts the annual national club Poc Fada event, which attracts top players nationwide.

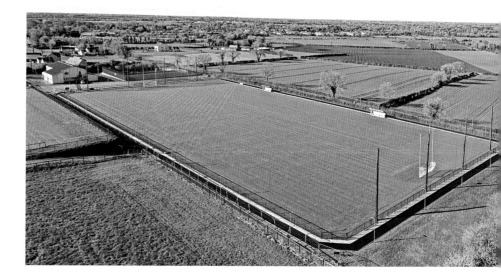

Donnelly Loughran's new pitch is flanked by an all-weather facility and a new training pitch, and surrounded by a walking track

Kilmessan are the most successful hurling club in Meath, having won the county championship all of 29 times. Founded in 1896 by Henry (Harry) Coady, the club's first chairman and later chairman of Meath County Board, Kilmessan focused on football to begin with and had their first county success when they won the SFC in 1903. A hurling team was founded in 1902 through the encouragement of John Chambers, and hurling would go on to be Kilmessan's top sport.

Playing initially at Curtistown and in Doran's Field, in March 1936 the Land Commission allocated the club four acres in Ringlestown on land that had been owned by the Wilkinson family since the mid-1800s but was acquired by the commission in the 1920s.

Kilmessan hurlers won their first county title in 1907 but didn't reach another final until the 1920s. In the 1930s and '40s they came into their own, taking four SHC titles in the '30s and then six in a row between 1943 and 1948.

KEY DATES

1907
Kilmessan defeat Athboy easily in the county hurling final by a score of 7–8 to nil

1924
Kilmessan hosts Aeridheacht festival, with hurling and camogie matches, on 20 July

1936
Club wins the Meath SFC title and goes on to win the hurling and football double in 1939

1938
Meath SHC final declared void due to Kilmessan and Trim fielding 'illegal' players

1979
Meath Macra na Tuaithe hold their annual sports day at the ground on 20 May

TONY DONNELLY AND JOEY LOUGHRAN

Joey Loughran and Tony Donnelly shared in many victories in both codes for Kilmessan and Meath. These include ten SHC titles when they played side by side, the football/hurling double in 1939, two more SFCs in '36 and '42 (the latter with Donaghmore), the 1933 NFL title, the Leinster SFC in 1939 and 1949, along with Railway Cup football in 1939, and finally the All-Ireland JHC title in 1948.

Joey had already won a junior hurling title as a teenager in 1927 and was over 40 when he won his second one. Tony represented Meath in both hurling and football at different levels from 1933 to 1948. Both men were exceptional players who

All-Ireland senior football finalists 1939 – (1) Joey Loughran and (2) Tony Donnelly with their Meath teammates

represented their teams with honour and distinction and sadly both of them died at a young age. The Meath minor hurling cup is named in their honour.

LAYING THE GROUND FOR MEATH'S HURLERS

Kilmessan purchased the land at Ringlestown, now consisting of over five acres, on 5 October 1955. Club member Jim Malin borrowed a Drott, the equivalent of today's JCB, from his employer, local developer Cormac Murray, which took much of the labour out of draining and levelling the ground. In 1959 the club decided to dedicate the pitch to Tony Donnelly.

The pitch was fenced in 1966 and the following year dressing rooms were built at a cost of £500. It was not until 27 April 1969 that the ground was officially opened by Kilmessan's parish priest, Fr Fox, and dedicated to Joey Loughran along with Tony Donnelly.

Meath hurling teams played matches at the venue, though very little development was carried out over the next 20 years, when the club opened a pavilion on 4 August 1989.

SPENDING WELL – AND THROWING SHAPES

Kilmessan built an all-weather, floodlit pitch and a hurling wall in 2009 with the support of Sports Capital funding of €94,000. The club also refurbished the main

playing pitch and erected new fencing around it.

By the end of 2015, the cost of the development of the all-weather pitch was paid for in full and it began to generate income. A 'Strictly Come Dancing' competition kept the parish on its toes in 2015 and in January 2016 Kilmessan added to their facilities by purchasing a piece of land at the rear of the clubhouse.

AND THE AWARD GOES TO …

By 2019 the original pitch was 50 years old and Kilmessan launched a three-year plan to modernise the ground. To raise funds the club ran an 'Oskars' event that saw budding actors from the club play movies on screen – Dublin football manager Jim Gavin made a cameo appearance in *Waking Ned.* The pitch was levelled, extended and resurfaced, new dugouts were built and a walking track was laid around the perimeter for community use. A further, larger undertaking was to develop another playing pitch. Assisted by GAA grants, government support and continued local fundraising, the work was carried out throughout 2020 and 2021 and it was ready for play in 2022.

1989
Meath footballers entertain Armagh in a football match at the official opening of the club's pavilion

2009–18
Club wins ten Meath senior camogie titles in a row and three All-Ireland junior titles

2013
Kilmessan takes senior hurling and senior camogie county titles in the same October weekend

2022
Kilmessan launches a Healthy Club initiative supporting the health of club members and the wider community

O'Connor Park

LOCATION
Arden Road, Tullamore

NAMED AFTER
Offaly's O'Connor Faly sept

OPENED
1934

CAPACITY
17,200

PITCH DIMENSIONS
145 x 87m

COVERED ACCOMMODATION
Yes

FLOODLIGHTS
No

CLUB
No, but has a long-term lease arrangement with Tullamore

Tullamore GAA is the Faithful County's largest club and has enjoyed considerable success on the field. 'The Blues' have amassed 28 senior county titles in football, the most recent in 2021, and ten senior county titles in hurling, the most recent in 2009. Off the field the club is no less active, having developed impressive facilities across the road from O'Connor Park at its headquarters in O'Brien Park.

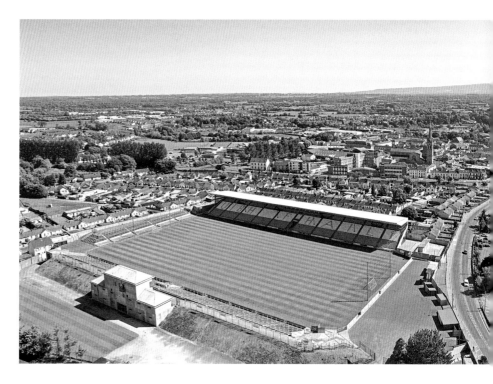

Gaelic games in Tullamore started when a few men gathered in the town's Trade and Labour Hall in May 1888 to set about founding a club. They began practising in a field off Church Road and plainly discovered a talent for football – the new club reached the semi-finals of the Offaly SFC in 1889, won the title the following year and won it again in 1891.

Much work and careful planning has gone into making O'Connor Park one of the best grounds in Leinster

Having previously played matches at rented lands on Church Road and also at Tinnycross, in 1913 Tullamore GAA Club acquired the Sports Ground in Ballyduff a mile outside town. The GAA now had grounds they could call their own and began to reorganise the association in the county.

The Sports Ground remained the home of Gaelic games in Offaly for 20 years. However, it could not be vested in the GAA as it was sublet and some also felt that the pitch was too far from Tullamore. A committee was formed to explore sites in the town but their efforts came to nothing.

KEY DATES

1913
Tullamore GAA Club lease the Sports Ground in Ballyduff at an annual rent of £12

1920s
Tullamore transfer use of their green, white and gold colours to the Offaly team

1934
Kildare defeat Galway's footballers, and Galway defeat Tipperary's hurlers at the opening of O'Connor Park on 24 June

1967
Tullamore GAA Club buys land from J. Kearney for £5,815 as site for its own ground

O'CONNOR FALY

One of the six O'Connor septs, the O'Connor Faly claimed descent from Cathaoir Mór, a second-century king of Ireland. They were powerful in their midland kingdom until the 16th century.

NEW RESIDENT ON ARDEN ROAD

In the spring of 1932, the Tullamore club secured a piece of land on the Arden Road from the Land Commission at a cost of £815 and set about developing it. A park committee that included Stephen Cloonan, Patrick O'Brien and Seán Robbins was formed to arrange its opening, and persuaded Taoiseach Éamon de Valera to perform the ceremony two years later, with Pádraig Ó Caoimh, GAA General Secretary, also in attendance. The Artane Boys Band made their first appearance in Tullamore on the day. Facilities at the new O'Connor Park were extended in the 1950s with the construction of new dressing rooms and showers, while sideline seating for 16,000 spectators was installed in the 1960s. Then in 1967 Tullamore GAA Club acquired land across from O'Connor Park on Arden Road and developed it as O'Brien Park, solely owned by the club.

The original sign, typical of the style erected in many GAA grounds in the 1920s and '30s, can still be seen over the main gate

FOUR DECADES OF DEVELOPMENT

The club began redeveloping O'Connor Park in 1989. A new stand was built and a tunnel was cut through a hill that divided the dressing rooms and the pitch. This allowed players and officials to walk onto the pitch directly rather than making their way through the crowd as before. Offaly County Board granted the club a loan of £45,000 to assist with the development. Former GAA president John Dowling, a native of Tullamore, reopened the park on 19 May 1991.

Ten years later Tullamore GAA Club held an EGM to consider a proposal to lease O'Connor Park to Offaly County Board. They agreed on a 35-year lease from 4 March 2002. O'Brien Park became the club's home ground while O'Connor Park, still owned by the club, became Offaly's county ground.

O'Connor Park's central location in Ireland made it an ideal venue for high-profile games but the need to modernise the ground was made clear in 2004 when Leinster Council ruled that it could not host the Leinster SFC game between Offaly and Westmeath as the capacity was insufficient. That game was transferred to Croke Park. The All-Ireland hurling qualifiers in 2005 were also moved for the same reason.

Tullamore club man John Dowling came to prominence as a fine football and hurling referee before his term as a very popular president of the GAA

These decisions forced the county board to embark on a substantial redevelopment programme for O'Connor Park. A new 6,540-capacity stand with press and wheelchair facilities and terracing on the north side of the ground with a capacity of 7,114 was constructed in 2006–07. Three years later a new terrace and a TV tower were completed on the east side, along with four new dressing rooms. The project raised O'Connor Park's status to one of the best venues in Leinster. However, in 2021 a keen dispute arose between Offaly County Board and the Tullamore club regarding the terms and conditions of the lease on the ground, but following a protracted period of negotiation between the two an agreement was finally reached in November 2022.

1984
Boundary wall 621 yards long and 12 feet high constructed around O'Connor Park at a cost of £42,700

2003
Offaly County Board approved for initial government grant of €300,000 for new stand in O'Connor Park

2010
GAA President Christy Cooney and Taoiseach Brian Cowen open final phase of redevelopment

2021
Tullamore named Offaly GAA Club of the Year

St Brendan's Park

LOCATION
Railway Road, Birr

NAMED AFTER
Saint Brendan of Birr (d. 573)
Patron saint of the parish

OPENED
1928

CAPACITY
9,000

PITCH DIMENSIONS
143 x 87m

COVERED ACCOMMODATION
Yes

FLOODLIGHTS
No

CLUB
Birr

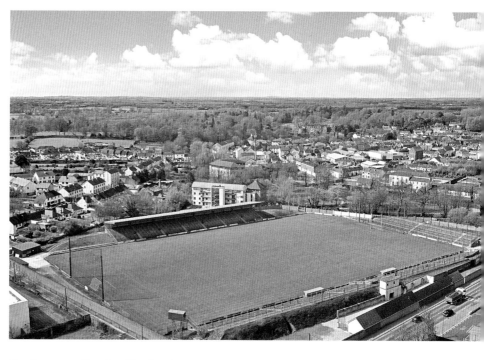

Hurling rules in Birr GAA Club and little wonder when you list their achievements: four All-Ireland senior club titles, seven Leinsters and 22 county championships. They have also produced many fine players for the county teams, including stars like Joe Errity, the Whelahans, Hannifys and Pilkingtons.

The first ever All-Ireland hurling final was played in John Farrell's Field in Birr. It was organised and supervised by local Fenians and members of the Land League. Meelick of Galway and Thurles, Tipperary, met on Easter Sunday 1 April 1888, playing for the 1887 title.

From early in its life St Brendan's Park was known as a top-quality ground and that reputation is still maintained today

The teams togged out in Cunningham's Hotel in Main Street and paraded through town to the field, but before the match could start the referee announced that he was facing a conundrum. Patrick J. White, an assistant in Treacy's Drapery in Birr, informed the teams that since he was a native of Co. Tipperary he didn't think he could take charge of the game. The players, however, pleaded with him to carry on. When the Galway team assured him that they were confident of his impartiality, Mr White finally took up the whistle and refereed the match, which Tipperary won.

Birr's hurlers dressed up in period costume to replay that moment in history during the town's Vintage Week Festival in 1969.

KEY DATES

1888
3,000 spectators watch Tipperary beat Galway in the first everAll-Ireland hurling final

1911
Fr Michael Crowe, chaplain at Birr Workhouse, becomes a key figure in Birr GAA Club

1928
Offaly play Laois in the inaugural Leinster MHC, the first game at Brendan's Park

1935
Sligo defeat Tipperary by 4–2 to 2–5 as Birr hosts the All-Ireland JFC final

SAINT BRENDAN OF BIRR

St Brendan founded the monastery at Birr in about 540 AD and served as its abbot. He was known as St Brendan the Elder to distinguish him from his contemporary and friend, St Brendan the Navigator. Known as one of the Twelve Apostles of Ireland, Brendan's monastery produced the wonderfully illuminated Mac Regol Gospels in about 800 AD. A facsimile copy is on display in Birr library.

Birr parish church honours the saint in name and pane where he is shown reading from 'The Book of Birr'

PUTTING DOWN ROOTS IN A DEEP HOLLOW

Birr fielded three hurling teams in the Offaly senior championship in 1889 – Allen, Larkin & O'Brien's, St Brendan's and Birr, which was testament to the strength of the sport in Parsonstown, as the town was called at the time. In 1898 members of the three teams joined with players from Seir Kieran and Drumcullen hurling clubs and calling themselves Fortal won the Offaly championship that year.

Birr GAA Club as it is today was founded in 1909 and played in the Old Sportsfield. The club won the county championship in 1912, 1913 and 1915 but found themselves without a pitch some ten years later. However, in May 1927 under the chairmanship of Seán Robbins a field owned by Captain C. B. Hackett, formerly let to Messrs John Dooly and Sons, was purchased by Birr for £400, of which £200 was granted by Leinster Council.

The site was set in a deep hollow, with a spring well in the middle of the pitch, but it was cultivated and levelled by an army of volunteers led by Jim and John Hickey and opened in 1928. St Brendan's

A happy crew of volunteers c.1930 mixing cement for seating benches to enhance the ground

Park gained renown when it hosted the 1931 and 1932 inter-provincial hurling semi-finals. It also played host to eight All-Ireland SHC semi-finals between 1929 and 1974, with over 15,000 filling the ground to watch Tipperary overcome Galway in a thrilling match in 1971.

YANKEE COUSINS PAY A VISIT

A novel match was played at the ground on 20 September 1964 when the New York football team met Offaly in the final game of their world tour. The Leinster Council nominated the park as the best maintained ground in the province in the same year.

Press and TV facilities were added in 1981 and in 1999 a 3,000-spectator stand opened at a cost of €400,000. The 1990s also saw Birr emerge as one of the most successful clubs in hurling history, winning the All-Ireland senior club titles in 1995 and 1998 and adding back-to-back successes in 2002 and 2003.

NO REST FOR THE VIRTUOUS

In 2009 the club bought a six-acre field on the Kinnitty Road as a new training pitch. The club renovated St Brendan's Park over the next few years. The slopes at either end were terraced and the playing surface brought up to modern standards. New dressing rooms were added in 2019 to cater for a squad of 40 players. History was made that year when the Offaly women's football team played a competitive fixture at St Brendan's Park for the first time. Further improvements followed, while plans to build a clubhouse encompassing a museum in honour of one of the biggest club grounds in the country are ongoing.

1971
Roscrea defeat St Rynagh's in the inaugural All-Ireland SH Club Championship final at St Brendan's Park

1999
Galway's hurlers defeat Offaly as GAA President Joe McDonagh opens the new stand

2009
Birr hosts the official opening of the 39th Féile na nGael All-Ireland festival

2022
A 40-metre ball wall, an astro-turf area and an onsite gym planned for St Brendan's Park

Cusack Park

LOCATION
Friar's Mill Road, Mullingar

NAMED AFTER
Michael Cusack (1847–1906)
Teacher, journalist, GAA founder

OPENED
1933

CAPACITY
11,000

PITCH DIMENSIONS
145 x 84 m

COVERED ACCOMMODATION
Yes

FLOODLIGHTS
No

CLUB
No

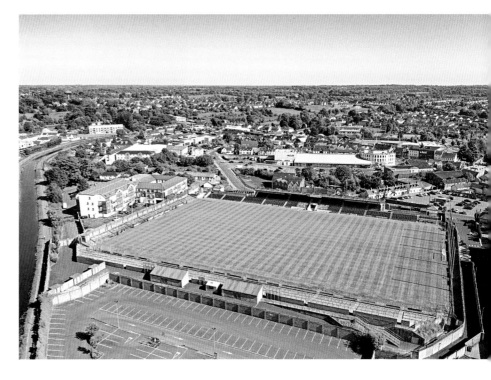

THE BOY BROADCASTER

Cusack Park hosted the All-Ireland football semi-finals of 1933, 1937 and 1938. The last of these, between Galway and Monaghan on 14 August, featured an 18-year-old Mícheál O'Hehir giving his first live broadcast from a tiny commentary box that was just big enough to hold himself and his father, Jim.

Westmeath GAA suffered a huge embarrassment when they were unable to host a county competition on Easter Sunday 1931 because Mullingar soccer club was using the only available venue on the same day. The GAA and the soccer club had been sharing the grounds at Mullingar Mental Hospital, but this turn of events set the GAA on a new path.

The possibility of developing a county ground had been discussed at the 1929 convention when Leinster delegate Patrick Carey suggested using the Barrack Square, but the Department of Defence rejected the GAA's approaches. A venue between Harbour Street and the Royal Canal was finally located in February 1932. The six-acre site had an irregular shape but adding an adjoining strip of land made space for a full-sized pitch. The ground, however, had a 14-foot slope, which meant that one half of the field had to be filled with almost six feet of earth and the other half had to have eight feet of rock taken out of it.

Regulars to Cusack Park talk of its particular charm and cracking atmosphere when full for a big game

KEY DATES

1900s
Games are played at the horse show grounds, Clonmore, and Gaelic grounds, Dublin bridge

1932
County board led by Captain Peadar Cowan purchase two parcels of land for £658. 14s. 0d.

1933
GAA Secretary General Pádraig Ó Caoimh opens Cusack Park on 16 July

1966
New stand opened on Easter Sunday to coincide with 50th anniversary of Easter Rising

MICHAEL CUSACK

Michael Cusack was born in 1847 in Carron, Co. Clare. After attending Trinity College Cusack established his own academy, where students were encouraged to take part in rugby, cricket, rowing and weight-throwing. He set up Cusack's Academy Hurling Club and used his growing profile as a journalist to campaign for a new body to organise and govern athletics in Ireland. To that end Cusack convened the first meeting of the 'Gaelic Athletic Association for the Preservation and Cultivation of National Pastimes' on 1 November 1884, a date that marks a turning point in the history of Irish sport.

WORKERS STRIKE OVER LOW WAGES

The county executive organised a public meeting to form a development committee, which included public nominees headed by Rev. E. C. Crinion, Dr A. J. Stanley, state solicitor E. J. Wallace and Westmeath councillor Patrick Brett, along with representatives from the county board and the business community. This moved the ground's development outside the confines of the GAA itself. The committee initiated, supervised and controlled all the work relating to the development of the ground.

However, when work began in July 1932 it was soon interrupted by serious labour disputes after trade union officials demanded an increase in workers' wages. This was refused and workers were sacked and replaced. Tensions escalated into a full-scale riot during which police fired shots in the air to restore order. Negotiations eventually led to a settlement that allowed work on the ground to go ahead.

BIG BUZZ BEFORE THROW-IN

Some 13,000 people turned out to see Ulster champions Cavan play Kildare and Kerry play Dublin at the official opening on 16 July 1933. The day began spectacularly thanks to Westmeath GAA chairman Captain Peadar Cowan's novel idea of starting the game by dropping the match ball from an aeroplane. The plane, hired at a cost of £3. 10s. from Iona Airways, arrived from Dublin 'something not unlike a bird with huge wings' according to the *Midland Reporter,* manoeuvred over the pitch and dropped the ball between the players.

PAUL HUGHES – WESTMEATH EXAMINER

High drama Iona Airway's Gipsy Moth sweeps in to deliver the ball and start the opening day game

PLAYING THE LONG GAME

Though there was ongoing remedial work to the pitch, overall progress at Cusack Park proved to be slow. A proposal in 1960 to build a stand came good six years later. GAA President John Dowling launched a park development fund in April 1988, but 12 months further on not enough was raised to finance the project.

In 1990 the county board set about improving the playing surface and building a 1,200-seat stand with dressing rooms and other facilities. The ground closed from 1992–96 while the stand was being built. Following a detailed analysis in 2021, upgrade works began again aided by a €300,000 Sports Capital grant and over €100,000 from the innovative Lake County Movathon fundraiser.

1982
The park is closed for four months as drainage work is carried out

1996
The ground hosts Cumann na mBunscoil finals, its first games in four years following redevelopment

2007
Plan to sell Cusack Park and move to new site fails due to economic downturn

2022
New bucket seats installed in the covered area of the stand

Páirc Chiaráin

LOCATION
Cloghanboy, Athlone

NAMED AFTER
Saint Ciarán (c. 516–549)
First abbot of Clonmacnoise

OPENED
1960

CAPACITY
5,500

PITCH DIMENSIONS
142 x 85m

COVERED ACCOMMODATION
No

FLOODLIGHTS
Yes

CLUB
Athlone

Athlone GAA are Westmeath's most successful club, having won 20 senior football titles, the most recent in 1998. They achieved an unprecedented six-in-a-row between 1955 and 1960. In 2001 club man Rory O'Connell won Westmeath's first All-Star and the midfielder was also pivotal when the county side captured their first Leinster senior championship in 2004.

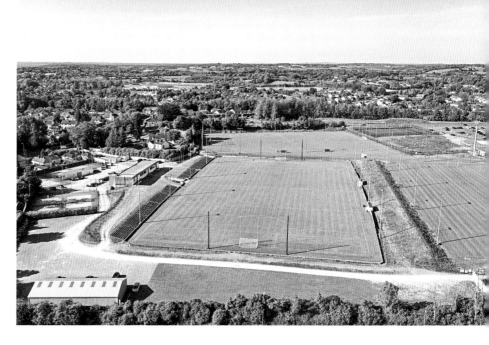

At the turn of the last century Gaelic games in Athlone were played on the town's Fair Green, in Rafferty's Field, Garrycastle, the Sports Field at Lake View Park, and the Meadows. The town had a number of clubs, among them T. P. O'Connor's, St Ciaran's hurling club and Athlone Volunteers, the forerunners of Athlone GAA Club.

Páirc Chiaráin can claim to be at the centre of the GAA, and the country, with its three floodlit championship standard pitches

The Athlone Sports Company Ltd was set up in 1915, with Athlone GAA Club as one of its shareholders, to provide the town with a sports ground. They leased the Sports Field from the Department of Defence, who also rented it to other sports bodies. The 1915 Connacht senior hurling final and the semi-final of the football championship were played at the ground. The following year it hosted the 1916 Croke Cup hurling and football finals, the Connacht SFC semi-final and an All-Ireland hurling and football semi-final. Clare and Galway contested the All-Ireland football semi-final there in 1917.

KEY DATES

1885
Members of Parnell's Irish National League set up Athlone Volunteers, one of Westmeath's oldest clubs

1905
Athlone Volunteers win the Westmeath SFC title and St Ciarán's the SHC title

1911
The Meadows makes history by hosting Connacht inter-county hurling and football matches

1954
The GAA buys 13.5 acres at Cloghanboy from William J. Young for £3,000

SAINT CIARÁN

Athlone and nearby Drum and Clonown have a long association with St Ciarán, one of the Twelve Apostles of Ireland, who established the great monastery and centre of learning of Clonmacnoise.

THE WILDERNESS YEARS

When the General Textiles Co. (Gentex) acquired the Sports Field in 1935 the Athlone club had to move. They rented Scanlan's Field in Arcadia for a year, at £1 a month, and then moved to Hoey's Field, which they rented from Athlone UDC. They followed the UDC to Grace Park in 1947 and offered to buy it a few years later. The deal fell through when pressure was put on the council not to sell public property to a private entity. The club went back to Hoey's Field. In 1953 they offered the UDC £1,350 for a 99-year lease, but Leinster Council refused to approve the purchase.

Athlone GAA Club was aggrieved about these setbacks. 'It is the avowed aim of a section here to put the GAA out of Athlone,' the club stated, 'but we are not going.'

RAFFLES PROVE A BIG DRAW

In 1954 Westmeath County Board, Leinster Council and Central Council bought three fields on the Ballymahon Road, Cloghanboy. Athlone GAA Club under Br Hubert took possession on behalf of the association and quickly set about finding 20 guarantors to cover an overdraft of £2,000 from the National Bank. County board chairman Charles Fagan told the guarantors that they need have no worries – the GAA would always be behind them.

Fundraising was overseen by Paddy Linehan and Kieran Hunt. A draw for a Morris Cowley valued at

£515 sold 30,000 tickets nationwide and made a profit of £1,090. A draw for a student scholarship raised £1,557. A draw for a trip to Lourdes, a card drive and a house-to-house collection brought in £3,500. Developing the ground cost in the region of £6,000. The first games on the new pitch was on 21 February 1960 when Athlone played St Brigid's, Mullingar, in junior hurling and Boher in senior football.

UPCYCLED DRESSING ROOMS

A Nissen hut bought from Bórd na Móna became the park's dressing rooms, toilets and showers in 1964. Expanding the range of sports at the site, an 18-hole pitch and putt course was laid out in 1969 and two tennis courts the following year. Though without a stand, the venue hosted the All-Ireland SHC semi-final between Wexford and Galway in 1970, two All-Ireland SHC quarter-final matches in 1974 and another quarter-final in 1975.

Souvenir programme of the official opening on 24 April 1960

'2020 VISION'

Through the 1980s the pitch was re-sodded, part floodlighting installed and infrastructure improved. The club then bought Lynch's Field, which ran parallel to the main pitch, and opened it as a second pitch in 1996. Managed by Martin Flynn and Andrew O'Sullivan, both pitches were floodlit in 2002 and the clubhouse was extended, and four years later the club developed a third pitch on the old pitch and putt course.

In 2019 the club launched its '2020 Vision' strategic plan, prioritising coaching and games development alongside developing club facilities. 'We have three fully floodlit championship standard pitches. We have our own gym. We have everything going for us,' Athlone GAA chairman Fergal O'Toole noted. 'All Athlone is really missing is a stand.'

1960
Tipperary play Galway in hurling at the official opening of Páirc Chiaráin on 24 April

1960s
The park hosts several All-Ireland colleges football finals, some with attendances over 10,000

1975
GAA President Dr Donal Keenan opens new £60,000 sports and social centre

2012–19
Ongoing improvements include a hurling wall, fitness centre, upgraded floodlights and ball catchers

Wexford Park

LOCATION
Clonard Road, Wexford

OPENED
1933

CAPACITY
18,500

PITCH DIMENSIONS
141 x 84 m

COVERED ACCOMMODATION
Yes

FLOODLIGHTS
Yes

CLUB
No

Sparkling ground by a shining sea – Wexford Park has gone through a major upgrade in recent years with the addition of floodlights being particularly welcome. This ground has been synonymous with Gaelic sports in the county town for almost 130 years – a long tradition that is not surpassed in any other county

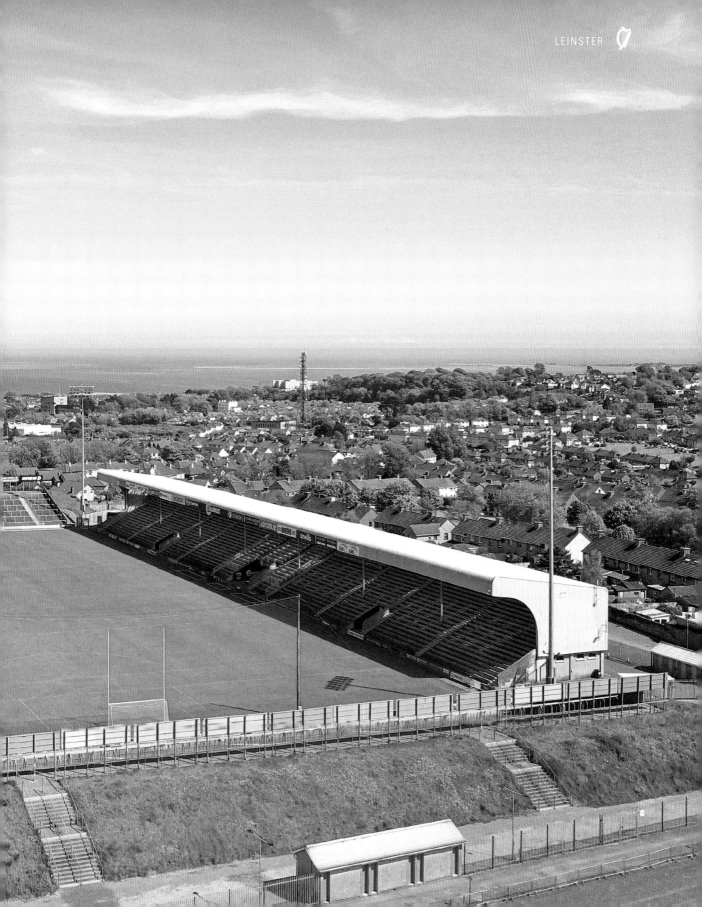

SCAREDY CATS AND FENIAN FUNDRAISERS

Of all principal county grounds, Wexford Park is the one with the longest history of hosting Gaelic games under the same name. The title was conferred in October 1893, when the park at Summerhill was used primarily as a racecourse. It emerged in the GAA sphere in June 1894 by staging the delayed 1893 Leinster SFC final, Wexford vs Kilkenny. On that day Kilkenny led at half-time, but refused to resume play, alleging too much roughness; and so Wexford were declared winners.

The following month the park hosted a tournament between clubs from Wexford and Dublin to raise funds for the monument to Terence Bellew McManus, a Fenian who had taken part in the 1848 uprising. The park was also used for coursing and agricultural shows, and was one of the earliest venues for GAA provincial matches, particularly when Wexford man Walter Hanrahan was Leinster secretary between 1900 and 1916. It also hosted the All-Ireland SFC semi-finals of 1906 and 1917.

GAA TAKE OVER WITH LONG-TERM LEASE

In May 1921 John Edmond Barry leased the park to the Wexford Sports Company Ltd, who assigned the land to building contractor John Browne in September 1922. When Mr Browne died in 1931 his representative, Christina McKnight, signed a 61-year leasehold agreement with trustees of the GAA. Subsequently, on 26 March 1933, Wexford Park was officially opened as a GAA-owned ground, albeit on a long-term lease.

COUNTY BOARD SHOW FAITH IN THE HARRIERS

A new lease for 999 years was agreed between the landowners and trustees of the GAA in February 1938. The price paid was £900. The embankment at the Clonard end of the ground was acquired as a freehold from Wexford Corporation on 26 January 1948 for £600.

In 1961 the Wexford County Board handed over responsibility for managing the ground to local club Faythe Harriers, who carried out extensive improvements. The park also served as the landing pad for President John F. Kennedy on 27 June 1963 after he left O'Kennedy Park, New Ross, to visit Wexford town.

The ground closed in November 1964 for five months when work was carried out on the pitch but overall development was slow and only undertaken when the budget allowed. A stand was built to seat 500 spectators and uncovered seating was also installed, facilities for players and seating on concrete terracing for 4,500 people came through in 1979 and a new press and television box followed in 1982.

Plans moved up a gear in 1995 when Wexford County Board put forward a three-phase schedule to build a new stand to accommodate 5,000 people and improve the ground generally.

NEW MILLENIUM MAKE-OVER

In 1997 the pitch was re-sited, drained and re-sowed and a new all-weather sand-based pitch was laid in 1998 and a new boundary wall constructed. The old stand was dismantled and sold for £2,500 and in 1999 work began on a new covered stand with dressing rooms, gym, first-aid room, canteen and offices. This brought the ground's capacity to approximately 25,000 but sadly three men who were synonymous with Wexford Park, Jimmy Roche, Pat Ffrench and Fergie Duff, passed away before this milestone was reached. The refurbished stadium opened on 9 June 2001 when Wexford and Westmeath footballers played out a 1–19 draw in an All-Ireland qualifier.

DOMINIC WILLIAMS

Up until his death in 1998, Wexford District Secretary Pat Ffrench was a daily visitor to his beloved park

KEY DATES

1893
Meeting in Wexford Park to revive the GAA in the county

1933
Park is officially opened by Rev. J. Sinnott as Wexford defeat Cork in NFL Division 2 final

1969
Pitch reopens for the Dublin vs Kilkenny Leinster SHC match on 22 June

1973
As many as 520 games played on Wexford Park's pitch through the year

1978
Wexford Park designated a county ground

THE YELLOW BELLIES

The legend of the Yellow Bellies, Wexford's nick-name to this day, owes its origins to a mythic match between a Wexford hurling team and their counterparts in Cornwall back in the 18th century. The game was organised by Caesar Colclough, owner of large estates in the Duffry region and Tintern Abbey, who is said to have been a generous landlord and an outstanding sportsman in his own right. Some accounts recall that the contest was sparked by Caesar's friendship with King William of Orange while others date it to a later Caesar Colclough, friend of King George.

At all events, when the 21 Wexford men lined out for the game they wore yellow sashes around their waists to distinguish them from their opponents. The queen, it is said, was so impressed by their skills that she quickly became a fan, supporting them with shouts of 'Come on, the yellow bellies!' The players brought the nickname home with them.

While hurling in Wexford is recorded in a ballad as early as 1688, hurling in Cornwall has a long history too. Cornish historian Richard Carew describes two variations of the game played in 1602 – 'hurling to goal,' which was played on a pitch, and 'hurling to country,' which was like the old inter-parish games in Ireland. Exhibition matches were twice held in London – Oliver Cromwell was among the spectators in 1654. The Cornish tradition is commemorated with an annual game between the Townsmen and the Countrymen at St Columb every Shrove Tuesday, while on Bodmin Moor there are three circles of standing stones known as 'The Hurlers.' Legend has it that men of the area broke the Sabbath by playing the game and were instantly turned to stone as a consequence.

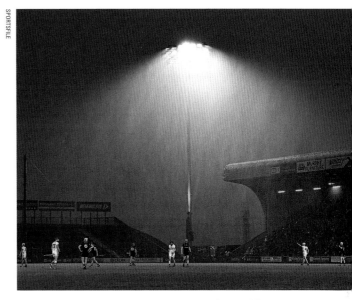

SPORTSFILE

Saturday night lights – Wexford Park's recently installed flood-lights illuminate the action as the Yellow Bellies play host to Galway in an NHL fixture on a wet February night in 2023

FIREWORKS LIGHT UP THE NIGHT

Ten years after the park was renovated, Wexford County Board launched a five-year strategy to upgrade it further. The plan proposed improving the playing surface to reflect inter-county standards, refurbish the dressing rooms and modernise press facilities, renovate the terraces and above all install floodlights.

Fans queued outside the ground in advance of the first game under lights on 22 January 2023. First-year hurlers from Wexford CBS and Good Counsel kicked off proceedings in the schools final, and masses of youngster had a puck-around on the pitch during the break. A huge fireworks display lit up the night sky just before Wexford and Kilkenny took to the field with a place in the Walsh Cup final at stake. Wexford beat 'the old enemy,' to the cheers of the 12,500-strong crowd.

2001
8,000 people venerate the relics of St Thérèse of Lisieux (the Little Flower) during a pageant-filled celebration in the park

2012
Central Council grants Wexford County Board permission to sell land at Glenbrien for €28,000 to reduce outstanding debt

2013
Wexford Park the first GAA ground to provide free access to high speed wi-fi

2013–14
Ground closes for four months due to problems with the playing surface

2023
Leinster chairman Derek Kent flicks the switch to turn on the new floodlights

Bellefield

LOCATION
Bellefield Road, Enniscorthy

OPENED
1889

CAPACITY
4,000

PITCH DIMENSIONS
140 x 82 m

COVERED ACCOMMODATION
No

FLOODLIGHTS
Yes

CLUB
Rapparees–Starlights

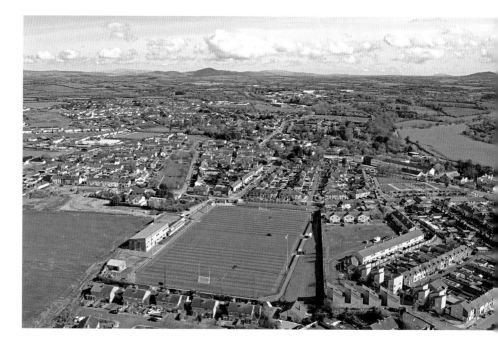

The exotically named Rapparees–Starlights GAA Club fields teams in hurling and camogie as the Rapparees and in football as the Starlights. Since its formation in 1971, the club has won five Wexford senior football titles, most recently in 2020, and two senior hurling titles, the latest coming in 2021.

The first game in Co. Wexford under the rules of the GAA was played on the Enniscorthy steeplechase course under the auspices of Vinegar Hill Harriers. The football match on 6 January 1887 between Enniscorthy and Ballaghkeene ended in a draw, with the teams racking up just one point each. From 1889 Gaelic games in Enniscorthy moved to Bellefield, which was leased by the Wexford United Agricultural Society from the Earl of Portsmouth's estate.

In the early years Enniscorthy was represented by clubs such as Slaney Harriers, John Street Volunteers, Enniscorthy Emmets, Shamrocks and the Red Rapparees, who played out keen local rivalries between the different parts of town. The Starlights club was established in 1917. The founders, standing outside the house where they held their first meeting, took their inspiration from the brilliance of the starry night sky above their heads. When a ladies' club was formed several decades later, many people wondered if they might become known as the Starlettes.

Bellefield derives its half-French name from a Georgian-era house of this title, built by the Lett family. This pretty park has hosted Gaelic games since 1889

KEY DATES

1904
Bellefield hosts the 1903 Leinster SFC first round match between Wexford and Wicklow on 24 July

1904
Enniscorthy's first hurling club, the Red Rapparees, are named after 17th-century rebels

1906
Kilkenny defeat Dublin by two points in the 1904 Leinster SHC final in Bellefield on 10 June

1927
Wexford County Board erect timber fencing topped with barbed wire around ground

1927
Wexford outclass Clare at Bellefield to win the first ever football match between the sides

STARS LIGHT UP BELLEFIELD

Starlights, through the Wexford County Board, bought a tenant's interest in the ground at Bellefield from the existing tenant, a Mrs Long from Liverpool, for the sum of £70 in 1923. The area consisted of 6 acres and 33 perches. In 1930 the county board set its sights on buying the ground and agreeing terms with the Starlights also. In the meantime, Bellefield hosted a Leinster SFC match on 5 July 1931, when Dublin defeated Wexford by 4–3 to 1–3.

The venue also hosted athletics meetings. Enniscorthy saw two-time Olympic gold medalist Pat O'Callaghan achieve a European record of 186 feet 8.5 inches in the 16 lb hammer throw there in September 1933. The All-Ireland NACA championships were also held at the ground in 1941.

The Cork-born athlete, Dr Pat O'Callaghan, was a superstar in his day and attracted large crowds everywhere he competed

PLAYER RELEASE FOR PRISONER RELEASE

In May 1934 a row broke out between Wexford County Board and the Starlights when the club announced that they would not release any of their six players selected to play for Wexford against Kildare in the Leinster SFC until three Enniscorthy men sentenced to three-months imprisonment for assaulting a political opponent were released. The impasse was resolved on the eve of the match, helping Wexford to a 1–5 to 0–6 win over their rivals.

GROUND BOUGHT FROM PORTSMOUTH ESTATE

Ground development was scant during the war years. In 1941 a boundary wall was built to replace the original timber one and two years later the pitch was drained and levelled. In 1945 a shed bought for £8 was turned into dressing rooms. After the county board bought the ground outright from the Portsmouth estate for £274. 5s. 0d. in December 1946, the club purchased a tricolour for £5 and flew it at all matches, the first venue outside of Croke Park to do so. The following year Bellefield hosted the 1947 All-Ireland JHC final on 14 September when Cork defeated London by 3–10 to 2–3.

50 YEARS OF TRANSFORMATION

In 1971 Bellefield became the home of the newly formed Rapparees–Starlights GAA Club, when Starlights' and Emmets' footballers and the St Aidan's and Shamrocks hurling clubs amalgamated.

The new club set about developing Bellefield and in 1974 it became one of the first grounds in Wexford to have facilities specifically for the press. The following year the club opened a community centre. A new handball court proved popular and was used for many national competitions. These facilities were extended in 1985 with the addition of a function hall, a new handball alley and a squash court.

More ambitious plans followed in the new millennium when floodlights were installed, an all-weather playing pitch developed and player facilities improved. Social facilities were updated too. In 2004 the old clubhouse gave way to a new building and in 2009 €500,000 was invested in improving and extending the playing area, which involved taking out the open seating on the Patrick Street side of the ground. In 2016 the club launched a five-year strategic plan that offered a blueprint for further development. This was superseded in 2022 with a plan that included two new sand-based pitches and a hurling wall. Conscious of knitting the ground into the community, the plan also promised a playground and a walkway for local use.

1948	1979	2009	2021	2022
Timber laid on concrete blocks provides seating for spectators	Club shocked as goalposts are sawn off to three feet just days before county SHC final	Bellefield closes for a year as major work on the pitch gets underway	Rapparees defeat St Anne's 6–18 to 1–17 to win their second ever Wexford SHC title	New development begins as the €1.2m Building Bellefield project is launched

O'Kennedy Park

LOCATION
Knockavilla, New Ross

NAMED AFTER
Seán O'Kennedy (1884–1949)
Accountant, dual star, GAA administrator

OPENED
1953

CAPACITY
3,000

PITCH DIMENSIONS
147 x 81 m

COVERED ACCOMMODATION
Yes

FLOODLIGHTS
No

CLUB
Geraldine O'Hanrahans

The club's golden age was in the mid-1940s when they won three senior hurling titles in a row in 1943–45. As well as the O'Kennedy brothers the club had other multi-title winners at All-Ireland level, such as hurlers Mick Morrissey, Tom Neville and Jimmy O'Brien. Club man Shane Roche acted as a selector and manager of the Wexford senior football team between 2020 and 2022.

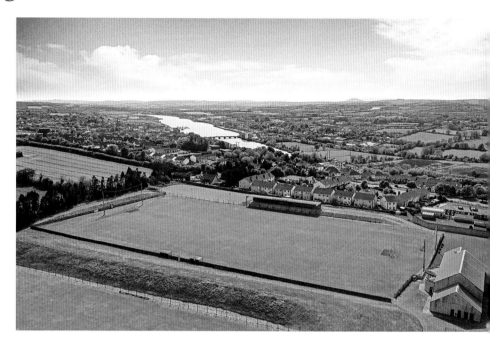

The first ever Leinster SFC final was played on the 23 September 1888 at Talbot Hall, a demesne outside New Ross, when Kilkenny (Kilmacow) defeated Wexford (Blue & Whites). The game was facilitated by the New Ross Commercial Club on the day. In 1899 New Ross Gymnasiums took the county title, beating Mulgannon Harriers from Wexford, and maintained it until 1902. The New Ross Boys Sodality Football Club was founded on 21 November that year, changing their name to Geraldines when the club affiliated to the GAA in February 1903. New Ross had many entities in the early days of Gaelic games.

The New Ross O'Hanrahan's Hurling Club was formed in 1917. Named in honour of local man Michael O'Hanrahan, who was executed following the Easter Rising, the club took the anti-Treaty side at the onset of the Civil War. Geraldines, for their part, supported the Treaty. The divisions between these clubs were eventually laid to rest when they amalgamated as Geraldine O'Hanrahans in February 1941.

Nestling above New Ross and the River Barrow, O'Kennedy Park's splendid facilities are a boon to the community

KEY DATES

1915
New Ross Geraldines win their first Wexford SFC title

1929
Kilkenny defeat Dublin as New Ross hosts its first and only Leinster SHC final, but both teams are subsequently disqualified for arriving late on the field

1943
Geraldine O'Hanrahans win the first of their three-in-a-row Wexford SHC titles

1953
10,000 watch Wexford beat Kilkenny in NHL tie at O'Kennedy Park's opening on 1 February

SEÁN O'KENNEDY

One of a family of five boys and one girl, Seán played hurling and football with the Geraldines and by 1908 was a regular on the Wexford senior hurling team. He won an All-Ireland SHC medal in 1910 before captaining the Wexford senior football team to three All-Ireland titles in 1915–17.

During his playing days Seán also served as county chairman in 1911, '14 and '15 and as county secretary from 1907–10 and again in 1915. He played his last game for Wexford in 1922 when he went to watch the hurlers play in Croke Park and ended up playing in goal because the team was short on numbers.

As the first three-in-a-row captain, Seán was allowed to keep the All-Ireland trophy, the Great Southern and Western Railway Cup. The O'Kennedy family later presented it to the GAA and it is now in the Croke Park museum

FINDING AND BUILDING A HOME

In 1945 the Geraldine O'Hanrahans Hurling and Football Club trustees reached an agreement with the Hogan family to lease the seven-acre Barrett's Park from 1 February 1946 to 31 December 1948 (excluding the month of January in 1947 and '48) at an annual rent of £45. Acting on behalf of the GAA in New Ross, Senator Michael O'Hanlon (a former Olympian) then bought the ground outright in April 1947 for £1,050 and transferred ownership to local businessmen Michael Sheehan, Andrew Holden and James Hanrahan, who subsequently had it vested in the GAA on 19 January 1953. The ground was opened as O'Kennedy Park by

GAA President Vincent O'Donoghue the following month and Geraldine O'Hanrahans became Wexford County Board's tenants.

SETTING THINGS STRAIGHT

The O'Kennedy Park pitch was not symmetrical so extra land was purchased in the early 1960s which allowed it to be realigned. An eight-foot boundary wall was then built to enclose the ground.

UPGRADING IN THE '80s

In 1980 the county board embarked on developments that included new offices, shower units and toilets and, not least, a covered stand with a press box. Geraldine O'Hanrahans were interested in buying the park but instead, on 22 January 1981, the board agreed to a long-term lease at nominal rent. In 1985 the club was granted £50,000 for park improvements, which went to erecting fencing and dugouts and upgrading the stand seats.

LAND SWAP AND BUY OUT

In 1994 the club swapped a portion of their land for a six-acre site beside the park. This arrangement gave them two pitches side by side. The club also purchased the main field from the county board for £45,000. Geraldine O'Hanrahans began building a clubhouse in 2002 that included an indoor handball and hurling alley, meeting rooms, four dressing rooms, first-aid room and referee's room, which opened in 2004.

PRESIDENT KENNEDY VISITS HIS NAMESAKE

On 27 June 1963 O'Kennedy Park welcomed its most famous visitor when four US helicopters landed in the park carrying President John Fitzgerald Kennedy and his entourage on their visit to the nearby homestead of the president's ancestors. Children created the shape of the word Fáilte while the Artane Boys Band played the president onto the pitch.

1960s
Sideline seating and embankments improve facilities for spectators

1992
A club lotto, the brainchild of Fr Jackie Power, Tom O'Shea and Benny Wall, is launched and helps fund current and ongoing development

2009
Hurling wall constructed and merchandise shop opened

2022
The clubhouse hosts its first ever wedding ceremony as club member Georgina Haberlin ties the knot with fiancé Robert Finn

County Grounds Aughrim

LOCATION
Rednagh Road, Aughrim

OPENED
1933

CAPACITY
7,000

PITCH DIMENSIONS
145 x 86 m

COVERED ACCOMMODATION
Yes

FLOODLIGHTS
No

CLUB
No

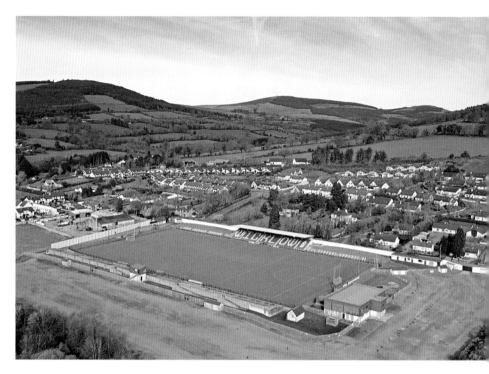

'Among the Wicklow Hills' – Aughrim GAA ground plays a huge part in the life of the 'Granite City,' and visiting teams find it very hard to break down Wicklow on this home ground

The early days of the GAA in Wicklow were dominated by Annacurra and Rathnew football clubs. Games in Aughrim were played on land belonging to Aughrim Flour Mills' owner William Fogarty, which also doubled as a racecourse.

Wicklow County Board nominated Rathdrum as the county ground in 1928 but this only lasted a few years. The board's fortunes took a turn for the better in 1933 thanks to the people of Aughrim. That April representatives of the Leinster Council visited Rathdrum, Ashford, Woodenbridge and Aughrim in search of a suitable ground. The Aughrim pitch could not be inspected on the day as it was covered with snow but it was designated as the location for Wicklow's new county ground nonetheless.

After paying £300 to the Land Commission the business and townspeople of Aughrim presented the 11-acre site to Wicklow County Board free of debt. This gesture was in no small part due to the good offices of local businessmen P. J. Phelan, William Hunt and William Morrissey among others.

KEY DATES

1900
Aughrim GAA Club founded and adopts the sobriquet 'Granite City'

1933
3,000 spectators celebrate Wicklow junior footballers' defeat of Wexford 4–7 to 0–1 when Aughrim opens as the new county ground on 21 May

1942
Wicklow go down 2–4 to 3–5 to Wexford as Aughrim hosts its first Leinster SFC match

1956–58
County finals move to Pearses' Park, Arklow, while Aughrim is being refurbished

GRATEFUL BOARD GETS TO WORK

Wicklow County Board took possession at the beginning of May 1933, becoming property owners for the first time. In recognition of Aughrim business people's contribution to the GAA, the board set aside a number of days when the local donors could hold events in the ground to help them recover their initial spending.

The pitch was badly in need of repair – part of it was set in a depression and required lorry loads of stones and earth to make it level with the rest – but with the aid of further fundraising and a grant of £300 from Leinster Council the ground was improved over the next few years. Aughrim hosted its first Leinster SFC match on 26 April 1942 between Wicklow and Wexford. The county board erected sacking along the road-side to prevent people from getting a free view of the games going on inside. Another Leinster SFC game was played there again in 1944 but there were no further Leinster senior matches until 1967.

In 1956 the ground was closed for renovation. New dressing rooms replaced the original tin building and, to flatten the uneven surface, the developers lowered the level of the pitch overall rather than raise it. The result, unfortunately, was that the ground became more liable to flooding from the nearby river.

FORTY YEARS A-GROWING

The dressing rooms got electric lighting in the 1960s and the showers were heated. Sideline seating was also added. The ground hosted the All-Ireland JFC semi-final between Wicklow and Galway on 17 August 1969. In 1983 work began on building a covered 500-spectator stand. A timber press box was also constructed in the stand, albeit with only a limited view of the pitch. Between 1988 and '90 new ladies'

and gents' toilets were built and new dugouts installed and further concrete seating was provided after a time. A project to concrete the entire bank on the river side of the ground was launched in 1996 through the local FÁS Community Employment scheme, under the supervision of Wicklow County Council. The county board took over the work themselves due to a lack of progress, and the structure eventually provided the base for seating some 3,800 spectators.

RIVALS LOCK HORNS

Alan Newsome explains some of the finer points of Gaelic football to a friend before the infamous 1986 'Battle of Aughrim' Leinster SFC tie between Wicklow and newly crowned League champions Laois. The locals shocked the GAA world by defeating their much fancied opponents.

FACILITIES ENHANCED IN NEW MILLENIUM

Aided by a Sports Capital grant of £100,000, Wicklow County Board spent over £300,000 in 2000 on four large dressing rooms, a meeting room and new kitchen facilities as well as ancillary work around the ground. Six years later the park was closed to facilitate work on the pitch, which also allowed improvements to toilets and dugouts, the installation of ball barriers behind the goals and new tarmacadam along the entrances.

After being granted planning permission in 2012, the old stand was demolished to make way for a new 1,300-seat structure. Terraced seating at both sides of the stand held another 500 spectators. The old press area was also totally refurbished. These enhanced facilities were officially opened in 2015 by John Horan, chairman of Leinster Council, which along with Croke Park had contributed almost €1m to the venture.

2000
County board chairman Mick O'Hagan opens Aughrim's new pavilion on 29 October

2006
Volunteers help with renovations as ground is closed for upkeep

2015
New stand opened on 11 October

2022
Wicklow County Board introduces a 'pop-up Gaeltacht' at Aughrim during an NFL match on 13 March

Pearses' Park

LOCATION
Vale Road, Arklow

NAMED AFTER
**Pádraig and Willie Pearse
(1879–1916; 1881–1916)**
Volunteers in the Easter Rising

OPENED
1963

CAPACITY
4,500

PITCH DIMENSIONS
138 x 84m

COVERED ACCOMMODATION
Yes

FLOODLIGHTS
No

CLUB
Arklow Geraldines Ballymoney

The club still awaits its first county senior title in either code, though they may not have too long to wait as they were only narrowly defeated in the 2019 football final. AGB's underage footballers have achieved great success in recent years while the club's women's teams, established in 2003, have won several county titles and the Féile Division One county title in 2023.

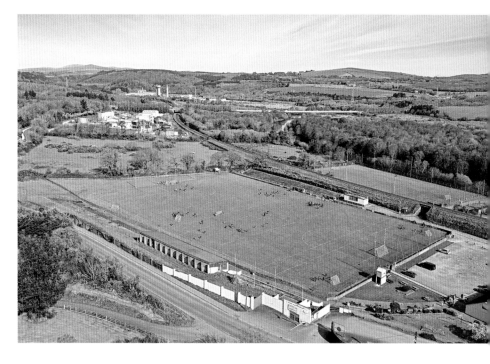

Arklow's early GAA clubs were as colourful as their names. One of the first, recorded playing football in 1888, was the Arklow Rock. Over the next 30 years many more came and went, among them Fishermen of Arklow, the Bluebirds, Ramblers, Dreadnoughts and Arklow Gaelic Pastimes. Ballymoney hurling club was in existence by 1906 while Fr Michael Murphy's became dominant in the 1920s.

Since completing the purchase of Pearses' Park from the county board in 2019, AGB has done great work to enhance its facilities

Arklow Pottery emerged in the 1930s. Renamed Arklow Town GAA Club in 1938, they secured the use of land at Lamberton from local merchant Myles Doyle shortly afterwards but did not survive for long. However, the club provided the nucleus for Arklow Geraldines, founded on 26 March 1940. Led by Pat Kinsella, Eamon O'Brien, Michael Kelly, Peter Tolan and William Redmond, the club purchased three fields on the Wexford Road in 1949 and with the loan of a bulldozer and topsoil from Wicklow County Council, dug out ditches, raised three-quarters of the ground by ten feet, and laid out a playing area.

KEY DATES

1949
Arklow Geraldines buy ten acres on the Wexford Road from William Dillon for £846

1952
Kilkenny hurlers defeat Wexford in a hurling challenge at the opening of Pearses' Park

1976
John Bruton TD opens new handball alley in Pearses' Park on 18 April 1976

1978
County board appoints its own caretaker to the ground in place of Arklow Geraldines'

PÁDRAIG AND WILLIE PEARSE

Teacher, writer and political activist Pádraig Pearse was leader of the 1916 Rising. His brother, Willie, was a sculptor, and studied at the Metropolitan School of Art in Dublin and in Paris. Both fought in the GPO, were court-martialled subsequently, and executed by firing squad.

WHEN SPORT AND POLITICS MIX

Ballymoney, who would later amalgamate with Arklow Geraldines, won their one and only Wicklow senior hurling championship in 1910 in unusual circumstances. The club was due to play Rathnew in the final in Shillelagh on 11 December but Rathnew insisted that they would not travel – they had to stay for a meeting in support of local politician John Muldoon's candidacy for the East Wicklow constituency. Ballymoney was awarded the title.

Senator Margaret Pearse in 1952 at the opening of Pearses' Park at its first home on Wexford Road

FROM THE WEXFORD TO THE VALE ROAD

Pearses' Park was officially opened on 14 September 1952 by Senator Margaret Pearse, sister of the Pearse brothers, Pádraig and Willie. It was intended initially to call the ground Pearse Park, but Senator Pearse asked that it be named in memory of both her brothers.

When the club expressed an interest in buying the Arklow Greyhound Track on Vale Road four years later, Leinster Council agreed to act as guarantor on a loan of £1,200 from the National Bank. The racing track was bought in 1960 and the loan repaid two years later when the Wexford Road ground was sold for the same amount. The new ground was levelled and seeded with the aid of a £500 grant from Leinster Council and opened for play in 1963. The club planned to formally open the new Pearses' Park in 1965 but after a series of unsuccessful attempts the official opening was abandoned, which was very unusual at the time.

1970s: DECADE OF DEVELOPMENT

Pearses' Park underwent continuous improvement through the 1970s. The pitch was drained and levelled and in 1973 a large prefabricated unit that accommodated four dressing rooms, toilets and a social centre was installed. The existing stand was re-timbered and painted and new entrance gates were erected. The stand was refurbished again in 1979. The general renovation was completed in March 1981.

NEW SET-UP FOR NEW MILLENNIUM

Arklow Geraldines and Ballymoney amalgamated in 1999 as Arklow Geraldines Ballymoney (AGB), but the club's use of Pearses' Park was restricted because the ground was shared with the county board. Meantime, Ballymoney had their own pitch at Shelton, complete with a clubhouse. Both grounds were improved in tandem. The club and county board took on a joint venture to provide an all-weather pitch at Pearses' Park in 2004, which was opened in 2006 and named in honour of club stalwart Liam Walker.

In December 2017 Central Council gave AGB permission to purchase Pearses' Park outright from Wicklow County Board for €250,000. The sale was completed in 2019 under the guidance of club member and former Wicklow secretary Jimmy Dunne. Since then extensive improvements have taken place, including the upgrading of the dressing rooms, a new electronic scoreboard and major pitch improvements. AGB now has two main grounds supporting the development and progress of Gaelic games in Arklow and its environs.

1979	1999	2004	2020	2021
Stand is re-roofed with the assistance of a £3,000 youth employment scheme grant	New Wicklow County Board offices opened in Pearses' Park	New juvenile pitch is developed in Vale Road	Club legend Jimmy Dunne inducted into the Wicklow GAA Hall of Fame	Club gets permission to install floodlights at Pearses' Park

Ashford GAA Grounds

LOCATION
Ashford

OPENED
1932

CAPACITY
2,500

PITCH DIMENSIONS
133 x 88 m

COVERED ACCOMMODATION
No

FLOODLIGHTS
No

CLUB
Ashford

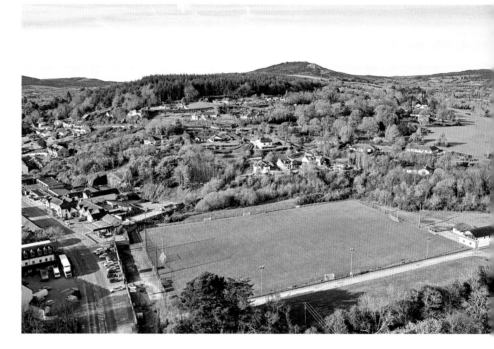

Led by county players like the Carthys, Behans and Pat O'Connor, the club won its only county SFC title in 1974. In recent times they have been successful at junior level. In 2018 they became one of the rare clubs in Wicklow to have won all five championship grades in the county. Ashford formed their first adult ladies' team in 2023.

Ashford was one of the first affiliated GAA clubs in Co. Wicklow and became very active in the maiden year of the association. They played the first ever match involving a Wicklow club against Dalkey of Dublin on 21 September 1885 and that Christmas hosted the first match between two Wicklow clubs with Barndarrig as opposition.

Loyalty and tradition run deep in Ashford GAA Club, whose members voted down a proposal to move to a much bigger site outside the village

Ashford won their first county championship on 20 May 1927 when they took the 1926 JFC title. In the 1930s and '40s the team played in a field owned by Cunniams, proprietors of the Glen Hotel, Ashford. The Cunniams were GAA supporters and their field and pavilion were always available for use. In 1931 Margaret Cunniam agreed to lease the ground to the East Wicklow Board for a period of 75 years at a nominal rent but subject to several conditions. These included using the hotel as the board's headquarters as well as bringing all county semi-finals and finals, and inter-county matches assigned to Wicklow to the venue.

KEY DATES

1898
Ashford footballers play under the name of Klondyke Rovers

1932
Ground levelled at a cost of £1,000

1954
Support from Wicklow County Board and Leinster Council makes purchase of ground possible

1974
Ashford wins its one and only Wicklow SFC title, defeating Carnew Emmets by 4–4 to 1–8

TAKING BACK CONTROL

Improvements to the pitch did not do enough to impress Leinster Council chairman Bob O'Keeffe. After a visit in 1932 he said that he would not recommend provincial investment as he felt the ground was not centrally located and that it was also too small. By 1952, the *Wicklow People* reported, the football field had fallen 'under the control of people who sponsored foreign games' and it was thought that the ground was 'lost to the GAA forever.' However, led by Billy and Paddy Lawless, Mick Turner and Peter Kavanagh, the Ashford club succeeded in purchasing the field from Cunniam Ltd on behalf of Wicklow County Board on 4 January 1954 for the sum of £800. Ashford then became the county board's tenants.

HOME TO WICKLOW'S HURLERS

In 1959 the pitch was drained and extended to allow for sideline seating and the entrance was improved. Ashford became Wicklow's main inter-county hurling venue while Aughrim and Arklow were the first choices for football.

In the mid-1960s an issue arose regarding access which forced the club to open another entrance and in 1968–69 a new boundary wall with new gates and two stile gates were erected. The playing area was drained again, and new dressing rooms and ladies' and gents' toilets were built. The white pebble-dashed boundary wall, however, was continually being blackened by the exhausts of lorries that parked up against it on market day.

CROKE PARK ARCHIVES

Wicklow has always been proud of its involvement in Gaelic games and documented its first 50 years of GAA history in this publication from 1935

FUNDS PUT TO GOOD USE

In 1972 Wicklow County Board sold a hilly portion of the ground consisting of about six acres to developers for a housing project. The park was closed in early 1986 while the pitch was re-sodded, and toilets and showers were installed in the dressing rooms. The refurbished ground was reopened on 8 June. When local hotelier Declan Roche supported the club with a donation of £2,000 and an interest-free loan of £5,000 in 1988, plans were drawn up to relocate seating at the ground, erect new wire fencing around the pitch, put up ball-stops behind the goals and construct a new scoreboard. Despite the improvements Ashford has not been used as a county ground since 1990 by Leinster Council, who felt that it was not up to standard.

CLUB VOTES TO STAY PUT

In 2003 Wicklow County Board unveiled plans to sell the nine-acre Ashford ground and purchase 30 acres at Ballyhenry, 1.5 km from the village, and create a modern complex there. Club members, however, voted against the move and decided to remain where they were. Over the next ten years Ashford saw little development, but in 2014 the club finally bought the ground from the county board for €225,000 and immediately put in place plans to build a new clubhouse. The building, with dressing rooms, a referee's room, hall, kitchen and a balcony over-looking the pitch opened on 19 August 2017. In March 2021 the club received planning permission to construct a grassed embankment on the north side of the pitch to be used as a spectator viewing area.

1976
Football match between Wicklow's 1955 team and the famed Jimmy Magee All-Stars raises funds for St Catherine's School, Newcastle

2001
Ashford win the Wicklow Intermediate Football Championship

2015
Club launches a buy-a-brick campaign to kick-start funding for new clubhouse

2021
Club history is made when Jennifer Byrne is elected as the club's first female chairperson

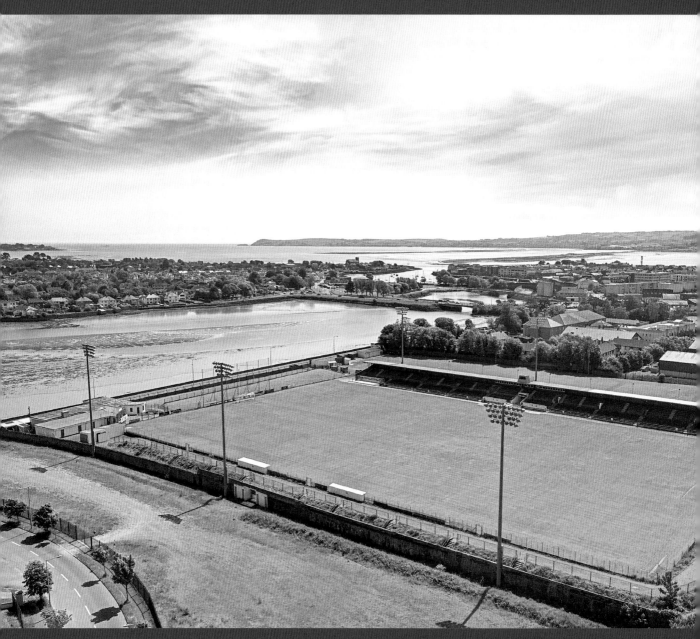

Fraher Field, Dungarvan, Co. Waterford

MUNSTER

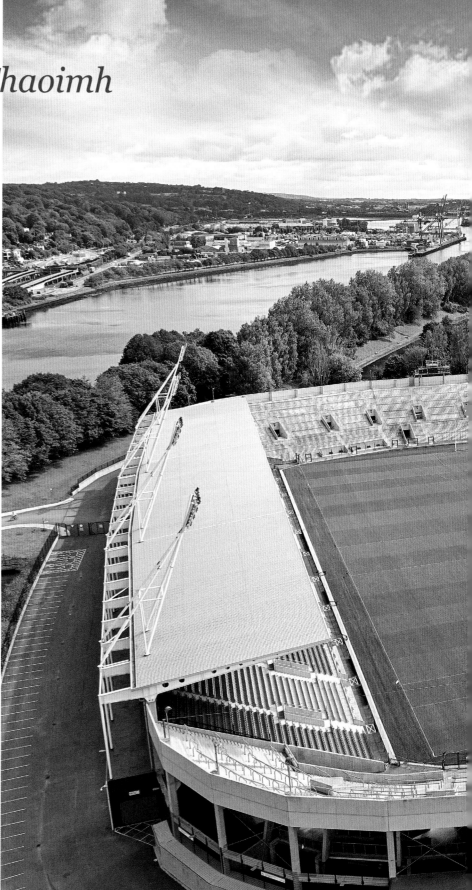

Páirc Uí Chaoimh

LOCATION
Ballintemple, Cork

NAMED AFTER
Pádraig Ó Caoimh (1897–1964)
Teacher, Irish Volunteer, long-serving secretary of the GAA

OPENED
1904, 1976, 2017

CAPACITY
45,000

PITCH DIMENSIONS
148 x 83m

COVERED ACCOMMODATION
North and South stands

FLOODLIGHTS
Yes

CLUB
No

Páirc Uí Chaoimh, Cork's colosseum on the banks of the Lee, has undergone three major rebuilds in the course of its long life. In its newest iteration it ranks among the finest stadiums in Europe

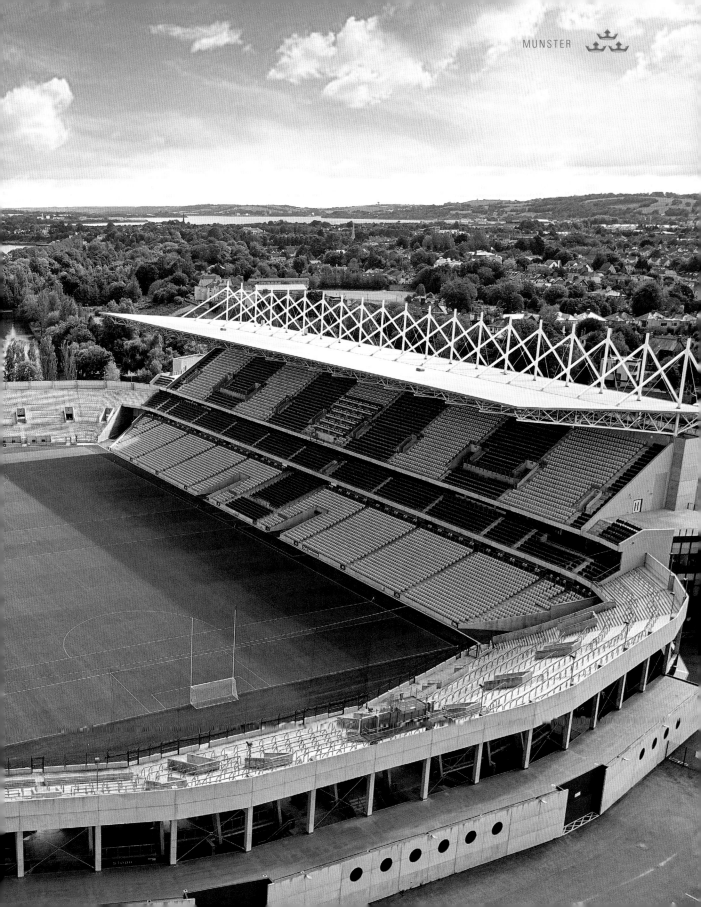

BALLINTEMPLE SPORTING MECCA

Cork Park, some 27 acres of land in the Ballintemple area now occupied by Páirc Uí Chaoimh, was originally a venue for many different sports from as far back as the 1860s. Leased by the County Cork Agricultural Society from Cork Corporation, it was host to horse racing and rugby, and from 1892 Cork Cycle Club, Cork Athletic Club, Cork Gun Club, United Football Club and the Irish Automobile Club. The park also became the main city venue for Gaelic sports from 1886.

The county board was eventually allowed to enclose part of the site and began to create their own area within the park. A contract was placed with builder William Fleming and by July 1898 an enclosure was erected. 15,000 people turned up for the first big occasion at the new ground – the 1897 Munster semi-finals in hurling and football between Cork and Tipperary, played in August 1898. The turnstiles could not cope and thousands climbed over the hoarding without paying the threepence admission. Following several similar mishaps, the GAA were forced to move their games to Turners Cross.

CROWDS THRONG TO NEW GROUND

In 1902 the Cork Athletic Grounds Company Ltd under the chairmanship of James Crosbie was formed in a fresh attempt to provide Cork with a proper athletics venue. The county board invested £30 and won representation on the board. They obtained a lease on a six-acre site at the lower end of Cork Park and set about developing it.

When it was opened on 11 September 1904 by Lord Mayor Augustine Roche the Athletic Grounds hosted the much-delayed 1902 All-Ireland hurling final between London Irish and Dungourney, who represented Cork, and the football final between Bray

An aerial view of Cork Athletic Grounds in 1933 looking north over the Lee towards Montenotte. A sizeable crowd gathered to see Limerick and Waterford contest the Munster hurling final

Emmets, representing Dublin, against London. But this time over 20,000 spectators turned up and were delayed getting in for the first match. Many clambered over the corrugated-iron fence and onto the roof of a refreshment room, which collapsed under the weight of people. Fortunately, no one was injured.

ROLL-UP, ROLL-UP, ROLL-UP!

Within two years the Athletic Grounds had hosted the delayed 1903 (Home) All-Ireland football final replay and second replay, and the 1904 final. The ground was also let out for hockey and soccer, but from 1906 onwards, with J. J. Buckley as Cork county secretary, it was used exclusively for Gaelic games.

Run by a private company, which included the new Munster Agricultural Society, the owners promoted the stadium by placing advertising around the pitch, installing a shooting gallery and weighing machines,

1887
Lees and Emmets play the first county championship match at Cork Park

1904
The Barrack Street and Butter Exchange bands play at the opening of Cork Athletic Grounds

1914
British military commandeer the ground for stabling horses as WWI breaks out

1935
Three exit gates and 18 turnstiles are installed to cope with attendances

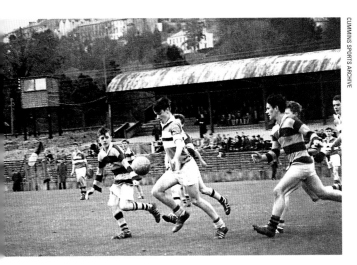

The Athletic Grounds never won any beauty contests but it was really showing its age when this photograph of a game between Coláiste Chríost Rí and De la Salle, Macroom, was taken in 1962

and allowing ladies in for free. The ground also hosted a Grand Flying Exhibition on 13 November 1912, which saw crowds flocking to see aviators from the Dublin Aviation School taking to the sky.

GAA OFFICIALS UNDER FIRE – LITERALLY

1920 was a tumultuous year. Two of Cork's lord mayors died in 'the Troubles,' martial law was imposed and the centre of the city burned. When Tipperary and Limerick were due to play in the Munster SHC on 8 August, the officials going down to open the Athletic Grounds found the turnstiles occupied by British Army machine-gunners, who fired over their heads and forced them to retreat. The teams and spectators made their way to Riverstown, where Limerick won the match 5–7 to 3–3. Games were not played at the ground again until 26 February 1922. Inter-county competition returned that April when Cork defeated Limerick in the delayed 1920 Munster hurling final.

PÁDRAIG Ó CAOIMH (1897–1964)

Roscommon-born Pádraig Ó Caoimh is considered by many as 'the architect of the modern GAA.' He grew up in Cork and became a teacher at Presentation College. In 1919 he joined the IRA's Cork No. 1 Brigade. He was elected secretary of Cork County Board the following year, despite being on the run. Five months later he was sentenced to 15 years penal servitude but was released in 1922 after the Treaty was signed. He took the republican side in the Civil War.

In 1929 he was elected General Secretary of the GAA. As well as overseeing major stand developments at Croke Park, his lasting legacy was the drive he initiated with Martin O'Neill, Leinster secretary, to have a GAA-owned pitch in every parish in the country, an initiative supported by a grant-aid scheme to encourage clubs and county boards to purchase their own grounds. The remarkable fact that O'Neill and provincial secretaries Seán McCarthy (Munster), Gerry Arthurs (Ulster) and Tom Kilcoyne (Connacht) held office throughout a 30-year period, 1934–64, underpinned the exponential progress of field investments during the Ó Caoimh era.

Pádraig Ó Caoimh died a few months before completing 35 years as general secretary. *The Irish Times* noted that 'under his administrative genius the GAA became by far the strongest sports organisation in the country and reputedly the biggest amateur association of its kind in the world.'

1950
Munster Agricultural Society ask their tenants, Cork Athletic Grounds Co., to leave – when they can

1976
Cork defeat Kilkenny in hurling and lose to Kerry in football at the opening of Páirc Uí Chaoimh

1983
Páirc Uí Chaoimh stages the All-Ireland SFC semi-final replay, Cork vs Dublin, but home advantage cannot prevent an away win

1999
Gardaí ban klaxon horns and flares at the Clare vs Tipperary Munster SHC match on 12 June

2017
GAA President Aogán Ó Fearghail opens the new stadium on 22 October

BUILDING HISTORY

Between December 1934 and June 1935 infrastructure – drainage, entrance and exit gates, roads access – was overhauled and a new covered stand built to accommodate 700, all at a cost of £3,000. The ground was at this stage under the joint control of Cork County Board and the Cork Athletic Grounds Company, subject to a lease from the Munster Agricultural Society. The Cork venue pioneered the schoolboy 'penny gate,' which brought 2,000 schoolboys to a Noonan Cup final between Cork and Tipperary's hurlers.

Though there was further development in 1952, by the early '60s it was obvious that the grounds were no longer a suitable headquarters for Cork GAA. The possibility of building a new stadium in Bishopstown was explored but came to nothing. Instead, in 1972 the association acquired extra land from their accommodating neighbours, the Munster Agricultural Society, and set about building the GAA's first custom-built stadium. In 1974 the Athletic Grounds was demolished to make way for the new Páirc Uí Chaoimh. The modern bowl-shaped structure, with one covered stand (named after Seán Mac Cárthaigh, the second Cork president of the GAA), an open-air stand and terraces behind each goal, had a capacity of 50,288 and seating for 19,688. It was opened in 1976 at a cost of £1.7m.

DRUMBEAT OF PROGRESS

Throughout the 1980s the ground hosted many lucrative concerts with world-famous acts that filled Cork County Board's coffers and helped purchase Páirc Uí Rinn. In 2007 the county board announced plans to redevelop Páirc Uí Chaoimh as a state-of-the-art 60,000-seat sports and concert venue at an estimated cost of €30m. Seven years later, the project got planning permission, and the government approved grant-aid of €30m, but by now costs had risen well beyond the original estimate.

Like the Athletic Grounds before it, the old stadium was demolished. Construction began in 2015.

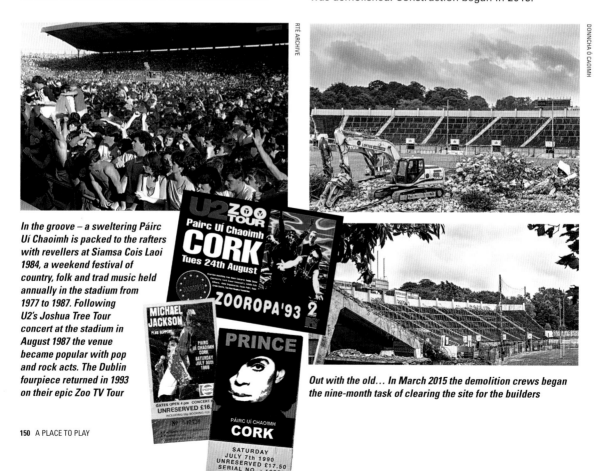

In the groove – a sweltering Páirc Uí Chaoimh is packed to the rafters with revellers at Siamsa Cois Laoi 1984, a weekend festival of country, folk and trad music held annually in the stadium from 1977 to 1987. Following U2's Joshua Tree Tour concert at the stadium in August 1987 the venue became popular with pop and rock acts. The Dublin fourpiece returned in 1993 on their epic Zoo TV Tour

Out with the old… In March 2015 the demolition crews began the nine-month task of clearing the site for the builders

Two seated stands were built to accommodate 21,000 spectators, with a 24,000-standing capacity on both terraces. The stadium boasted four 35-space dressing rooms with underfloor heating, physio, drug-testing, referees' and medical rooms, warm-up spaces and a gym. It also included corporate boxes, a TV studio, conference centre, restaurants and a museum. Behind the South Stand, on land that was once the Cork Showgrounds, a fully floodlit all-weather pitch formed part of the stadium's centre of excellence. Depending on the source of information, the cost of the redevelopment was any amount between €86.4m and €110m.

Inishannon club Valley Rovers and Blarney's hurlers played the first competitive match in the new ground, a Cork premier Intermediate Hurling Championship tie on 19 July 2017. The stands were full for the All-Ireland SHC quarter-finals, Tipperary versus Clare, two days later, while Cork's senior hurling and football county finals were played at the official opening on 22 October 2017.

CONCERT SPARKS CONTROVERSY

Singer-songwriter Ed Sheeran's concerts in Páirc Uí Chaoimh in late April 2022 packed the stadium but sparked controversy because the venue was not available for Cork's Munster SFC semi-final clash with Kerry a week later. The playing surface had to be regrown after the concerts before it could be used for playing football.

But Cork GAA CEO Kevin O'Donovan pointed out: 'This facility has to work on a commercial basis. There is a significant debt on us.' The GAA in fact launched bold proposals to move beyond the ground's €30m debt. These included expanding Páirc Uí Chaoimh's conference and exhibition areas, integrating the stadium's footprint with the rejuvenated Cork docklands, and creating a new GAA museum and visitor centre to offer the historic ground as a tourist destination also.

July 2017, all dressed up and ready to go. A resplendent Páirc Uí Chaoimh a few hours before it hosted its first game

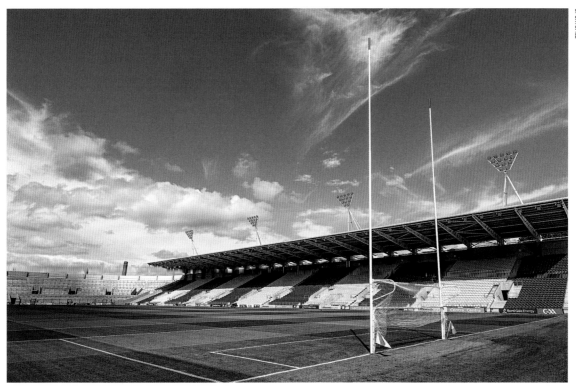

SPORTSFILE

Páirc Uí Rinn

LOCATION
Ballintemple, Cork

NAMED AFTER
Christy Ring (1920–1979)
Legendary hurler

OPENED
1993

CAPACITY
16,400

PITCH DIMENSIONS
145 x 86 m

COVERED ACCOMMODATION
Yes

FLOODLIGHTS
Yes

CLUB
No

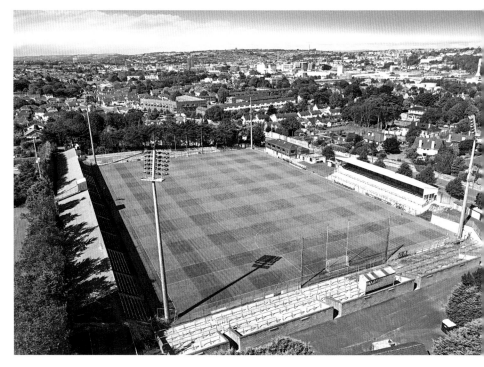

Man United at Flower Lodge, February 1962. When a big freeze in Britain brought sport to a standstill, John Giles and his star-studded club played a friendly against Bolton on an appallingly wet and mucky pitch. Giles' team won 2–0

W. Marsh & Sons, Auctioneers, Cork, were instructed on behalf of the representatives of the late Patrick Hyde to put the property held as two portions at Flower Lodge, Ballintemple, up for auction on 8 October 1947. The 22 acres, with a residence, extensive outhouses and stables, was withdrawn at a bid of £5,000 and subsequently sold privately. In 1952 AOH (Ancient Order of Hibernians) FC purchased 11 acres of Flower Lodge for £5,581. The GAA had also tried to acquire the ground but the soccer club beat them to it.

'The Flower Among Them All' – Cork GAA had to beat off many suitors for the right to develop Páirc Uí Rinn

The club's grounds committee brought the top bands of the day, such as Clipper Carlton and Victor Silvester, to play fundraising dances at Cork City Hall, and launched a football pools which offered a top prize of £350 for an outlay of one shilling. The pitch was laid with a crown type surface, highest along the middle spine and falling towards both sides, and hosted its first competitive game in 1957 between AOH and Sligo Rovers in the FAI Cup.

KEY DATES

1957
3,000 spectators watch AOH lose 1–0 to Sligo Rovers at the Lodge's unofficial opening

1971
The ground hosts a European Cup tie between Cork Hibs and Borussia Mönchengladbach

1979
Cork hurling legend Christy Ring collapses on a Cork street and passes away on 2 March

1988
The AOH accepts the GAA's bid of £260,000 for the ground in November

CHRISTY RING

Christy Ring was born in Kilboy, near Cloyne, Co. Cork. After finishing primary school he did an apprenticeship as a mechanic and later worked as a delivery driver with Shell Oil. He won an All-Ireland minor medal in 1938 and made his senior debut the following year. From then until his retirement in 1967 'Ringy' became one of the most honour-laden players in hurling history.

Let no one say the best hurlers belong to the past. They are with us now, and better yet to come'

– Christy Ring

Among his many awards, he won eight All-Ireland SHC titles, captaining the team to three of those, and three NHL titles. He achieved a record 18 Railway Cup medals with Munster. He also won 14 county hurling titles with Glen Rovers and captained his club to their first ever Munster club championship title in 1964.

'It was never my ambition to play the game for the sake of winning All-Ireland medals or breaking records,' Christy insisted, 'but to perfect the art as well as possible.'

SOCCER BLOOMS, THEN WILTS AT THE LODGE

A number of Cork soccer clubs used Flower Lodge but it became most associated with Cork Hibernians after they transferred to the ground in 1962. Ten years later they drew a full 26,000 to the stadium, while the Lodge also hosted many of soccer's greats – George Best, Denis Law, Johnny Giles, Kenny Dalglish and Liam Brady among them. The Republic of Ireland played a friendly against Spain there in 1985, but by then Cork Hibs had been wound up and Flower Lodge was suffering drastically falling attendances.

A NICE BIT OF BUSINESS

In September 1988 the AOH put Flower Lodge up for sale. Cork GAA lodged two secret bids within a month, using different firms of solicitors to ensure the vendors were unaware of their identity. The GAA feared that the AOH might not want to sell the park to a rival association.

Cork City FC was also interested, though they faced difficulties raising the capital. The GAA, however, had cash in hand from two concerts Michael Jackson had played in Páirc Uí Chaoimh that August bank holiday.

It wasn't obvious to the owners that it was just one entity making both offers for the ground, or even who they were, and in the event they accepted the GAA's bid. Once the purchase was secured and just before announcing it publicly, Páirc Uí Chaoimh groundsman Tommy Lynch was sent to inform an astonished AOH that the GAA were the new owners of Flower Lodge.

'It was undoubtedly one of the best pieces of business we have done,' Cork GAA's then secretary Frank Murphy said some years later.

NEW LEASE OF LIFE FOR HISTORIC VENUE

Páirc Uí Rinn was opened by GAA President Peter Quinn on 23 May 1993. The old terraces, pavilion and dressing rooms had been demolished, the pitch resized for Gaelic games, and a new 3,600-seat stand constructed at a total cost of £1–1.25m.

Páirc Uí Rinn became the venue for NHL, NFL and Cork championship fixtures. It was refurbished in 2015 to bring it up to senior championship standard, and with expanded stands, two terraces and a wheelchair area continues to serve as Cork GAA's second home.

1993
Páirc Uí Rinn opens with Cork taking on Kilkenny in hurling and Meath in football

2003
Cork play Kerry in the NFL in the first competitive inter-county match under lights

2015
Covered stand is improved with an additional 1,500 seats taken from Páirc Uí Chaoimh

2022
Park hosts Cork vs Kerry Munster SFC semi-final clash despite reservations about venue's suitability

Fitzgerald Park

LOCATION
Colmcille Street, Fermoy

NAMED AFTER
Mick Fitzgerald (1881–1920)
Irish Volunteer, hurler

OPENED
1934

CAPACITY
3,500

PITCH DIMENSIONS
142 x 91 m

COVERED ACCOMMODATION
Yes

FLOODLIGHTS
Yes

CLUB
Fermoy

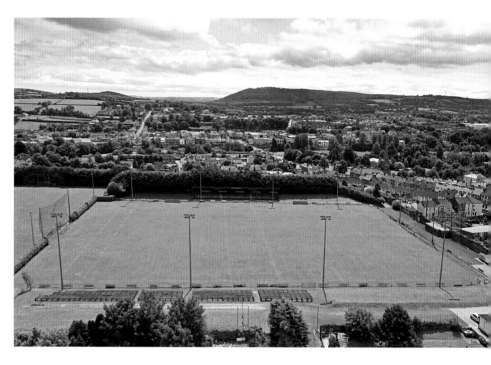

Adopted by Fermoy, Ballingeary native Andy Scannell was a Cork senior football team selector and a senior member of Cork County Board and the Munster Council. He is one of the select few GAA executives to have a cup named after him. It is presented to the winning captain of the Cork senior football champions.

The British Army's presence in Fermoy, from the early 19th century until independence in 1922, was marked by the military barracks straddling Barrack's Hill. Today's GAA ground sits on the site of the former barrack square.

Fermoy GAA have embarked on a multi-phased redevelopment of Fitzgerald Park in order to keep up with the demands placed on the club by a fast-growing urban area

The park's ornamental gate was part of the original barrack wall and is one of the few remaining remnants of the military's time in the town.

While Clondulane village on the outskirts of Fermoy was the hub of Gaelic games in the early years, due to the employment at the flour mills located there, Fermoy GAA Club was founded in the National League Rooms in 1886 and played at Downey's Field on the old Dublin Road (where St Joseph's Square now stands). They also played in Carrigabrick and on Rice's land in Strawhall.

The first championship match ever held in Fermoy was the 1892 Munster SFC final between Kerry and Waterford. Set for 4 December, Kerry won by 11 points to nil in a game played out in a heavy snow.

KEY DATES

1887
Club chairman William Troy elected one of the first vice-presidents of the GAA

1895
Fermoy wins its first Cork SFC title and goes on to win three in a row between1898 and 1900

1934
New ground hosts the National Athletics Championships on 1 July

1969
GAA secure full freehold title to Fitzgerald Park on 24 October

MICHAEL FITZGERALD

Born in Ballyoran near Fermoy, where his father, Edmond, worked as a gardener on the local Briscoe estate, Mick worked at a variety of jobs locally after finishing school and played hurling with Fermoy. He joined the Volunteers after the 1916 Rising and was appointed OC of the Fermoy Battalion of Cork No. 2 Brigade in January 1919.

Fitzgerald took part in several IRA actions and was charged along with others for the killing of a British soldier on 7 September 1919. On 11 August 1920 Fitzgerald and other republican prisoners in Cork Gaol began a hunger strike in protest at their continued detention without having been brought to trial. He died after 67 days on hunger strike, the first IRA volunteer to do so during the War of Independence.

Blessed are the just who suffer for justice sake.

Sacred Heart of Jesus. Have mercy on him.

In Affectionate Remembrance of
Michael Fitzgerald
Commandant 1st Batt.
Cork No. 2 Brigade, I.R.A.
Who gave his life for Ireland at the hands of the British Government in
CORK JAIL on OCT. 17th, 1920.
AGED 38 YEARS.

As a true Soldier of Irish Liberty his love for Erin was the passion of his life ; his brightest day-dream was to fight for her.

PAT JOYCE

ATHLETIC GROUNDS WASH-OUT

The Fermoy club moved to a field at Barnane known as the Athletic Grounds around the turn of the last century. Sited beside the River Blackwater it had its own purpose-built stand and was the venue for many Munster championship and Cork county championship matches from 1906 to 1916, when a huge flood that November swept away stand, goalposts and equipment and forced the club to return to Strawhall.

FERMOY SPORTSGROUND

When the British left Fermoy in 1922 the barracks were burned to the ground. The Minister for Finance leased part of the site to the Fermoy Sports Company Ltd on 7 March 1933 for a period of 99 years at an annual rent of £20. The company, supported by private individuals and local business people, who contributed £2,000 to the venture, developed the 16 acres and 3 roods into a venue suitable for field games and athletics. The new park, called the Fermoy Sportsground, was surrounded by a cycling and athletics track, and was opened officially on 6 May 1934 by Ard Rúnaí Pádraig Ó Caoimh.

NEW LEASE, NEW NAME

In March 1945 ownership of the ground was transferred from Fermoy Sports Company to the Munster Council, Cork County Board and Fermoy GAA Club on a 99-year lease for £1,000. The ground was officially reopened in front of 3,500 spectators on 29 March by Munster Council chairman Canon Hamilton and dedicated to the memory of Mick Fitzgerald.

CONSTANT IMPROVEMENTS

In the 1970 and '80s a clubhouse, dressing rooms and squash court were built. The main pitch was realigned to facilitate a new training pitch. The playing area on the main pitch was re-fenced, seated accommodation extended, and players' dugouts and a new scoreboard installed.

Work started on a second set of dressing rooms in 1994 and the following year on a cantilevered spectator stand with a capacity of 1,500, which opened on 19 April 1998. 2007 brought two gymnasiums and upgraded dressing rooms.

The stand was demolished in 2022 to make room for a new all-weather pitch, to be completed in 2023. This will be followed by a new dressing-room complex, overhead area and spectator stand on the pitch and putt side of the ground, due to open in 2024.

1970s
Club develops a pitch and putt course on west side of the pitch

1977
New clubhouse is built; expanded in 1979

2010
Postponed for a month due to heavy fog, floodlights finally switched on on 6 March

2022
Fermoy honours Mick Fitzgerald's memory by incorporating his image on their jerseys

Mallow

LOCATION
Carrigoon, Mallow

OPENED
2008

CAPACITY
8,000

PITCH DIMENSIONS
145 x 88 m

COVERED ACCOMMODATION
Yes

FLOODLIGHTS
Yes

CLUB
Mallow

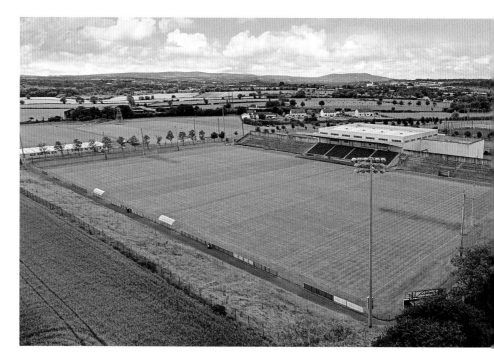

Willie Clancy with two and Fergal McCormack with one are the only Mallow players with All-Ireland senior hurling medals to go with their NHL and Munster medals. Since the club's move to Carrigoon progress on the pitch has been steady, bringing success in hurling and football at underage level.

The Rakes Hurling Club, whose name was no doubt linked to the well-known tune of the 1740s, *The Rakes of Mallow*, was founded in December 1887, and with Edward Hyde and Con O'Donovan as its first officers affiliated to the GAA the following February. Mallow Football Club was founded that month, too, and shortly after that both clubs joined together as Mallow GAA Club.

Mallow GAA have come a long way from their days in the Long Meadow to their purpose-built complex at Carrigoon whose facilities few clubs can match

Matches were played in the Big Meadow, Racecourse Inch at Firville, the Goalfield at Ballyellis and fields at Oliver's Cross and Carhookeal, all outside the town. The first playing ground in Mallow itself was in the Town Park, also known as the Long Meadow, on the banks of the Blackwater. The GAA and other sports clubs were granted a 35-year lease on the land in 1895 at a cost of £75 per annum. The Long Meadow was a popular venue as the Great Southern and Western Railway connected Mallow with other towns and cities and made it easy for spectators to travel.

KEY DATES

1889
Munster SFC and SHC semi-finals and the SFC final played in the Long Meadow

1928
Mallow senior hurlers make their only appearance in a Cork SHC final

1937
Mallow club withdraws from GAA activities but cordial relations are restored with the county board the following year

1955
Monsignor Sheedy PP, and Andy Scannell, Chairman Cork County Board, open the new Mallow club pitch in the Town Park on 1 May

A LONG TIME IN THE MEADOW

Local business and sports groups came together to form the Mallow Town Park Company Ltd, which was granted a 99-year lease on the park from 16 December 1907 at an annual rent of £70. The committee closed off the pitch with galvanised sheets in 1916, but disaster struck the following year when all the sheeting was swept away in a flood.

Other sports such as soccer and rugby were played on separate pitches in the park. However, it transpired that Mallow GAA Club had general permission from Mallow UDC to use the venue while the soccer and rugby clubs were obliged to apply for permission any time they wished to play there. A dispute broke out about this between the soccer and rugby clubs and the UDC in 1952. The upshot was that in July 1953 the council agreed to sublease eight acres of the park to Mallow GAA Club, who enclosed the pitch and built grand entrance gates which are still there today.

The new pitch was formally opened on 1 May 1955 and named Bishop Casey Park in memory of the Bishop of Ross, who was much involved in a very successful period for the Mallow club between 1918 and 1934.

FROM BISHOP CASEY PARK TO CARHOOKEAL

Mallow GAA Club continued to play at Bishop Casey Park for over 30 years, but though dressing rooms were built very little infrastructural development was carried out. In 1985 the Mallow club decided to find a ground of their own. A development committee chaired by John O'Connell identified a suitable site at Carhookeal House on the Old Cork Road in 1986 and the following year paid £145,000 for the premises and 20 acres of land. The Georgian country house was developed into a clubhouse and was opened on 14 July 1988 by Cork County Board Chairman Denis Conroy. Over £500,000 was spent on the new ground and its facilities, which were officially opened on 8 June 1991.

SETTLING IN CARRIGOON

The club moved again in 2005. Following a land swap with local property developer John Barry of Castlelands Construction, they secured 35 acres at a greenfield site in Carrigoon in the north-eastern part of the town. Castlelands developed a new complex there incorporating a function room with catering and bar facilities topped off with excellent playing pitches.

Mallow's superb sports complex is a major sporting, recreational and social centre for north Cork and further afield

When they reviewed the financing of the whole development, the club found that there was a deficit of €8m in their budget. However, this shortfall was gifted to them by John Barry.

The new complex was opened by GAA President Nickey Brennan on 11 May 2008. It includes four full-length pitches (two floodlit), indoor and outdoor all-weather synthetic pitches, a 2,000-seat stand, terracing for 5,000 people, ten dressing rooms, two hurling alleys, steam rooms, a medical room and a gymnasium, together with a mile-long, fully-lit perimeter walkway. Since its opening, the grounds have hosted many inter-county and colleges matches, and it has also been the venue for concerts and science exhibitions.

1988	2008	2017	2019
Club moves to new ground at Carhookeal, formerly owned by the Williamson family	*New complex at Carrigoon pioneers ecology with use of geothermal and solar energy*	*Mallow intermediate footballers win the first county title played in the new Páirc Uí Chaoimh*	*Mallow wins the County Division 2 football league title, defeating Castlehaven by 2–16 to 0–16*

Cusack Park

LOCATION
Francis Street, Ennis

NAMED AFTER
Michael Cusack (1847–1906)
Teacher, journalist,
GAA founder

OPENED
1936

CAPACITY
18,800

PITCH DIMENSIONS
146 x 88m

COVERED ACCOMMODATION
Yes

FLOODLIGHTS
No

CLUB
No

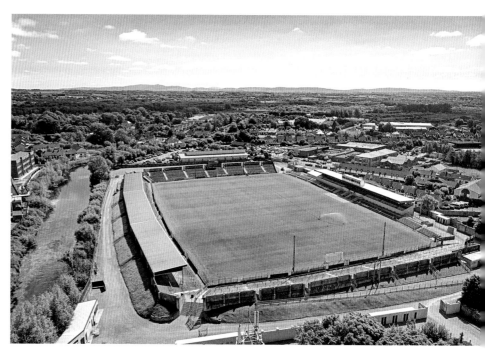

CROKE PARK ARCHIVES

GAA President and Laois All-Ireland winning hurler Bob O'Keeffe cut the ribbon on opening day. A legendary figure who liked to hurl in his socks, the Leinster SHC trophy is named in his honour

During the GAA's jubilee celebrations in 1934 Clare County Board decided to acquire their first headquarters in the county. The site they chose, however, would prove problematic for years.

After decades of combatting the River Fergus flood waters, the issue was finally resolved through clever engineering

The Abbey Field, which sat in a low-lying position adjacent to the River Fergus, was originally used as a municipal dump. Nonetheless the Dalcassians GAA Club, Clare County Board, Munster Council and Central Council leased it from sisters Brigid and Lillie Howard in November 1934 and set about transforming it into a playing field, beginning with extensive drainage. More than 2,000 lorry loads of cinders were then spread across the playing area. Levelling the pitch and building an embankment was done by volunteers, aided by a grant of £100 from the Board of Works to repair the riverbank, a grant of £200 from Central Council and a loan of £300 from Munster Council. Another £100 came from America. Some 6,000 spectators crowded into the ground for its official opening by GAA President Bob O'Keeffe in May 1936.

KEY DATES

1900s
Ennis Showgrounds used as Clare GAA's home ground

1934
County board chairman Canon Michael Hamilton secures a lease on Abbey Field for £300 including rent

1936
Clare play Cork in Munster senior and minor football championships and Clare plays Kilkenny in hurling challenge at opening of Cusack Park on 24 May

1946
Sideline seating, new turnstiles, gates and a boundary wall strengthen the facility

MICHAEL CUSACK

Michael Cusack was born in 1847 in Carron, Co. Clare. He grew up on the eastern edge of the Burren in a small cottage with his parents, sister and four brothers. Cusack was a fine athlete, and after attending Trinity College established his own academy where students were encouraged to take part in rugby, cricket, rowing and weight-throwing. He set up Cusack's Academy Hurling Club, one of the first of its kind in the country, and used his growing profile as a journalist to campaign for a new body to organise and govern athletics in Ireland. To that end Cusack convened the first meeting of the 'Gaelic Athletic Association for the Preservation and Cultivation of National Pastimes' on 1 November 1884, a date that marks a turning point in the history of Irish sport.

An impressive 2.4m-high statue of Cusack stands at the entrance to the ground. Fittingly for a man from the Burren, it is carved from limestone

WHEN THE NEIGHBOURS POPPED OVER

The GAA sold a small parcel of land beside Cusack Park to garage owner Thomas Shiels for £50 in 1944, with a condition that he build a six-foot wall to separate his section from the park. Mr Sheils did that but then back-filled his side almost level with the top of the wall so that spectators could in fact stand on Sheils' property to watch a match, or simply drop over the wall and into the ground.

BACK FROM THE BRINK

The playing surface fell into disrepair throughout the 1950s and '60s and by the 1970s it was obvious that a reconstruction job was necessary. Deciding that the soil in Cusack Park did not lend itself to further development, negotiations were set in train with the diocesan clerical authorities to buy land at Clareabbey owned by St Flannan's College as the site of a new county headquarters. Several other sites in and around Ennis were also inspected but none of these options proved to be successful.

In 1977 the county board finally decided to develop Cusack Park and install a sand-based Prunty pitch. When the work, which also included roofing the north terrace, was completed the ground was reopened on 29 June 1980 by President of Ireland Patrick J. Hillery himself a proud Clare man.

Born in Miltown Malbay, Patrick J. Hillery served as president between 1976–1990

DRAINING AND DEVELOPING

The River Fergus, flowing alongside the entire length of the northern side of the ground, made flooding a persistent problem for many years. A major re-drainage programme was instituted in 1998 when a chamber was built to hold the water and pump it back into the river.

A health and safety audit in 2011 saw the capacity of the ground reduced to less than 15,000. In 2014 Clare County Board purchased 1.8 acres of land known as the Cloister site adjacent to the western end of the ground for €550,000. It was an integral part of plans to develop the park. The existing seated stand was replaced in 2015, new changing rooms and public toilets built and media facilities upgraded. The next phase, aimed at achieving an approximate capacity of 20,000, will see the commencement of work on the western side of the ground, including the upgrading of the car park. In 2021 Clare GAA applied to make the Cloister car park a commercial facility, potentially a vital source of revenue for the county board.

1975
Debenture loan scheme and assistance from Munster and Central councils help fund renovations

1986
Clare County Board acquires absolute ownership of the ground in March

1997
Cusack Park hosts its first NHL final, in which Limerick beat Galway on the unusually late date of 5 October

2016
Cusack Park hosts the All-Ireland U21 Football Championship final, Mayo scoring five goals to beat Cork

Hennessy Park

LOCATION
Flag Road, Miltown Malbay

NAMED AFTER
Patrick Hennessy (1889–1920)
Farmer, footballer

OPENED
1925

CAPACITY
4,500

PITCH DIMENSIONS
145 x 90m

COVERED ACCOMMODATION
Yes

FLOODLIGHTS
Yes

CLUB
St Joseph's Miltown Malbay

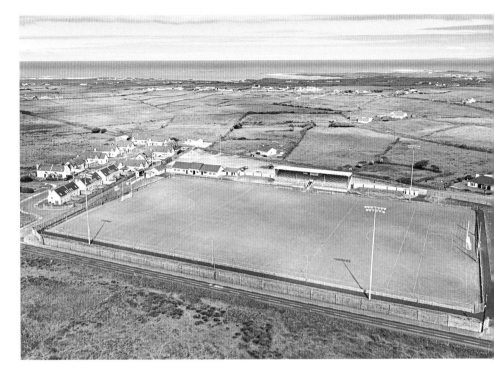

St Joseph's Miltown Malbay is one of the traditional powers of Clare Gaelic football having won 15 senior titles, their most recent coming in 2019. The club, often referred to simply as 'The Town,' has teams in both male and female competitions across all age groups.

In 1924 St Joseph's Miltown Malbay approached Ellen McMahon, owner of two fields on the Spanish Point road, hoping to find a ground for their club. The district nurse agreed to lease the

Hennessy Memorial Park, one of the largest fields in the country, is blessed with an excellent playing surface no matter the weather

land to them at an annual rent of £15 for a period of 150 years, though she retained the right to graze sheep there 'so long as the premises are not required by the lessees for the purpose for which they hold the same.' Ellen and her husband Michael Hillery had a one-year-old son, Patrick, at the time. He would later become President of Ireland and a patron of the GAA.

A concert in the parochial hall helped raise funds to carry out work at the new ground, which was initially named the Miltown Malbay Athletic Grounds. It hosted its first inter-county games on 14 June 1925, when Clare beat Waterford twice on the same day – in the Munster JHC and again in the Munster SFC.

KEY DATES

1887
Lord Clare's GAA Club, which eventually becomes St Joseph's, founded in Miltown Malbay

1902
Miltown are awarded the Clare SFC title after an objection but go on to win the 1906 title on the field of play

1947
Major fundraising campaign initiated with generous support from Miltown exiles in New York

1968
Ground hosts the 1968 Munster JFC final, when Kerry defeat Clare by 3–11 to 2–6

PATRICK HENNESSY

The youngest child of Anthony and Mary Hennessy, farmers with a smallholding just outside Miltown, Patrick played with Clare from 1910 until 1919. Winning their first Munster football title in 1917, he played in the county's one and only All-Ireland SFC final that December, though they lost to Wexford. However, he won a Clare SFC medal for the 1916 championship, played in April 1917.

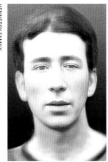

Patrick Hennessy's killing meant his young widow Brigid was left to raise their sons, Joseph (standing), Michael and Paddy

HENNESSY FAMILY

police and military fired on a crowd celebrating the release of IRA hunger strikers from Kilmainham jail in April 1920. Three men were killed, including Patrick. The inquest returned a verdict of wilful murder but no action was taken.

Brigid gave birth to their son, Paddy, a few weeks later. Paddy became a noted referee and the first chairman of the Clare Football Board, while his brothers Joseph and Michael went on to represent Clare in football. His son, Michael, and grandson Peter continued the Hennessy tradition of playing for their club and county.

Patrick married Brigid Blake, an excellent singer and musician who ran her father's pub in Miltown. Brigid was expecting their third child when

IMPROVEMENTS THROUGH THE DECADES

The pitch was levelled, sideline seating installed, banking raised, and a wall built around the ground in 1947 and it was renamed Hennessy Memorial Park on 20 May 1951. Between 1949 and '59 three leases were signed between the Hillery family and the GAA. The final lease was purchased by local victualler Thomas Hynes from Michael Hillery's son Desmond in the late 1950s. In 1989 the club reached an agreement with Thomas's son Michael to buy the freehold of the ground for €15,250, which paved the way for major redevelopment in the 1990s.

A new pitch was laid in 1993 and floodlighting and an electronic scoreboard were also erected, along with four large dressing rooms replacing those built in the '70s. Most of the work was carried out by local FÁS workers and club members' voluntary labour. Sand from Doonbeg strand spread on the pitch in 1998 made Miltown's playing surface one of the best in Clare and it hosted both inter-county matches and Clare county finals.

SALTY FACES AT SPANISH POINT

The park may have had an excellent surface for the players but their supporters had no place to shelter when wind and rain came in from the Atlantic. The club decided in 2007 to build a stand at an estimated cost of €120,000 and formed a committee to raise money. A €25,000 grant from Clare County Board and funding from the Munster Council aided the development, and the club also raised €10,000 from a 10k 'Salty Faces' run at windswept Spanish Point. Voluntary labour again saved the club many thousands of euros.

The new 1,200-seater stand, which housed a press box and four dressing rooms, opened in 2011. Later that year the county board confirmed that Hennessy Park continued to be a secondary county ground – a status that had been put in doubt – and next in line to Cusack Park as a venue for inter-county football games.

1989
Michael Mahony, John Reidy and John Coyne negotiate purchase of the ground's freehold

1998
Former Munster Council chairman Noel Walsh opens the redeveloped park on 8 November

1999
St Joseph's Doora Barefield defeat Sixmilebridge in the only Clare club SHC final played in Miltown

2015
Dublin defeat Clare in a football match to mark the switching-on of upgraded floodlights

Dr Daly Park

LOCATION
Knockadoon, Tulla

NAMED AFTER
Dr Tommy Daly (1894–1936)
GP, hurler, referee

OPENED
1941

CAPACITY
4,000

PITCH DIMENSIONS
147 x 85 m

COVERED ACCOMMODATION
Yes

FLOODLIGHTS
Yes

CLUB
Tulla

Tulla GAA Club is the oldest club in Clare and has captured the county senior hurling title on 11 occasions, most recently in 2007. Many fine players have swapped 'the claret and gold' for 'the saffron and blue' of Clare including, in more recent times, the Quinn brothers, Andrew and Brian, and David McInerney.

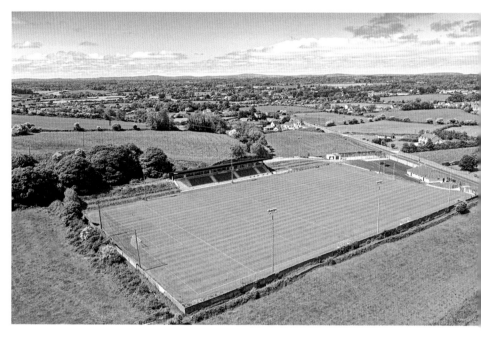

The splendid new sports pavilion and viewing stand at Dr Daly Park has provided a great boost to the club and wider community

Tulla is synonymous with two stalwarts of Irish culture, the Tulla Céilí Band and Tulla GAA Club. Founded under the name of Robert Emmet's in 1887, the following year the club defeated Feakle to win one of the oldest prizes in GAA – the Carrahan Flag. They won the Clare SHC in 1889 and went on to represent Clare in the second ever All-Ireland hurling final that November, against Kickhams of Dublin, a match the men from Tulla played in their bare feet.

The club played at O'Gorman's Field in Knockadoon, which they eventually bought in 1938. A park committee led by chairman Michael Meaney and honorary secretary Jim Liddy set up fundraising groups in Dublin, Limerick, Nenagh and New York which, together with an appeal from Rev. Murphy of St Flannan's College, raised enough to develop the ground at a cost of £1,289. 3s. 0d. Limerick's Ahane and Éire Óg from Kilkenny played at the opening in May 1941, when the hill at the side of the pitch offered excellent viewing for spectators.

KEY DATES

1885
GAA holds an athletics meeting in Tulla on 1 February aimed at reviving Irish sports

1897
Tulla GAA Club wins the prestigious Croke Cup representing Clare

1938
Club buys O'Gorman's Field of over five acres for £300 plus £62 in annuities

1941
GAA President Pádraig McNamee opens the Dr Tommy Daly Memorial Park on 18 May

DR TOMMY DALY

Tommy Daly was born in Tulla, where his father, John, farmed and kept a hardware shop. An All-Ireland junior medal winner with Clare in 1914, Tommy went on to become one of the great goalkeepers of his era. He won six Fitzgibbon Cup medals with UCD, where he studied medicine. He could not play for Clare due to the non-residence rule at the time, so he lined out with Dublin, with whom he won four All-Ireland hurling titles in 1917, 1920, '24 and '27. He returned to Clare in 1930 and finally made his senior debut for his native county at the age of 36. He helped Tulla to win the Clare senior title in 1933.

After his retirement he became a noted referee and took charge of the 1935 All-Ireland final between Kilkenny and Limerick. Dr Daly died tragically in a car accident near Tuamgraney in 1936 at the age of 42.

WILLS'S CIGARETTES.

DR. T. DALY, (DUBLIN).

CROKE PARK ARCHIVES

After graduation Daly practised as a doctor in London but regularly travelled back to Ireland for matches. A recognised star of the game, he was one of 50 hurlers featured on a Wills cigarette card collection produced in the 1920s

LAMENT FOR TOMMY DALY

*No more shall limewhite goalposts
Soar tapering and tall
Above the greatest goalman
That ever clutched a ball.
Nor yet he'll rouse the echoes
Of ash in native air,
Nor heed the throbbing thousands
Tense with pride of Clare.*

– Bryan MacMahon

HURLING'S HEYDAY

No significant development was carried out for over 35 years after the pitch opened. Even so, in 1975 Tulla was presented with the Denis Moran plaque for the best-kept hurling ground in the county.

New dressing rooms, showers and public toilets costing over £8,000 were built in 1977. Twelve people each loaned the club £200 to assist with these developments and all were repaid in full. The following year the club sought help from Munster Council to carry out work on the hillside embankment; five rows of terracing were cut into the slope, making it safer and more comfortable for spectators.

In the 1970s Dr Daly Park became a fortress for Clare hurlers – they won 15 NHL games in a row at the venue, which included defeating Kilkenny five times, Galway three times and Tipperary twice. The successful run came to an end on 27 November 1977 when Clare were beaten by Wexford. The last league match played in Tulla was on 24 February 1980, when Clare overcame Limerick by 1–11 to 1–7.

A MATCH FOR SEMPLE STADIUM

Heavy flooding caused the pitch to deteriorate in the late 1990s and in the end the club decided to install a sand-based surface. The ground was re-laid in 2002–03 at a cost of € 100,000, and considerably improved by lengthening and widening it to the dimensions of Semple Stadium in Thurles. € 200,000 in National Lottery funds aided the project and helped build new dressing rooms.

In 2009 the club embarked on an ambitious plan to upgrade the ground, but though floodlights were erected most other facilities had to wait due to the downturn in the economy. The plans were revived ten years later and in 2022 the club completed construction on its new covered stand, with an internal viewing area for 200 people. The innovative design incorporated a gym, medical treatment room, changing rooms, commentary box, kitchen and meeting rooms. The construction was piloted by Mark Quinn, whose family's association with the club goes back to its very foundation.

1983
John Joe Doyle retires as secretary of the park committee after more than 34-years' service

2004
The park reopens in March following extensive refurbishment

2008
A hurling wall is erected on the site of the old dressing rooms

2022
Modern new facilities enhance Tulla's standing among Clare grounds

Fitzgerald Stadium

LOCATION
Upper Lewis Road, Killarney

NAMED AFTER
Dick Fitzgerald (1882–1930)
Footballer, coach, GAA administrator and political activist

OPENED
1936

CAPACITY
38,000

PITCH DIMENSIONS
144 x 83m

COVERED ACCOMMODATION
Eamonn O'Sullivan Stand

FLOODLIGHTS
No

CLUB
No

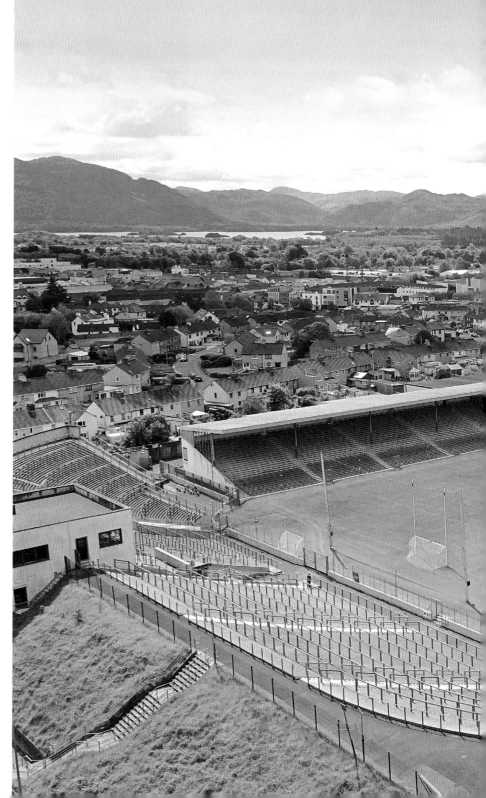

The MacGillycuddy Reeks provide a majestic backdrop to Fitzgerald Stadium, home ground of the Kerry football team. Between 1995 and 2023 the Kingdom racked up an unbeaten run of 39 games, earning the venue the moniker 'Fortress Killarney'

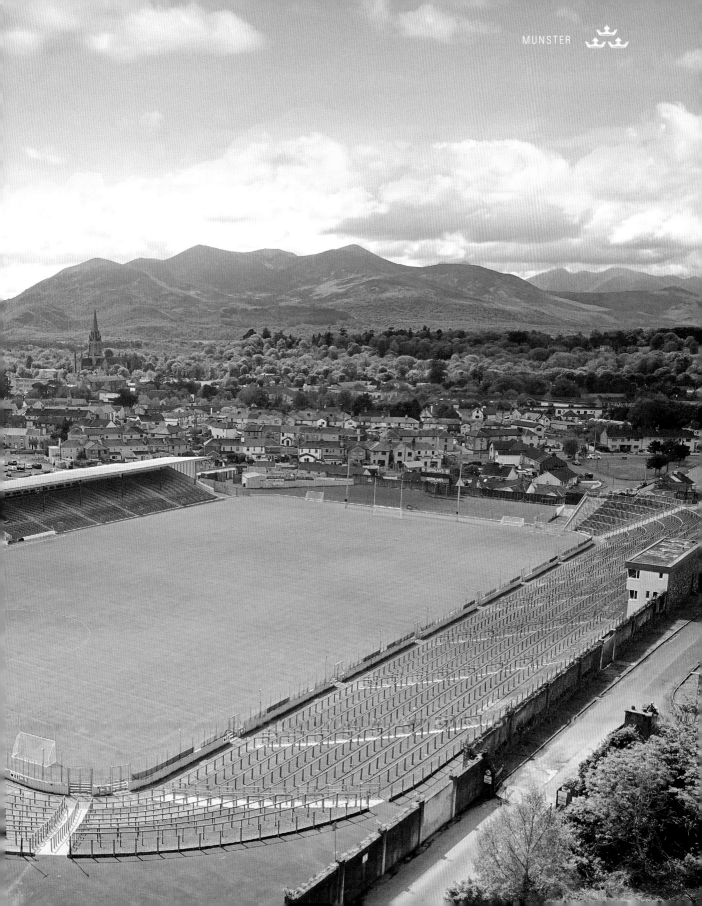

GROUND LAID FOR LOCAL LEGEND

At a general meeting of Dr Croke's Club, Killarney, on 14 November 1930, six weeks after the legendary Kerry footballer Dick Fitzgerald sadly passed away, it was decided to build a football stadium in his honour. Dr Croke's had grown out of the Killarney Gaelic Athletic Association, founded in 1886, and played in a number of places including the Cricket Field, Flesk Bridge, until then.

A site of almost 12 acres was purchased just over a year later. It sloped down from the wall of St Finan's Mental Hospital to the centre of the ground

Dressing rooms were often very basic in the early days, like this one in Fitzgerald Stadium. In the countryside many grounds had none at all, and players togged out on the side of the road or in the shelter of a ditch

CROKE PARK ARCHIVES

some 27 feet below. This incline had to be levelled to form the pitch, and a cinder-banked cycling track was built around it.

The pitch was the largest in the country when it opened on 31 May 1936. Over 20,000 people crowded in to watch Kerry play Mayo in football and Cork take on Tipperary in hurling. All of 43,638 people filled the stadium the following year to see Tipperary beat Kilkenny in the All-Ireland SHC final – the first time since 1909 that the match was played outside of Croke Park.

INNOVATION AND NEW IDEAS

Dr Eamonn O'Sullivan, who would train eight of Kerry's All-Ireland winning teams between 1924 and 1962 and held positions as chairman and president of the Croke's club, sat on the ground development committee alongside Eugene O'Sullivan, John Clifford and others. Dr O'Sullivan was the Resident Medical Superintendent at St Finan's Mental Hospital. Occupational therapy for mental health patients was unheard of at the time, but he believed that they benefited from outdoor work and got permission to allow them to work on the ground. O'Sullivan became an authority on occupational therapy and wrote a textbook based on his experiences working on the stadium. 'It was the very first undertaking of the subsequently developed Occupational Therapy Department of the hospital,' he wrote, 'and could be described as its Magnum Opus.'

LET THE GAMES BEGIN

Garda Síochána Chief Commissioner Eamon (Ned) Broy, President of the National Athletic and Cycling Association and President of the Olympic Council of Ireland, thought the stadium compared favourably with those in Paris, Amsterdam or Berlin. A particular feature of the ground was that the track had a lap of 600 yards rather than the normal 440 yards, which would lend itself to record-breaking. The only thing that needed to be overcome to hold the Olympics in Killarney, he told the *Irish Independent* in 1936, was the question of population, and raising the town to the status of a city.

na Cluichí Oilimpeacha XI
KILLARNEY 1936
29 MEITHEAMH – 22 IÚIL

AGUSTAF HJORTZBERG – WIKIMEDIA COMMONS

What might have been…

1932
Dr Croke's purchase a field from Dan Courtney and an adjoining half acre for a cost of £830

1936
Dr Michael O'Brien, Bishop of Kerry, and Dr John Harty, Archbishop of Cashel, officially open Fitzgerald Stadium

1937
The All-Ireland hurling final played in Killarney yields record receipts – £4,480, or about €326,500 today

1950
The stadium's capacity is severely tested when an estimated 50,000 people turn up for the Munster hurling final between Cork and Tipperary, encroaching on the pitch as the game reaches its climax

DICK FITZGERALD

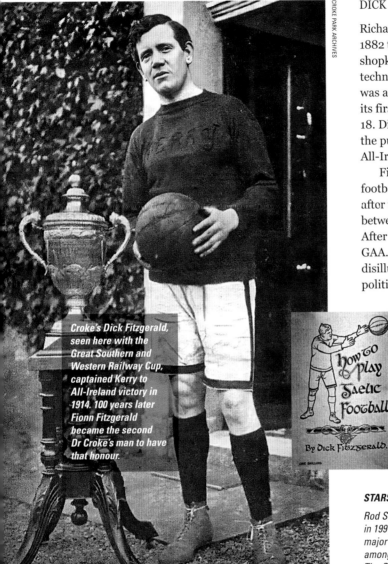

CROKE PARK ARCHIVES

Croke's Dick Fitzgerald, seen here with the Great Southern and Western Railway Cup, captained Kerry to All-Ireland victory in 1914. 100 years later Fionn Fitzgerald became the second Dr Croke's man to have that honour.

Richard (Dick) Fitzgerald was born on 2 October 1882 to Michael and Bridget Fitzgerald, who were shopkeepers in Killarney. His wonderful football technique was apparent even as a teenager, and he was a key player on the Dr Croke's team that won its first ever Kerry SFC in 1901, when he was just 18. Dickeen, as he was familiarly called, caught the public eye when Kerry played Kildare in the All-Ireland final in 1903.

Fitzgerald played in seven All-Ireland senior football finals, winning five. Interned in Frongoch after the 1916 Rising, he refereed a football match between the men, 'The Shirts' versus 'The Waistcoats.' After his release he became an administrator in the GAA. By the late 1920s, however, he had become disillusioned by the Civil War divisions in national politics and saddened by the death of his young wife, Kit, in April 1927. Dick Fitzgerald died following a tragic accident in which he fell from a roof in Killarney on 26 September 1930, two days before Kerry were to meet Monaghan in the All-Ireland football final.

CROKE PARK ARCHIVES

how to play gaelic Football

By Dick Fitzgerald.

ONE SHILLING

KERRY'S FOOTBALL MASTER

Published in 1914, Dick Fitzgerald's How to Play Gaelic Football *was the game's first definitive coaching manual. It laid out the tactical deployment of players on the pitch, as well as their individual roles and the skills needed to fulfil them.*

STARS SHINE IN KILLARNEY

Rod Stewart drew an audience of 25,000 people to the ground in 1991. This bold fundraising initiative led to a who's who of major artists playing in Killarney for most of the next 20 years, among them Status Quo, Westlife, Elton John, David Gray, The Cranberries, Bryan Adams, Simple Minds, The Corrs, Kris Kristofferson, Snow Patrol, Westlife and the Pussycat Dolls.

1976
The erection of the Dr O'Sullivan Stand and pavilion bring the ground's capacity to 39,000

1985
The pitch is re-laid and ongoing development of stand and terraces increases capacity to 50,000

1996
To meet stringent new safety laws, the stadium committee carry out further improvements costing £1.9m

2008–09
A €4.8m facelift includes new terracing, dressing rooms, medical and physiotherapy facilities, and media area

2016
The stadium finance committee launches a new development scheme, the fourth of its kind

Austin Stack Park

LOCATION
John Joe Sheehy Road, Tralee

NAMED AFTER
Austin Stack (1879–1929)
*Irish Volunteer commander,
TD, footballer*

OPENED
1903

CAPACITY
12,000

PITCH DIMENSIONS
144 x 90m

COVERED ACCOMMODATION
Yes

FLOODLIGHTS
Yes

CLUB
No

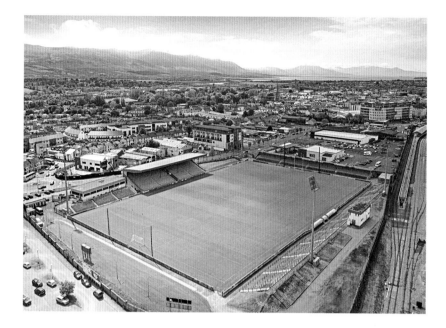

1893 map of Tralee Sports Field – the venue was a hive of activity in the early days before Gaelic games began to dominate. Cricket, athletics, cycling, tennis and clay-pigeon shooting were catered for

TONY O'KEEFFE, TRALEE

Tralee Sports Field, home to the Kerry Amateur Athletic and Cricket Club, was an oval-shaped ground surrounded by a sloping cinder track that was one of the best in the country. But when the GAA, under the name of the National Athletic Club, sought permission to hold a sports meeting there in June 1885 they were turned down. The event went ahead instead at Rathonane Paddock, a large field in the Rock Street area. The Athletic and Cricket Club organised a rival meeting for the same day but it was poorly attended, while 10,000 people turned up at the Paddock.

Fans have always cherished the atmosphere Austin Stack Park creates but never more so than on packed-out nights under lights

Gaelic games were played at the Sports Field eventually and the GAA took over as tenants in 1903. The All-Ireland SFC semi-final between Kerry and Cavan was held there on 23 August 1925. Kerry beat Cavan by a point. A local reporter recorded that after the match some Cavan men released two carrier pigeons bearing the news home that they had been beaten but not disgraced. Later, Cavan and Kerry objected that each fielded an ineligible player, both teams were thrown out, and Connacht champions Galway were awarded the All-Ireland title.

KEY DATES

1887
The Gaelic Athletic Championship, under GAA and Irish Cyclists Association rules, is held at the Sports Field

1903
The GAA pays the £120 rent due on the Sports Field and take over as tenants

1907
Kerry defeats Limerick as Tralee hosts its first Munster SFC final, the 1905 decider

1932
Kerry outplay United Irish Universities as Austin Stack Memorial Stand is unveiled on 1 May

AUSTIN STACK

Tralee man Austin Stack and Thomas F. O'Sullivan, Listowel, were instrumental in reorganising the GAA in Kerry in the early 1900s. Stack recognised that if Kerry was to compete for All-Ireland honours the principle of having the county champions represent the county had to change. Though his own club, the Mitchels, dominated the game locally from 1902–10, he persuaded the club to look beyond its own members and select the very best players in Kerry. He also organised training camps and challenge games for players in contention for the county team. He himself captained Kerry to All-Ireland victory in 1904.

Stack, Commandant of the Kerry Brigade of the Irish Volunteers in 1916, was a Sinn Féin TD from 1918 to 1927 and served in the First Dáil. He died aged 49 in large part because his health had suffered as a result of many periods of imprisonment.

SQUARING THE CIRCLE

Kerry County Board purchased the ground outright in 1929. Kerry footballers set off for the USA to help raise funds, with matches in Yankee Stadium, New York, and Comiskey Park, Chicago. In 1932 the Sports Field became Austin Stack Park. The oval ground was converted to a rectangular shape in order to host the All-Ireland semi-final between Kerry and Dublin in 1934 and the athletics and cycling track was taken out and a small stand built to replace the old wooden one. Tralee's four GAA clubs willingly provided the

Tralee's Arc de Triomphe – prior to 1974 a splendid arched gate, topped off with a concrete Sam Maguire, greeted patrons. The structure, built in 1944, was lost to road development but the Sam is safely in storage awaiting installation in a new place of prominence

manpower to work on the embankments surrounding the pitch.

Austin Stack Park continued to develop and in January 1965 Kerry County Board nominated it as their principal county ground. A new pavilion, with a large assembly hall for board meetings, was opened in 1967. Galway's footballers spoiled the celebrations, though, when they trashed Kerry 4–16 to 1–11 on the day.

NEW STAND AND SECOND-HAND SEATS

During the early 1990s more than €1m was spent on developing the stadium. The pitch was lengthened, widened and resurfaced, seats taken from the demolished Cusack Stand in Croke Park were installed on the terrace, and a new stand replaced the one built in the 1930s.

STAYING PUT

In 2005 Kerry County Board announced an ambitious plan to relocate to the Ballybeggan Racecourse site on the edge of Tralee. A new stadium was to be constructed there while training pitches would be located in the nearby village of Currans. Austin Stack Park would in effect be swopped for this development.

However, in 2009 these plans were put on hold due to the financial crisis and eventually abandoned. Instead, in 2016 a programme of renovation costing over €1m began as part of a long-term plan to upgrade the venue. Tralee's business community raised €250,000 in support of the venture in just two days. They came together again in 2021 with a promise to raise €141,000 over four years towards funding the third phase of development, terracing the Horan's end to match the covered terrace erected at the Mitchels end in 2019.

1983
Park hosts the James Last Orchestra as part of the Rose of Tralee festival

1983
Kerry defeat London at Austin Stack Park to win the All-Ireland 'B' Hurling Championship

1994
GAA President Jack Boothman reopens the refurbished stadium

2001
John Mitchels and Ballymacelligott play out a draw in the first game in Kerry played under floodlights

2019
Terrace at Mitchels end of the ground, nicknamed The Shed, is roofed

LEO WHELAN, HUGH LANE GALLERY

KENNELLY ARCHIVE

Frank Sheehy Park

LOCATION
College Cross, Listowel

NAMED AFTER
Frank Sheehy (1905–1962)
Teacher, footballer, Kerry
County Board chairman

OPENED
1899

CAPACITY
4,000

PITCH DIMENSIONS
142 x 85m

COVERED ACCOMMODATION
Yes

FLOODLIGHTS
Yes

CLUB
Listowel Emmets

*When it was founded in 1956
Listowel Emmets united the
several clubs in the town,
whose history reached back
to 1885. Their ground was
renamed in 1981, the year
Emmets' Tim Kennelly won
his fifth All-Ireland medal.*

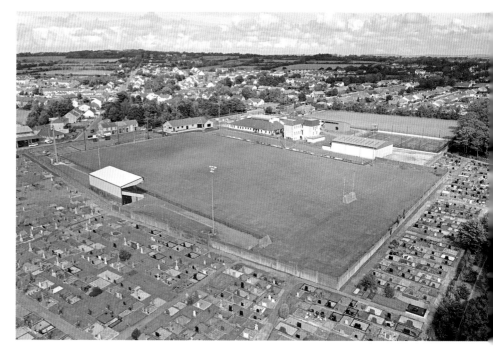

For a ground that eventually became a central part of local life, Listowel sportsfield had a somewhat fractured origin. Listowel's first GAA club, Feale Amateurs, was formed at a meeting on 27 June 1885 in Listowel Town Hall, and after several years playing in local fields finally took root on land granted by the Earl of Listowel to the people of the town. However, the club split in April 1895, when the breakaway Listowel Temperance Society Club (St Patrick's) was founded, though they reunited the following year as Listowel Wild Geese.

No matter how boisterous Frank Sheehy Park gets, its neighbours will always rest in peace

The new club set about procuring a sports field with the support of North Kerry Cycling Club, and together the Listowel Sports Field Committee acquired the Earl's ground in 1899. At a public meeting that February the Listowel football club proposed a motion to protect the GAA's interests in the new ground, which opened with a cinder cycling and running track around the perimeter of the pitch. When a Gymnasium Hall was added in 1902, this fine facility became a social hub in the town of Listowel.

KEY DATES

1885
On 27 June that year, 'We, the people of Listowel, in a public meeting assembled, hereby establish a branch of the GAA'

1898
Local representatives meet Mr D. J. Crosbie, agent of the Earl of Listowel, and secure a sports field for the town, which opens the following year

1925
The playing pitch is enclosed with steel railway stakes from the Lartigue monorail, which had closed the previous year, at a cost of 2/6d (or about 10 cents) each

1937
The popular Gymnasium Hall is closed and the spectator stand has to be demolished

FRANK SHEEHY

Frank Sheehy was born in Charles Street, Listowel, on 17 November 1905 to John and Annie Sheehy. His father served as a draper's assistant in Listowel, and his mother was a native of Co. Tipperary. The youngest of four children, he won a scholarship to UCD, and played on the university team that won the Sigerson Cup and Fitzgibbon Cup in 1927, and the Sigerson Cup again in 1929. He quickly graduated to the Kerry team.

KENNELLY ARCHIVE

A dedicated sports administrator, in the 1930s Frank acted as honorary secretary of the Primary Schoolboys League in Dublin and joint secretary of the Dublin branch of the Fitzgerald Memorial Park, Killarney, project. In 1937 he became secretary of the Kerrymen's Association in Dublin and was active in raising funds to help the county football team.

After returning to Listowel, Frank immersed himself in the local club and county GAA scene and was elected chairman of the Kerry County Board in 1953, a position he served in until 1961. He organised the golden jubilee of the county's first All-Ireland success in 1903 when Kerry defeated Kildare, and was also instrumental in initiating the scheme that allowed Kerry All-Ireland medal holders the right to apply for two tickets whenever the county reached the final. He served as Munster Council president from 1956–58 and was narrowly beaten for the presidency of the GAA by Dr J. J. Stuart in 1958.

In 1961 Frank took on a new challenge, when he took up a position as Professor of Educational Science at a training college in Asaba, Nigeria. He died there on 4 November 1962 aged 57.

SMOOTHING RUFFLED FEATHERS

Two more football clubs emerged in Listowel in the 1930s. Their origins lay in Civil War differences – Listowel Ashe's were Republican, Listowel Pearse's Free State. In a bid to have one united club, with no political affiliations, Blackcock's Feathers was founded on 23 July 1935. Its name came from the celebrated book by Listowel writer Maurice Walsh, one of the bestselling novelists of the time. Blackcock's Feathers morphed into the Maurice McGrath Club in 1941 and then became Listowel GAA Club once more in 1943. The following decade, in 1956, Listowel Emmets was founded, and remains the north Kerry town's club through to today.

MAKING A SPLASH

When the club drafted a redevelopment plan that included a major overhaul of the entire facility in 2001, Emmets' president John B. Keane wrote to the chairman, Stephen Stack.

I am delighted you and your committee have decided to develop Frank Sheehy Park. I remember a sending off during the course of a Listowel Town League final many years ago when I was young and Finn McCool and the Fianna rode through the bogs and hills of North Kerry. The late Vincent Hartnett [it was in fact Darby Broderick] of Greenville jumped on Lofty Kelleher and pinned poor Lofty face down into a pool of water on the twenty-one-yard line by the simple manoeuvre of sitting on him. Vincent was sent off and when he enquired of the referee the exact offence that led to his premature dispatch to the dugout, the referee Bernie Browne replied, 'Attempted drowning, Vincent.'

1956	1979	2001	2008
Listowel Emmets is formed and work starts on refurbishing the ground, which re-opens on 15 May 1960	Major redevelopment brings a new stand and better facilities for players and patrons. The ground is reopened on 24 May 1981 and renamed Páirc Mhic Shíthigh	A fresh overhaul includes the installation of floodlights, club rooms and function rooms. Sheehy Park reopens in May 2004 and is the training ground for the senior team's North Kerry Championship victory that December	The final phase of redevelopment begins in September, as the stand and terraces are upgraded

Gaelic Grounds

LOCATION
Ennis Road, Limerick

OPENED
1928

CAPACITY
44,000

PITCH DIMENSIONS
145 x 85m

COVERED ACCOMMODATION
Mackey Stand

FLOODLIGHTS
Yes

CLUB
No

The Gaelic Grounds (aka Páirc na nGael) is widely admired for its fine playing surface and ability to cater for huge crowds on big match days. With the approach of its 100th anniversary, the county board has ambitious plans for upgrades and renovations

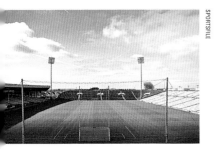

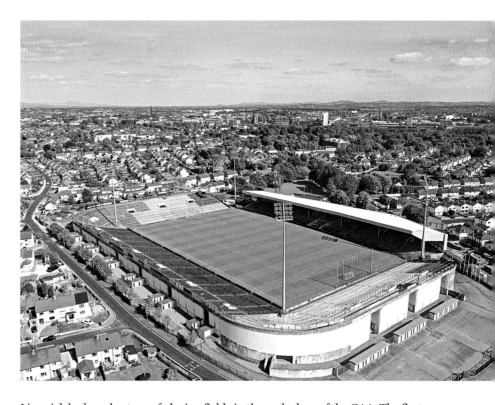

SPORTSFILE

Limerick had no shortage of playing fields in the early days of the GAA. The first recorded hurling match was played on the old Ballinacurra Racecourse, and the inaugural game under GAA rules was between St Michael's and Shamrocks at Rosbrien. The Island Bank, the Fair Green, Brown's Field in Ballyneety and several other places also held games, as did the Grocer's Field, now Lansdowne Park housing estate on the Ennis Road.

Limerick County Board made the Markets Field in Garryowen their permanent base in 1896. The ground was home to Garryowen rugby club, and sharing the pitch meant that the goalposts had to be put up for each match and taken down afterwards. The first inter-county game there saw Commercials of Limerick play Kickhams of Dublin in a football challenge on 20 April 1899. The following year the ground hosted the 1899 Munster hurling and football finals, though the latter was abandoned at half-time due to a dispute over the score.

KEY DATES

1887
The Grocer's Field hosts Limerick's first county finals on 17 July

1927–28
Site of Gaelic Grounds costs £1,209. 9s. £1,083 is spent on developing it

1931
17,324 attend Aonach Kincora, organised by the GAA and the Gaelic League, yielding £1,361. 17s. 6d.

1941
The ground hosts its first Munster SHC final on 26 October between Tipperary and Cork

1957
Munster Council refuses permission for a baseball match between two US army teams

SMALL FARM BECOMES GAELIC GROUND

Supported with a grant of £1,000 from Munster Council, in February 1927 a farm of 12 acres 36 perches at Coolraine on the Ennis Road was bought for development as a GAA ground.

The property was vested in the association through Limerick Gaelic Grounds Ltd, formed in March 1928. The shareholders were the Munster Council with 67.5%, Central Council 20% and Limerick County Board 12.5%. The Gaelic Grounds was one of the first county grounds in the country to be fully owned by the GAA.

The pitch had a pronounced slope and uneven sod, but even so hosted its first games, two junior hurling matches, on 9 September 1928 and its first Munster SHC match on 30 June 1929, when Waterford defeated Limerick 4–4 to 2–4.

RENOVATIONS, REPASTS AND REVENUES

A development committee formed in 1932 spent almost £3,000 on the ground between then and 1935, when the improved stadium became the venue for Munster championship matches at all grades in hurling and football. During the war years progress was hindered by the fact that the county board was usually in debt. The committee sought funding from the Munster Council to build a stand, but though the materials were delivered it was never constructed due to lack of money.

The ground was the only venue in the city for Limerick club games and tournaments and inevitably the pitch deteriorated. Even so Páirc na nGael was hugely popular, and between 1945 and '49 a new embankment and sideline seating for 15,000 spectators brought capacity up to 40,000. When the first round of the Munster SHC between Cork and Tipperary was played there on 29 May 1949, the organising committee went to great pains to ensure that everyone coming to the city for the match was well catered for, publishing a list of establishments and their prices for a four-course lunch, meat tea, plain tea and accommodation. It was an added bonus for local businesses that the game ended in a draw and went to a replay that June.

Limerick GAA also benefited. The 1951 Munster SHC final between Cork and Tipperary attracted a record crowd of 43,236 spectators, who contributed £6,207. 9s. 5d. – almost double the previous best – to the Munster Council. Crowds of up to 50,000 attended games during the '50s, including the 1954 Munster SHC final between Cork and Tipp.

The Gaelic Grounds finally got a covered stand in 1958. It was in fact the Hogan Stand, transported to Limerick from Croke Park. The 1,000-seat stand was opened on 27 April 1958 and a large open stand built alongside raised the general accommodation substantially.

MAJOR INVESTMENTS

The 9,000-seater Mackey Stand replaced the old Hogan Stand in 1988. The stadium was rejuvenated in 2004 with the opening of a new 12,000-seat uncovered stand along with new terraces behind both goals at a cost of €12m. Floodlights costing €1.5m were erected in 2009 and the following year brought two state-of-the art dressing rooms under each terrace. In May 2019 a plan was launched for the Gaelic Grounds to be substantially redeveloped and modernised.

WIKIMEDIA COMMONS

STAND NAMED FOR A STAR

Castleconnell native Mick Mackey (1912–82) was the catalyst in Limerick hurling's golden age of 1933–40, driving his team to three All-Ireland titles, five Munster championships and five national leagues. One of the greats of his era, Mackey is regarded as the first superstar of the game and his swashbuckling style is captured in this 1936 book illustration

CARBERY'S ANNUAL 1936

1961
Record 61,174 attend Munster SHC final – up to 10,000 morepile in without paying

1988
GAA President John Dowling opens the Mackey Stand, named after hurling legend Mick Mackey

2010
Gaelic Grounds hosts International Rules Football first test, in which Australia beat Ireland

2014
Mayo play Kerry in All-Ireland SFC semi-final, the first outside Croke Park in over 30 years

2023
Limerick beat Clare by one point in the Munster SHC final at Gaelic Grounds, to win a fifth consecutive provincial title

Páirc na nGael

LOCATION
Church Street, Askeaton

OPENED
1930

CAPACITY
2,000

PITCH DIMENSIONS
143 x 83 m

COVERED ACCOMMODATION
Yes

FLOODLIGHTS
No

CLUB
Askeaton–Ballysteen

Askeaton–Ballysteen GAA Club can claim four Limerick SFC titles won by its two clubs before amalgamation. Their first county hurling title was the 1935 junior championship. Tony Fitzgerald of Askeaton captained Limerick footballers to a shock win over Cork in 1965, and played for Munster in the Railway Cup.

Before the GAA was founded, men from Askeaton and the nearby village of Ballysteen regularly played games of *abhaile* against each other. Using an oval ball made of animal skins stretched around an inflated bladder, the winner was the team that took the ball to their own church gates. This rivalry between the two villages would be played out, on and off, for many years to come.

Páirc na nGael, long regarded as one of the better sportsfields in the county, has recently completed a major upgrade of its facilities

A GAA club was in existence in Askeaton by 1885 and in 1888 Askeaton Desmonds was fielding two hurling teams. Ballysteen formed a club the same year. Around that time Askeaton Desmonds played Kildimo Sarsfields at O'Shea's Field, Kildimo. Sarsfields took home the match prize of a horse.

When the British government declared in July 1918 that the GAA was 'a dangerous organisation' and decreed that no games could be held without an official permit, Askeaton Desmonds played Ballysteen as the GAA responded by organising matches without permits all over the country at 3pm on Sunday 4 August – Gaelic Sunday.

KEY DATES

1910
Askeaton GAA Sports Day held in The Meadow, owned by Robert Hunt JP

1934
Askeaton and Ballysteen set up ladies' camogie clubs

1938
Askeaton hosts the Limerick SFC finals of 1937 (played in 1938), 1939 and 1941

1949
Parish footballers play under the name of Askeaton for the first time

FROM TENANT TO OWNER

Askeaton and Ballysteen amalgamated in the early 1930s, with Ballysteen generally providing the footballers and Askeaton the hurlers. They played their matches in The Meadow, which was leased by Askeaton GAA Club from the Hunt family.

The 1932 West Limerick SHC final was held at the ground and it was also the venue for an NFL match on 27 November 1938 when Limerick defeated Clare on a waterlogged pitch. During the 1940s and '50s gymkhanas were held at the ground, at this stage known as the Sportsfield, every Easter, badly cutting up the turf.

1949 was a difficult year for hurling in Askeaton when the club proved unable to field a team. It was not until 1952 that hurling was revived when they entered a team in the West Limerick JHC. Six years later the club, under the guidance of Fr Patrick O'Dea, successfully acquired the field which they had being renting for over 25 years. Costing £500, most of this was contributed by locals in the form of loans. The club went from being a tenant to owner without any fanfare or formal opening. Shortly after its acquisition the ground was renamed Páirc na nGael.

BRINGING THE PARK UP TO SCRATCH

The early 1960s saw considerable developments carried out at the park when the pitch was drained, a new embankment was built, sideline seating installed and a new scoreboard erected. A dwelling house at the roadside owned by the club was swapped for land adjacent to the pitch which was subsequently sold to the Department of Education to build a school.

ARGUING THE TOSS

As in any relationship, it hasn't alway been smooth sailing for the Gaels of Askeaton and Ballysteen. The parish neighbours have had periods when they went their separate ways, with cutting words exchanged and sharp saws taken to goalposts. Their last trial separation came to an end in 1987 when Gerry O'Mahony, manager of a large local employer, Southern Chemicals, brokered a new amalgamation at a meeting in Cruise's Hotel in Limerick. The final piece of business, which place appeared first in the club name, was decided with the toss of a coin.

HAND-ME-DOWNS AND MAKING DO

Páirc na nGael hosted its first Munster SFC game on 5 July 1970, when Kerry defeated Limerick. Due to a clash of colours Kerry goalkeeper Johnny Culloty wore a white and blue jersey, which he borrowed from the present author, who was one of the Waterford minor team that had played Kerry in the preceding match.

Also improvising at an NFL match between Limerick and Clare on 1 December 1974 was club chairman Eddie Corbett, who came to the rescue when the scoreboard numbers went missing by repainting the board each time a score was signalled.

KEEPING UP APPEARANCES

Askeaton kept pace with ground developments through the 1970s and '80s. Work began on building a new clubhouse in 1976 and in 1983–88 the club built two new dressing rooms and renovated the two existing ones. They also built ladies' and gents' toilets and players' dugouts, and then rooms for referees.

The club bought land for £650 in May 1990 which gave spectators access around the perimeter of the pitch. They also constructed a stand and completed a boundary wall. Additional land was purchased in 2009 and the east embankment and tunnel from the dressing rooms were demolished.

In November 2019 the Askeaton–Ballysteen club received a Sports Capital grant of €92,212 to assist their strategic development plan, which came to fruition in May 2022 when new dugouts and scoreboard were installed along with a new floodlit astro-turf pitch and extended hurling wall.

1964
Ballysteen win the Limerick SFC title; Askeaton take the title in 1965 and 1966

1966
Mai Collins is elected to the Askeaton–Ballysteen club committee, reportedly one of the first women to occupy a position on a GAA committee in this era

1984
Goalposts in both Ballysteen and Askeaton grounds are cut down maliciously

1991
Limerick beat Tipp 0–14 to 2–7 in the last Munster SFC match played in Askeaton's Páirc na nGael

Páirc Sheáin Mhic Gearailt

LOCATION
Emmet Street, Kilmallock

NAMED AFTER
John Fitzgerald (1910–1976)
Postman, GAA administrator

OPENED
1949

CAPACITY
6,000

PITCH DIMENSIONS
145 x 83m

COVERED ACCOMMODATION
Yes

FLOODLIGHTS
No

CLUB
Kilmallock

Kilmallock GAA Club is a Limerick hurling power with 11 senior county titles to its name along with three Munster championships (1992, 1994, 2014), going all the way to the All-Ireland decider in 1993 and 2015. 'The Baalbec' have produced many fine players for the county hurling team, including All-Stars Dave Clarke, Mike Houlihan, Andrew O'Shaughnessy and Graeme Mulcahy.

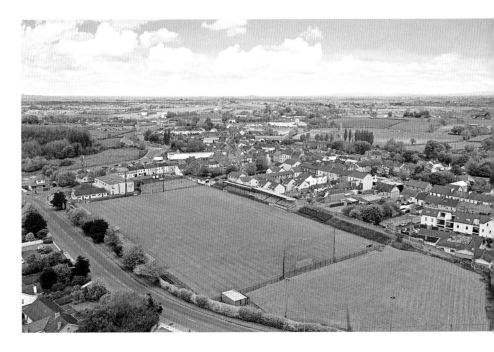

The Kilmallock Improvement Committee was set up around 1878 with the aim of procuring land from Colonel Robert George Stone Maunsell to hold fairs and other such activities in the village. The Fair Green, as it became known, also became a field for Gaelic games. Kilmallock GAA club, which had affiliated to the GAA in 1885, was given authority to manage the Fair Green in January 1896 and allowed to take a percentage of the gate from each game. They erected a fence around the pitch and built a small stand, and the Munster senior hurling and football finals of 1895 between Limerick and Tipperary took place there on 23 February 1896. Tipperary had objected to the choice of venue but in fact won both encounters. Limerick's footballers then lodged an objection, claiming that the referee had blown the whistle seven minutes early. However, the result stood.

The 1896 and '98 Munster SHC finals between Tipperary and Cork were also played in Kilmallock, though these were the last of the senior finals played at the ground.

The impressive state of Páirc Sheáin Mhic Gearailt is due to the collective efforts of generations of club members. Current members continue the work

KEY DATES

1885
Kilmallock GAA Club is known as the Baalbec – the village's nickname, so called because its streets once had as many historic ruins as the ancient Lebanese city

1956
Work starts on building a new stand; it is extended in 1959

1978–80
Stand is extended, sideline seating for 1,500 installed, and the pitch is expanded

1980
Club chooses its first female honorary secretary, Catherine Leahy

JOHN FITZGERALD

Kilmallock native John Fitzgerald finished school at the age of 14 and went to work as a messenger boy with the Post Office. He spent his working life as the town's postman and at the young age of 21 became Kilmallock GAA Club's secretary. He was elected assistant secretary of the South Limerick Board aged 22 and later its secretary, a position he retained unopposed until his retirement in 1971. John was secretary of the inaugural grounds committee which purchased the Fair Green. He was grounds secretary when he died suddenly while working on his beloved pitch.

MIKE FITZGERALD

FAIR PRICE FOR THE FAIR GREEN

Kilmallock was a popular venue for inter club matches and also hosted National League games in the 1930s. The Green was maintained by various groups until 1949 when local GAA followers decided that it should be developed as a Gaelic ground only. A committee was formed, funds were raised and a bank loan taken out; Thomas Hannan, James O'Rourke and Denis Ahern acted as guarantors. Under the guidance of Fr James Culhane, John Fitzgerald and Con Randles the committee purchased the Fair Green for £500 that year, and another piece of land which allowed the pitch to be widened and gave space for an embankment and sideline seats. An adjoining piece of land belonging to Henry O'Rourke was purchased in 1951 and increased the size of the pitch further. A hurling match between Limerick and Cork was held to raise funds, with a prize for the winners of a pair of boots for each player.

BORROWING AND REPAYING

The 1950s saw a great deal of development, beginning in '53 when local volunteers dug out a 300-metre ditch running from Millmount to Emmet Street and built a two-metre-high wall in its place. Four new dressing rooms were built in 1963 at a cost of £800. Despite this spending, the men who had acted as guarantors for the bank facility were released from their obligations in 1970.

JUMBO DEMOLITION JOB

In September 1977 the famous Fossett's Circus, whose lion tamer was Mike Sheedy from Kilmallock, visited the town. During a break in one performance a circus elephant went walkabout and when it came to the wall of the ground began rubbing its bum against it. Two metres tall or not, the wall was no match for the elephant and toppled over. The grounds committee came to an arrangement with local builder Ned Cronin whereby he put up a new wall in exchange for the club granting him a portion of land to square off his yard.

RENAMING THE GREEN

Ground improvements continued from 1978 and the renewed ground was renamed Páirc Sheáin Mhic Gearailt in 1980. Subsequently the surface was drained, levelled and re-laid and hot showers were installed in the dressing rooms. The club was awarded the 1983 Munster club hurling final and replay between Midleton and Borrisoleigh, and hosted Munster SFC matches between Limerick and Cork in 1996 and 2000. However, following a Munster Council inspection in 2006 and the advent of stricter safety rules it was decided that the ground was no longer suitable for high-profile games.

1980
Ground dedicated to club stalwart John Fitzgerald

1988
Limerick hurlers play Clare as a £125,000 sports centre opens on 28 August

2006
Club declines an offer to swap the park for a new facility at Gortboy

2017
Planning permission granted for major new developments

2022
Club receives €150,000 Sports Capital grant funding

Semple Stadium

LOCATION
Gortataggar, Thurles

NAMED AFTER
Tom Semple (1879–1943)
Railway guard, hurler, GAA
administrator

OPENED
1910

CAPACITY
45,700

PITCH DIMENSIONS
145 x 80 m

COVERED ACCOMMODATION
**Ardán Ó Riain,
Ardán Uí Chuinneáin**

FLOODLIGHTS
Yes

CLUB
No

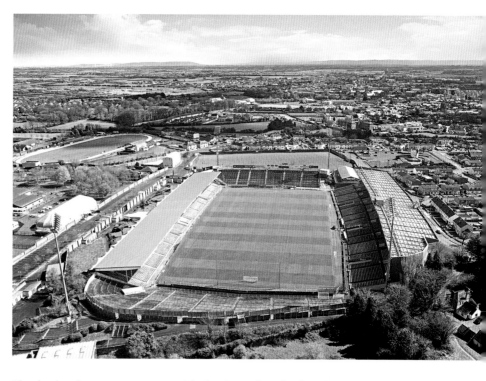

Semple Stadium, Thurles, the Mecca of hurling. Generations have travelled to the mid-Tipperary town on big match days to watch the spectacle of their heroes playing on the stadium's immaculate pitch

Thurles has been synonymous with the GAA since its foundation in Hayes's Hotel in the town square on 1 November 1884. Just a kilometre west of the square sits Semple Stadium, one of the association's best grounds, with what is widely regarded as the finest playing surface in the country.

The stadium originated on a 12-acre site which Thurles Agricultural Society had subleased from the estate of local merchant Joseph Molloy. The land, known as Castle Meadows and Muttonfield, subsequently became the Thurles Showgrounds and a venue for Gaelic games. Thurles GAA Club played their home games there, and the ground hosted both the 1905 All-Ireland SFC final between Kildare and Kerry played in June 1907, and the Home final of the 1908 championship between Dublin and Kerry played in May 1909.

When the Agricultural Society decided to dispose of its leasehold interest in the site, Canon M. K. Ryan, who later became chairman of Tipperary County Board, launched a bid to purchase it.

KEY DATES

1911
Tipp hurlers beat Irish-Americans in one of the first matches in Thurles Sportsfield

1913
Tipperary ease past Waterford 2–4 to 1–1 in the ground's first Munster SFC contest

1926
New 2,000-spectator stand built for £1,000

1953
Tipp captain Tommy Doyle fills urn with stadium soil destined for Belfast's new Casement Park

TOM SEMPLE

Thomas Joseph Semple was born in Moyaliffe, Drombane, Co. Tipperary to Martin and Anne Semple. His father worked as a butler and a coachman. Tom attended Thurles CBS and after leaving school at the age of 16 went to work with the Great Southern & Western Railway. After a few years he was appointed passenger guard on the Cork–Dublin line. During the War of Independence he used this position to organise dispatches for the republicans.

Tom excelled at hurling with the Thurles Blues and captained the team that won six county championships between 1904 and 1911. He became a regular on the Tipperary team in 1900 and won All-Ireland SHC medals that year, and in 1906 and 1908 as captain. He led the Tipperary hurlers on a trip to Belgium to play exhibition matches in 1910.

Semple retired from hurling in 1911 and soon entered into the games' administration. He was chairman of the Tipperary County Board between 1915 and 1917 and represented his county on the Munster and Central Councils. A charismatic, imposing individual standing over 6' 3" he earned much respect for his fairness as an administrator and as a successful manager who trained the Tipperary All-Ireland winning teams at senior, junior and minor levels in 1930.

THURLES SPORTING GROUNDS

A meeting of 'Thurles Gaels' in April 1910 decided to purchase the grounds from the owners, William and Denis Daly, for £900. Shares were issued to cover the cost of buying and developing it, and the people of Thurles took these up at £1 each. A committee, which included Tipperary hurler Tom Semple, was formed on 10 May to manage the affairs of the new Thurles Sporting Grounds. The committee agreed to run a fundraising hurling tournament that would have 'bran new, valuable double-barrelled shotguns' as the prize.

HOPES OF A JUBILEE FINAL DASHED

Often simply called Thurles Sportsfield, the ground soon needed to be expanded to accommodate the crowds. In 1926 a new spectator stand that also housed dressing rooms was constructed, along with a small wooden stand. The Munster Council invested £250 in the ground and GAA President Seán Ryan was appointed to the sportsfield's management committee.

In March 1934 the Munster Convention recommended that the jubilee All-Ireland hurling final should take place in Thurles. In anticipation of hosting the match, embankments around the field were raised and extended and the stand accommodation was also increased to cater for an expected attendance of up to 60,000 spectators. However, at that year's Congress, held in Thurles, a motion to hold the All-Ireland in the Tipperary town was rejected. It was ruled that the motion was not properly before Congress and that the standing rule was that All-Ireland finals should be played in Croke Park. Despite an impassioned appeal from Tom Semple the game between Limerick and Dublin went ahead in the capital.

In 1935 the proprietors of the Thurles Sportsfield Committee accepted an offer from Thurles Gaelic Sportsfield Society Ltd to take over ownership of the

1970	1995	2016	2017	2018
County convention proposes ground be renamed Semple Stadium	Plaque unveiled to commemorate Tipp players in Croke Park on Bloody Sunday	Hawk-Eye used for the first time in Thurles at Munster SHC quarter final	Park is the inaugural winner of the Pitch of the Year award	Development plans launched but later stymied by onset of Covid pandemic

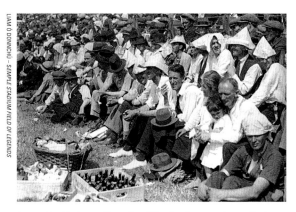

LIAM Ó DONNCHÚ – SEMPLE STADIUM FIELD OF LEGENDS

Improvised hats are the order of the day for crowds sweltering in the heat at the 1934 Munster hurling semi-final between Cork and Limerick. Thankfully there seemed to be plenty of minerals available to slake people's thirst

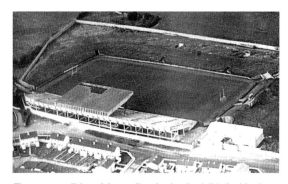

The poor condition of the stadium is clearly visible in this photo taken in 1978. The embankments had not changed in decades and on the side of the ground that had been developed, the roof of the stand had suffered storm damage. Much work was required if it was to host the 1984 centenary All-Ireland final

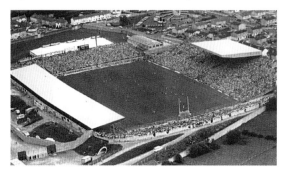

2 September 1984 – 60,000 pack Semple Stadium for the first All-Ireland final staged outside of Croke Park since 1937. A unique pairing also, Cork vs Offaly, with the Rebels coming out on top

ground. Their accumulated debt of over £1,000 was cleared and existing shareholders were offered three shares for every one of their original investment.

Munster Council led improvements through the 1930s and '40s in order to cope with the swelling attendances, but spectators were often delayed going into matches when the council insisted on buying Irish-made turnstiles though they were known to be slow and unreliable.

NEW FUNDING, NEW PLANS

The GAA's Central Council became the major share-holder of the sportsfield company in 1956. When the association set up Bord na bPáirc in 1963 to identify grounds for special development, Thurles was selected as one, and to avail of the additional support this would bring, the existing shareholders were asked to relinquish their holdings, which were transferred to nominees of the GAA.

Building on developments in the 1940s, the new funding from Central Council went towards replacing the old galvanised stand with the new 16,000-seater Ardán Uí Chuinneáin (named after Dr Jeremiah Kinane, Archbishop of Cashel & Emly), built in 1967 at a cost of £107,000 and officially opened on 9 June 1968.

Ten years later part of the roof of the stand was blown off in a January storm. Later that year a de-velopment committee launched a plan that included building another stand on the opposite side of the ground. The phased plan also included further terracing at both ends and the modernisation of players' facilities.

DARING ROBBERY AT MUNSTER FINAL

Armed robbers got away with over £24,500 – more than half the gate receipts – during the 1977 Munster SHC final at Semple Stadium. Shortly after half-time three men wearing wigs and dark glasses and armed with revolvers opened the unlocked door of the counting room where officials were checking the day's gate. They ordered Munster Council treasurer Tadhg Crowley, his nine-year-old son Tadhg Jnr, former Waterford hurler Seamus Power and Timmy Grace, who worked at the stiles, to lie on the ground as they packed £24,594 of the takings into a briefcase.

The hold-up, the *Tipperary Star* noted, was all the more daring given that there was unprecedented security surrounding the attendance of President

Patrick J. Hillery, Taoiseach Jack Lynch and several other members of government at the match.

CENTENARY HURLING FINAL

A new stand, named Ardan Ó Riain after Canon Ryan, and terracing at the town end of the field were completed in 1980 at a cost of £500,000 in time for the Munster SHC semi-final between Tipperary and Cork that year.

Work stepped up after the GAA Congress of 1981 decided to hold the centenary hurling final in Thurles in 1984. The final phase of development began in 1983 with improvements to the terracing on the Killinan end of the ground. These improved facilities, along with major work on the pitch, set the stage for the final on 2 September 1984, when Cork overpowered Offaly by 3–16 to 1–12 to take the title.

THE TRIP TO TIPP

Work on the stadium left an outstanding bill of over £1.28m. By the late 1980s the state of the playing surface had also deteriorated due to overuse and with no funding available from Tipperary County Board at the time a series of fundraising Féile Festivals were organised between 1990 and 1994. These concerts

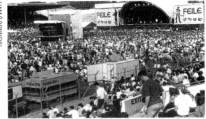

LIAM Ó DONNCHÚ

Féile 1990 captured the imagination of young people across the country and over the following three summers the 'Trip to Tipp' became an annual pilgrimage. The huge crowds were wooed by international artists such as Meat Loaf, Elvis Costello and Bryan Adams along with home grown acts The Cranberries, The Saw Doctors and The Stunning

proved to be a great success and cleared the debt on the ground by 1994. The following year the Semple Stadium Committee handed over management of the facility to the Tipperary County Board.

BIRTHDAY CELEBRATIONS

Stands and terraces underwent major improvement from 2006, as did players' and spectators' facilities, with support funding from a Sports Capital grant. In fact, the overall cost of the stadium upgrade reached an estimated €18m. The newly floodlit stadium reopened in February 2009, marking the start of a programme of celebrations in Tipperary commemorating the founding of the GAA in Hayes's Hotel 125 years previously.

A multi-functional hall known locally as 'the Dome' was constructed at the rear of Ardán Uí Riain in 2009 also, hosting guests for corporate lunches and functions on match days. The venue for the majority of All-Ireland U21 hurling finals, Semple Stadium may be the association's number two venue after Croke Park, but it stands as an icon in the GAA's birthplace.

Hurling's holy ground – the beautifully manicured playing surface of Semple Stadium in high summer

SPORTSFILE

Clonmel Sportsfield

LOCATION
Western Road, Greenan

OPENED
1930

CAPACITY
5,000

PITCH DIMENSIONS
142 x 81 m

COVERED ACCOMMODATION
Yes

FLOODLIGHTS
No

CLUB
Clonmel Commercials (Football)
St Mary's (Hurling and Camogie)

Clonmel Commercials are a major power in Tipperary football having won the senior county title on 20 occasions, the most recent in 2022. In 2015 they captured the Munster title by beating Nemo Rangers in a thrilling final.

St Mary's has scored its major successes at under-age level and takes great pride in fostering a love of hurling and camogie among youngsters by providing them with the opportunities they need to develop their skills.

Clonmel boasted no fewer than seven GAA clubs in 1897, while the town's Clonmel Shamrocks went on to represent Tipperary and beat London in the 1900 All-Ireland SFC final. Games were played in Magner's Field, owned by the Clonmel Horse Show Society. The GAA had little security of tenure there, however, and efforts to improve the ground or buy part of it outright came to nought.

Situated 'in the valley near Slievenamon,' Clonmel Sportsfield is home to two thriving clubs and equally fine facilities

In 1929 the Clonmel Sportsfield Company Ltd was set up with the aim of sourcing a Gaelic ground. With town mayor Tom Condon, James Lonergan and Thomas Ryan acting as directors and Richard O'Donnell as secretary, the company issued 2,000 shares for public purchase at £1 each. A campaign to raise money for the shares quickly brought in almost half that amount in the O'Connell Street and Irishtown areas of the town alone. The citizens of Clonmel subscribed around £900 and Munster Council contributed £400, leaving £700 worth of shares to be taken up.

KEY DATES

1929
New St Mary's club practise in O'Donnell's Field, Cashel Road, but want their own ground

1930
Sportsfield hosts All-Ireland colleges football semi-final between Leinster and Munster on 10 April

1930
Cork hurlers play Tipperary and Limerick play Waterford at the official opening on 1 June

1930
Clonmel's first Munster championship game, Waterford vs Limerick in the MHC on 15 June

OPENING TINGED WITH SADNESS

A 99-year lease on 12 acres of land on the Western Road, known as 'The Nursery,' was bought from J. Higgins for £1,200. This also included an interest in the nearby Cottage Hospital and a small plot of land, both of which would bring in an annual revenue. The Sportsfield Company spent £350 on laying a new pitch, aided by the boys from St Mary's CBS, who were given time off class to help pick stones. The company also built a caretaker's house beside the ground and local man Jim 'Boss' King became its first incumbent.

The first match played on the new ground was a Munster football league game between Tipperary and Cork on 23 March 1930. 3,000 spectators attended the official opening by Mayor Tom Condon on 1 June. Sadly, Thomas Ryan, former South Board secretary and the main driving force behind the ground's acquisition, passed away on the eve of the big day.

NEW AND RE-FORMED CLUBS SETTLE IN

A year after the Sportsfield opened, the new St Mary's club, which had been instrumental in promoting the ground, was put on a more formal footing, while the modern Clonmel Commercials Football Club was re-formed in 1934. After the lease on the field was extended in 1946 sideline seats were installed, but facilities at the ground made little advance until 1965 when dressing rooms were built and an entrance gate erected. Two years later a new pitch-side wall replaced the original barbed-wire and wooden railing, and four new dressing rooms and an office were completed in 1971 at a cost of £4,500. In 1974 the committee built a spectator stand, unusually sited between the 20 and 45 metre lines. It was located

there to prevent spectators watching games for free from the hospital across the road.

A social centre built in 1977 became a focal point for the GAA in Clonmel. A practice pitch adjacent to the main pitch was laid out and levelled in 1980 and after some further improvements through the decade a new Sportsfield committee was formed in 1992. Made up of members of Clonmel Commercials and St Mary's GAA clubs, they set out to reduce the ground's debt of approx. £26,000 as it had become clear that the GAA authorities would not invest further unless the debt was cleared.

Michael Maher (left), Tipp's colossus full-back from the '50s and '60s, and teammate Theo English flank Christy Ring at a charity event held in the Sportsfield in 1969. The Cork legend was persuaded to don the blue and gold but seems to be having second thoughts

CLONMEL NATIONALIST

SAFEGUARDING OWNERSHIP

A legal issue arose in 1993 over ownership of the ground. The original Sportfield Company had dissolved on 9 May 1989 and few records existed of the people who had originally bought shares in 1929. With the assistance of Tipperary County Board legal ownership of the ground was established and is held in trusteeship for the GAA by St Mary's and Clonmel Commercials. €50,000 was raised in 2001 to assist in the construction of a new 950-seater stand while a €208,000 grant from the National Lottery helped to build new dressing rooms and realign the pitches in 2010. The committee completed fencing right around the field between 2015 and 2019 and developed a walkway around the main pitch, used by players and the local community.

1946
Sportsfield Company agrees a new 99-year lease with John P. Bagwell, Marlfield House, from 1 May 1953

1984
Sportsfield hosts the Daredevils American Thrill Show, featuring the human cannonball, Carol Bolton

1986
Work begins on constructing two new dressing rooms in May, completed August 1987

2018
Sports grant of €75,000 received to build an all-weather facility

MacDonagh Park

LOCATION
St Conlon's Road, Nenagh

NAMED AFTER
Thomas MacDonagh
(1879–1916)
Teacher, Easter Rising leader

OPENED
1942

CAPACITY
5,000

PITCH DIMENSIONS
142 x 78m

COVERED ACCOMMODATION
Yes

FLOODLIGHTS
No

CLUB
Nenagh Éire Óg

Nenagh Éire Óg field teams in hurling, Gaelic football and camogie, and is a centre for handball too. Nicknamed 'the Blues,' they won the North Tipperary Club of the Year award five times between 1979 and 2014.

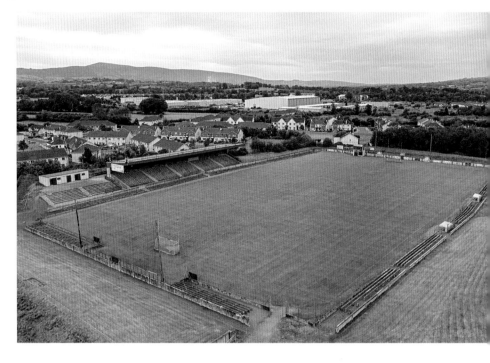

On 30 November 1884, just a month after the GAA was founded, Nenagh Cricket Club met to discuss ways of reviving native sports in Tipperary. Three weeks later the club started a hurling branch, and at 11 o'clock that day a dozen cricket players walked to Tyone, where a field was lent to them, and by midday half the countryside had gathered to see 'the hurling.'

The complex at MacDonagh Park is the result of sustained planning, with further development in the pipeline

Renamed John Mitchel Hurling and Football Club in 1886, by 1902 the club had moved to the new Showgrounds, which were also let for agricultural shows, rugby matches and athletics, and could accommodate up to 10,000 spectators.

The ambition of securing a GAA ground was revived at a meeting in the Town Hall Reading Rooms on 12 October 1926, attended by many representatives of the Nenagh Licenced Grocers and Vintners Association, who felt that such a field was essential in the interests of the town's businesspeople. However, it was another 16 years before a site was finally found. The ground was formally opened on 27 September 1942 and named MacDonagh Gaelic Park.

KEY DATES

1942
Cost of new park reaches £2,510, largely funded by local collections and a draw in the Irish Sweepstakes

1942
MacDonagh Gaelic Park opened officially on 27 September by Frank McGrath, Chairman Gaelic Park committee

1955
Éire Óg's sister club, Nenagh Olympic Athletic, is founded but banned from using the playing pitch for running

1970
Issues arise between the park committee, owners of the ground, and Éire Óg, who are in effect tenants, regarding access to the facility

NATIONAL LIBRARY OF IRELAND

THOMAS MacDONAGH

Born in Cloughjordan, Co. Tipperary, in 1879, Thomas MacDonagh was a poet and teacher (and co-founder of the ASTI), and then a leader of the Irish revolution. When the Irish Volunteers were formed in 1913, MacDonagh was appointed to the Central Committee and co-organised the Volunteers' march to Howth in July 1914 to collect arms from the *Asgard*. A battalion commandant in the 1916 Rising, he was executed on 3 May for his part in the insurrection.

TOP PRIZE PUNCTURED

In 1905 the North Tipperary Show Committee decided to hold a 'Monster Hurling Tournament' with a prize of 17 Irish-made bicycles, one for each member of the winning team. The runners-up would be awarded a set of solid silver medals. Fifty-eight teams from counties including Dublin, Cork, Galway, Tipperary, Clare, Offaly, Laois, Limerick and Kilkenny entered the competition, which was to be held in 1906. However, the organising committee was overwhelmed by the sheer logistics of organising the games and in 1907 the tournament was abandoned. No record exists of what happened to the bicycles, or indeed the silver medals.

A Pierce bicycle cost a considerable £12 in the early 1900s – around €1,600 in today's value

AUTHOR'S COLLECTION

HONOURING A PEACEMAKER

In July 2017 a plaque was unveiled in memory of Fr Alex Reid, who played a pivotal role in the Northern Ireland peace process which led to the historic Good Friday Agreement in 1998. Fr Reid played underage hurling with Nenagh before joining the priesthood.

CLUBBING TOGETHER

Hurling waned during the Troubles but came to the forefront again with the emergence of the Red Rovers in 1926. This team was drawn from a small area of the town around the Birr Road and the Turnpike. They subsequently changed their name to Éire Óg, playing alongside the old Nenagh GAA Club. In 1947 local curate Fr Joe Hayes succeeded in his quest to amalgamate Nenagh's two clubs under the name of St Mary's. The new club survived until the mid-1950s when, during a low period in their fortunes, it was decided to go forward under the present name, Nenagh Éire Óg.

'THE COMPLEX' TAKES SHAPE

In March 1987 Nenagh Éire Óg set out to build a modern sports and leisure complex. The plans included two playing pitches with a raised viewing area, a gym, changing rooms, a 40 x 20 foot handball alley, a sports and social amenity hall, as well as offices and meeting rooms. The Park's Committee donated a plot of land adjacent to the ground to help hold the new facilities.

With support from the North Tipperary Board, the Munster Council, Croke Park and the National Lottery, as well as a huge fundraising effort locally, 'the complex' opened on 30 October 1989. A new stand was added in 1997. The handball alley hosted a number of All-Ireland finals in the new millennium.

Timeline

1980
Ground hosts the All-Ireland U21 football final, when Cork defeat Dublin by 2–8 to 1–5

1982
Kerry defeat Offaly in the All-Ireland Ladies Football final at MacDonagh Park, the first of a nine-in-a-row sequence for the Kingdom

1992
Munster Council and Tipperary GAA boards appoint Nenagh Éire Óg GAA Club sole custodians of MacDonagh Park, resolving disputes with park committee

2019
Club purchases ten acres adjacent to the complex to develop another top-class playing pitch and facilities

Walsh Park

LOCATION
Slievekeale Road, Waterford

NAMED AFTER
**Willie (Liam) Walsh
(1879–1960)**
Businessman, GAA player,
referee, administrator

OPENED
1928

CAPACITY
11,000

PITCH DIMENSIONS
145 x 81 m

COVERED ACCOMMODATION
Yes

FLOODLIGHTS
No

CLUB
No

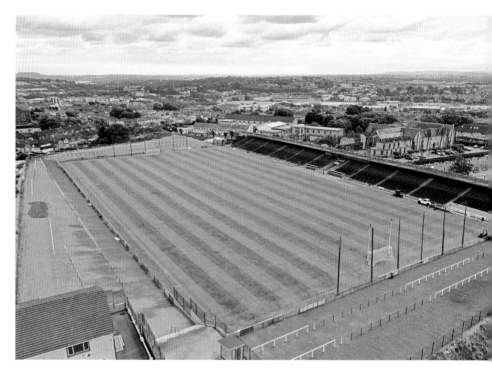

Exciting times ahead as the untapped potential of Walsh Park is set to be realised over the coming years. An ambitious three-phase plan has been put in place that will see the development of new covered and uncovered seating, dressing rooms and administration buildings along with other more general renovations

Hurling was being played in Ballytruckle as early as 1888, while GAA matches were also played at Slievekeale Road. In 1908 local businessmen formed the Waterford Gaelic Sports Field Company Ltd and took a lease on the Slievekeale site. The shareholders were mainly bankers, solicitors, cattle-buyers and newspaper proprietors among others, and their idea was to lay out the area and make it available to all sports, including cricket, rugby and soccer.

Waterford GAA was divided over whether or not to join forces with this venture. It meant the pitch would not always be available to them. Moreover, at a special meeting that March they petitioned to have the company's name changed to the Waterford Sports Field Company Ltd as the GAA did not favour other sports on a ground that had 'Gaelic' in its title.

The name was changed but the meeting refused to commit solely to Gaelic games. At this a number headed by Willie Walsh left and embarked on a campaign to overturn that decision.

KEY DATES

1911
Record 7,000 crowd watches Kilkenny hurlers play an Irish-American team at the Sports Field

1914
Sports Field hosts the Waterford Feis, opened by Pádraig Pearse on 12 July

1930
Waterford play Tipperary in the NHL, the new Sports Field's first major match

1940
Kerry defeat Waterford in the Munster SFC final at the ground on 21 July

1957
A famous day for Waterford as they beat Kerry in the Munster SFC semi-final on 2 June

WILLIE WALSH

Willie (Liam) Walsh was born into a family of three boys and six girls who experienced tragedy early in life when their father died aged just 34. Willie went to work at a young age in Phelan's Sack and Bag Merchants. He became a director of the company many years later, in about 1945.

Willie played hurling and football for Waterford, though his reputation would be won as a referee and administrator. He took charge of five All-Ireland SHC finals in a row, from 1915–19, as well as 1921 and the second replay in 1931. He also refereed the All-Ireland SFC finals in 1920 and 1921.

Elected as the first president of Waterford Athletic Club in 1924, he was chairman of Waterford County Board from 1930 to '35, when he became the board's president. He represented Waterford GAA at Munster and national levels from 1906 to 1940.

MAIRÉAD (MUD) BOURKE

A GAELIC FIELD FOR GAELIC GAMES

Many GAA members supported the sportsfield company allowing other sports on the ground because if it was used for GAA games only it might not be financially viable. On the other hand, Tipperary decided that no team from that county would play there. Teams from Cork, Limerick, Kilkenny and Wexford continued to travel to Waterford for a while, but their support waned too.

Both sides presented their case at a meeting of Central Council convened in 1911. The Willie Walsh faction prevailed. Council voted by a substantial majority that the ground should be a Gaelic field for Gaelic games and Gaelic games alone.

SECURING THE PROPERTY

Waterford Sports Field Company went into voluntary liquidation in 1917. Ten years later four of the men who had called for the Sports Field to be a Gaelic ground back in 1908, including Willie Walsh, succeeded in securing the lease. They immediately set about improving the ground and the first Munster championship match under the new management saw Waterford play Cork in the SHC semi-final on 13 May 1928.

When the grounds were put up for sale the following year a number of sports bodies were interested, but a committee headed by Willie Walsh raised the purchase price of £800. They developed the ground further, and when the Munster Council allotted it a Munster hurling championship match on 21 May 1933 the Sports Field became established as a major venue.

In 1938 the grounds became the property of the GAA and most of the committee had their initial subscriptions returned. The last two shareholders were bought out in 1943 and the grounds were vested in the GAA, while the Munster Council became the new owners.

DON'T MOVE, IMPROVE

Between 1962 and 1966 considerable work was carried out on the park, including closing it for 18 months to refurbish the pitch. Little more was done for almost 30 years after that, when despite a proposal to move to a greenfield site the county board decided instead to upgrade what was now Walsh Park. The redeveloped ground hosted its first Munster SHC match in 21 years when Waterford played Tipperary on 2 June 1996.

Another 20 years passed before the county board looked at upgrading the ground again. An €8m plan which would increase capacity to 15,500 was announced in 2019; after the pandemic hiatus phase one of the development began in late 2022.

1960
Following the death of Willie Walsh in August, Munster Council agree to name the ground the Liam Breathnach Memorial Park, or Walsh Park, in his honour

1962
Questions are raised when a baseball match is played between Brise Norton Broncos and Alconbury Spartans, but the GAA turns a blind eye

1991
Plans to sell Walsh Park and move to a greenfield site cause consternation locally

1995
New 5,200-seater stand with better facilities for players, officials and media opened

Fraher Field

LOCATION
Shandon, Dungarvan

NAMED AFTER
Dan Fraher (1852–1929)
Draper, sportsman, referee, GAA administrator

OPENED
1885

CAPACITY
5,500

PITCH DIMENSIONS
148 x 88 m

COVERED ACCOMMODATION
Yes

FLOODLIGHTS
Yes

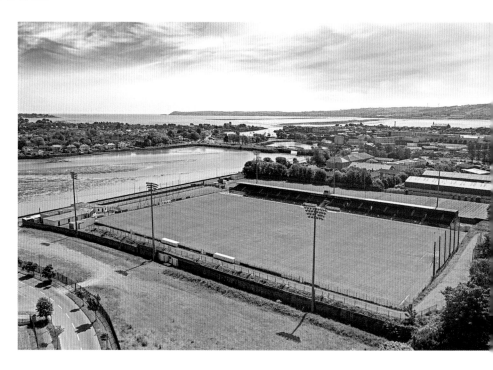

Dan Fraher's name is immortalised on the ground that he bought 111 years ago. This photograph, taken at Dungarvan in the early 1890s, shows the soccer-style goals and point posts that stood on such Gaelic fields in his playing days

WATERFORD COUNTY MUSEUM

Fraher Field is unique in that it was owned and envisioned by one man, Dan Fraher, who went on to develop the venue as a prototype for Gaelic grounds all around the country.

Once the property of John Henry de la Poer, Earl of Tyrone and 5th Marquis of Waterford, the nine acres of land was bought by Captain Richard Curran from Shandon, Dungarvan, in March 1877. Curran was captain of the brigantine *The Island Queen* and a member of a prominent merchant family whose ships plied between Dungarvan, the UK and North and South America between 1820 and 1920.

The grounds were used by the Dungarvan Cricket Club and Captain Curran also rented it to the Dungarvan Agricultural Society for their annual shows. In 1885 Dan Fraher leased the field from Curran and set about developing the venue as a GAA sports ground. Known as Shandon Gaelic Ground, it became home to the Dungarvan Shandon Rovers football team, with Fraher as their goalkeeper.

KEY DATES

1885
Dungarvan GAA Club, the first in Co. Waterford, is founded on 1 June

1887
On 24 July Dungarvan hosts one of the first All-Ireland championship matches ever played as Kilkenny and Cork compete in both hurling and football

1888
Ground hosts its first Munster SHC match between Cork and Waterford

1903–11
Shandon Gaelic Ground hosts All-Ireland SHC finals in 1903, 1905, 1907 and 1911, more than any ground outside of Croke Park

DAN FRAHER

Dan Fraher was born at Skaheens, near Touraneena, Co. Waterford, and after an apprenticeship in the drapery trade set up his own business, the Gaelic Outfitting Store, at 17 Grattan Square, Dungarvan, in 1892. Heavily involved in the nationalist movement of the time and a noted sportsman in his own right, he was also a referee and memorably took charge of two All-Ireland senior finals on the one day – the 1892 hurling final between Dublin and Cork, and in football between Dublin and Kerry. Renowned as a sports administrator, he served on the Munster Council, as president of the GAA in Waterford and as a Central Council trustee, when he acted as one of the guarantors on the purchase of 'the Jones Road field' in 1913, now known as Croke Park.

IAN HANNIGAN – TIMELESS COLOUR, WATERFORD COUNTY MUSEUM

CLASH OF TITANS

In 1908 the field hosted a unique contest between two giants of athletics. Mayo's Martin Sheridan, winner of nine Olympic medals for the USA at various events, took on Olympic and world champion hammer-thrower Tom Kiely from Carrick-on-Suir. The two competed over five throwing events. Each won two contests then fouled their fifth throws, so the competition was declared a draw.

FRAHER'S FORESIGHT

Fraher bought the grounds outright on 31 March 1912. He changed the layout of the pitch and installed modern facilities as a model for other GAA grounds, with hot showers, toilets and an enclosed pitch. Ownership of the property transferred to Dan's son Maurice on 10 July

1925. Following his death in 1951 title passed to his sister, Cáit, who had married Dungarvan man Pax Whelan.

WHELAN CUSTODIANSHIP

From the 1940s onwards the ground was variously called Shandon Gaelic Ground, Shandon Field, Gaelic Field and finally Fraher Field from the mid-1950s. By then the venue had fallen into disrepair. The playing pitch, railings, gates, turnstiles, dressing rooms, drainage and terracing all had to be overhauled, and without any financial assistance from the GAA the Whelan family gradually restored Fraher Field to a high standard.

Representations were made to Pax Whelan in the late 1940s and early '50s to sell the ground to the GAA but no agreement was reached. Over the next 20 years the field was maintained by the Whelan family and continued to attract county and provincial matches. The upkeep became too much, however, and the ground was closed in 1971. In March 1973 ownership passed to the GAA for the sum of £40,000 and Fraher Field was officially reopened on 12 August 1973 by former Kerry footballer John Joe Sheehy.

LIFE AS A COUNTY GROUND

Fraher Field was declared a county ground in December 1975. New dressing rooms were completed in 1981 and in July 1993 work began on building a new stand. Following this, Fraher Field was officially reopened on 15 May 1994 by GAA President Jack Boothman.

In 2011 floodlights were installed and extra land to the north of the ground was purchased that will allow for additional development to accommodate a further 11,000 patrons. New seats were installed in the stand in summer 2023.

1930
Kerry win the Munster SFC title and are presented with the Dan Fraher Memorial Cup

1973
Waterford County Board contribute £20,000, Munster Council £10,000 and Dungarvan-born industrialist John A. Mulcahy £10,000 to cover purchase of Fraher Field

1993
Pitch and stand development is supported by grants from Munster and Central councils

2023
A new wheelchair access area is installed in the stand

McQuillan Park, Ballycastle, Co. Antrim

U L S T E R

Corrigan Park

LOCATION
Whiterock Road, Belfast

NAMED AFTER
**John (Seán) Corrigan
(1881–1916)**
*Railway clerk, referee, GAA
administrator*

OPENED
1926

CAPACITY
3,750

PITCH DIMENSIONS
142 x 79 m

COVERED ACCOMMODATION
Yes

FLOODLIGHTS
No

CLUB
St John's

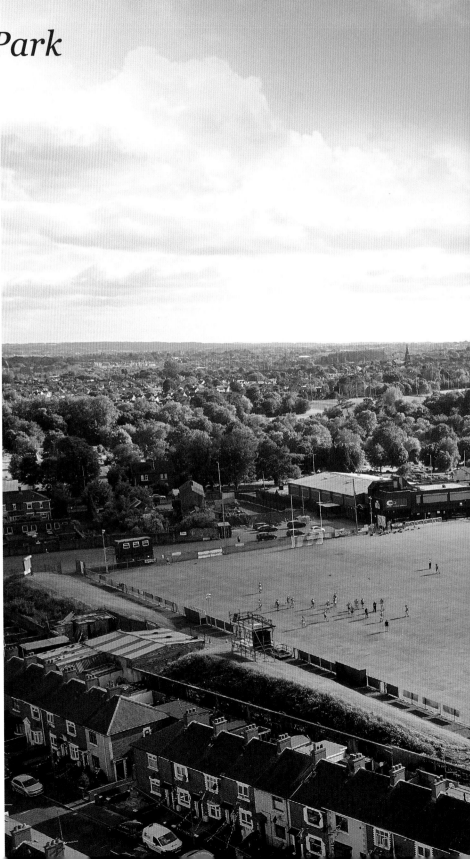

*A neat little ground 'in a neat
little town,' Corrigan Park
holds a special place in the
affections of Antrim Gaels.
Through its long history it has
done much to keep the flame
of our national games burning
brightly in Belfast*

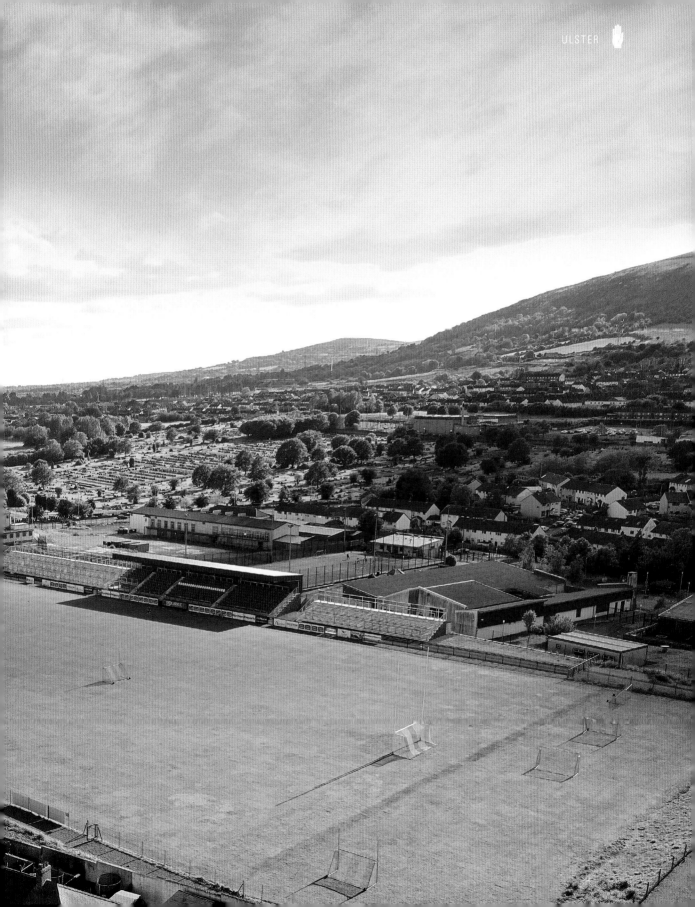

St John's lead the Antrim SFC list with 24 titles, adding to their seven SHC titles. The club's Andy McCallin, a dual player, is the one and only Antrim football All Star to date – he was selected on the first ever team in 1971. His father, Andy Snr, was often referred to as 'Mr St John's.'

All Star corner forward, Andy McCallin

PUBLICAN SECURES LAND FOR GAA

The nationalist community's spirit was at a low ebb after partition and in Belfast Gaelic games were languishing. Intent on reviving the sports, Antrim County Board leased land in the Norfolk Drive area in February 1923, naming their two new pitches Norfolk Park and renaming them Corrigan Park in January 1924, but within a year they had to vacate the grounds to make way for new housing.

The second Corrigan Park came into being when James O'Hare's farm off the Whiterock Road came on the market. The county board negotiated a price of £1,600 for just over six acres on 4 April 1926, but the board, as it happened, had only £450 to hand and none of the banks would advance the balance. King Street publican Joseph Cosgrove stepped in to complete the purchase that November and in October 1929 made a loan arrangement with the GAA, who would pay the £1,600 at a rate of 6% with annual repayments of £120. The GAA took final possession on 21 December 1940, and could now boast their own home.

Corrigan Park's old stand forms the backdrop as Antrim and Galway parade before the 1946 All-Ireland Camogie final. The Ulster women's victory was the second in their famous three-in-a-row

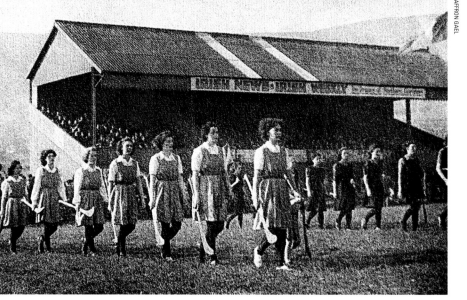

1903
Gaelic games in west Belfast played mainly in Shaun's Park on Whiterock Road – later MacRory Park

1926
Corrigan Park opens officially on 12 September

1929
Sunderland Forge and Engineering Co. build a 900-capacity stand at a cost of £1,439

1932
Frank Kerr, father of Brian Kerr, wins an Ulster title for Corrigan Park Boxing Club

1943
Ground is the scene of probably the greatest-ever GAA occasion in Belfast as Antrim beat Kilkenny in the 1943 All-Ireland hurling semi-final

JOHN CORRIGAN (1881–1916)

John Corrigan was born in Newtownbutler, Co. Fermanagh. His father, John, a labourer, died while John was still a boy and he moved to Belfast with his mother and sister to live with his uncle, John Baxter. After leaving school John gained employment as a railway clerk alongside his uncle.

Though he did not experience organised hurling in his native county, John joined Brian Óg, a pioneering Belfast hurling club, in 1903. By 1907 he was being praised as its 'able and energetic secretary,' and he also served as a referee. He was elected as Antrim County Board secretary in 1908, and again in 1913–14, and also acted for a time as delegate to Central Council.

Long illness forced him to retire as county secretary in 1915. He died aged 34 on 29 April 1916, the day of the rebel leaders' surrender in the Easter Rising in Dublin.

The Corrigan Memorial Cup was inaugurated in his honour, and after the purchase of Norfolk Drive the South Antrim Board moved Corrigan's memorial from cup to ground.

Clareen King's County Farmer who ... 10 July 1908 granted at Mullingar to John Corrigan Farmer Effects £478

CORRIGAN John William [383] 5 July Probate of the Will of John William Corrigan late of 10 Lavinia Street Belfast Clerk who died 29 April 1916 granted at Belfast to Sara Flanagan Spinster and Margaret Corrigan Widow Effects £78 4s. 0d.

CORRIGAN Michael [64] 3 February Administration of the Estate of Michael Corrigan late of Ballynadri... Athboy County Meath Farmer who died 21 December 1915 granted at ... Widow

John Corrigan's will, showing that the young man left a total of £78 and 4 shillings to be shared between a Sara Flanagan, possibly his girlfriend, and his mother Margaret

GREAT OCCASIONS DESPITE BASIC FACILITIES

In 1929 a simple corrugated-iron stand was built with wooden benches sitting on earth floors. There were no changing facilities or running water. Nonetheless, through the 1930s Corrigan Park became the chief venue for Antrim's inter-county and South Antrim Board fixtures. When WWII arrived the venue also hosted a series of baseball matches for the benefit of American forces stationed near by. In 1945 Corrigan Park was the venue for a famous Railway Cup hurling match when Ulster defeated a star-studded Leinster team by 3–1 to 2–3. The ground was also the scene of great successes for Ulster women when the All-Ireland Senior Camogie Championship finals of 1946 and '47 brought victories for Antrim over Galway and Dublin respectively.

CROKE PARK ARCHIVES

1948 programme cover for Corrigan Park Week, a fund-raising sporting and cultural festival

But the park was in a poor state and though the St John's club took over management in 1955 its decline continued. A wall crumbled under the weight of spectators at one match and then in 1968 a fire gutted the pavilion.

KEEPING GAELIC GAMES ALIVE IN BELFAST

When the British Army occupied Casement Park in 1971, inter-county games moved to Corrigan Park. Prunty pitches were laid in 1973–74 and facilities modernised. The refurbished venue served as Belfast's second GAA ground for the next three decades. Yet facilities could not be maintained to senior inter-county standard and increasing health and safety concerns saw its official capacity lowered to 1,000 and the historic 80-year-old stand was closed.

However, when Casement Park closed for extensive redevelopment in 2013 Corrigan Park became Antrim's home venue once again and in 2017 the St John's club sought support from the GAA to help refurbish it. A €1m project brought improvements to the west side and a new state-of-the-art stand, with terracing on either side, in 2021. Corrigan Park continues as the second-longest-serving county ground in Ulster, behind Breffni Park.

1953
Corrigan Park is the first Gaelic ground to appear on television in Ireland, when a snippet from Fitzgibbon Cup final is broadcast on the new BBC Belfast

1970
St John's open a social club which becomes a major source of club finance

1974
GAA President Dr Donal Keenan opens reconstructed park on 25 August, when Antrim play Cork in All-Ireland U21 football semi-final

2021
New stand to cater for 387 spectators opens

Casement Park

LOCATION
Andersonstown Road, Belfast

NAMED AFTER
Roger Casement (1864–1916)
*Diplomat, humanitarian,
Irish revolutionary*

OPENED
1953

CAPACITY
33,000

PITCH DIMENSIONS
145 x 90m

COVERED ACCOMMODATION
Yes

FLOODLIGHTS
Yes

CLUB
No

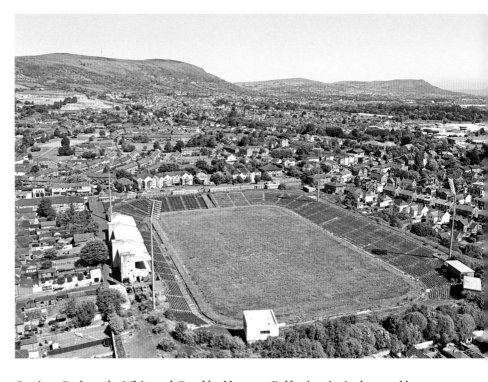

A field of weeds instead of dreams – Casement Park in summer 2023 is a picture of neglect after its proposed re-development had languished in planning purgatory for nearly a decade. There are, however, green shoots of optimism that the West Belfast venue will once again echo with the sounds of passionate sporting rivalry

Corrigan Park on the Whiterock Road had become Belfast's principal ground by 1928 and hosted most of Antrim's home games in the Ulster senior football and hurling championships from 1931 on. The Corrigan Park reconstruction committee was set up in March 1944 to buy the ground outright and develop it, but though a good deal of money was raised a joint committee that included Antrim County Board members subsequently decided that the park would not be suitable in the long run, mainly because access to the ground was limited.

Antrim county chairman Seamus McFerran and Tommy Crummey pointed to two large fields on the Andersonstown Road in west Belfast as an alternative. The land was rough and uneven but the board decided to go ahead. The Bishop of Down and Connor, Daniel Mageean, announced the purchase on 12 December 1946. For now the ground was simply the New Corrigan Park. Its development costs would be covered by a five-year fundraising drive that generated more than £100,000.

KEY DATES

1946
Antrim County Board buys Andersonstown Road site from McMaster Estates for £5,000

1953
Casement Park hosts its first Ulster SFC fixture, Armagh vs Derry. Armagh overcome All-Ireland champions Cavan in the Ulster final at the venue on 26 July

1956–62
Stand used as classrooms for schools in the local St Teresa's and St Agnes' parishes

1968
Casement Social Club makes history when it is granted a bar licence – the first in any GAA club

THE HARD WORK BEGINS

It was not long after WWII had ended. Rubble caused by German bombing was still piled up in the city and tons of it were transported by Belfast Corporation to build an embankment around the ground. As the fields were shaped into a playing arena, drains were dug and stones laid to create a solid foundation before cinders from the Belfast Gasworks were spread on the surface to help with soakage. Topsoil was replenished with 1,400 tons

OPENING DAY PAGEANTRY

By the start of 1953 the county board had settled on 'Slemish Park,' in honour of St Patrick, as the ground's name, but this was subsequently changed to Roger Casement Park.

Four days before the official opening on 14 June 1953, a fire was started maliciously underneath the stand. Some heavy machinery sitting there was destroyed but luckily nearby residents saw the

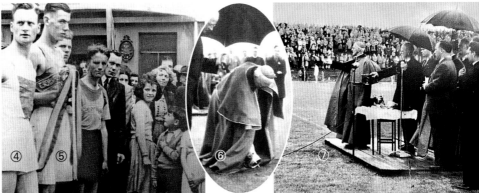

LIAM Ó DONNCHÚ – SEMPLE STADIUM FIELD OF LEGENDS

① ② ③ ④ ⑤ ⑥ ⑦

of sand transported from the shores of Lough Neagh.

Terracing was installed and a boundary wall erected at a cost of £20,000. Reclaimed steel from abandoned American aircraft hangars was sourced from Enniskillen to build the main stand. More steel was secured from a flying boat company based in Lough Erne. Household waste from the city's homes was piled up to create an embankment on the Mooreland Park side, and when the ground was finished each Belfast club was assigned a section of 'the hill' to maintain.

All the while funds were being raised. Subscriptions to the Jockey Pools Club generated a constant cash flow and bazaars in St Mary's Hall, Bank Street, returned a good profit from selling eggs, butter, sugar, poultry, whiskey and wine at a time when food was rationed.

THE ODYSSEY OF A SILVER URN –

• *Tipperary's Mickey Byrne (1), county board secretary Phil Purcell (2), and Tommy Doyle (3) pose with the silver urn containing soil carefully dug from Semple Stadium*

• *Outside Hayes's Hotel, Thurles, athletes Cormac Boomer (4) of Corrigan AC and Jimmy Semple (5), son of Tom after whom the stadium is named, prepare for the start of the relay run*

• *Upon arrival in Belfast the contents of the urn are sprinkled in the centre of Casement Park by Cardinal John D'Alton (6) who presided over the opening ceremony during which Bishop Daniel Mageean (7) blessed the ground*

smoke and called the fire brigade, who extinguished the blaze before more damage could be caused.

For the opening ceremony a relay team of 27 runners set out from Thurles on the previous evening

1978
8,000 spectators locked in the ground as a paramilitary group protests against conditions in the Maze prison

1984
During an Ulster championship match two men disguised as ambulance men rob the gate takings at gunpoint and get away with £6,000

2006
Floodlights installed but not officially switched on until 10 February 2007

2013
Park hosts its final Ulster SFC game before redevelopment project is due to begin

NATIONAL LIBRARY OF IRELAND

ROGER CASEMENT

Born in Sandycove, Co. Dublin, to Capt. Roger and Anne Casement, Roger was raised by his uncle John near Ballycastle in north Antrim,

TOM DALY

❝ So long as the village fires of the Congo burn, so long will there be men who tell the story of Casement. The man they remember as 'The Protector' ❞

– *Opening day programme foreword by Capt. Robert Monteith, Casement's friend and compatriot*

after his parents died. He spent most of his formative years in England and joined the British Civil Service. He was a British consul in what are today Mozambique, Angola and Congo, where his work in revealing the atrocious cruelty of white traders exploiting native labour won him international renown. He did as much again in Peru, which earned him a knighthood.

From a Unionist background, Casement joined the Irish Volunteers in 1913. He went to America to raise funds and then to Germany to seek support for the 1916 Rising. He was arrested in Co. Kerry days before the Rising and was tried for treason in London. Casement was hanged in Pentonville Prison on 3 August 1916. In 1965 his remains were returned to Ireland and reinterred in Dublin after a state funeral.

SPORTSFILE

Casement Park in its pomp on an Ulster football championship Sunday. A great atmosphere is created by the crowd packed into the old stadium on a sunny June day in 2007. The match, a quarter-final between Antrim and Derry, goes with form and a win for the Oak Leaf county

carrying a silver urn bearing soil from Semple Stadium. Running through the night, stopping only in Dublin to add a sample of Croke Park's soil, the urn arrived in Belfast on the Sunday afternoon. Ulster sprint champion Frank O'Gara, from the Corrigan Athletic Club, had the honour of completing the last lap into the stadium. The earth was sprinkled onto the pitch by Cardinal John D'Alton to the applause of some 30,000 spectators.

CASEMENT PARK GETS THE NOD

In 1963 GAA Central Council decided to develop only one ground in each province; Casement Park was chosen in Ulster. With fresh funding available, work was carried out on the stand in 1966 when railings were set up to enclose a reserved seating area.

The last Ulster senior football final played at the park was on 25 July 1971, when Down defeated Derry by 4–15 to 4–11. On Monday 3 July 1972 British Army soldiers forced an entry into the ground and occupied it, an action that drew angry criticism from local residents and the GAA. On the day the army finally withdrew, 26 October 1973, vandals ransacked the park's buildings causing thousands of pounds worth of damage. After this had been made good, in 1975 Ulster Council named Casement Park as one of its three main provincial grounds, along with Clones and Breffni Park in Cavan.

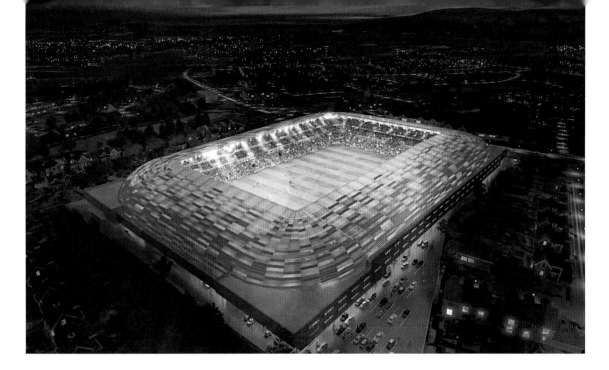

PROGRESS AMID A POLITICAL MAZE

By 1989 the stand needed re-roofing, which cost £40,000, and the following year new toilets were installed in the building. Press and broadcasting facilities were improved in 1991–92, when new turnstiles were also added and the parking area was refurbished.

In light of an improving political situation and the county board's ambition to host bigger games, in 1997 concrete terracing replaced the grass banks which surrounded much of the pitch. The ground's facelift was completed in 1999, leading to more championship games being played at what was now a 32,000 capacity stadium.

In 2006 proposals were raised to build a new multi-purpose stadium on the site of the old Maze prison near Lisburn, which would host soccer, rugby and Gaelic games. Ulster GAA was one of the partners in the project, but when opposition to the idea led to Ulster Rugby and the IFA to move on with renovating their existing stadia, the GAA pulled out in favour of remaining at Casement Park. This seemed a fortuitous move when the Northern Ireland Executive announced grant aid of £138m for stadium redevelopment projects throughout Northern Ireland in 2011. Ulster Council would receive £61.4m of this. Having hosted eight Ulster football finals between 1953 and 1971 and all of the Ulster senior hurling finals bar one from 1990 to 2012, the idea grew that Casement Park could become a 40,000 all-seated stadium with £15m in partnership investment from GAA Central Council, making it the largest stadium in Ulster.

The future looks bright – the upper reaches of the new stadium will be constructed of a translucent material that will be able to change colours depending on the event being hosted and means that the stadium is not a large, dark building in the centre of a residential area

A DECADE OF FALSE DAWNS ENDS AT LAST

In early 2012 it was announced that Casement Park would be upgraded and that work would start at the end of 2013; this was expected to last two years. Ulster GAA also planned to move their playing headquarters from St Tiernach's Park in Clones to Casement Park when it was completed. The park hosted its last Ulster SHC final on 8 July 2012 between Antrim and Derry and its final Ulster SFC match on 9 June 2013, when Monaghan defeated Antrim by 0–11 to 0–6. However, planning permission for the development – which had started off as an upgrade but morphed into a new stadium – would wait for several more years, and in the meantime the old ground lay idle.

In July 2021 permission was finally granted and then interrupted by a legal challenge which was overcome in May 2022 in the High Court. This ruling cleared the way towards the construction phase of the project, anticipated to start in 2023. The bowl-design stadium, developed by the architects behind Dublin's Lansdowne Road and Arsenal's Emirates ground, has a planned capacity of 34,500 and includes conference facilities, a social club and an education and heritage centre, all aimed at being 'a seven-day-a-week community hub supporting the social, economic and cultural development of the local area.'

McQuillan Park

LOCATION
Whitepark Road, Ballycastle

NAMED AFTER
McQuillan clan
Historic Antrim clan

OPENED
2007

CAPACITY
4,500

PITCH DIMENSIONS
145 x 88 m

COVERED ACCOMMODATION
No

FLOODLIGHTS
No

CLUB
McQuillan's

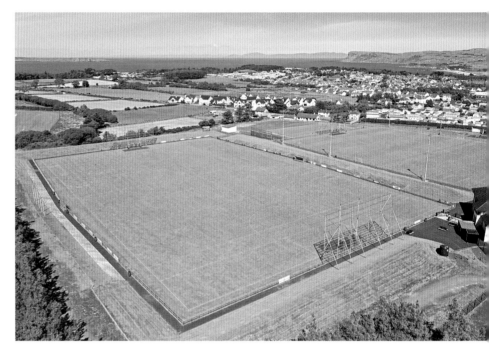

The McQuillan club has produced many Antrim county players over its history, with the Donnelly dynasty leading the way. The club holds 17 Antrim SHC titles, including two sets of three in a row. The club had three players on the team that contested the 1989 All-Ireland hurling final, Paul McKillen, and Brian, Dessie and Terence Donnelly.

The most northerly county ground in Ireland is also among the newest, opening as a completely new venue in 2007. The hurling tradition here, however, goes back to before the GAA, though it was not until 1907 that the first formal Ballycastle club affiliated. Ballycastle McQuillan Gaelic Athletic Club was founded in that year with Edward Donnelly as its first chairman and William Scally as secretary. In the early years they played their home games in a number of grounds in Ballycastle, while the town itself quickly became established as a hurling centre for north Antrim. The town hosted four consecutive Antrim SHC finals in 1912–15, most likely at Bonamargy on the eastern outskirts of Ballycastle beside the Glenshesk River – this land later became part of the town golf links. Leyland Road on the western side became the club's base from about 1920 and for the next few decades, though different fields in this vicinity were also used from time to time.

Set in the seaside town of Ballycastle, famous for its annual Auld Lammas Fair and for its hurling, McQuillan Park looks across to Scotland and the Mull of Kintyre

KEY DATES

1907
McQuillan's GAC is formed after many long discussions and debates in John O'Brien's barbershop

1909
McQuillan's win their first title, the North Antrim SHC. The Antrim SHC follows in 1913

1920–30s
Based at Leyland Road, McQuillan's add county junior and minor football titles to their record

1952–54
Club wins three consecutive county SHC titles

McQUILLAN CLAN

Club and ground were named in tribute to the McQuillan clan, who ruled part of north Antrim for several centuries. Traditionally they were described as descendants of the O'Neills, but the modern view is that the McQuillans descended from Hugh de Mandeville, who settled in Ulster during the 12th-century Anglo-Norman invasion. They assumed the Gaelic name Mac Uighilin – or McQuillan. Rulers of the Glens from the late 13th century, the McQuillans built Dunluce Castle as their principal residence. By the 1540s, however, Anglo-Scottish incursions in Ulster were beginning, and the McQuillans were eventually overcome by the McDonnells.

Ladies could sweet bake their way, free of charge, into the 1953 county championship victory party but gents had to stump up half a crown

> ### McQUILLAN G. A. C.
>
> You are hereby invited to Victory Party Celebration in Royal Hotel Hall on Wednesday 2nd December, 1953, at 9. 0. p.m.
>
> **Admission**
>
> Gents: 2/6 Ladies: Cake
>
> Ladies are requested to hand in cakes on Tuesday or at latest mid-day on Wednesday to one of the following: – Misses N. Harkin, E. Walsh, X. Jennings, T. Gallagher or E. Donnelly.

HOSTING INTER-COUNTY GAMES

The 1930s saw Ballycastle take its place as an inter-county venue. Antrim and Donegal dominated Ulster hurling and met in the Ulster SHC every year of that decade. Ballycastle's location suited the profusion of north Antrim and north Donegal players on these teams: for the Letterkenny and Inishowen men, as well as the men from the Glens, Ballycastle was probably easier to reach than Belfast. However, after Antrim hurlers won at Corrigan Park to reach the 1943 All-Ireland final, that venue grew in status, and from 1953 Casement Park's superior surface and spectator facilities copper-fastened its advantage.

BENMORE PARK

In 1964 club chairman Rev. F. C. Denvir suggested that McQuillan's should buy their own ground. Two years later they purchased a 7.5-acre site along Leyland Road costing £1,126.10 from Danny McCouaig, a club supporter. Over the following few years, a pitch was laid, a pavilion built and a perimeter wall erected. The ground was opened in 1970 by GAA President Pat Fanning and named Benmore Park in memory of John 'Benmore' Clarke, a Ballycastle native and famed author of stirring prose about local and national affairs, not least hurling.

NEW ERA ON A BRONZE AGE SITE

The club's growth and expansion gradually created a need for a second playing field, but Benmore Park was too small to provide it. The club bought a 17.5-acre site at nearby Whitepark Road in 2003. Development work uncovered the remains of a Bronze Age settlement, which slowed progress, but the project was completed in 2006 and officially opened and named McQuillan Park in 2007, the club's centenary year.

Continued improvements brought two full-sized pitches, floodlit facilities, a training area, a hurling wall and multi-purpose clubrooms, as well as a wind turbine on site. Ballycastle received the Antrim and Ulster GAA Ground of the Year awards in 2012, and the protracted closure of Belfast's Casement Park brought further opportunities to showcase the new ground. Throughout its recent history McQuillan Park has hosted all but one Antrim SHC final from 2013 to 2020, seven NHL games between 2014 and 2016, and three Leinster SHC matches. The park was again selected in 2015 as the Best Club Ground in Antrim.

Redevelopment will eventually restore the primacy of Casement Park. Yet many supporters may long for a day out in Ballycastle, to see Antrim hurlers playing amid the glory of the Glens, against the backdrop of Knocklayde mountain.

1980
McQuillan's is the first Antrim team to contest an All-Ireland club hurling final, losing narrowly to Castlegar of Galway by 1–11 to 1–8

2007
The new ground is opened with Páirc Mac Uilín emblazoned large on its entrance gates

2015
Antrim defeat Laois in a 63-point thriller in the Leinster SHC in Ballycastle on 3 May

2020
Dunloy defeat Loughgiel as the ground hosts its seventh Antrim SHC final since 2013

Fr Healy Park

LOCATION
Lough Road, Loughgiel

NAMED AFTER
Fr John Healy (1872–1928)
Parish priest, club supporter

OPENED
1955

CAPACITY
3,500

PITCH DIMENSIONS
143 x 87m

COVERED ACCOMMODATION
No

FLOODLIGHTS
No

CLUB
Loughgiel Shamrocks

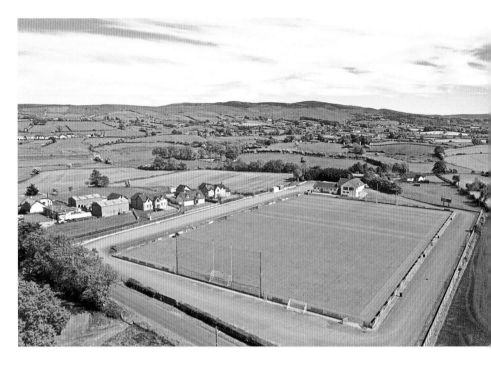

Catering primarily for hurling and camogie, Loughgiel Shamrocks hold a unique record in Ulster hurling, having won two All-Ireland Club SHC titles. Among the club's star hurlers are Aidan McCarry, Dominic McKinley, Niall Patterson, Dominic McMullan, and possibly one of the most skilful, Liam Watson.

The Ordnance Survey parish memoirs for Co. Antrim, compiled in the 1830s, noted that in Loughgiel 'Their principal amusements are dancing, cards and cock-fighting. The latter are on the decline. A sort of hurling, or "cammon playing" as it is called in the North, is still kept up here chiefly among the Catholics.'

Fr Healy Park was originally two fields and required an enormous amount of work, much of it done voluntarily, to convert them into a pristine pitch

Loughgiel's introduction to hurling under GAA rules came in 1904 courtesy of the Tír na nÓg club, who played their early matches in Alex McCloskey's Field outside the village. They practised by taking on their near neighbours Carey Faughs and Cushendun on the Antrim coast.

Loughgiel had another club by 1907, Dalriada, while one of the first mentions of Loughgiel Shamrocks was recorded in 1911 when the club was represented by Eddie McCormick at a county committee meeting on 13 August. Loughgiel Shamrocks played their games all over the parish, in nine different fields stretching from the top of Corkey to the foot of Magherahoney.

KEY DATES

1929
Shamrocks win a fourth Antrim SHC title, defeating O'Connell's of Belfast in the final

1947
Loughgiel wins the Antrim Senior Camogie Championship for the first time

1953
Club adopts red jerseys after previously playing in blue and later in saffron

1958
Ground hosts inter-provincial Ulster vs Munster camogie match on 5 October

1968
Fr Healy Park hosts the All-Ireland U21 hurling semi-final, Antrim vs Cork

FR JOHN HEALY

John Thomas Healy was born in Ballyveely Upper, Ballymoney, Co. Antrim, to John and Catherine Healy. His father served in the RIC and was domiciled in the Loughgiel constabulary barracks, just across the road from the present pitch. John went to Maynooth College and was ordained in 1898. He became parish priest of Loughgiel in 1919 and a stalwart supporter of his local club.

SMOOTH TRANSITIONS

Changing from one pitch to the next didn't seem to hinder Loughgiel Shamrocks' hurlers. In 1919 they won the North Antrim League and followed up with the 1920 Antrim SHC title, played in June 1921.

FROM BOYLE'S FIELD TO CROKE PARK

Loughgiel Shamrocks won the Antrim SHC in 1938, the first year the competition was played on an all-county basis. The outbreak of WWII brought a pause to the club's success but in 1943 they defeated O'Connell's in Boyle's Field, Ballyknock, to take the title once more. Three Loughgiel players lined out for the Antrim team that was defeated by Cork in the All-Ireland SHC final that September.

SHAMROCKS PUT DOWN ROOTS

Setting out to find their own ground in 1952, the club bought land from Brigid McAleese at a cost of around £1,500 and then exchanged it for two fields belonging

BOBBY McILHATTON

SPORTSFILE

A FAMILY TRADITION

When Lucia (above) and Úna McNaughton and Katie, Maria and Annie Lynn lined out for Loughgiel Shamrocks in the All-Ireland Senior Camogie Club Championship final against Sarsfields of Galway in 2022, they brought a remarkable record of family history onto the pitch. Their grandmother, Mary McGarry, had played on the Antrim team that won the All-Ireland Camogie Championship three times in a row in 1945–47.

to local farmer Eddie McAleese on the Lough Road. Senior club members Eddie Connolly and Brendan Carey organised an army of volunteers to clear the fields of stones, fences, hedges and ditches, while a bulldozer from the McGuckians of Cloughmills helped to level the ground. A pavilion, dressing rooms and ladies' and gents' toilets were also built bringing the overall development cost to circa £2,000. Fr John Healy Memorial Park was officially opened by Loughgiel man Dr Cahal Daly, later Cardinal Daly, on 22 May 1955.

UPGRADING FACILITIES

Under the guidance of Denis McIntyre and Anthony Waide, new dressing rooms were built, largely by voluntary work, and opened on 17 August 1980. The committee also purchased pockets of ground to provide a parking area beside the pitch.

BUILDING ON ALL-IRELAND GLORY

Loughgiel created history in 1983 when they became the first Ulster club to win the All-Ireland SHC title. They enlarged on their success two years later when they acquired a 100-year lease on parish ground from the then parish priest, Fr John Barrett. Sitting 700m from Healy Park on the Lough Road, this was developed into a full playing pitch and named Fr Barrett Park in memory of the club's benefactor. New clubrooms and changing rooms were built at Fr Healy Park in 2001. The club also bought land adjacent to Fr Barrett Park where they built two all-weather training pitches and a third playing pitch, completed in 2022 with the help of an Ulster Council grant.

1983
Fr Healy Park's greatest day, 13 February, when Loughgiel defeat Moycarkey–Borris on way to becoming Ulster's first All-Ireland Club hurling champions

1990
Antrim play Dublin at the official opening of Fr Barrett Park on 27 May, while Loughgiel hurlers face Dunloy

2012
Club win their second All-Ireland Club SHC title, defeating Coolderry of Offaly in the final

2022
Camogie team lose to Sarsfield's, Galway, in All-Ireland club final

Athletic Grounds

LOCATION
Dalton Road, Armagh City

OPENED
1936

CAPACITY
18,500

PITCH DIMENSIONS
141 x 82.5m

COVERED ACCOMMODATION
East Stand,
Drumarg Terrace

FLOODLIGHTS
Yes

CLUB
No, but has a historic
connection with Pearse Óg

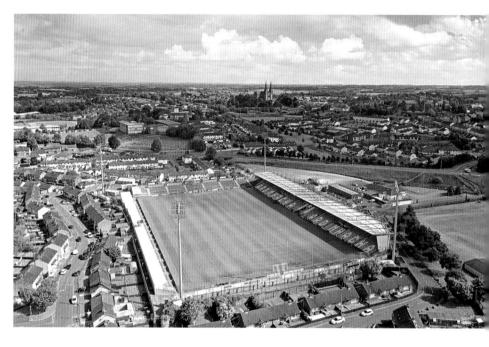

Formed in 1950, Pearse Óg won their first Armagh SFC title in 1985. The club helped the Athletic Grounds regain its status through the 1980s, when it hosted the 1985 All-Ireland SHC semi-final and the 1989 Ulster SHC final – the first such fixture since 1946. The club acquired its own ground, Pearse Óg Park, on the western outskirts of Armagh, in 2007.

Football matches were played at a number of grounds in Armagh city – among them Abbey Park, Rock View, Duke's Grove and Armagh Seminary – before the Gaelic Field, as it was known, emerged as the Armagh Athletic Grounds in the late 1920s.

The Athletic Grounds nestles neatly into the urban landscape and is only a stone's throw from Armagh's famous cathedrals

'Athletic Grounds' was used as a generic name for urban GAA parks. The association remained active in organising track-and-field athletics into the 1920s, and so the moniker was apt to convey their grounds' multi-sports functions. The Athletic Grounds of Cork and Dundalk were the chief examples between 1900–25.

Eight special trains carried passengers from all over the north to Armagh Athletic Grounds' first showpiece event – the 1927 Ulster SHC semi-final between Antrim and Donegal, followed by the Ulster SFC final, Armagh versus Monaghan. The pitch was reportedly quite narrow and had a slope too. Armagh led 2–5 to 1–2 after 'playing downhill' in the first half, but after the turnaround it was all Monaghan, who came out on top, 2–5 to 3–5.

KEY DATES

1891
Cavan defeat Antrim at the home of Armagh Harps on 17 October in the first Ulster championship to be played in Armagh

1927
Armagh Athletic Grounds hosts its first Ulster SFC final as Armagh play Monaghan on 31 July

1930s
Park hosts prominent exhibition games: Armagh vs Garda 1930; Armagh vs Dublin and Ulster select vs Garda 1931; Dublin vs Clare hurling tie 1933

1947
When Davitt Park opens in Lurgan the Athletic Grounds loses its status as the leading county ground, a situation that continues until the late 1970s

NOT STANDING ON CEREMONY

Armagh County Board set about purchasing the Athletic Grounds in 1935 and clinched the deal at a price of £1,000 the following year, helped by donations from the clergy, the Feis Committee and a number of private individuals – contributions from people like Gerry Arthurs, P. J. O'Neill and Alf Murray were crucial. Unlike other county grounds in Ulster, which were launched with great fanfare, the Athletic Grounds had no official opening ceremony. By the same token its name survived by custom, without any proposals to change it. The ground barely changed either.

Sitting on the outskirts of Armagh, farm animals grazed on the county board's land on the Irish Street side, while on the other the gable end of John Kirk's Scotswell House stood close to the 14 and 21 yard lines. The cows and hens in the farmyard were kept inside during a game, and after the match the gate money was counted in Kirk's kitchen.

FANS GIVE REF HIS MARCHING ORDERS

In 1938 the park was the scene of a famous Ulster SFC semi-final, when Armagh defeated a Cavan side that had been champions for seven years. Weeks later the ground hosted the Ulster final, but the referee, Monaghan's nominee, vexed many of the 7,500 spectators with his decisions, and when Monaghan won he was attacked as he left the field.

CENTREPIECE OF THE CITY

Armagh's Young Ireland's and Tír na nÓg clubs and the county teams all used the Athletic Grounds. The county board decided to give local clubs the authority to manage the ground and its development, and though improvements were modest, not least because of the shortages caused by WWII, they continued through the 1940s and '50s. The hill at the top end of the pitch was levelled and seating installed at one side using

sleepers from the defunct Great Northern Railway. Later this was replaced by concrete and the field was enclosed by a wall. During the 1960s grants from the GAA helped to install an extensive drainage scheme, dressing rooms and a scoreboard for matches. In the 1970s Pearse Óg Club, which had no ground of its own at the time, settled into the Athletic Grounds, building a social club and improving the player facilities.

ORCHARD COUNTY HEADQUARTERS

In 1982 the ground was closed for major refurbishment. It reopened in the GAA's centenary year, 1984, with a challenge match between Armagh and Dublin. The complex now included a new Armagh GAA headquarters, a handball alley and an extended and re-seeded playing area. However, the cost of maintaining the ground proved too much for the Pearse Óg club, who handed it back to the county board in 1990.

SUPPORTERS TAKE A SEAT FOR LIFE

Ulster Council announced an upgrade to the stadium in 2002. The withdrawal of pledged UK National Lottery funding of £2m threw the project into jeopardy but new Sports Council NI funding, grants from Ulster Council, Central Council, local council and donations of £1,000 each from clubs accounted for £3.5m, which was enough for progress to be made. Floodlighting installed in 2008 brought the total cost of the development to £4.6m.

With the county board now facing a deficit of over £1m, a supporters network, 'My Armagh,' was set up to clear the debt, and launched innovations such as a 'Seat for Life' for each £100 donor. A new stand was constructed in 2010 and the new and vibrant stadium was reopened officially on 5 February 2011 with an NFL match between Armagh and Dublin.

Clann Éireann club man Alf Murray, a former Armagh star and future GAA president, played a pivotal role in the development of the Athletic Grounds

1950s	1982	1980s	2008	2023
Athletic Grounds become the regular venue for NACA inter-county athletics contests for the Primate's Shield / Cardinal D'Alton Games	*The ground is closed for major work; the pitch is widened, lengthened and re-seeded*	*Men sit on the roofs of local houses to watch matches in a packed-out park*	*Games resume following a six-year closure, but the ground closes again in 2010 to build a new East Stand and new indoor facilities*	*Derry defeat Monaghan as ground hosts All-Ireland MFC final*

Davitt Park

LOCATION
Francis Street, Lurgan

NAMED AFTER
Michael Davitt (1846–1906)
Land League leader, MP,
journalist, GAA patron

OPENED
1947

CAPACITY
4,000

PITCH DIMENSIONS
149 x 81 m

COVERED ACCOMMODATION
No

FLOODLIGHTS
Yes

CLUB
Clan na Gael

The club dominated Armagh
football from the late 1960s for
a ten-year period. Central to that
success was talented footballer
Jimmy Smyth, captain of the
county team that contested the
1977 All-Ireland final against
Dublin along with Colm
McKinstry. Club men Diarmaid
Marsden and Barry O'Hagan
played in Armagh's landmark
All-Ireland victory of 2002.

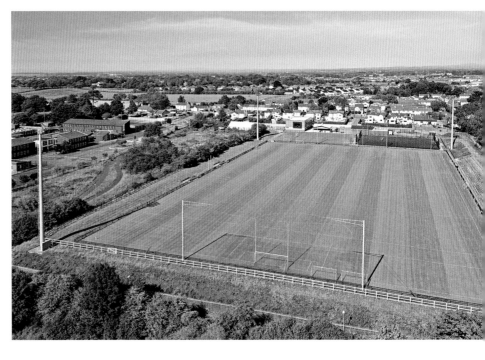

Lurgan's first GAA club was Lurgan Gaelics, who played football in 1888. Michael Davitt GAA Club, based in the Francis Street / Silverwood area, was formed in 1909. They petitioned to play their games in Co. Antrim, arguing that it would be impossible for them to take part in the Armagh championship because the district they would have to pass through was hostile to Sunday games and that would probably arouse bad feeling locally. An Ulster Council meeting considered the matter in September 1910 and agreed that Lurgan town should be considered part of Co. Antrim for GAA purposes, and play their matches under the auspices of the Antrim County Board.

The carefully planned and well managed work carried out in recent years at Davitt Park has transformed it into a fine modern sports facility

The Davitt's club disbanded in 1921 but they reformed the following year under the new name of Lurgan Clan na Gael. Glenavon soccer club offered them a set of jerseys as a gesture of support, and Clan na Gael added a GAA crest to the shirts to complete their new kit.

KEY DATES

1922
Lurgan Clan na Gael
GAC is founded in the
premises of the Lurgan
Catholic Association

1944–46
The slope at Francis Street is
levelled, embankments built,
and a cowshed is converted
into a pavilion

1947
GAA President Dan O'Rourke opens
the park. Ten seconds of colour film
of the pre-match parade survives –
perhaps the earliest known
colour footage of a GAA event

1950
Davitt Park hosts its first-
ever county SFC final
between Clan na Gael
and St Peter's

MICHAEL DAVITT

Michael Davitt, co-founder of the Land League, was also an MP in the 1880s and '90s and a journalist of note. Davitt was one of the GAA's first patrons (and a patron of Glasgow Celtic FC). When a group of athletes became stuck in America during an exhibition tour to promote Gaelic games in 1888, he paid £450 to settle their bills and enable them to return home. The GAA failed to reimburse him. Davitt Park is the foremost memorial to the man in the GAA today.

PUBLIC BACK FUNDRAISING DRIVE

Lurgan Gaels met at the Cumann Gaedhealach premises on 1 June 1944 with the aim of securing 'the first permanent and suitable home for Gaelic Games in the North Armagh area.' The initiative was the brainchild of Alf Murray of the Clann Éireann club. He had recently retired as an Armagh and Ulster player, and with his hallmark organisational skills an executive committee and seven subcommittees, including the Davitt Park Field Committee, were set up and quickly got to work.

Fundraising produced £803 within nine days, and 60 house-to-house collectors gathered £450 inside three weeks. £2,000 was reached within two months, covering the asking price of £1,600 for the land at Francis Street owned by local GP Dr Michael Deeney. Carnivals, tournaments, American donors, a prize draw for a bull calf and social events, along with grants from Central Council, Ulster Council and Armagh County Board kept things moving. 1,737 subscribers were listed in the booklet for the official opening, from James Tipping's £100 donation to Mrs Berry's threepence.

Torrential rainfall flooded the pitch on the morning of the official opening on 1 June 1947 and volunteers rushed to join Lurgan fire brigade to pump the water away. Sunshine returned in the afternoon as the ground was opened and named Davitt Park.

ARMAGH'S NUMBER TWO

Davitt Park was popular for prominent games for about 35 years. Having the best spectator facilities in the county for much of this period, it staged many of Armagh's NFL and Ulster SFC matches, and seven Ulster SFC semi-finals. The park continued as the county's second ground into the 1980s, but from the 1990s onwards lost out on major games. Incidents in the Troubles proved damaging, but neither were facilities significantly enhanced, drainage problems persisted, and no stand was built. Armagh's revamped Athletic Grounds and Crossmaglen came to dominate fixtures schedules.

Volunteers deal with the deluge that flooded Davitt Park on opening day in June 1947

GRANT-AIDED DEVELOPMENT

In 2009 Clan na Gael launched a redevelopment plan and the park closed for two years as the pitch was resurfaced, a multi-purpose games area laid, and terracing and floodlights installed. The club raised £500,000 and received the same amount from the Department for Communities in matching funds. The ground reopened in April 2012. Six years later a new-build clubhouse comprising dressing rooms, meeting rooms, kitchen and viewing area was opened. The £600,000 cost was offset by a £500,000 grant from the Department of Social Development. In 2021 the club adopted a comprehensive new three-year strategic plan that aims to build a covered stand and resource Davitt Park still further.

1974	1982	2012	2018	2022
Clan na Gael defeat UCC at Davitt Park to reach the All-Ireland club SFC final for the first time	Armagh scores six goals against Kerry in NFL tie at Davitt Park, winning 6–7 to 4–8	Clan na Gael ladies football club founded and wins the 2019 junior county title	New clubhouse complex opens while the original clubhouse continues to be used as a gym	Clan na Gael celebrates its centenary

St Oliver Plunkett Park

LOCATION
Dundalk Road, Crossmaglen

NAMED AFTER
**Saint Oliver Plunkett
(1625–1681)**
Archbishop of Armagh

OPENED
1959

CAPACITY
5,000

PITCH DIMENSIONS
145 x 86 m

COVERED ACCOMMODATION
Cardinal Tomás Ó Fiaich Stand

FLOODLIGHTS
No

CLUB
Crossmaglen Rangers

One of the greatest clubs of all time, winning six All-Ireland, 11 Ulster and 46 Armagh titles, Rangers were backboned over many years by local families such as the McConvilles, McEntees, Hanrattys and Kernans.

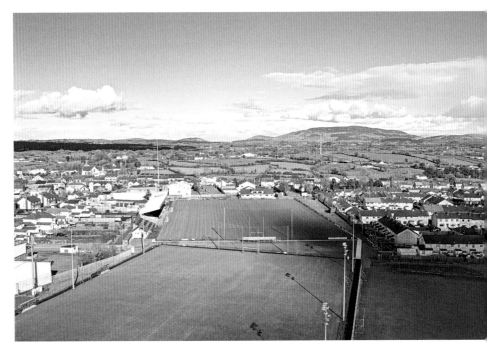

Crossmaglen's first GAA club, Red Hands, was founded on 1 October 1887. The club changed its name to Crossmaglen Rangers in 1909 and topped the Armagh SFC roll of honour for decades. They played on various local fields – at Monog, Crinkill, McConville's Field on the Culloville Road and McConville's Meadow on the Castleblayney Road, as well as Willie Hale's Field on the Dundalk Road. Between the 1920s and '40s they turned to the Schoolhouse Field on the 'Blayney Road. This pitch was renowned for its heights, hollows and bushes – visiting Lurgan clubs dismissed it as 'a golf course.'

Plunkett Park looks over a wide expanse of land taking in Armagh, Louth and Monaghan, a landscape criss-crossed by the border but united in sport

Following a meeting between the club's committee, the parish priest and the town's principal businessmen in 1949, Crossmaglen Rangers decided to purchase their own grounds. Though the club had little money in the bank, four fields comprising eight acres on the Dundalk Road were bought from Joe Fitzpatrick for £1,200. A club official ceremonially turned the first sod in April 1950.

KEY DATES

1909
Club name Rangers and black-and-amber colours adopted at a meeting in Owen Traynor's pub

1959
3,000 watch Meath play Derry at the park's official opening on 19 April

1967
Crossmaglen Rangers complete a three-in-a-row of Armagh SFC titles

1979
Ulster GAA clubs and senior national GAA officials join protest marches in Crossmaglen

1985
New Ó Fiaich Cup brings inter-county football back to Plunkett Park and becomes an annual four-team tournament

OLIVER PLUNKETT

Following the trumped-up 'Popish Plot' of 1678, Archbishop of Armagh Oliver Plunkett was found guilty of high treason in 1681 'for promoting the Roman faith' and was hanged, drawn and quartered at London's Tyburn. The last Catholic martyr to die in England, he was canonised in 1975, becoming the first Irish saint for almost 700 years.

HE WHO PAYS THE PIPER...

As the committee decided against raising a large overdraft, the process of field development took longer than most. Grants of £200 each from Ulster Council and Central Council raised a third of the purchase price. A supporters' subscription scheme generated another £500. The club's amusements committee raised £1,200 inside a year. The club ran *céilithe* also, though the inclusion of old-time waltzes brought criticism from the county board for being in breach of the GAA's 'céilí music only' rule. Rangers' Hall was opened on 20 December 1953, and in 1959, ten years after the initial purchase, Blessed Oliver Plunkett Park was officially opened by Fr Tomás Ó Fiaich. The best-equipped field in south Armagh was soon drawing high-profile games.

TROOPS IN AND OUT

The ground lost its position abruptly when the Troubles intensified in south Armagh. Soldiers from the adjacent British Army base began playing soccer in the park during 1971 and to land helicopters during games. In May 1972 soldiers landing from a helicopter made to clear the pitch, knocking a Silverbridge player, Patrick Tennyson, unconscious with a rifle and injuring several spectators. The army demolished part of the perimeter wall to allow ease of access to their barracks and requisitioned some of the club's land for a helicopter pad, which frequently churned up the pitch.

These events caused uproar in Crossmaglen. The Rangers mounted protests, finally suing the British government and winning a £150,000 out-of-court settlement in 1985.

Eventually, as the peace process took hold, the army returned the club's land in 1999. This move was a catalyst for the removal of Rule 21 – the GAA's ban on members of the Crown forces – two years later.

RANGERS' GLORY YEARS

The end of the occupation enabled Rangers to renovate their grounds, and Plunkett Park started to host NFL and McKenna Cup games. A new 1,200-seater covered stand, the Cardinal Tomás Ó Fiaich Memorial Stand, opened on 23 March 2003. The main pitch was reconstructed with a state-of-the-art Prunty playing surface. Crossmaglen served for a while as the main county ground while Armagh Athletic Grounds were being refurbished.

Rangers' upsurge also had a transformative effect: a prolonged period of dominance in the Armagh SFC from the mid-1990s yielded a series of 11 Ulster titles and six All-Ireland club victories between 1996–97 and 2011–12.

In 2022 the club set up a GAA for All programme to cater for children with special needs, with the highlight of the year being a visit to Croke Park. Future plans envisage floodlighting, terracing on the Lismore side, a new dressing room complex and gym, upgraded training facilities and the creation of a walking track around the ground.

CROSSMAGLEN RANGERS

A remarkable photo circa 1976 shows Brendan Bellew's lorry ferrying players from the dressing rooms to the pitch through a quagmire created by the activities of the British Army

2002
Club is awarded £450,000 from the British government for the occupation of their ground

2010
100 years after first Ulster SFC match played in Crossmaglen, town hosts its first qualifier game

2020
Park hosts All-Ireland IFC semi-final; Magheracloone (Monaghan) defeat Mattock Rangers (Louth) on 11 January

2022
Club is one of ten Ulster clubs to take part in the GAA Green Club Project based on UN Sustainability goals

Breffni Park

LOCATION
Park Lane, Cavan

NAMED AFTER
**Medieval Gaelic kingdom
of Bréifne**

OPENED
1923

CAPACITY
25,264

PITCH DIMENSIONS
143 x 86 m

COVERED ACCOMMODATION
Yes

FLOODLIGHTS
Yes

CLUB
No

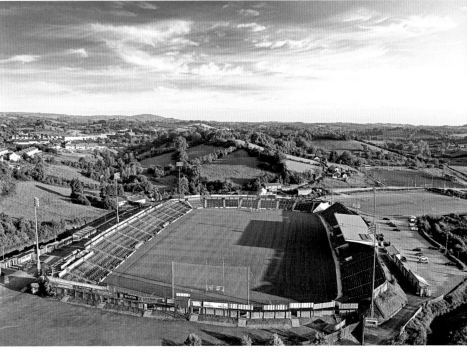

*Set in a natural amphitheatre
and covering an area of 27
acres, complete with practice
and all-weather pitches,
Breffni Park can claim to be
one of the neatest and most
innovative county grounds
in the country*

Breffni Park was developed against the backdrop of the Civil War and opened on 22 July 1923 with GAA President Dan McCarthy and Frank Fahy – pro- and anti-Treaty TDs respectively – sharing the same platform, an achievement no other organisation had accomplished at that time.

Until then games had been played in a variety of grounds in Cavan town, including the Showgrounds, while many of Cavan's home fixtures were played in Cootehill or Belturbet. Following a meeting on 5 November 1922 between Cavan UDC and Cavan County Board, a committee chaired by B. C. Fay set about acquiring a county ground and found two fields at Rosculligan belonging to Arthur Roy Taylor. 'The preliminary enquiries were carried out with the greatest secrecy,' Cavan Slashers club official Eugene Smyth recalled. Thomas McGuinness, a council clerk, handled the negotiations. The sale was agreed in early December and just a few months later the Cavan Athletic Grounds, later Breffni Park, became the first ground in Ulster to be vested in the GAA.

KEY DATES

1922
*GAA buys land at
Rosculligan, which
includes a third
field overlooking the
Green Lake, for £700*

1923
*Cavan defeat Monaghan
in Breffni Park's first
Ulster SFC final on
29 September*

1923
*Cavan defeat Monaghan
in Breffni Park's first
Ulster SFC final on
29 September*

1952
*Ground hosts the Ulster
SFC final on 27 July
when Cavan defeat
Monaghan 1–8 to 0–8*

1976
*Refurbished ground
hosts Cavan and
Donegal in the
Ulster SFC*

BREFFNI

Bréifne – more often spelled in the anglicised form Breffni – is now synonymous with Co. Cavan, due in no small part to the name of the GAA park, but it was not always so. The historical kingdom of Bréifne was a region stretching from areas of modern Leitrim and Sligo to parts of what is now Meath.

KINGDOM OF
Bréifne

BREFFNI AND CAVAN GLORY DAYS

Over the next 14 years the park hosted many high-profile games, including four All-Ireland SFC semi-finals in 1928, '31, '33 and '37. A reported crowd of 17,111 saw Cavan snatch a famous victory in 1933 over a Kerry side chasing its fifth All-Ireland in a row. Instead, Cavan went on to defeat Galway and win Ulster's first All-Ireland SFC title.

The park became a fortress for Cavan, who won 20 Ulster SFC matches at Breffni Park from its opening in 1923 until 1953. Even so, after hosting its seventh Ulster SFC final in 1943 the ground's stock dropped. In October 1948 the Ulster Council voted that Ulster's two provincial grounds would be in Clones and Belfast and refused Breffni Park this status.

Cavan County Board responded by launching a redevelopment plan. The purchase of seven adjoining acres in 1948 allowed the pitch to be enlarged, with the orientation changed from east–west to north–south, and sideline seating was provided for over 6,000 spectators. Having been closed for two years, the park was reopened by GAA President M. V. O'Donoghue on 8 June 1952 and it hosted that year's Ulster SFC final. However, Breffni's ninth Ulster final in 1963 proved to be its last, and without the revenues these finals brought, and Cavan's lack of provincial honours, from 1969 Breffni Park began to decline.

THE ANGLO-CELT

FORTUNES REVIVED IN THE 1970s

The Breffni Park Redevelopment Committee came together in 1972 with the aim of reviving the stadium. A new stand, new dressing rooms with showers, players' dugouts, press box and a new scoreboard were constructed. A new boundary wall and access road were laid, the playing area was fenced in, and a new entrance with eight turnstiles were all in place by 1978. Over £120,000 was spent on improvements over a six-year period. They yielded some rewards for Breffni Park. Ulster SFC semi-finals returned from 1979 until 1988, as did NFL quarter-finals and Railway Cup fixtures (including the 1983 football final), but no Ulster final was forthcoming

THE CALL OF HOME

A stone plaque outside the ground honours local hero Willie Doonan, a legend of Cavan football and two-time All-Ireland senior medal winner. The much-loved, free-spirited character joined the British Army and fought in Italy during WWII. One well-known anecdote told about him describes how Willie's army buddies feared that he'd been killed in action only to find him later up a tree with the platoon radio trying to tune into the 1943 Cavan vs Roscommon All-Ireland final.

AN EYE TO THE FUTURE, A VIEW OF THE PAST

Undeterred, the county board embarked on further plans between 1981 and 1985 when substantial work was carried out on the embankments and the purchase of additional land gave greater access to the ground.

Ten years later Breffni Park closed again as a sand-based Prunty pitch was laid and the main stand extended, including a VIP area. Cavan County Board purchased more land in 2019 to house the Polo Grounds Centre of Excellence. Under the 'This is Cavan' initiative, GAA President Larry MacCarthy opened The Breffni Gallery at the ground on 24 September 2022, an exhibition celebrating the heritage and achievements of the GAA in Cavan.

1979	2003	2006	2013	2023
Cavan play old rivals Kerry at ground re-opening on 13 May	Eight acres of land adjacent to park purchased for training grounds	Interprovincial football semi-final is first game under new floodlights	Park hosts the first Men's International Rules test, Ireland vs Australia	Innovative sensory room opened by All-Star footballer Raymond Galligan and golfer Shane Lowry

Hugh O'Reilly Park

LOCATION
Church Street, Cootehill

NAMED AFTER
Hugh O'Reilly (1904–1976)
Member of the Defence Forces, footballer, coach, administrator

OPENED
1981

CAPACITY
4,000

PITCH DIMENSIONS
140 x 82 m

COVERED ACCOMMODATION
Yes

FLOODLIGHTS
No

CLUB
Cootehill Celtic

The club's greatest footballer, Charlie Gallagher, made his senior debut for Cavan aged 17 and led Cootehill to two county titles in 1954 and '55. The club's hurling team has contested eight senior county finals in the ten years between 2013 and 2022, winning five.

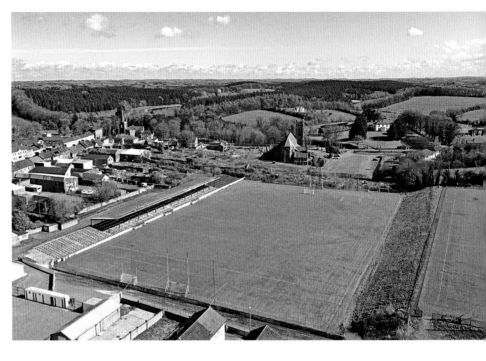

Cootehill Celtic was formed in 1894 by followers of Glasgow Celtic soccer team. Tommy McBreen, Mr McCudden and Tom Kelly had all worked in the Scottish city, and were joined by Micky Lynch, a fan of his native Belfast Celtic. Though their original idea may have been to set up a soccer club, others wanted to play Gaelic games, and in the end that's what they agreed. The club kept the Celtic tag, though, and the famous green and white hoops.

Cootehill played their first recorded Gaelic football match that March against Drung. After playing on the Fair Green and Castle Dawson Hill, the club soon had a pitch made available to them thanks to the Moorehead family from Errigal. The Meadow, as it was known locally, was officially named Celtic Park on 29 June 1905, and as one of the few full-sized pitches in the county hosted its first Ulster championship match, the 1906 tie between Cavan and Monaghan, on 21 April 1907.

Players are literally playing ball in the back garden when they take to the field in Hugh O'Reilly Memorial Park. The impressive ground began life as 15 privately owned town gardens

KEY DATES

1920
Celtic Park ground purchased for the parish by Fr Patrick O'Connell for £300 on 10 April

1924
G.V. Maloney, solicitor, donates a cup for a football tournament played to raise funds to clear the debt on the field

1932
Cootehill Celtic's hurlers win their first county senior title

1953
Start of club's golden era, winning the first of a three-in-row of Cavan SFC titles

1969
Profitable bingo sessions in St Michael's Hall lead fundraising drive

HUGH O'REILLY

Cork-born Hugh (Hughie) moved with his family to Tullyin near Cootehill when he was 16. He won three All-Ireland medals with Cavan, junior in 1927 and senior in 1933 and '35. He went on to be the team's trainer when Cavan won the All-Ireland SFC in 1947, '48 and '52, as well as National League titles in 1948 and 1950. Hughie also coached Cootehill to win the Cavan junior championship in 1952 and to three consecutive Cavan SFC titles in 1953, '54 and '55. He served as the club's vice-chairman and president during the 1950s and '60s and was presented with the Cavan GAA Hall of Fame Award in 1975.

LEO'S PLAN PROVES TO BE A BLESSING

Unfortunately, the park, situated beside the Annalee River, was prone to flooding, and very little development happened through to the 1950s. Alternative fields were looked at before Leo Blessing, whose family was connected with the local GAA since 1894, came up with a radical proposal: to purchase 15 gardens stretching from St Michael's Church on Station Road up to what was then Cootehill Poultry Products in Church Street. Many of the gardens were overgrown and it was in this wilderness that Leo proposed siting a new football pitch.

HARVESTING THE GARDENS

The project was a legal nightmare. Each owner had to agree to sell, as did the ground landlord, Brigadier O'Gorman. Nonetheless, in early 1962 the area was mapped out, boundaries were identified and the

THE ANGLO-CELT

Hughie O'Reilly (left) with his 'gallant' captain John Joe Reilly and the Sam Maguire in 1948

HUGHIE'S COMMANDMENTS

As a coach O'Reilly was a strict disciplinarian but with a gift for inspiring his charges. He focused on the basic skills of catching, kicking and passing the ball and set out his philosophy in 28 short rules, the last of which stated:

❝ **Go out and win but for God's sake, play the game** ❞

process was handled free of charge by solicitor T. P. O'Reilly, who was also Cavan County Board chairman. By 1968 the individual owners were on board and the total price for the gardens came to approximately £3,000. That August some 40 volunteers led by Herbie Clegg set about clearing and burning the overgrown shrubbery, armed with slash-hooks, spades and shovels.

EFFORT YIELDS REWARDS

Work on facilities had not been completed when the first game was played on the new pitch on 3 May 1975. Dressing rooms were built in 1977 and in 1980 sideline seating, terracing and a stand were constructed. The covered, seated accommodation was one of the first at any GAA pitch in Ulster. The years of effort came to fruition when GAA president-elect Paddy Buggy performed the park's official opening on 31 May 1981, with the Artane Boys Band in attendance. The club's ambition was to be able to host an Ulster senior football final at the venue.

NURTURING A PROUD HURLING LEGACY

Cootehill Celtic can lay claim to be the only dual club in Cavan. Their hurling history goes back a long way but the game had all but died out in the mid-'80s. In 2004 a hurling subcommittee was formed to revive hurling from underage level. They fielded an U10 team that year with the stated aim that ten years down the line they'd be competitive again in the Cavan SHC. True to their word, in 2014 Cootehill won their first SHC since 1965 and followed it up with two more in 2015 and 2016. Their success continued with two championship wins in a row in 2021 and '22.

1971
Bulldozers level new ground; an embankment is built in 1974–75

1981
Monsignor James O'Reilly, who had helped to re-establish the club in 1930, blesses the ground at its official opening

1990
New entrance and tunnel leading from dressing rooms are built

2018
Club lays out a second pitch, which is completed in 2022

Ó Raghallaigh Park

LOCATION
Corrygarry, Kingscourt

NAMED AFTER
The Gaelic Ó Raghallaigh and O'Reilly clan

OPENED
1951

CAPACITY
2,500

PITCH DIMENSIONS
141 x 82m

COVERED ACCOMMODATION
Yes

FLOODLIGHTS
Yes

CLUB
Kingscourt Stars

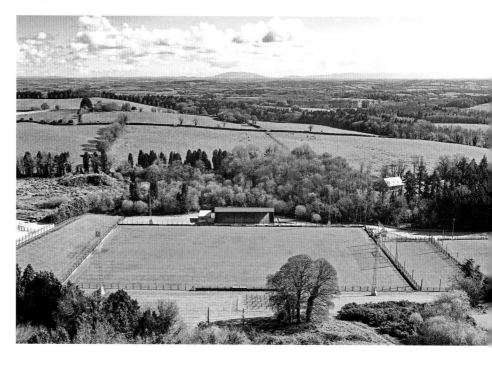

Kingscourt Stars dominated senior football in Cavan throughout the 1980s and early '90s, winning eight county titles in 14 years. Included in the list of key players for the club at the time were Jim Reilly and the Faulkner, McCaul and McCormack brothers. Padraig Faulkner won a prestigious All-Star Award at the full-back position in 2020.

Kingscourt GAA Club, founded in 1890, was the only Cavan club still affiliated six years later. For a time in the 1900s the club was called Kingscourt Sinn Féin. They played in Carney's Field on the Kells Road before setting up the Cabra Park Gaelic Athletic Sports Ground Committee in 1948 under the chairmanship of the parish priest, Fr Michael Marry. They identified a ground in Kingscourt owned by Mervyn Pratt of the Pratt estate at Cabra Castle. On 21 July that year Fr Marry, James Carolan, Joseph Farrelly and Eugene Murtagh finalised the purchase of the 11.5 acres at a cost of £450. The land formed a natural amphitheatre, ideal for a sports ground, but a hill had to be removed and a river diverted underground before it could be turned into a playing pitch.

The ground, originally called Cabra Gaelic Athletic Sports Park, was vested in the GAA on 13 February 1950. The following month tenders were sought from 'competent contractors' to build a terrace.

The Gaels of Kingscourt moved mountains (well, a hill) and diverted a river when creating Ó Raghallaigh Park. The modern, well-equipped facility does justice to their endeavours

KEY DATES

1950
Navan businessman William Walsh offers Kingscourt a suite of furniture valued at £105 as first prize in a fundraising sweepstake for the ground

1951
Park opened and blessed by Most Rev. Dr Kyne, Bishop of Meath, on 6 May

1967
6,000 pipes are laid for drainage prior to re-turfing the pitch

1980
Showers installed in the dressing rooms and training lights erected around the pitch

Ó RAGHALLAIGH

The Ó Raghallaigh, anglicised as O'Reilly, were the dominant clan in the Gaelic kingdom of Breffni, spanning land across counties Cavan and Longford. They were known as the Princes of East Breffni, descended from Raghallach, Prince of Breffni in 981. O'Reilly is still the most common surname in Cavan today.

NEW NAME FOR NEW GROUND

When it opened on 6 May 1951 the ground was named Ó Raghallaigh Park after the great Cavan clan, the 1916 patriot The O'Rahilly, and local priest Fr Peter O'Reilly, who had built St Mary's church in 1870. Playing before a 7,000-strong attendance, Cavan lost out to Louth in a Spicer Cup semi-final on the day. Louth went on to win the final against Meath, played 12 months later. Each Louth player went home with a woollen rug while the losing Meath players received a silver cigarette lighter each.

Six weeks after it opened Ó Raghallaigh Park was the venue for Cavan's victory over Down in the Ulster SFC on 17 June. This, however, was the only time the ground ever hosted an Ulster SFC match.

NATIONAL LIBRARY OF IRELAND

Kerry man Michael Joseph Rahilly, co-founder of the Irish Volunteers and who styled himself as 'The O'Rahilly' is also said to have inspired the ground's name

gates in the perimeter fence and upgrading of the Corrygarry entrance were completed in 1987 and the following year some of the playing surface was re-sodded and a training track was built around the field.

Work began on erecting a steel-and-concrete, covered stand incorporating dressing rooms and meeting rooms in 1991. The estimated cost of £135,000 had escalated to £225,000 by the time the building was completed in 1992, but in the meantime the old wooden goalposts were also replaced with a set of steel uprights and turnstiles were installed at each entrance.

The club laid out a juvenile pitch on the Corrygarry side of the ground in 1994 and improved the general surrounds by planting trees and shrubs along the perimeter. Between 1998 and 2000 the main pitch's surface was improved, ball-stop nets were set up behind the goals and the quality of the driveways and car parks was revamped. At the dawn of the new millennium Kingscourt was named Cavan Club of the Year and won the award again in 2001. GAA President Seán McCague officially opened the redeveloped Ó Raghallaigh Park that May. Just a year or two beyond target and costing £650,000 overall, the new Kingscourt facility seemed worth that little extra.

LONG-TERM PLAN PROVES SUCCESSFUL

The club sold a portion of its ground to Cavan VEC for £36,250 in 1983. The funds helped the club embark on a 15-year development plan under the stewardship of Phil Smith, Seán Farrelly and others.

Kingscourt began by building a boundary wall around the playing pitch, at a cost of £20,000, adding dugouts in 1986. Press facilities, new scoreboard,

GIRLS TAKE TO THE FIELD, BOYS TO THE SCREEN

The U12 girls team were the first to represent the Kingscourt Stars when a ladies football wing was added to the club in 2009. The boys' minor team made history a year later when they were the first side to be streamed live on an Ulster club website, another innovation linking club and community.

2001
Floodlights installed on the main pitch and training lights on the juvenile pitch

2017
New dressing rooms and improved terracing officially opened on 24 May

2017
Ó Raghallaigh Park named Cavan County Board Club Ground of the Year

2023
Club lay a new all-weather astro-turf training pitch between their two playing pitches

Celtic Park

LOCATION
Lone Moor Road, Derry

OPENED
1894

CAPACITY
18,500

PITCH DIMENSIONS
138 x 84 m

COVERED ACCOMMODATION
Tommy Mellon Stand

FLOODLIGHTS
Yes

CLUB
No

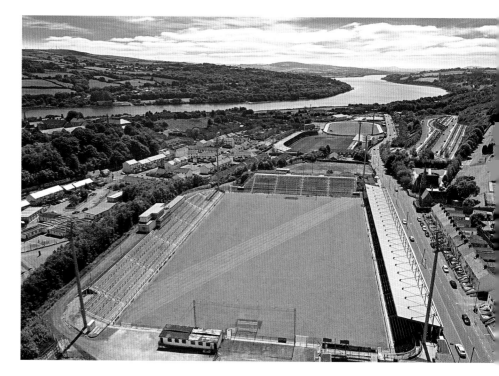

*Derry's sporting quarter –
Celtic Park sits on a bend of
the River Foyle with Derry City
FC's ground, the Brandywell
(renamed Ryan McBride
Brandywell Stadium in 2018)
and Derry Greyhound
Stadium further on*

Today Celtic Park is synonymous with Gaelic sport in Derry, but the ground began as a soccer pitch. It was officially opened as Derry Celtic Park on 6 October 1894. Derry county team played their games in various other grounds in the city from 1902 to 1913, such as Pennyburn near the Buncrana Road, where Derry's first home Ulster SFC match was played, the Demesne off Beechwood Avenue and Ard na bhFiann in Rosemount. Soccer dominated the city's sporting scene, though that was not the GAA's only problem. The lack of grounds in a walled, hilly, densely populated city was further complicated by opposition to games being played on Sundays. The GAA's biggest difficulty, the county secretary wrote in 1906, was 'Unctuous Sabbatarianism.'

But in 1913 Derry Celtic switched suddenly from soccer to Gaelic, after being refused admission to the Irish League – amid rising sectarian tensions. Outraged, Celtic promptly turned to Gaelic football for the next season, and all at once Celtic Park was available to Derry GAA.

KEY DATES

1901
Celtic Park's first inter-county game is a soccer match between Derry and Antrim

1914
First Ulster SFC match in the park is Derry vs Monaghan on 21 June

1920
First Ulster SFC match at the Brandywell sees Derry play Donegal on 30 May

1943
As Derry City Board buys Celtic Park, Derry Journal prints lists of subscribers, including 'Old Gael' (£5) and 'Head Down' (£3)

SOCCER TAKES OVER AS GAA FADES

Derry GAA football teams played their home games in Celtic Park until 1920 when they moved to the council-owned municipal pitch at the Brandywell. But as the effects of partition took hold, the nationalist parties lost control of the city corporation. The GAA in Derry collapsed shortly afterwards, while the county did not enter a team in the Ulster SFC in 1924 or '25 or again between 1929 and 1945. At the same time Derry City FC was formed and admitted to the Irish League in 1929. The soccer club returned to the Brandywell and it effectively became their home ground, while Celtic Park reverted to soccer too.

PUBLIC SUPPORT PURCHASE

When Celtic Park came on the market in 1943 the newly formed Derry City GAA Board, under the chairmanship of Jack Timmins and with a mere £2 to its name, bought the ground in September for £1,000. £733 was collected from public subscriptions, many gathered by board member Eddie McAteer – later Nationalist Party leader and MP. Celtic Park was one of the primary recreation sites in the city, with a greyhound track and tennis courts as well as a football pitch.

The city board set about developing the ground and in 1945 it hosted Antrim and Donegal in the Ulster SHC final. But with most of Derry's inter-county matches being played in Ballinascreen or Magherafelt, Celtic Park failed to develop as a GAA venue.

BACK FROM THE BRINK

When GAA President Alf Murray and Ard Stiúrthóir Seán Ó Síocháin visited Derry in December 1966 they saw sheep grazing on a waterlogged Celtic Park that looked nothing like a county ground. The Troubles made things worse. After the Battle of the Bogside in August 1969 the park became a virtual no-man's-land.

The Celtic Park Development Committee was formed in the mid 1980s to reverse the situation. The park was too small to facilitate a full-sized GAA pitch so a portion of land at Old Bluebell Hill was purchased from the Gaslight Company for £12,000 and ground owned by St Columb's College was also acquired for £7,500.

In the late 1980s Central Council and Ulster Council provided the bulk of a £350,000 investment that saw the pitch extended, seating installed for 5,000 spectators and terracing bringing capacity to 10,000. Topsoil was brought in from Dungiven and Culmore and spread over the playing surface.

View from the stand on the Lone Moor Road side and the TV gantry opposite

The reopening on 27 May 1990 featured Derry and Fermanagh in the Ulster SFC, the first Gaelic match of any kind on the pitch in 18 years.

NEW CENTURY, NEW CONFIDENCE

Improvements continued into the new millennium and floodlights were installed in 2007–08. A comprehensive £1.8m revamp began later that year. A new covered stand with seating for 3,600 was built on the Lone Moor Road side. Other additions included a control room, media room and TV gantry, stewards' room and extra exit gates, as well as improved disabled access and toilet facilities. Celtic Park was named as a potential venue in Ireland's bid to secure the 2023 Rugby World Cup finals. Though the bid failed, the park's nomination underlined its status in the GAA's portfolio of grounds.

1946	1970	1984	1994	2022
Derry beat Antrim in the Ulster Camogie Championship at Celtic Park; but Antrim object that the pitch is over-sized, and win the replay	*In March, the British Army removes the tricolour from the park flagpole*	*Ulster Council survey of grounds in Co. Derry does not even mention Celtic Park*	*Celtic Park hosts Down's victory over reigning All-Ireland champions Derry*	*Derry overcome Donegal to win their first Ulster SFC title in 24 years*

Owenbeg Derry GAA Centre

LOCATION
Foreglen Road, Dungiven

OPENED
2013

CAPACITY
6,800

PITCH DIMENSIONS
146 x 90 m

COVERED ACCOMMODATION
Yes

FLOODLIGHTS
Yes

CLUB
No

Headquarters of Derry GAA, both a multi-field site and inter-county ground, the state-of-the-art centre boasts media and event control features as well as performance analysis equipment for coaches and players

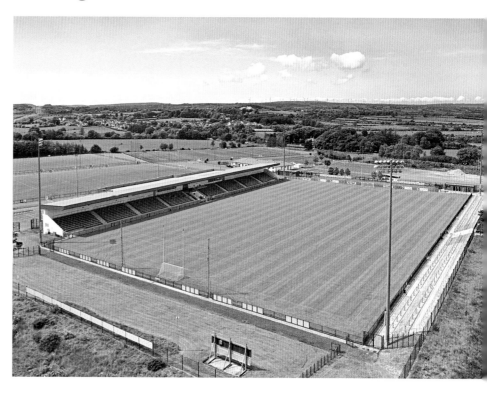

The Owenbeg project began when Derry County Board decided to build training facilities for Derry's club and county teams. Until then, many teams had difficulty training on club fields on winter nights, and only one club had adequate lighting. A finance committee was set up by Derry County Board in 1992 under the leadership of Johnny Burke and Bernie Mullan to identify and acquire a suitable site that could accommodate several GAA pitches. In late 1993 a 104-acre farm on the main Derry–Belfast road came up for sale. Spanning both sides of the road, the site had hosted the Northern Ireland Ploughing Championships in 1985. Discussions reached agreement on a price of £180,000 for the land. The committee, which had decided to stay independent of the Derry County Board, did not have sufficient funding, but one of their members, Seán Donaghy from Kilrea, generously provided the purchase price interest free and the site was secured in 1993, when the county had just captured the Sam Maguire.

KEY DATES

1993
Limavady Borough Council refuse to give Derry County Board planning permission to develop ground

1996
Administration block with changing and meeting rooms constructed at Owenbeg

2011
First sod of the Centre of Excellence turned in May

2013
Ground hosts its first championship tie on 5 May, Derry vs Wicklow in the Christy Ring Cup

AMBITION IS REWARDED

Shortly after the purchase the committee decided to sell the land on the opposite side of the road for £110,000 and develop the remaining 48 acres. As development work continued over the next few years, fundraising followed. There were draws, dinners, golf classics and donations, with many Derry clubs contributing £5,000 each.

The ambitious venture's end-product was three all-weather playing fields, two of them floodlit, a complex of five changing rooms and an administration block with meeting rooms, all completed by 1996. GAA President Joe McDonagh officially opened the Owenbeg centre in June 1998, when over 500 children took part in GAA blitzes. And with their task completed, Seán Donaghy repaid, and over £1m raised for the project, the finance committee disbanded in 2000 and handed the facility to Derry County Board debt free.

ALL AGES, ALL GRADES WELCOME

For its first decade, Owenbeg was used almost exclusively as a Centre of Excellence for training club and county teams. Clubs began to have more presence after the introduction of the Go Games youth games in the mid-2000s; up to 800 children could play there at once.

A new fundraising committee was set up in 2005 and work began on laying another full-length pitch with the same dimensions as Croke Park. Under

Showing the way – the manner in which Derry went about creating their impressive centre is a template for others

A MONUMENTAL FEAT

Owenbeg was as central a place as could be got for a county that hasn't always had a united identity. It lies beside the Glenshane Pass, the arterial route through the county. The nearby Owenbeg (Abhainn Bheag) provided its name, and an adjacent standing stone marks its antiquity. Today teams of all levels, male and female, converge to train here.

the chairmanship of the county board's John Keenan, in 2011 work began on a new development that included a 2,000-seat covered stand housing a gym, dressing rooms, medical rooms, dining area and the Seán de Búrca (Johnny Burke) suite, memorialising a man who was involved in negotiating the purchase of the site two decades earlier. At the official opening on 28 July 2013, John Keenan stated that Owenbeg 'is there to help develop young club and schools players from U8s upwards as much as to develop the county players of the future.'

Supported by a £765,595 grant from the Department of Agriculture and Rural Development, work began on a full-size, floodlit 4G pitch in December 2013, which opened in May 2014.

SHINING LIGHT FOR ALL

Over the years Owenbeg consolidated its position as the preferred ground for Derry's inter-county and club championship matches and it also hosted the Ulster SHC finals from 2014–17. Remedial work on the ground ruled it out of inter-county games for about 18 months until summer 2018, when Derry returned there for the All-Ireland football qualifiers.

The debt on the Owenbeg facility was cleared in October 2020, making it one of the most successful projects undertaken by any branch of the GAA. The unique combination of facilities at Owenbeg seems set to guarantee its place as the hub of Derry GAA well into the future.

2013
Owenbeg officially named as Derry's second county ground

2014
GAA President Liam O'Neill opens 4G floodlit pitch

2014
Car park extended to provide 465 spaces

2021
Two new training pitches opened bringing the total number of pitches to six

2023
Owenbeg hosts the 2023 GAA World Games from 24–27 July

Dean McGlinchey Park

LOCATION
Straw, Ballinascreen

NAMED AFTER
Rev. James ('Dean') McGlinchey
(1863–1951)
Parish priest, GAA mentor

OPENED
1954

CAPACITY
6,000

PITCH DIMENSIONS
145 x 79m

COVERED ACCOMMODATION
Yes

FLOODLIGHTS
No

CLUB
St Colm's Ballinascreen

St Colm's use the original Irish placename, Baile na Scríne (Ballinascreen), rather than the official Draperstown, a name bestowed by the London Drapers Company. Ballinascreen has won four SFC, three SHC and two ladies football county titles, while the club's most successful players, Eamon Burns and Tony Scullion, have both won All-Ireland, Ulster and NFL medals.

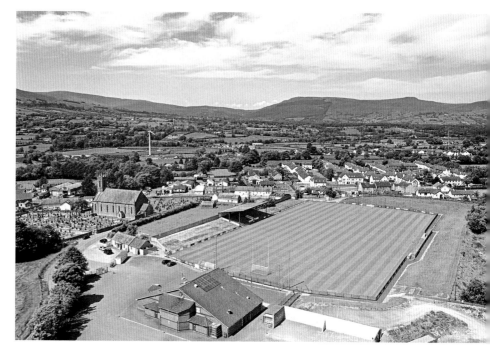

The rules in the Official Guide that bar clubs and trophies from being named after living people were never replicated for playing fields, although GAA officials have almost universally acted as though they were. Dean McGlinchey Park was an exception in that regard, because the man who inspired its name was not only still alive when the ground opened, he threw in the ball for the first match.

Fr James 'Dean' McGlinchey was the first president of St Colm's GAA Club, founded in 1933. The club played in local farmers' fields for many years, particularly at Straw, which was unusual among GAA grounds at the time as it was literally a level playing field. When the 14-acre farm where the pitch was located came up for sale in 1950 the club decided to buy it for £2,200. They sold a portion of the farm for £1,200 and the old farmhouse for £400, which left them with just £600 to raise.

Clever innovations such as Cáirde Screen, through which club members commit to regular financial contributions, have helped St Colm's turn the park into a sporting shrine – scríne

KEY DATES

1939
Ulster senior and minor hurling championship matches between Derry and Down held at Straw

1950
Derry play Kildare in a football challenge as a fundraiser for new ground

1954
Bishop Neil Farren officially opens McGlinchey Park on 9 May, when Derry defeats Cavan

1957
Derry overcome Antrim 4–14 to 0–8 on 9 June as park hosts its first Ulster SFC match

REV. JAMES ('DEAN') McGLINCHEY

James McGlinchey was born in 1863 in Killygordon, Co. Donegal. After his ordination he served as a curate in Claudy and Carndonagh and was appointed Dean of Boarding at St Columb's College, Derry, in 1908. He was the prime mover in St Columb's entering Derry Gaelic football leagues in 1913 – the first school in Ulster to enter GAA competitions.

Fr McGlinchey became parish priest of Ballinascreen in 1925 but continued to be called 'the Dean' because of his years at St Columb's. The Dean travelled around by pony and trap when he first came to the town, and though he bought a car eventually he never learned to drive it. McGlinchey donated a cup to Derry County Board in 1934, the first ever trophy for a senior football tournament for teams in the South Derry District.

PARISH PRIEST RALLIES COMMUNITY TO THE CAUSE

The pitch was improved and granted provisional inter-county status but further development took four years and a huge community effort. Leading the club's workers was a past chairman of Derry County Board and the Ulster Council, Rev. Michael Collins, who became parish priest of Ballinascreen after Fr McGlinchey's death. A passionate GAA man, it was rumoured that Fr Collins occasionally rescheduled church services to suit Gaelic fixtures.

GROUND'S STOCK RISES WITH THE COUNTY TEAM

The town was bedecked with bunting for the park's official opening on 9 May 1954. As Derry climbed new heights, winning a first Ulster SFC and reaching the All-Ireland SFC final in 1958, McGlinchey Park gained preference over Magherafelt and Celtic Park as the county's home ground. Derry went unbeaten in senior competition matches there until Cavan defeated them in the 1963 Ulster SFC.

The lengthy process of ratification as the main county ground was finally confirmed in 1967. Now qualifying for larger grants, concrete seating was laid for almost 3,000 spectators and a pavilion was built. Further work provided new terracing, dressing rooms and pitch renovations. As the park consolidated its status as Derry's home ground through the 1970s, more improvements were made, including a covered stand to house 1,000 spectators which was completed in 1980.

A fresh round of work between 1981 and 1987 maintained the ground's profile. But after Derry lost to Down there on 29 May 1988, McGlinchey Park hosted no more Ulster SFC games, and was displaced as the main county ground by the reopened Celtic Park in Derry. It retained some inter-county profile due to Derry's rising stock in hurling, and hosted Kilkenny teams for the 1993 All-Ireland U21 HC semi-final and an NHL match in 2001.

JAMES McNALLY PARK

The club bought adjacent land in 2000 and built a second pitch, named James McNally Park in 2015 after the club's late chairman. A fundraising initiative – Cáirde Screen – was launched in 2010 to back further improvements. Floodlights and dugouts made the ground a championship-approved facility, while a hurling wall and a state-of-the-art high performance centre were also built. A Lottery Development Fund grant of £9,960 helped to create a health and wellbeing hub for community use which opened in 2021.

NONE FOR THE ROAD

One of the first mentions of the GAA in Ballinascreen was in 1892, when it was reported that a full 50 members were enrolled in the local Total Abstinence Association.

1965
Electric bulbs are installed to provide lighting for county minors training for the All-Ireland football final

1980
Covered stand containing new dressing rooms and press facilities completed

1984
St Colm's voted Derry GAA Club of the Year

1994
GAA President Jack Boothman opens Dean McGlinchey Park's new clubhouse

2021
Lighted walkway around the ground opened to the public at Easter

O'Donovan Rossa Park

LOCATION
Castledawson Road, Magherafelt

NAMED AFTER
Jeremiah O'Donovan Rossa (1831–1915)
Fenian leader, newspaper man

OPENED
1960

CAPACITY
3,500

PITCH DIMENSIONS
129 x 82 m

COVERED ACCOMMODATION
No

FLOODLIGHTS
No

CLUB
O'Donovan Rossa

The Niblock family are synonymous with Magherafelt GAA, with Frank being part of the Derry team that won its first NFL title in 1947. His nephew, Mickey, was one of Derry's greatest players, winning two All-Ireland club titles with Nemo Rangers, Cork. Magherafelt has won six Co. Derry SFC titles.

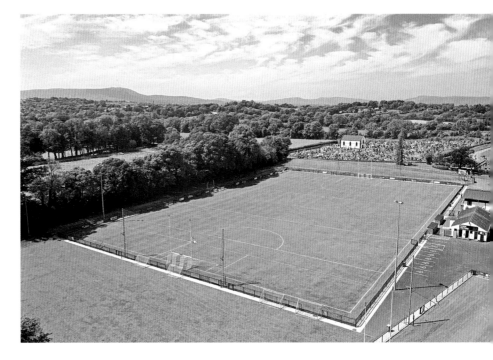

O'Donovan Rossa's pitch was the first county ground in south Derry and integral to the formation of a GAA identity in the county.

Over the decades O'Donovan Rossa have had many challenges to overcome while developing their grounds in the east of the county

Set up in 1934 by Pat Keenan, John Walls, Gerry Gallagher, John Kearns, Charlie Mac Flynn and Paddy Mac Flynn, who later became the 26th president of the GAA, the Rossa club played at Bellevue Park and Millbrook Park (at the corner of Pound Road and Castledawson Road) before setting their sights on a field owned by Margaret Keenan at Aghagaskin, about 1km further outside town. Through the generosity of the people of Derry the land was procured in 1939 and formally purchased for £500 by Derry County Board, Ulster Council and Central Council on 29 December 1941.

An advertisement calling for support in 1942 echoed one of Churchill's wartime speeches, urging 'GAELS OF DERRY – Make Your Supreme Effort Now.' But though the park was already hosting Derry's home games, the money simply wasn't there to bring it up to proper inter-county standard.

KEY DATES

1931
Motion passed at Ulster Convention that Magherafelt be included in Antrim for GAA purposes

1939
O'Donovan Rossa GAA Club wins its first Derry SFC and adds three more in the 1940s

1950
Seating is installed before hosting Derry's All-Ireland JFC semi-final vs Limerick, which leads to a first national championship for the Oak Leaf county

1950
South Derry Agricultural Society holds its annual gymkhana in the ground on 6 June

JEREMIAH O'DONOVAN ROSSA

Born in Rosscarbery, Co. Cork, O'Donovan Rossa lived through the Famine and subsequently advocated that Ireland would only ever win independence by force of arms. Imprisoned and then exiled as a member of the IRB, he remained a leading voice in the republican movement. Several GAA clubs preserve his name, four in Ulster as well as Skibbereen, Co. Cork.

ROSSA'S TAKE OVER GROUND

In December 1944 the county board devolved management of the ground to the South Derry Board, while the Rossa club paid £10 annual rent to play there. The county ground hosted the first Ulster SFC match held in Co. Derry in 25 years on 9 June 1946, when Derry took on Fermanagh. Derry's rising fortunes led them to a shock triumph in the 1946–47 NFL final, their first time winning that title.

Yet conditions at Magherafelt remained unsatisfactory. The field was uneven and often sodden, as drainage laid in 1945 was set too deep. Underinvestment kept it out of the running as a neutral venue for big games. When other clubs began to invest in grounds in the early 1950s, the South Derry Board decided to hand the park's management to the Rossa club.

ORANGE LODGE OBJECTS TO FLAG

In 1954 Aghagaskin Orange Lodge petitioned the Minister for Home Affairs, G. B. Hanna, to remove the tricolour from the field lest there be 'very serious trouble, for … the Loyalists will take the matter into their own hands.'

Hanna replied that as long as the flag was 'not carried in procession through a Unionist area, I am afraid we must give those who fly it at meetings of this particular kind the benefit of the doubt as to their motives; and I think the less notice we take of them the less satisfaction they will derive from proceedings.'

TWENTY YEARS IN THE MAKING

Fresh progress was made once the Magherafelt club acquired the deeds to the ground in 1957. To level the pitch, the topsoil was pushed aside, replaced by 1,000 tons of stones, and the sod re-laid. Finally, almost 20 years after it was first acquired, the new O'Donovan Rossa Park was officially opened on 29 May 1960. There were tensions on the day when police officers and detectives, who had mingled with the crowd, prevented the tricolour being flown.

The seventh Ulster SFC match at the park, played in 1962, turned out to be the last. Its soggy surface and shortage of spectator accommodation, set against Ballinascreen's growing profile, caused Magherafelt to lose out. Though improvements were made in later years, by the 1970s Rossa Park was long gone as an inter-county venue.

Inspired by Patrick Pearse's graveside oration for O'Donovan Rossa, the club's name was proposed by a young Paddy Mac Flynn in 1934. 45 years later Mac Flynn made his maiden oration as President of the GAA

NEW CENTURY, NEW IMPROVEMENTS

Redevelopment initiated in 2005 brought an upgrade to the park and a new full-length floodlit pitch and training area. Sport NI, Ulster Council and Magherafelt District Council provided vital grant aid. GAA President Christy Cooney opened the new facilities on 12 September 2010, with founding member Paddy Mac Flynn as a special guest. The club's exploits on the pitch since 2018 have been very successful, winning football county titles at U16, minor, U21 and senior level.

1960	1977	1985	2005	2019
Alf Murray officially opens Rossa Park, with Derry vs Galway as the headline football match	Club wins High Court case against Magherafelt council's decision to preclude them from coaching scheme	New pavilion vandalised for the second time two weeks prior to its official opening in July	£750,000 development launched, bringing new facilities and a much-needed facelift to the park	Magherafelt win the Derry SFC title for the first time since 1978

Mac Cumhaill Park

LOCATION
Main Street, Ballybofey

NAMED AFTER
Seán Mac Cumhaill (1901–1949)
IRA leader, GAA administrator

OPENED
1956

CAPACITY
17,500

PITCH DIMENSIONS
138 x 90m

COVERED ACCOMMODATION
Yes

FLOODLIGHTS
Yes

CLUB
Seán Mac Cumhaills

Seán Mac Cumhaills is one of the bigger GAA clubs in Donegal and fields teams in both codes and all age-groups. They have won a total of six senior football and two senior hurling county championships. The club's footballing heyday was in the 1960s when they collected three titles in a row from 1962 to 1964 while their hurling successes are of a more recent vintage, 2010 and 2016.

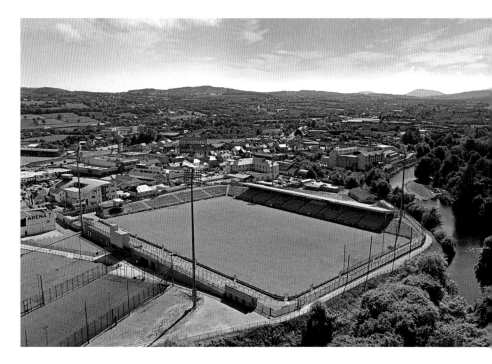

The linked towns of Ballybofey and Stranorlar had separate clubs, Éire Óg's formed in 1916 and Stranorlar Sarsfields the following year, who played in separate pitches in Cavan Lower and Stranorlar – the first GAA pitches in the area.

Twin Town treasure – the picturesque Mac Cumhaill Park has become a fortress for Donegal football teams over the years

When the clubs amalgamated as Erin's Hope in 1926 they had no ground of their own until they found four acres at Drumboe which was owned by the Irish Land Commission. The club trustees acquired the land for £67 in 1937, to be paid at a rate of £3. 3s. 8d. per annum.

In 1944 Erin's Hope attempted to purchase a field within the boundary of Ballybofey, beside the River Finn. The owner, cattle dealer and exporter Mark Byrne, eventually agreed to part with the 4.5 acre site for £1,000, a high price in the club's opinion, but seven men pledged to cover a loan. The field was bought finally by a special committee of club members who saw the need for a park conveniently situated for the Twin Towns.

KEY DATES

1946
Site in Ballybofey is secured for £1,000 – £200 more than the asking price two years earlier

1956
GAA President Seamus McFerran opens Seán Mac Cumhaill Park on 22 April before a 6,000-strong crowd

1973
New centre with both sport and social facilities adds to the park's resources

1987
Mac Cumhaill Park is nominated as Donegal's county ground in place of O'Donnell Park, which became a secondary county ground

SEÁN Mac CUMHAILL

John James McCool was born in Killybegs but moved to Ballybofey as a child with his father, Daniel, a train driver from Derry, and his mother Mary Ann from Stranorlar.

Changing his name to Irish, Seán Mac Cumhaill trained as a schoolteacher and became involved in the republican movement after witnessing the Bloody Sunday massacre in Croke Park in 1920. At the age of 21 he was an adjutant in the Donegal IRA and his continuing IRA activities through the 1930s and '40s saw him imprisoned several times north and south of the border. He went on a number of hunger strikes in protest, including a 50-day fast which affected his health when, as Chief of Staff of the IRA, he was interned in the Curragh during WWII. He stood as a candidate for Clann na Poblachta but left the party after it went into government with Fine Gael. Seán served as Donegal County Board secretary from 1946 until his death in 1949 at the age of 48.

BUILDING STAND, SEATING AND WALLS

The Land Commission allowed the club sell the Drumboe ground and it went for £230 at auction in 1952. Aided by grants from Ulster and Central councils, and local fundraising, a stand was built in Ballybofey, sideline seating installed and the pitch was levelled. The county board insisted on a wall being built around the pitch to keep spectators from running on or creating any kind of melee. It was the only ground in the county with this amenity for many years.

Donegal lost to Tyrone in the first Ulster SFC match at the new ground on 14 June 1953. Under the guidance of Paddy McNulty, Paddy Murphy and Ben Griffin the

SEÁN MAC CUMHAILLS

official opening followed in 1956. Shortly afterwards Erin's Hope changed their name to Seán Mac Cumhaills to match the name of the club's new ground.

MOP-UP AND STATUS UPGRADE

The River Finn flooded in 1965 and did much damage to both pitch and buildings. The club built a retaining wall at the river end, and in 1969 the pitch was re-sodded, seating laid for 3,000 spectators and embankments constructed on three sides of the ground.

In the 1970s the club spent £15,000 on building a social centre, and then dressing rooms, a referee's changing room and a press box, which was upgraded in 1985. Two years later the Ulster Council decided that the improved park should be the official county ground for Donegal.

**An Fhinn
RIVER FINN**

AGREEMENT KICK-STARTS 25 YEARS OF GROWTH

After protracted negotiations between the club and Donegal County Board about the use of the ground, the two bodies finally reached an agreement in 1995. The county board now set out a vision of development that would effectively continue for the next 25 years. The ground got a new stand and terracing at the Town End, while the new millennium brought new dressing rooms and referee's room, upgraded media facilities and floodlights. Further improvements included facilities for disabled spectators and a hospitality suite, as well as a new astro-turf pitch. However, in 2012 capacity was reduced to 12,250 following a safety audit. This threatened the park's ability to host major games but Donegal GAA responded with works which brought capacity back up to 17,500 and secured Ballybofey's status as a venue for major games.

1997–99
£90,000 from National Lottery and £125,000 in Sports Capital grants support significant work

2007
Ulster Council President Tom Daly switches on the floodlights for inter-provincial semi-finals

2019
Donegal beat Derry in the first inter-county championship match played under lights at the park

2022
Draft proposals in place to improve pitch, dressing rooms, toilets, access gates and stand

O'Donnell Park

LOCATION
Lismonaghan, Letterkenny

NAMED AFTER
**Patrick Joseph O'Donnell
(1856–1927)**
Cardinal, Archbishop of Armagh

OPENED
1937

CAPACITY
8,200

PITCH DIMENSIONS
145 x 91 m

COVERED ACCOMMODATION
Yes

FLOODLIGHTS
No

CLUB
St Eunan's

Joint leaders in the Donegal SFC title ladder with 15 wins, St Eunan's club can boast five members with All-Ireland SFC medals: Charlie Mulgrew, Paul Carr, Mark Crossan, Rory Kavanagh and Kevin Rafferty. The club's ladies senior football team won 13 out of the first 14 Donegal county championships, with four Ulster titles thrown in.

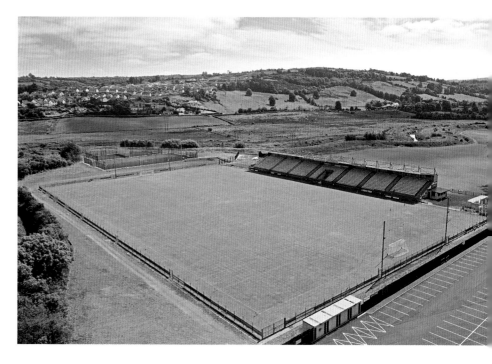

On 18 September 1905 the Lámh Dearg GAA Club was established in Letterkenny following a meeting in the Literary Institute. They played their first hurling match on St Stephen's Day against St Mura's of Fahan in the grounds of the local mental hospital (Bernard McGlinchey Town Park today), with the club's patron, Bishop O'Donnell, in attendance.

O'Donnell Park has won many admirers as host to county finals and occasional NFL games

Donegal County Board was also formed in 1905 but due to the popularity of soccer in the county and organisational difficulties within the board the GAA movement slipped into decline after 1907. New clubs which had replaced Lámh Dearg – Tirconaill, Faugh a' Ballagh, Robert Emmets, the O'Donnells – failed to last. A fresh attempt at revitalising Gaelic games took place in 1919 when a new county board was put in place and a county championship format was set up. It was not until 17 June 1923, however, that the first Ulster SFC match was played in Letterkenny, when Donegal took on neighbours Derry in a field lent by Charles Kelly at Steam Mills.

KEY DATES

1925
Letterkenny Rovers and Geraldines GAA clubs share a pitch at Ballymacool

1937
Club turns down bid to use their new ground for coursing

1937
St Eunan's spark controversy by playing a soccer match in Ramelton wearing their club jerseys

1951
Donegal draw with Antrim in the last of four Ulster SFC matches held at O'Donnell Park since 1945

CARDINAL PATRICK JOSEPH O'DONNELL

Patrick Joseph was born in Glenties, Co. Donegal, one of nine children of Daniel O'Donnell, tenant farmer, and his wife Mary. He went to the High School, Letterkenny, and was ordained in 1880. He enjoyed a flourishing academic career before being consecrated Bishop of Raphoe at the age of 31. He was appointed Archbishop of Armagh in 1924, and Cardinal a year later.

Deeply interested in social and political issues, he was a noted supporter of Sir Horace Plunkett's co-operative society. Plunkett's cousin, Elizabeth, Countess of Fingall, recalled: 'Many people say that Dr O'Donnell had the biggest brains of his Church, and even outside it, in Ireland.' O'Donnell also championed Gaelic culture, helping to establish Feis Thír Chonaill, and was the first Catholic primate to advocate Gaelic sports.

O'Donnell was proud to have built St Eunan's Cathedral in Letterkenny 'without a penny of debt to Almighty God'

THE FOUNDING OF ST EUNAN'S

By 1925 there were three GAA clubs in Letterkenny: Tír Conaill Mental Hospital, Geraldines and Letterkenny Rovers. But against a background of continuing emigration Letterkenny Rovers broke up due to falling numbers, shortly after winning the 1927 championship. Rovers' remaining players joined with the Geraldines to form a new club, St Eunan's, but this only lasted until June 1928.

Eventually, representatives of An Garda Síochána, Tír Conaill Mental Hospital and former club members met in the Catholic Club Rooms on 19 February 1930 to reform the old St Eunan's and re-establish Gaelic games in the town. A year later they secured a lease on a field in Glencar from Margaret Kelly of Bomany and played there until 1937. This ground was known as Gaelic Park.

FINDING A HOME IN THE BURN FIELD

Eager to find a home of their own, the club set up a park committee led by John Hourihane, John Crumlish and Johnny Curran. Letterkenny UDC agreed to sell a seven-acre field, called the Burn Field, to the club for £270 on 17 June 1935. The new pitch was officially opened as a county ground on 2 May 1937 by Ulster Council chairman Patrick MacNamee and named O'Donnell Park.

SETTLING IN

Focused on reducing their debt, the club carried out very little development work on the park over the next 20 years. The playing surface was improved in 1955 but further significant development waited until 1978 when two large dressing rooms, with three showers each, were added along with two dugouts, a press box and two ladies' toilets.

DEVELOPMENT MOVES INTO OVERDRIVE

Progress moved up a gear in 1994 with the purchase of 14 acres of land, supported by a two-year fundraising drive that offered a house as the prize. Plans were drawn up in 2003 to build two Prunty pitches, six dressing rooms, a 3,000-seat spectator stand and a modern clubhouse.

In 2008 the club bought 13.5 acres of land adjoining their 1994 acquisition, while they also completed perimeter fencing, turnstiles and exit gates, new road entrances and spectator embankments. A new floodlit all-weather pitch was opened in 2017.

2021 was a special year, when St Eunan's men's senior football and reserve teams and senior hurling team, the ladies intermediate football team and the U21 football and hurling teams all brought county championship titles home to Letterkenny.

1982
New social centre opens on 19 February

2005
O'Donnell Park regains its county ground status having lost it in 1987 due to issues with capacity

2007–09
Club wins three Donegal SFC titles in a row

2017 & 2019
O'Donnell Park nominated for the GAA County Pitch of the Year award in both years

Fr Tierney Park

LOCATION
The Rock, Ballyshannon

NAMED AFTER
Fr Cornelius Tierney (1871–1931)
Parish curate, martyred
Columban missionary

OPENED
1954

CAPACITY
5,600

PITCH DIMENSIONS
147 x 84 m

COVERED ACCOMMODATION
Yes

FLOODLIGHTS
No

CLUB
Aodh Ruadh

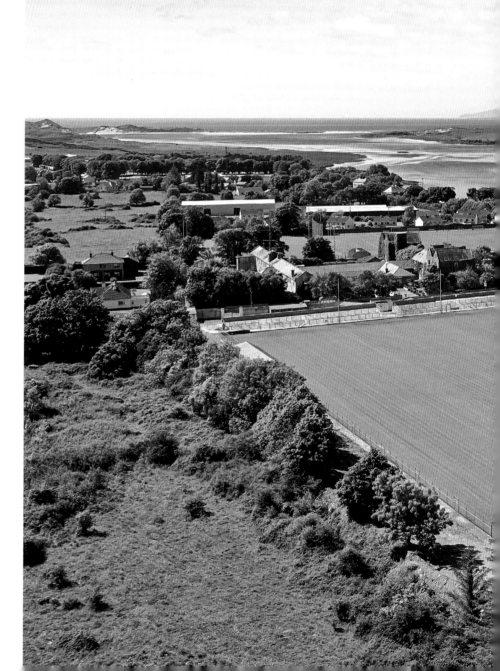

Picture perfect – Fr Tierney Park's location on Donegal Bay makes it one of the most scenic grounds in the country, and the recent work carried out by Aodh Ruadh GAA Club has made it even more so. Upgrading the playing surface was a major priority for the club and the fine new pitch can be seen here in 2023 before the goalposts were reinstalled

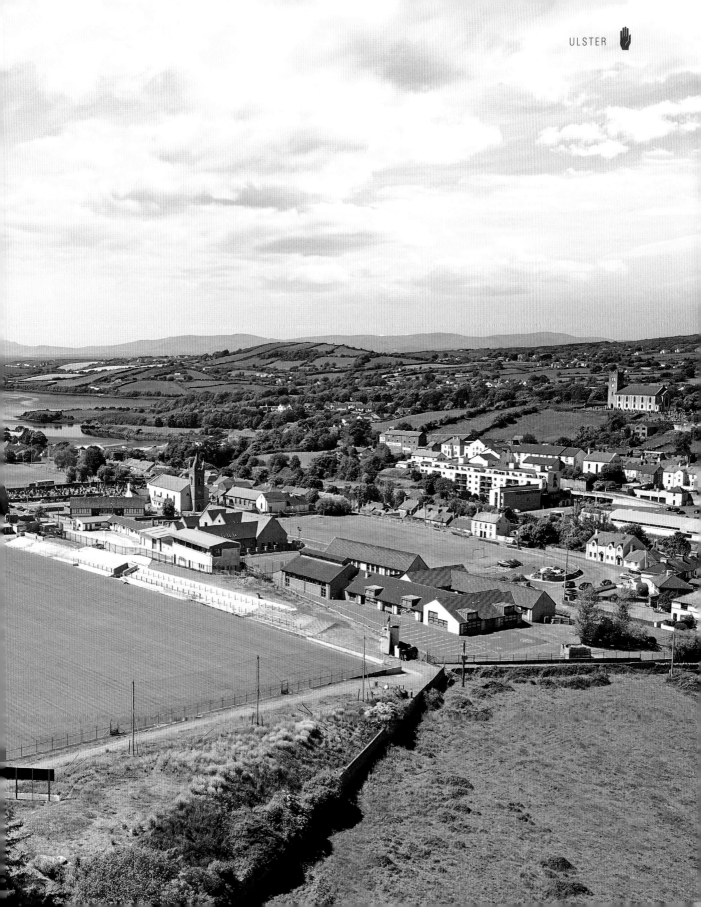

Castle Street, Ballyshannon, October 5th, 1910,

The Annual General Meeting of the Members of the Aodh Ruad Hurling and Football Club will be held in the Rock Hall on Sunday, October 9th at 12.30 p.m. You are requested to attend and bring any of your friends who would wish to come.

Is mise

S. Mac Stiopáin,

Runaide

[Irish Paper.–Irish Ink.]

It's the small things that count – in 1910 Aodh Ruadh were doing their bit to support native products by printing their AGM notice with Irish ink on Irish paper

Winners of 12 county senior football titles and five senior hurling titles, Aodh Ruadh is in the top three clubs in the county. It has also produced many inter-county footballers for men's and ladies' Donegal teams, among them Brian Murray, Sylvester Maguire, Pauric McShea, Gary Walsh, Grace Meade and Breda Tinney.

FROM A MEADOW TO A ROCK

The Aodh Ruadh GAA Club was founded at a public meeting in Ballyshannon on 24 October 1909 called by local curate Fr James O'Daly. Seven days later they were playing at the Workhouse Meadow, later known as Munday's Field, with an admission fee of one shilling.

By 1910 the club was playing in The Rock area in the town and in around 1916 moved to Erne Park, which was also being used by other sports. The relationship continued until the 1940s when the land was requisitioned by the ESB as work began on the Erne hydroelectric scheme. Electricity wires installed over the pitch would make it impossible to play Gaelic games there. The club decided that they needed their own ground and in April 1947 bought 7.5 acres of rough land back in The Rock for £1,059. 18s. 10d. It was designated a county ground in December 1948, though there was still a great deal of work needed to make it worthy of the title.

Fr Tierney's name has appeared in several formats over the main entrance of the park since it opened. Below is a striking version in old Irish script from the 1960s

BALLYSHANNON MUSINGS

1904
The O'Donnell Hurling Club, forerunner of Aodh Ruadh, is established

1909
Aodh Ruadh founded as a hurling and football club with members paying a penny a week to help the club get started

1925
Donegal defeat Fermanagh in the first Ulster SFC played in Erne Park on 14 June

1957
Donegal beat Down on 16 June in the only Ulster SFC match played in Fr Tierney Park

FR CORNELIUS TIERNEY

Born in Clones, Co. Monaghan, Cornelius Tierney was ordained in 1899 and appointed curate to St Joseph's parish, The Rock, Ballyshannon, in 1911. He served there until 1917 when he left to prepare for the new Maynooth Mission to China, setting out with 16 other missionaries in March 1920. Having spent some time in America he returned to China in 1928, during the Chinese civil

COLUMBAN MISSIONARY SOCIETY

war, working first in Hanyang, part of present-day Wuhan, and then as director of the Kien Chang Mission in Nancheng. He was kidnapped by Communist soldiers in 1930, mistreated and accused of being an 'imperialist spy.' He died in captivity after spending months in a prison camp.

❝ *If God wishes that I should recover my liberty, He can devise means. I leave it all in His hands. Pray for me* ❞

Fr Tierney in a letter shortly before his death

LEVELLING AND ROLLING THE ROCK

The rocky terrain had to be levelled manually, which took up to two years. The pitch was then rolled and levelled, but it was not until 1952 that grass was sown on it. 150,000 tons of filling was spread on the southern side of the ground during 1953 to build an embankment that could cater for 16,000 spectators and sideline seating was also installed. The ground was finally opened and named Fr Tierney Park on 9 May 1954 by the Ulster Council's Alf Murray before a 4,000-strong crowd.

COUNTY GROUND PROMOTION

In December 1968 Donegal County Board decided to give priority to developing Fr Tierney Park as a secondary county ground. New dressing rooms and referees' room with hot showers and toilets were built in 1969–70. Much progress was made through the 1970s and continued in the 1980s under the supervision of the park committee's secretary, Tom Daly. The first spectator stand in a Donegal GAA ground was completed in 1981 at a cost of £20,000. An embankment for spectators followed,

BREAKING THE GLASS CEILING

Aodh Ruadh created their own bit of GAA history in December 2011 by electing an all-female club executive, with Betty McIntyre as chairperson, Emma Gaughan, secretary, and Catherine McKee, treasurer. 'It is just the way it evolved,' Betty remarked. 'What goes on on the pitch is much more important.'

along with additional dressing rooms, training lights and a full-sized scoreboard.

In 1987 Aodh Ruadh purchased Munday's Field, where the club started out, from local shopkeeper John Munday for £60,000. Just across the road from the park, it served as a second ground.

EXPANSION AND DEVELOPMENT

When the county board included Fr Tierney Park in its 1996 county development plan the playing pitch was extended and widened. Work also began on a new clubhouse with a function room/clubroom and a media centre. Built by part-time workers on the Community Employment Scheme, Áras Aodh Ruadh was officially opened by Ulster GAA President John O'Reilly on 25 February 2001. The club opened its second ground, Páirc Aodh Ruadh, in Munday's Field on the centenary of the club's foundation.

Project 2024 was launched in 2019 to win GAA funding and support in modernising Fr Tierney Park, including renewing the playing surface with a new Prunty pitch, a new terrace and floodlighting. Work began on the pitch in 2021 and was completed in spring 2023.

1979
A new boundary wall is built on the town side after the original one is deemed unsafe

1988
'Baron of Ballyshannon' election proves to be a popular fundraiser

1994
Fr Tierney Park the venue for the 1994 All-Ireland Rounders finals on 16 October

2023
Aodh Ruadh hurlers host a visiting club from the Czech Republic, Píobairí Strakonice, in Munday's Field

Páirc Esler

LOCATION
Warrenpoint Road, Newry

NAMED AFTER
Archdeacon Hugh Esler
(1906–1983)
GAA enthusiast

OPENED
1964

CAPACITY
15,200

PITCH DIMENSIONS
138 x 81 m

COVERED ACCOMMODATION
Yes

FLOODLIGHTS
Yes

CLUB
Newry Shamrocks

Newry Shamrocks, formed in 1931, have won three Down SFC titles, in 1951, '56 and '61. Club members Tony Hadden, John Murphy, Collie Burns and D. J. Kane have won All-Ireland SFC medals, while the club's hurlers attained senior status for the first time in 2022. Club legend T. P. Murphy was Down county secretary for 28 years.

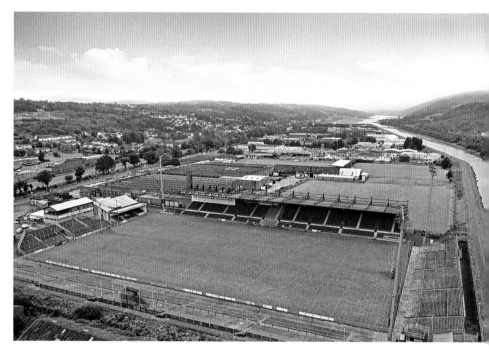

From marshland to fine sporting stadium, Páirc Esler is the only county ground that is not located entirely within its own county

Athletics meetings under the banner of the GAA were held in Newry as early as 1885. Four local clubs grew from there, with the most prominent – Fág-an-Bealach – playing in the Marshes off the Warrenpoint Road. The War of Independence and partition hindered the GAA's progress but things changed with Fr Hugh Esler's arrival in Newry in 1937. He and Brother Newell of the Abbey CBS launched a street league competition that became a nursery for Gaelic players.

Club games continued at the Marshes and the Abbey Grounds, with most inter-county games in Newcastle. Fr Esler, however, was adamant that the GAA should have its own ground and that this should be in Newry, the centre of Gaelic games in Co. Down. When the county committee instead proposed purchasing land from the Annesley estate in Newcastle, Fr Esler was not happy. He stormed out of the meeting with the parting shot: 'Gentlemen, there will be a ground in Newry in spite of you!'

KEY DATES

1888
Newry Emmets is founded, the first of the four clubs playing in a Newry league

1901
St Joseph's and John Mitchels hurling teams from Newry play the first recorded Gaelic game at the Marshes on 28 April

1930–40s
Gaelic games played in a field later turned into a greyhound track by Matt O'Hare

1942
Newry Gaels Athletic Association begins developing a pitch at the Marshes

1956
The new ground hosts its first Ulster SFC match when Armagh play Down on 24 June

ARCHDEACON HUGH ESLER

Hugh Esler was born in Ballynahinch, Co. Down, to Hugh and Jeannie Esler. He was just two years old when his father, a grocer in the town, died. Educated in St Colman's College and Maynooth, Hugh was ordained in 1933 and appointed curate in Newry in 1937. He quickly began re-energising Gaelic games in the soccer-mad town. His dedication to the GAA continued through his appointment as parish priest of Warrenpoint in 1961, canon of Clonallan in 1972, and archdeacon in 1980. Just a month before he died Archdeacon Esler celebrated his golden jubilee as a priest by meeting Pope John Paul II in the Vatican in October 1983.

NEWRY SHAMROCKS

50 VOLUNTEERS WANTED
(WITH SHOVELS AND SPADES), in the
GAELIC FIELD, WARRENPOINT ROAD,
On WEDNESDAY EVENING NEXT, at 2.30 p.m.,
(WEATHER PERMITTING)
Lend a Hand to Aid the Good Work.
(SEE COLUMN SIX)

Fr Esler and Newry Gaels make a successful plea for willing labour

VOLUNTEERS RISE TO THE CHALLENGE

The Newry Gaels Athletic Association – with Fr Esler, John Quinn, Peter O'Hagan, John Brown, Patrick Crinion and Pádraig Ó Caoimh as trustees – bought five acres at the Marshes from local butcher Thomas Ruddy in November 1942 and further parcels of land from Hugh O'Hare. The area was aptly named. One part lay at least three feet lower than the rest, and volunteers had to work hard with picks and shovels to level the ground, while the earth was carted by Fr Esler's donkey. Newry UDC provided filling by making the ground a refuse dump; further material came from the Chivers factory site. By the mid-1940s a temporary pitch had been created and Newry Shamrocks began playing there.

CLUBS TAKE THE REINS

Many inter-county matches were played at Páirc an Iúir through the 1950s, though the official opening was not held until 1964. The field committee dissolved at this point and their responsibilities were transferred to the Down County Board. After a few years the county board handed authority for the ground's development to the local clubs, Shamrocks, John Mitchels and John Bosco. Shamrocks took on managing the facility and built dressing rooms and a social centre there.

OPERATION TRANSFORMATION

Newry Shamrocks continued to maintain the ground and took 10% of receipts from Down's inter-county games. There were improvements through the 1980s but following the Bradford (1985) and Hillsborough (1989) football stadium disasters, the trustees and Down County Board decided to upgrade the ground to a new standard.

The transformation of the Marshes began in 1996, beginning with terracing and a new 1,000-seat South Stand. From mid-1999 the park's name morphed unofficially from Páirc an Iúir to Páirc Esler, though from then until 2004 no senior inter-county championship matches were played there due to ongoing work.

The ground closed again in 2006 for development as £1,200,000 in grants from Central Council, Ulster Council and the input of fundraising group Club Down, supported the extension of the South Stand, a 200-seater East Stand, new floodlights and an improved playing pitch. On 20 May 2007 Páirc Esler hosted its first Ulster SFC match since 1999 when Cavan visited the stadium for a preliminary round replay which the home side won, 0–15 to 0–11.

1964
7,000 watch Down vs Kerry as GAA President Alf Murray officially opens Páirc an Iúir on 14 June

1969
The grounds are vested in the 'Gaels of Newry' rather than a specific club

1999
Páirc an Iúir becomes Páirc Esler as Phase 1 of major development is unveiled

2007
Newly redeveloped Páirc Esler officially reopened on 7 October

2020
Ballyhale Shamrocks defeat Slaughtneil in the All-Ireland club SHC semi-final in Páirc Esler

St Patrick's Park

LOCATION
Castlewellan Road, Newcastle

NAMED AFTER
Saint Patrick (d. c. 461 AD)
Patron saint of Ireland

OPENED
1939

CAPACITY
3,000

PITCH DIMENSIONS
148 x 85 m

COVERED ACCOMMODATION
Yes

FLOODLIGHTS
Yes

CLUB
Bryansford

Bryansford excelled at winning titles in sequential order, having won the Down SFC from 1939–42 and five more titles between 1969 and 1974. They were Ulster club champions in 1969 and 1970 and All-Ireland 7-a-side champions five times. Prominent county players include Eamon Burns, Brian Burns and Kalum King.

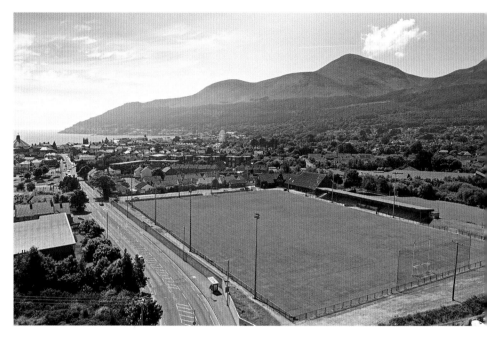

One of the earliest records of a hurling match in Newcastle was on 30 August 1903, when Ollamh Fodhla and John Mitchel's played an exhibition game for Feis an Dúin. Newcastle's own hurling team, Clann na Boirche, were winners of the Down SHC in 1905 and 1906.

A new era for Bryansford GAA Club may be dawning as the club works towards taking charge of St Patrick's Park and making their own of it

It was another 20 years before a football club was formed in the town. Bryansford only lasted six years and disbanded in 1932, but the club was reformed in 1935 and within four years won its first Down SFC title, defeating Saul by 8 points to 4.

On 4 September 1939 Down County Board entered an arrangement with the Annesley Estate to take a long-term lease on a ground on the Castlewellan Road. Bishop Mageean of Down and Connor, who had donated generously to the project, gave his approval to the purchase and named the ground St Patrick's Memorial Park. Help was promised from all over the county towards the cost of developing the grounds.

KEY DATES

1920
Newcastle hosts its first county SFC final on 4 April, but county chairman John H. King, a solicitor in the town, is arrested at pitch-side

1926
Bryansford GAA Club take their name from 17th-century Bryan Hugh Maginis, 5th Viscount Iveagh and one of the Maginis clan that ruled this part of south Down

1941
Ground hosts Down's biggest game yet, an NFL semi-final against Mayo before a crowd of 4,000 on 9 March

1971
Club lose to East Kerry in the first All-Ireland club final in Croke Park on 21 November

SAINT PATRICK

After being ordained as a bishop, in *c.* 432 /433 Patrick returned to Ireland, where he had been sold into slavery as a youth. He preached and converted until his death at Saul, Co. Down, on it is said 17 March 461 AD.

THRIVING AFTER TURBULENT TIMES

Despite winning four Down senior football titles in a row between 1939 and 1942, Bryansford disbanded again in 1945 and went through turbulent times once more in the 1950s. In the meantime, the county board acquired another parcel of land adjacent to its existing pitch on a 195-year lease from H. J. Wilson in 1956. Bryansford, encouraged by the impetus of Down's All-Ireland football success in 1960 and '61, reformed as a parish team in 1962 and dominated Co. Down football between 1969 and 1977, when they won six SFC titles. The club also played a major role in the redevelopment of St Patrick's Park after they leased it from the county board from 1979.

MAJOR UPGRADES

Through the 1980s Bryansford constructed a new access road to the pavilion and lengthened and widened the pitch in 1983. A lighted training area was laid out the following year and then a second pitch on adjacent parish property. In 1986 the club assisted the county board in building terracing, sideline seating and press facilities, as well as a covered 1,500-seat stand at a cost of £36,500.

A new development plan was launched in 1991 when 12 new turnstiles, a new boundary wall and extra gates were installed. The club was granted a 50-year lease from Down County Board in 1992 subject to Bryansford's management of the facility. The club began building a new pavilion and sports hall a year later, completed by 1996.

PROPOSED RELOCATION STALLS

In 2005 Down County Board instigated plans to sell St Patrick's Park to raise much-needed funds. However, Bryansford had 33 years left to run on their lease, so they would have had to be relocated. The board reached an agreement with the club in 2007 to move to a new 16-acre site on the Burrenbridge Road, about 2km north of the town, which the board had agreed to purchase

ALMOST A FINGER-TIPLESS SAVE

John Boden, Bryansford's and Down goalkeeper in the 1960s–70s, was known for his quick wit, and he didn't spare himself when it came to it. After losing the tops of his three middle fingers in a factory accident, he subsequently found himself facing Dan McCartan shooting from the penalty spot in the 1971 Down county final against Tullylish. Boden dived, got a hand to the ball, but it came off the post and McCartan put the rebound in the net. 'If this f—ing thing had been the full length,' Boden joked afterwards, 'I would have saved it!'

IRISH NEWS

Boden launching himself at McCartan's penalty

for £1.5m. The deal did not materialise in fact, due to issues regarding planning permission, and Bryansford never moved. Instead, the club plan to take up the county board's 2017 offer of selling St Patrick's Park to them, and are working towards that goal.

1983	1989	2004	2015	2022
Pitch refurbished at a cost of £20,000 with new drainage and stone-based foundation under the surface	*Social club on St Patrick's Road burned in an arson attack*	*Down senior county footballers and hurlers train under park's new floodlights*	*Club receives £10,000 grant from the National Lottery community fund*	*Club surpasses fundraising milestone of £200k to go towards the purchase of St Patrick's Park*

McKenna Park

LOCATION
McKenna Road, Ballycran

NAMED AFTER
Frank McKenna (1900–1953)
School principal, Gaeilgeoir, musician, hurling enthusiast

OPENED
1966

CAPACITY
1,320

PITCH DIMENSIONS
138 x 78 m

COVERED ACCOMMODATION
John Mallon Stand

FLOODLIGHTS
No

CLUB
St Joseph's Ballycran

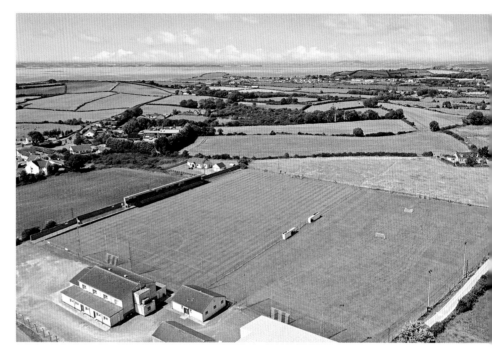

The Ards peninsula is home to the three most successful hurling clubs in Down – Portaferry, Ballygalget and Ballycran. St Joseph's has dominated county senior championships for the past 66 years. To date the club has the greatest number of Down SHC titles with 27, together with three Ulster senior hurling club titles in 1974, '76 and '93.

St Joseph's GAA Club, Ballycran, was formed in April 1939 when Hugh Gilmore and Pat Hamilton approached school principal Frank McKenna and sought his assistance in starting a hurling club. Hurling was flourishing in neighbouring Portaferry, and they helped St Joseph's get established by organising practice matches and loaning the club a few players to spread the skills of the game.

Despite the obstacles placed in their path, St Joseph's have created a fine sports ground and centre that serves club and community alike

Landowner Henry McCarthy gave St Joseph's a field close to the village church and later they rented from Harry Crawford, Willie Crawford, the De La Salle Brothers and George Bell. When the club decided in 1961 to acquire their own ground they were offered fields by Warnock Maxwell and Jim McNamara; part of the Plantation was suggested as was land in the Half Town; the De La Salle Brothers offered the Pond Meadow, while Harold Carson also had a field and so did George Bell. The club eventually decided to buy just over four acres from George Bell, though the ground was rocky and uneven.

KEY DATES

1949
St Joseph's claim their first Down SHC title when opponents Ballela fail to field

1962
Ballycran is the first GAA club in Ireland to be awarded a statutory grant for a pitch development from the Ministry of Education (NI)

1967
Down host Kerry in All-Ireland JHC semi-final at Ballycran, but referee Clem Foley (Dublin) gets lost and game starts without him

1992
Down beat Laois at McKenna Park on 16 February to record the county's first-ever NHL Division One win

FRANK McKENNA

Francis (or Frank) was born in Monaghan to Bernard McKenna and Mary Josephine Conlon. A fluent Irish speaker and talented musician, he was appointed principal of St Joseph's Primary School, Ballycranbeg, in 1933. A keen student of hurling, when he began training the school hurling team in 1939 he encouraged his pupils to practise every day at lunchtime, using a tin can as a sliotar.

When St Joseph's was founded it was agreed that the club's jerseys would be black and amber as a tribute to Frank's long-time friend, hurling legend Lory Meagher of Kilkenny. The esteem in which he was held locally is reflected in the fact that Ballycran not only has McKenna Park but also McKenna Hall, McKenna Road and the McKenna Accordion Band. Even the Friends of McKenna club lotto continues to bear his name.

BLASTING AHEAD

Assistance from Down County Board and the Ulster Council helped the club to complete the purchase and work on the pitch began in September 1962. Over the next few years club members, including Davy Bell, John Mallon and Hugh Gilmore, worked tirelessly to remove stones and rocks from the ground. Charlie Murray's JCB was very useful with the heavy work. Some boulders had to be blasted out with dynamite.

May 1993: inspecting the damage in the aftermath of another arson attack became an all too familiar duty for St Joseph's members. The 20-year-long campaign of destruction is estimated to have cost the club over £750,000

BUSTIN' OUTTA JAIL

Ballycran came up with a novel plot to raise funds for a new indoor hurling pitch. The Crumlin Road Jailbreak was launched in 2019 as the club celebrated its 80th anniversary. The concept was simple and effective: every person 'arrested' had to raise £2,000 in sponsorship to get out of jail on bail.

The club experienced a setback in 1963 when the Ministry of Education withdrew its financial support for the development. St Joseph's continued with their plans and set about their own fundraising activities.

GAA President Alf Murray opened the ground on 26 June 1966. St Vincent's hurlers and footballers from Dublin defeated Down that day, with Jimmy Keaveney scoring in both matches. Ballycran, and fellow Ards peninsula clubs Ballygalget and Portaferry, hosted many NHL games from then on.

'THE CRANS' PHOENIX-LIKE SPIRIT

Ard Stiúrthóir Seán Ó Síocháin opened St Joseph's new clubhouse in 1970. The building, which also served as a community hall, was repeatedly vandalised between 1974 and 1993 and destroyed by fire on three occasions. Each time it was burned down the club rose from the ashes and carried on again. Ground development persisted in other areas as well. Dugouts were constructed in May 1983 and training lights went up the following month. The club received National Lottery funding in 2000 to build new dressing rooms, and four years later work began on a second pitch beside the main one and a new stand was also constructed.

RECORDS AND TITLES

St Joseph's made history in 2012 when they became the first club to capture the Co. Down senior hurling and senior camogie championship titles in the same year. The camogie players went on to win the club's first Ulster Senior Camogie title that year.

2004
Stand opened and named after former club chairman John Mallon on 4 October

2016
Strategic plan launched to improve playing facilities

2019
Club wins prestigious MacNamee Award for best GAA club website

2020
Ballycran Community Complex, housing an indoor pitch and wellbeing centre, opens

Brewster Park

LOCATION
Erne Road, Enniskillen

NAMED AFTER
Michael Brewster (1938–1979)
Teacher, footballer, coach

OPENED
1982

CAPACITY
18,000

PITCH DIMENSIONS
145 x 83m

COVERED ACCOMMODATION
Yes

FLOODLIGHTS
Yes

CLUB
Enniskillen Gaels

Enniskillen Gaels have a proud history in Fermanagh football, having won the county senior title on 13 occasions, most recently in 2022 and including a remarkable six-in-a-row between 1998 and 2003. The Gaels also field hurling teams – their seniors won the county title in 1979, 1980 and 1990 – and have a very active ladies' football division.

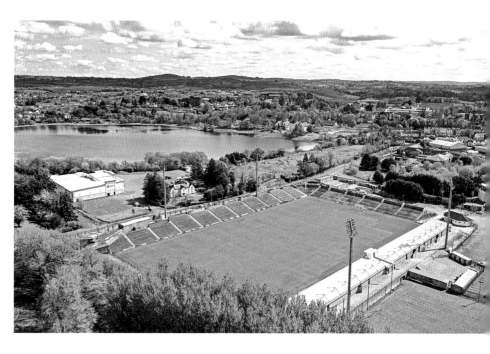

Though several GAA clubs were formed in Enniskillen between 1902 and 1927, green fields were not easily secured around the 'island town' lapped by the waters of Lough Erne. The Protestant sabbatarian tradition also made it difficult to lease a field for Sunday pastimes.

Brewster Park is a relatively young ground but its development has been ambitious and prudently managed

The first Ulster championship game in Enniskillen, played in January 1905 between Fermanagh and Monaghan, was held at Enniskillen O'Neill's club grounds at Killynure. There was only one local GAA club at any given time – after Enniskillen O'Neills (1904–12) came a string of short-lived clubs, among them Young Ireland's, Seán McDermott's, Enniskillen Maguires, Enniskillen Geraldines, St Michael's and Enniskillen Lough Erne Gaels. Soccer was the dominant game and Enniskillen's standing as a 'garrison town' was also relevant: constabulary league soccer attracted many erstwhile Gaelic players with the lure of a post-match meal. Political conflict also had an effect, forcing Fermanagh GAA out of existence for two years, while the Geraldines club folded in 1925 due to lack of numbers.

KEY DATES

1928
Fermanagh play Armagh in Gaelic Park's first Ulster championship match on 10 June

1932
A Mayo–Dublin challenge match in front of 7,000 spectators helps to raise funds

1946
Monaghan beat Fermanagh 8–6 to 7–4 in the last Ulster SHC match in Gaelic Park on 16 June

1974
Enniskillen Gaels buy a site from Miss Violet Rutherford and Mr and Mrs McNeary

1982
Former GAA president Padraig Mac Flynn opens Michael Brewster Memorial Park on 9 May

MICHAEL BREWSTER

BREWSTER FAMILY

Michael Brewster was born in Belleek, Co. Fermanagh. His father, Thomas, was in the RIC and the family moved to Enniskillen, where Michael grew up. He played on Queen's University's first successful Sigerson Cup winning team, and later returned to St Michael's College, Enniskillen, where he taught maths.

Michael played at midfield when Fermanagh won their first national title, the junior All-Ireland of 1959. He also represented Ulster in the Railway Cup. In 1971 he coached Fermanagh minors to their only Ulster league title, and to reach the Ulster championship final that year. He also coached St Michael's to a first MacRory Cup title in 1973. He was central to Enniskillen Gaels' success in the 1970s, winning two SFC and league titles. His sudden death at the age of 41 caused shock throughout Ulster. 'His ability to read a game,' county chairman John Vesey remarked, 'surpassed that of any other individual I have met.' Michael's sons Paul and Tom went on to become leading Fermanagh players.

SLIGO ROAD GAELIC PARK

Gaelic games revived in 1926 when Lough Erne Gaels junior club was founded by Felix Hackett, Tom Cox and Peter Maguire among others. The club morphed into the present Enniskillen Gaels club at senior level the following year and acquired their own field on the Sligo Road in 1928 when the owner, Peter Murphy, sold it for £300 to Felix Hackett and Tommy Cox, acting on behalf of the club. It became the county ground and one of the first grounds vested in Ulster GAA.

Gaelic Park hosted ten Ulster senior championship matches from then until 1946, when grounds in Irvinestown and Lisnaskea developed and county matches were switched there. When Fermanagh returned to the Ulster senior championship in 1960 following an 11-year lapse, pressure began to bear on Enniskillen Gaels to create better facilities in the county town.

A HOME ON ERNE ROAD

Club secretary Michael Brewster and treasurer John Vesey led the move to a new location. When a 13-acre site on the Erne Road came on the market in April 1974 the initial contract price for two plots of land was £35,000; however, this had soared to almost £82,000 before planning approval for the pitches and premises was finally obtained in 1979 thanks mainly to the good offices of Gerry Magee, Dessie Leonard and Richard Tracey. Over £120,000 was eventually paid out on developing the grounds and another £20,000 on building a boundary walls and fences. The clubhouse was completed in 1981 and the park was opened officially the following year, when 3,000 spectators watched Fermanagh footballers defeat Down on the day by 2–10 to 0–10. From the mid-1980s Brewster Park began to host inter-county matches and county finals.

Enniskillen Gaels invested again in 1996. Facilities were kept simple: seating along each sideline, standing behind each goal, and a new stand to hold 4,000 spectators. Further work carried out between 2005 and 2008 increased capacity to approx. 18,000. Enniskillen Gaels launched fresh development plans in May 2022, the 40th anniversary of Brewster Park's opening.

SILVER SCREEN SILVER

The Gaels were perhaps the first GAA club to use cinema to raise funds. The club needed Enniskillen Urban Council's permission to show a film on a Sunday, and on 24 October 1937 the musical Limelight drew 1,000 people to the Regal Cinema and raised over £300 on the night.

2000
Fermanagh defeat Monaghan 3–12 to 1–10 at the ground's first Ulster SFC match on 14 May

2002
The park holds its first major national match, the NFL semi-final, Tyrone vs Mayo

2005
New stand is dedicated to John Vesey, county chairman 1985–95 and Ulster Council president 1995–97

2008
Park's floodlights switched on for Ulster club final between Ballinderry and Crossmaglen

2022
Enniskillen-born actor Adrian Dunbar becomes a club ambassador

Emmet Park

LOCATION
Barnhill, Lisnaskea

NAMED AFTER
Robert Emmet (1778–1803)
*Republican, orator,
legal scholar*

OPENED
1956

CAPACITY
3,500

PITCH DIMENSIONS
144 x 86m

COVERED ACCOMMODATION
Yes

FLOODLIGHTS
No

CLUB
Lisnaskea Emmets

Lisnaskea Emmets have won 20 SFC titles between 1928 and 1994. Club legend Tommy Durnien won 12 from 1936 to 1950. The hurlers also took SHC titles in 1980 and 2005. Tragically, Brian Óg Maguire, IFC-winning captain of 2011, died after an industrial accident a year later.

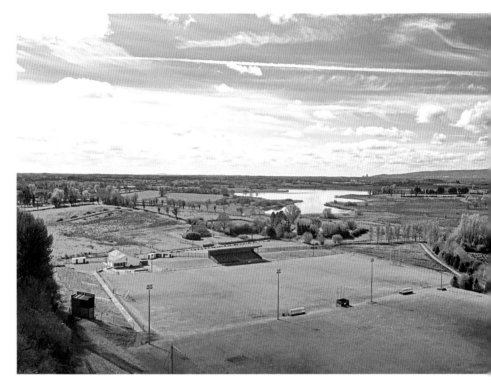

Lisnaskea Emmets GAA Club was founded in 1904 by James Hogan, Michael McManus, Paddy McQuaid and Johnny Maguire and formally affiliated to the Fermanagh County Board on 29 January 1905. The club was fortunate that one of its members, local landowner Peter Cosgrove, allowed the club to play on one of his fields, which became known as 'Peter's Hill.'

The club went out of existence between 1920 and 1926 due to the War of Independence and then partition, and by the time it was revived in 1926 Peter Cosgrove had died and the Peter's Hill land had passed into new ownership. The club found it very difficult to secure a ground of their own and played in a variety of venues. As the club was reorganised and began to operate properly a field was rented from Andrew Gavin on Drumbroughas North at a rent of £10 per season. This ground, known as Gaelic Park, was home to the club for some 20 years.

Lisnaskea Emmets have developed a fine ground, and pioneered the first Prunty pitch laid in Ireland

KEY DATES

1928
Lisnaskea Emmets win the first of its 20 Fermanagh senior football titles

1956
Athletic Grounds open, with a Railway End and Canal End like Croke Park

1971
Down play Cavan in a senior football challenge match to mark Emmet's Park reopening

1973
Emmet Park hosts Ulster U21 football final, Tyrone vs Monaghan, and Fermanagh's home NFL games

ROBERT EMMET

From a wealthy Protestant family, Robert Emmet joined in the United Irishmen's rebellion of 1798, and, after exile in France, plotted another insurrection in Ireland. The 1803 uprising failed dismally, but Emmet remained one of Ireland's most romanticised martyrs a century on, when many GAA clubs were being formed.

CLUB LOSE THE BUS BUT NOT THE PLOT

In 1945 club member and local publican Frank Reihill, an ex-RIC man, bought a farm from the Winslow family in Barnhill. He sold part of the land to Lisnaskea Emmets in May 1946 for £627. 3s. 0d. This became known as the Athletic Grounds. The club tried to buy a double-decker bus and convert it into dressings rooms, but a price could not be agreed and the club remained without.

A great deal of work was needed to create the pitch, which was done manually under the supervision of John Carron. Dressing rooms were eventually built and the ground was opened in 1956.

PRUNTY PITCH PERFECT UPGRADE

In 1968 the club decided on a modest plan to improve the ground. In fact the plan grew and laid the foundation for a revolutionary development in playing surfaces all over Ireland: the Prunty pitch.

The club engaged the services of Roslea man Joe Pat Prunty, an expert ploughman with a fascination for the soil. Together with Teagasc drainage expert John Mulqueen, Joe Pat developed a radical theory of using sand to strengthen the ground surface and improve drainage. He described it as 'a buttering of sand' complemented by a conventional system of shallow drains. Lisnaskea was the first GAA ground to employ this technique, which subsequently became the blueprint for hundreds of Gaelic and other sports grounds.

Lisnaskea Athletic Grounds was reopened as Emmet Park by Senator Andrew O'Brien, Ulster Council chairman, on 30 May 1971.

1980s DRIVE TO IMPROVE

'A pitch is a living breathing thing and has to be treated that way,' Joe Pat Prunty believed. 'You can't just lay it down and forget about it.'

Lisnaskea Emmets continued in that vein. In 1983 the pitch was ploughed and levelled and extended by 20 metres at the Lough Head end of the ground. The ground reopened in June 1984 and three years later the club embarked on a three-phase programme that included building a clubhouse to include four dressing rooms, toilets, showers and kitchen. A new boundary wall and entrance gates were also constructed and the whole project was completed by November 1988.

FUNDRAISING AND ALL-IRELAND SUCCESSES

The club purchased land adjacent to the existing pitch for £65,000 in 2004 and spent a further £340,000 on it. In 2007 they launched a fundraising initiative which saw 300 members commit to donating £5 a week for 12 months, an initiative that raised £78,000 in the most successful fundraiser in the club's history.

Lisnaskea men's team won the Ulster intermediate club football championship in 2011 and went on to win the All-Ireland, the first time any club representing Fermanagh won an All-Ireland title. Nine months later this feat was emulated by the club's women's football team, who won the All-Ireland intermediate club title in 2012, proof that parity brings esteem.

1977	1982	1993	2003	2018
Lisnaskea win county SFC and Emmet Park hosts its first Ulster Club SFC match, a home tie vs Cavan Gaels	Spectator seating is installed at the Railway End	Emmet Park hosts Fermanagh ladies' football league final, Newtownbutler vs Kinawley	A new spectator stand and pavilion are built at a cost of £80,000	Emmet Park is voted Fermanagh GAA Ground of the Year

St Molaise Park

LOCATION
Bridge Street, Irvinestown

NAMED AFTER
Saint Molaise (d.c.564 AD)
Early Christian saint

OPENED
1947

CAPACITY
5,000

PITCH DIMENSIONS
146 x 80 m

COVERED ACCOMMODATION
No

FLOODLIGHTS
No

CLUB
Irvinestown St Molaise

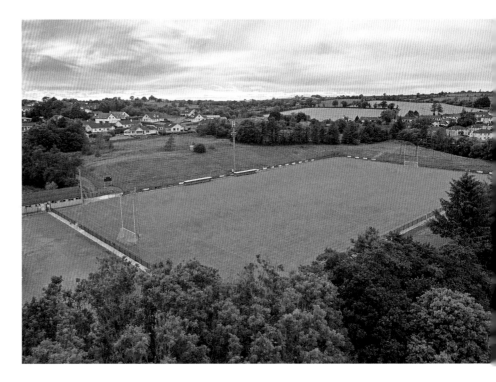

Irvinestown St Molaise have two Fermanagh senior county titles to their name, 1918 and 1952. In more recent times they won the county minor championship and league in 2021, with the seniors securing promotion to Division 1 of the Fermanagh Senior League for 2023, having gone through Division 2 unbeaten in 2022.

The first GAA club in Irvinestown was briefly called Michael Barrett's until co-founder Fr Pat McQuaid proposed that the name be changed to Irvinestown St Molaise in 1906. They played hurling in a ground on the Lack Road that opened on 16 April 1906 with a match against Owen Roe's of Tummery. The club turned out in green-and-gold jerseys knitted for them by a group of nuns in Donegal.

St Molaise fell into a period of inactivity later but re-affiliated to the GAA in 1918 as a football club, winning the 1918 Fermanagh SFC when the final was played in May 1919. In 1924 St Molaise moved to a field on the Dromore Road, on the town's eastern boundary, which was actually sited in Tyrone. An even more immediate problem was that spectators took to watching games from the roadside rather than pay at the gate. The club dealt with that by sewing hundreds of meal bags together to screen off the pitch.

St Molaise Park's status may have fluctuated over the years, but for a ground in a small town it has often punched above its weight

KEY DATES

1906
St Molaise GAA Club is founded and carries on the hurling tradition in this part of Fermanagh

1935
The Irvinestown club hosts its only Ulster SFC game at the Dromore Road ground

1947
Cavan play Roscommon in football as GAA President Dan O'Rourke opens St Molaise Park on 11 May

1952
St Molaise win their second Fermanagh senior football title

1964
After recent renovations, Irvinestown is nominated to host its first Ulster SFC semi-final, Cavan vs Donegal

SAINT MOLAISE

St Molaise founded a monastery on Devenish Island in lower Lough Erne in the 6th century. With some 1,000 monks at its peak, it remained a centre of art and learning through to the 16th century.

FLATTENING HILLS AND FILLING HOLLOWS

In late November 1945 the club bought two fields formerly known as the Bridge Street Meadow as the site for a new ground. The 6.5 acres were purchased from James Cassidy for £526. 14s. 6d. Funds were raised locally within a week.

The ground was vested in the GAA in 1946 and development work began in February 1947. The budget, a little over £3,000, covered the removal of 20-foot-high hillocks, filling in a large 15-feet hollow, building a 10-foot embankment and providing sideline seating for 3,000 spectators.

Gerry Magee, William Lennon and club chairman Rev. Bernard Lappin were the driving force behind the project. St Molaise Park opened on 11 May 1947, within 18 months of its acquisition. Special trains and buses ran from many parts of Ulster and brought the crowd close to 10,000 for the occasion.

HOSTING THE COUNTY SIDE

Irvinestown immediately became Fermanagh's home ground, displacing Enniskillen. However, in 1949 Fermanagh opted out of the Ulster SFC for a decade, which meant that the park saw few major games. This changed in 1959 when the All-Ireland JFC semi-final replay, Fermanagh vs Dublin, was fixed for 13 September in Irvinestown. In front of 7,000

WOOLLY WARRIORS

St Molaise was not unusual taking to the field wearing knit-wear in the early 1900s. The 1904 GAA Convention ruled that all teams should dress uniformly, with one newspaper declaring, 'jerseys of Irish manufacture should be compulsory.' It added, 'the knitting industry is one that should be encouraged, and a hurler with an Irish camán and an English shoddy jersey should be made to realise his inconsistency.'

spectators, Fermanagh beat Dublin by 4–13 to 3–8 and advanced to defeat Kerry in the final. It was the county's first visit to Croke Park and a first national title for Fermanagh.

HOSTING AN ALL-IRELAND FINAL

The club embarked on an extensive reconstruction scheme in 1963 aimed at increasing capacity to 25,000 with seating for 5,000. Almost £9,000 of the more than £14,000 budget was raised locally. The development won the ground Grade 1 status and from this point on St Molaise Park occasionally served as a neutral venue for Ulster semi-finals. More big games involving teams from different counties brought in large crowds and greater income, but even so the ground's status declined during the 1970s and the quality of the pitch deteriorated.

The situation was turned around in 1982 when new dressing rooms with showers, referee's room and first-aid facilities were constructed and opened in 1983 by Ulster GAA President Phil Smith. The pitch was also totally re-drained, which led the *Sunday Independent* to compare it to a golfing green at Augusta. It was a great day for the club when the All-Ireland U21 football final replay between Derry and Mayo was held at their ground on 30 October 1983. This was, remarkably, the first time that a major inter-county final was played in Ulster.

CHANGING TIMES AND STATUS

From 1995 St Molaise's star waned as the Ulster Council appointed more games to Clones and other venues, and Brewster Park became Fermanagh's principal ground. Though new dressing rooms were constructed in 1998, Irvinestown lost its premier county ground status altogether for some years but was granted secondary ground status in 2008.

1987
Armagh score five goals against Tyrone, All-Ireland finalists of the previous year, in an Ulster SFC semi-final at packed St Molaise Park

1988
New terracing installed along with an extended wheelchair area

2010
Sideline seating deteriorates and as a health and safety hazard is removed

2021
Club receives planning permission to build a spectator stand and new pitch

St Tiernach's Park

LOCATION
25 Roslea Terrace, Clones

NAMED AFTER
Saint Tiernach (d. c. 549 AD)
Patron saint of Clones

OPENED
1944

CAPACITY
28,000

PITCH DIMENSIONS
142 x 89m

COVERED ACCOMMODATION
Gerry Arthurs Stand
Pat McGrane Stand

FLOODLIGHTS
No

CLUB
Clones St Tiernach's

St Tiernach's is one of the oldest clubs in the GAA. They have one Monaghan SFC title and one Ulster intermediate football title to their name and have also been successful in county championship hurling and camogie. Clones' legendary handballer, Seamus McCabe, won 47 Ulster and four All-Ireland titles between 1960 and 1972, while club man Ciaran Murray won an All Star in 1986.

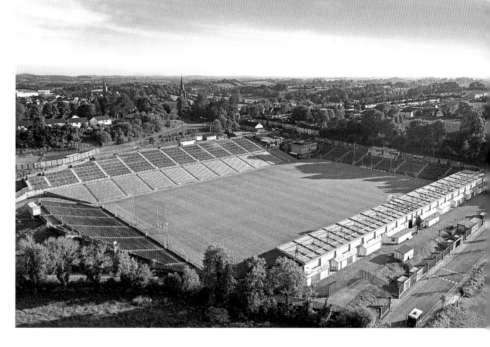

Clones has been the home of Ulster football for more than a century, hosting more Ulster SFC matches than any other venue. The fact that the town was the provincial hub for the Great Northern Railway was a vital factor in this, bringing supporters from Belfast, Portadown and Armagh, Dundalk and Cavan, and from Enniskillen. Another was the support of the community, who saw the benefit that these games brought to the town and its economy.

St Tiernach's Park is in need of substantial refurbishment and retention of the provincial championships in order to remain a flagship ground

The Red Hands of Ulster, the first club locally, affiliated to the GAA in 1887. As Clones Lámh Dearg they leased a field at Dromard, about two kilometres north of St Tiernach's Park, which became known as the Gaelic Grounds and from 1906 was a regular venue for Ulster SFC finals. The Ulster Council chose the ground because it drew the biggest crowds, though the support of Ulster GAA president Patrick Whelan and secretary Eoin O'Duffy, who both lived in this part of Monaghan, also did much to help Clones advance.

KEY DATES

1906–09
Clones' pitch at Dromard hosts the 1904, '06, '08 and '09 Ulster SFC finals

1943
St Tierney's win their first and only Monaghan SFC title captained by club stalwart Pat McGrane

1944
Rev. Canon James Marron, PP Clones, opens St Tiernach's Park on 6 August

1950
New dressing rooms and the Eoin O'Duffy terrace open on 26 March

ANDREAS F BORCHERT

SAINT TIERNACH

St Tiernach founded a monastery in Clones in the 6th century which remained the most important Christian site in Monaghan for centuries. Tiernach, who was Bishop of Clogher, is the patron saint of Clones.

The saint as he is depicted on a window in St Macartan's Cathedral, Monaghan

RISK IS REWARDED

Partition had a profound effect on Clones as the border cut across the outskirts of the town. Although four Ulster finals were held there between 1921 and '25, the town hosted no more for two decades. Traders worried that Clones would lose out even more over time.

In the meantime, Clones GAA club – then called Clones St Tierney's – began leasing a pitch in 1939 and bought it outright from Sam Keary, Church Road, for £700 in January 1944. They spent another £500 on levelling, re-sodding and enclosing it. Taking on such a debt in the war years was a brave step but subscriptions poured in, with the clergy leading the way, and income from céilís, concerts, plays, pantomimes, whist drives and raffles yielded £650.

Most of the work on the ground was done by volunteers and the local administration's involvement under Peter Connolly and Seamus McCabe was extraordinary. Assistant county surveyor J. Gilsenan took no fees for planning and overseeing the project; neither did solicitor J. B. Murphy. Dr P. J. Maguire, chairman of Clones UDC, was a club trustee, and town clerk Patrick Murtagh became club secretary later. These close relationships lasted for decades.

The ground was nominated for the 1944 Ulster SFC final on the Sunday before its opening, which caused a conundrum because that match would affect Clones' own gate a week later. They hosted the final anyway and then opened the park officially the following week.

FLUCTUATING FORTUNES

All but two Ulster SFC finals were played in St Tiernach's between 1944 and 1960. However, in 1957 the railway line closed. The rise of Co. Down teams and the opening of the M1 to Belfast combined to make Casement Park the main venue for Ulster finals in the 1960s. Clones became the favoured venue once again though when the outbreak of the Troubles in the late '60s made travelling north of the border difficult, and the ground hosted every Ulster football final from 1972 to 1990.

SPORTSFILE

Meet the press – media attention was intense when Arlene Foster in 2018 became the first DUP leader to attend an Ulster final. The Fermanagh woman enjoyed the novelty but was disappointed her beloved county came up short against Donegal

HOME OF ULSTER'S SHOWPIECE

The Ulster Council selected St Tiernach's Park as its provincial ground in February 1991. Now entitled to grants from Central Council, in 1992 the county board purchased land beside the ground and began work on the pitch irrigation system. Unfortunately, when Derry played Donegal in the first Ulster final on the new surface in July 1993, heavy rain made the pitch all but unplayable. This caused a public outcry but the county board pressed on. The £1.5m refurbishment, which included a new stand and terracing, was completed in time for the Ulster SFC final in 1994 before a capacity 35,000 attendance. Clones hosted the Ulster finals from then until 2004 when it was played in Croke Park because of its higher capacity. The 2005 and 2006 Ulster finals were also held in Croke Park after which time they returned to Clones.

1959	1975–81	1994	2018
'The Hill' is acquired and provides a platform for some 25,000 spectators	*New dressing rooms, entrances, terrace seating, media room add to the facility*	*GAA President Jack Boothman opens refurbished ground ahead of Dr McKenna Cup final*	*Arlene Foster becomes the first DUP leader to attend the Ulster SFC final*

St Mary's Park

LOCATION
Dublin Road, Castleblayney

NAMED AFTER
Saint Mary
Patron saint of Parish of Muckno

OPENED
1953

CAPACITY
6,700

PITCH DIMENSIONS
147 x 90 m

COVERED ACCOMMODATION
Yes

FLOODLIGHTS
Yes

CLUB
Castleblayney Faughs

Faughs are clear leaders for top honours in county football championship wins with 37 titles, along with three Ulster titles. Distinguished county players in the 1970s and 1980s include Gerry Fitzpatrick, Eamon Tavey, Nudie Hughes, Eamon McEneaney and Declan Flanagan. In 2008 club member Páraic Duffy was appointed Ard Stiúrthóir (General Secretary) of the GAA.

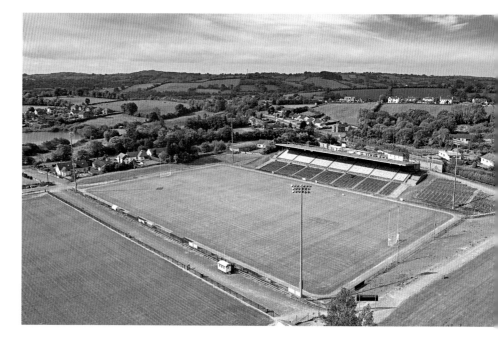

Gaelic football has been played in Castleblayney since 1888, with clubs such as Castleblayney William O'Brien's (later known as Young O'Brien's), Castleblayney Gladstonians and Castleblayney Fág an Bealach representing the town. However, in the 1890s GAA structures collapsed throughout Ulster, and young men in towns like 'Blayney often turned to soccer. Faughs GAA Club was re-launched on 12 November 1905 under the guidance of Fr Mark Clinton, who persuaded many local players to switch from soccer to football. Willie McGrath, captain of the 1907 SFC-winning team, was another key figure in this GAA revival.

St Mary's prominence as a venue for senior inter-county games has done much to create Castleblayney's football tradition

Faughs played in different fields during these years, including Dr Gilmore's Field (or 'the Pipers' Field') adjacent to the railway station, and Carragher's Field next to the Shercock Road, where they played from 1923. Ten years later the club leased land at Concra just outside the town from the Duke of Newcastle, Henry Pelham-Clinton-Hope, who was related to the Hopes of Hope Castle, Castleblayney. This would become one of the finest playing grounds in Ulster at the time.

KEY DATES

1905
Castleblayney Faughs founded and win the 1907 Monaghan SFC title, played in 1908

1909
First Ulster SFC match held in Castleblayney is played on 28 March

1933
Dublin defeat Kerry 3–4 to 2–3 in exhibition game at the official opening of new Concra ground

1953
Dr Eugene O'Callaghan, Bishop of Clogher, opens St Mary's Park officially on 31 May

VIRGIN MARY, MOTHER OF JESUS

Mary has been venerated since early Christian times. St Mary's Church, Castleblayney, was built in the 1850s.

CONCRA'S GLORY YEARS

The project to secure the site at Concra was led by local postmaster Tom Connaire. After it was enclosed and developed its superior pitch made it popular for Ulster SFC games. Castleblayney hosted four provincial finals in six seasons – the 1934, '36, '37 and 1939 deciders, which were all won by Cavan. This was more than any other venue in the 1930s.

Three of these were tense Cavan vs Armagh clashes. Both counties lay close to 'Blayney and their rivalry drew a crowd of 14,000 to the 1939 final, far beyond the park's 10,000 capacity. Spectators spilled over the sideline barriers and these incursions caused lengthy delays. In the end the crowd invaded the pitch when an Armagh player was struck by a spectator and the game had to be abandoned. The replay was held in Croke Park.

MOVING TO THE DUBLIN ROAD

Club official John Marray led the search for a new field within walking distance of town, and in 1946 they purchased 15 acres on the Dublin Road for £1,130 from the estate of the late Joe Daly. Former Faughs and Monaghan player Charlie McGrath made the winning bid at the

auction. A field development committee chaired by Fr James Duffy directed the complex task of bringing the ground up to playing standard, including the installation of drainage to combat winter flooding. Seven years later it was officially opened as St Mary's Park.

HOSTING CHAMPIONSHIP GAMES

Development over the years qualified St Mary's as a joint home venue, along with Clones, for Monaghan, and its centrality within the province led to its frequent appointment as a neutral venue for Ulster SFC games, though not finals.

An elaborate drainage system was laid in 1959, but the pitch still had to be raised by eight inches to solve the problem of flooding. New dressing rooms in 1976 gave players and referees direct access to the pitch – and a reprieve from walking through the public seated area, which had caused some skirmishes over the years. These and other improvements were rewarded with the hosting of eight Ulster SFC semi-finals in the 1970s and '80s.

COMING FULL CIRCLE

After 1993 St Mary's Park lost out on further Ulster SFC matches when Clones became the primary provincial ground. Over the next decade the park was refurbished, dressing rooms and referees' room were upgraded in 2003 and the pitch re-laid in 2011. A 2,000-seater covered stand in 2014 realised a long-held ambition. In 2017 the pitch underwent a Prunty redevelopment, an all-weather running track was laid and inter-county standard floodlights installed. The club purchased seven acres adjoining the park in 2020, where a full-sized pitch and smaller training pitch were laid with other facilities to follow. This land had been part of the Blayney and Hope estates in the 19th century, bringing the story of Faughs' search for a ground full circle.

MICHAEL BURNS

Elevated position – Dr Eugene O'Callaghan, Bishop of Clogher, performing the opening day ceremony from a stage perched on metal barrels in 1953

1985
Floodlights costing in the region of £50,000 installed

1986
Legendary player Nudie Hughes raises £14k for the club by soloing a football 300 miles around Ireland

1998
St Mary's hosts the first ever competitive inter-county GAA match played under floodlights as Monaghan overcome Longford in the All-Ireland B Championship

2023
New full-length Prunty pitch and training pitch are opened for play in April

Grattan Park

LOCATION
Kednaminsha, Inniskeen

NAMED AFTER
Henry Grattan (1746–1820)
Politician, lawyer

OPENED
2011

CAPACITY
5,175

PITCH DIMENSIONS
145 x 90m

COVERED ACCOMMODATION
Paddy O'Rourke Stand

FLOODLIGHTS
Yes

CLUB
Inniskeen Grattans

Grattans' footballers glory years were between 1939 and 1948 when they contested five county senior football titles, winning three and losing two. One of their most prominent players in the 1960s was Joe Carroll, who won a Railway Cup medal with Ulster in 1965. The club's hurlers played in nine senior hurling finals between 2010 and 2018, winning three and losing six.

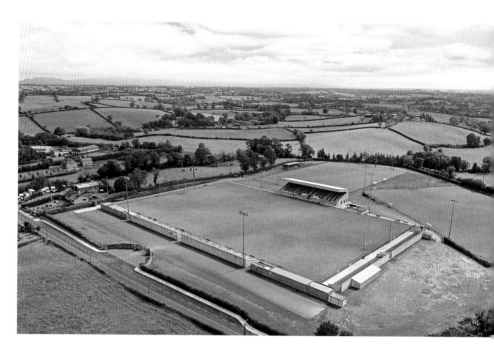

Inniskeen Grattans was one of the earliest Gaelic clubs in Co. Monaghan, first reported in action in October 1887. They won the first Monaghan SFC in 1888 and went on to represent the county in the first Ulster SFC, defeating MacFinn's, representing Cavan, in the final on 9 September 1888.

Since opening at Kednaminsha in 2008, Grattan Park has been one of the GAA's newest county grounds, and much favoured for Monaghan's home games in National Leagues

The club changed their name to Fane Rovers in the early 1900s but reverted to their original name in 1938. The Grattans played in different pitches down through the years, including Kenny's at Rocksavage, Byrne's Field at Momoney, Caffrey's Meadow at Annagerril, Meegan's Meadow at Lannett, Martin's Field in Knock, Toal's Field at Inniskeen and Carolan's Field in Moyles.

Grattans decided to look for a permanent home in 1950 and set up a sportsfield committee to raise funds. They settled on a ground they had been playing on which was owned by Daniel McNello at the Glebe. After lengthy negotiations an agreement was made on 31 December 1956 to purchase the ground for £800.

KEY DATES

1806
Poem 'Iomáin Athnasgaoin' describes Inniskeen playing Channonrock (Louth) on the riverside meadow in the middle of the village

1950s
A bullock is offered as first prize in the club's fundraising draw

1959
First game in new ground is between Inniskeen and Donaghmoyne on 26 April

1975
Original timber paling is replaced with a concrete boundary wall

1982
Sports centre with dressing rooms, committee rooms and handball alley completed at a cost of £60,000

HENRY GRATTAN

Henry Grattan was a leading member of the Patriot movement campaigning for the repeal of the Penal Laws, Ireland's right to free trade and ultimately for legislative independence. His work came to fruition in 1782 when the Penal Laws were ended and Ireland was granted a parliament of its own, which came to be called 'Grattan's Parliament.' The Irish Parliament came to an end in 1801 in the aftermath of the 1798 Rebellion when the Act of Union created the United Kingdom of Great Britain and Ireland and amalgamated the two parliaments.

O CONEY WHITE SOIL OF MONAGHAN ...

Patrick Kavanagh, one of Ireland's foremost poets, was born and bred in Inniskeen. He played in goal for Fane Rovers (Inniskeen) in the 1930 Monaghan county final against Latton O'Rahillys held in Carrickmacross. Near the end of the match when Latton were attacking Kavanagh inexplicably left his goal (some say to get an ice-cream) and in his absence the ball was fisted into the Rovers' unguarded net. Latton claimed victory by 2–1 to 0–4. Despite this peculiar lapse, the poet was elected captain, secretary and treasurer of Fane Rovers for a year and his image is depicted on the club's crest today.

CANUCKS COME CALLING

Frank O'Neill, President of the Ulster Council, opened Grattan Park on 29 May 1960. Monaghan beat Armagh by 2–10 to 2–4 on the day in front of a crowd of 2,000 spectators. A few months later a Toronto Gaelic football team became the first ever to represent Canada in a match in Ireland when they defeated Monaghan at the park on 18 September by 3–7 to 2–7.

PARISH TO THE RESCUE

Inniskeen Grattans took an innovative decision in 1979 to provide a children's playground in a section of the park to keep young people in contact with the GAA. However, by 2000 the club was running out of space due to the number of teams being catered for. In 2004 their development committee identified a new location just outside the village in Kednaminsha, and on 14 March a deal was struck with the owners, Tom Leem and Willie Brennan, to buy the 17.5 acres for €500,000. The decision to move met with opposition from some members, not least because the club had insufficient funds, but providentially they received financial support from local parishioners. The purchase was completed on 28 January 2005 while the Glebe was sold for €2.2m that April.

BIG MOVE PAYS DIVIDENDS

On 31 October 2005 the Inniskeen Grattans moved to their new site and set about developing the grounds to a high modern standard. They created three pitches adjacent to one another with a walkway encompassing them. The state-of-the-art dressing rooms came with ice baths fitted in each. The stand on the main pitch was built to seat 1,400.

On Friday 2 January 2009 the floodlights on the main pitch were switched on by GAA Ard Stiúrthóir Páraic Duffy. Floodlights were subsequently installed in the two other pitches. The magnificent new Grattan Park was officially opened by GAA President Christy Cooney on 2 May 2011. It was named Ulster Overall Club Ground of the Year in 2018.

2006
Inniskeen Grattans win the All-Ireland Intermediate football title, defeating Caherlistrane (Galway) in the final

2010
Inniskeen hosts its first NFL game, an all-ticket Monaghan vs Tyrone tie

2010
Main stand is named after Paddy O'Rourke (1923–2008), former club and county footballer, and club secretary for 56 years, 1946–2002

2022
Grattans beat Carrick Hurling 2–23 to 0-13 to win the Cúchulainn Cup in its inaugural year

Páirc Emmet

LOCATION
Ballybay Road, Carrickmacross

NAMED AFTER
Robert Emmet (1778–1803)
Republican, orator, rebel leader

OPENED
1953

CAPACITY
5,000

PITCH DIMENSIONS
130 x 84 m

COVERED ACCOMMODATION
Gary Sheehan Stand

FLOODLIGHTS
Yes

CLUB
Carrickmacross Emmets

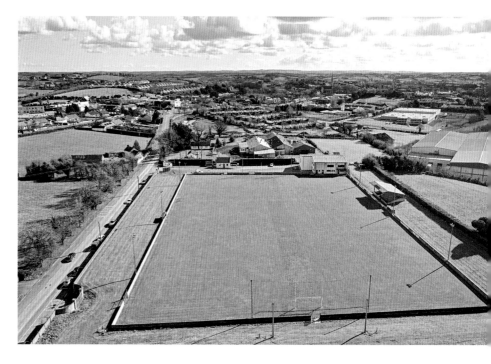

Emmets have won nine Monaghan SHC and seven SFC titles, with a three-in-a-row from 1908–10. The ladies football team were the Monaghan and Ulster junior champions 2021. Since 2015 the club has participated in rounders, winning the Men's All-Ireland senior title in 2020. Stephen Gollogly and Stephen O'Hanlon are the most recent club footballers to represent Monaghan.

Carrickmacross GAA Club was founded in 1887 but disputes led to a break-up into two clubs, O'Brien's and Sexton's. They eventually set aside their differences at a meeting in the Foresters Hall on 26 September 1903 and reunited as Carrickmacross Emmets.

The park's Gary Sheehan Stand is named after a much-loved Emmets' player and Garda who was killed in the line of duty

Emmets played in the Athletic Grounds, the first inter-county park in Carrickmacross. Monaghan and Armagh eked out the only scoreless game in Ulster SFC history there on 2 August 1914. Two years later a Monaghan vs Cavan gold medal challenge, billed as 'The Game of the Century,' was perhaps the first in Ulster to publish a match programme that listed players in their positions.

Emmets moved to the former Carrickmacross Show Field at Cloughvalley in 1928. The official opening on 2 September saw the ball being thrown in for another Monaghan vs Cavan match by the Irish Air Corps' Colonel James Fitzmaurice, who had made the world's first ever east–west transatlantic flight just a few months earlier.

KEY DATES

1916
Athletic Grounds host Monaghan and Wexford in the All-Ireland SFC semi-final on 22 October

1917
40 ploughs are booked to break up the field under wartime compulsory tillage, but club members stage a successful occupation to prevent it

1928
Emmets lease the Show Field and put in sideline seats at a cost of £220

1930
Cavan stages a boycott in protest at the choice of Carrickmacross as Ulster final venue, and a 'ghost' Breffni team loses to Monaghan.

ROBERT EMMET

From a wealthy Protestant family, Robert Emmet joined in the United Irishmen's rebellion of 1798, and, after exile in France, plotted another insurrection in Ireland. The 1803 uprising failed dismally, but Emmet remained one of Ireland's most romanticised martyrs a century on, when many GAA clubs were formed. There are clubs in 15 Irish counties – including eight of Ulster's nine – named after him, and at least ten Emmet Parks.

BIG GAMES BRING BIG CROWDS

The Carrick ground, unofficially named Gaelic Park, landed several big games, including the Ulster SFC finals of 1929 (replay) and 1930 – both Monaghan vs Cavan. The 1929 game drew a record 8,000 crowd, some sitting on the grass 'with their toes to the touch-line.' The park held several more Ulster SFC games until 1936, but because of its small size and sloping surface Emmets began to look elsewhere. In 1938 the club began negotiations with the Land Commission to secure six acres and 30 perches of the late Joseph Withrington's Bellevue estate on the Castleblayney Road. The purchase was completed at Halloween 1939 for £140. Club games were held there without delay, but further progress was slow.

'FOREIGN' MUSIC FINANCES FIELDWORK

Local curate Fr Patrick McHugh was very much to the fore in pushing the ground's development. Seeing that carnival dances that included 'foreign' music were the best money-spinners, Emmets set up an independent organising committee to circumvent the GAA's rules about holding non-céilí dancing events. The profits paid for a bulldozer to level the field and build embankments in 1950, and when the ground was vested in the GAA in 1951 the ensuing grants brought faster development, topped with an impressive entrance arch announcing Páirc Emmet. The park hosted its debut inter-county game, Monaghan vs Antrim, in 1951 and opened officially on 7 June 1953.

FARNEY ALL-IRELAND GLORY

On 14 October 1956 Emmet Park hosted the All-Ireland junior football final between Monaghan and London. When the home side won – the first national title for a northern team on Ulster soil – the huge crowd swarmed the pitch and chaired their heroes off. The good times did not last long, however. Carrick GAA supporters and businesspeople believed that their new ground was starved of big days, and when the 1957 Monaghan SFC final replay was switched from Emmet Park to Castle-blayney, the sportsfield committee closed their pitch in protest. Though it soon reopened, and would host other Monaghan club finals, there was never another Ulster SFC tie.

Crowds celebrate with their heroes in Emmet Park after the 1956 All-Ireland junior football final

COOLDERRY MOVE GOES COLD

Periodic improvements were made in the 1970s and '80s, including a new social centre with four new dressing rooms, squash and handball alleys, a meeting room and a lounge bar that opened in 1989. But the increasing strain on Emmet Park, as the sole pitch for several teams, led the club to decide to sell it and move elsewhere. Sale was agreed for €7.25m in 2006, and with the first tranche of payment (€3.25m) Emmets bought a 30-acre site at Coolderry on the Donaghmoyne Road in 2008. However, the completion of the sale of Emmet Park fell through and the club's main ground remains on the Ballybay Road.

1953
GAA President Vincent O'Donoghue opens Emmet Park officially on 7 June

1976
New dressing rooms with showers are installed

1999
Monaghan play Louth at the opening of the Gary Sheehan Stand

2022
Emmets receive €70,157 Sports Capital grant to assist in developing their new ground on Donaghmoyne Road

Healy Park

LOCATION
Lisanelly, Omagh

NAMED AFTER
Michael Healy (1926–1979)
Club groundsman, chairman

OPENED
1972

CAPACITY
18,000

PITCH DIMENSIONS
147 x 88 m

COVERED ACCOMMODATION
Yes

FLOODLIGHTS
Yes

CLUB
Omagh St Enda's

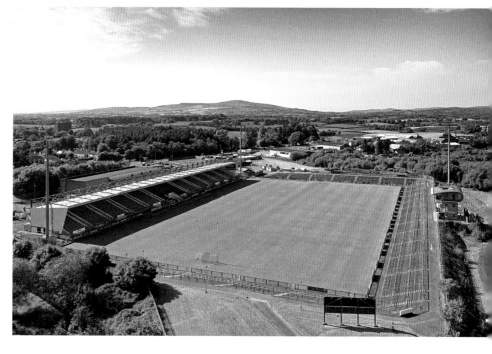

Winners of three SHC and nine Tyrone SFC titles, the last in 2017, Omagh St Enda's was the first club to win three titles in a row in 1952–54. The club can boast All-Ireland winners in brothers Joe and Justin McMahon, Conor Meyler and Ronan O'Neill. The club holds the record for winning All-Ireland senior Scór titles.

As the largest town in Tyrone and the west of Ulster, Omagh was slow to find a permanent home for Gaelic games. Ironically for a place that derived its name from 'plain,' the county town offered few suitable fields for play.

With hard work and skilled money management, St Enda's have created an arena for all major Tyrone games and the foremost sportsground in west Ulster

Being a market town as well as a garrison with soldiers based in its military barracks also gave an advantage to soccer and other sports. Soccer was the dominant game at the turn of the last century, with three strong clubs in the town: United, Rovers and Celtic. Several GAA and camogie clubs came and went in Omagh in the 1900s, most notably Sarsfields' hurlers and footballers playing at Castle Holm Park. After a lull, Omagh O'Neills emerged as a new Gaelic club in 1917, playing at Strathroy Holm. In 1920 Omagh Coleman's started playing at Lisnamallard Holm, recently purchased by farmer Patrick Cunningham. The Christian Brothers' school field became the main pitch during the 1920s, and hosted the town's first Ulster SFC ties.

KEY DATES

1926
CBS Park hosts Omagh's first Ulster SFC semi-final, Tyrone vs Antrim; Ulster Council deems this good 'for propaganda purposes' in the town

1934
Tyrone host All-Ireland champions Cavan at Lisnamallard in the Ulster SFC; most of 5,000 crowd celebrate a home triumph until referee declares Cavan winners

1963
Club chairman Michael Healy opens new clubroom in John Street, Omagh, in March

1972
New Park hosts its first inter-county game on opening day, Tyrone vs Donegal. Some Donegal players arrive late having been detained at the border

MICHAEL HEALY

A native of Dressogue, Drumquin, Co. Tyrone, Michael Healy was associated with St Enda's for over 21 years. He was club chairman when the land at Lisanelly was bought in 1962 and as development began in 1968 Michael was a constant presence about the ground, marking out the pitch, cutting the grass and laying flags. He was an ever-dependable volunteer for the club's youth section and in the mid-1970s became caretaker of the club's social centre. He was serving as the park committee chairman at the time of his sudden death in November 1979.

HEALY/BOWES FAMILIES

FINDING A HOME IN LISANELLY

St Enda's GAA Club, formed in early 1932, spearheaded the drive to develop a ground for Tyrone's county town. The club itself played at Coneywarren, close to the Omagh–Derry Road, but its location a couple of miles outside Omagh was a drawback. At other times St Enda's played on the CBS field before securing St Patrick's Park, Lisnamallard, as their home venue. The club lost in three county football finals in 1933, '34 and '35 but began to build a winning tradition in the 1950s, capturing four SFC titles in six years. Their efforts to purchase a ground, however, always ran into obstacles, but in 1958 the club set up a field committee to explore potential venues and four years later finally purchased 13 acres of land from Mrs Carlin for £1,300 at Lisanelly on the Gortin Road.

LAYING THE FINANCIAL GROUNDWORK

The area was a boggy site and a sizeable investment was needed to develop it. The club moved cautiously, raising funds before setting to work. A fortnight-long carnival in 1964 became an annual affair, amassing more than £20,000 over the next few years. In New York, a committee of former Omagh club members was specially convened to collect money for the venture.

GAA President Alf Murray cut the first sod near the end of 1967. Work began in the middle of 1968 with the clearance of ten feet of soil and bog and its replacement with tens of thousands of tons of gravel, stones and topsoil, coupled with an elaborate drainage system.

The field was sown early in 1969 and fenced a few months later. Following ten years of fundraising and development, the ground known as New Park was finally opened by Alf Murray on 17 September 1972.

EVER IMPROVING

The first Ulster SFC match played at the venue saw Derry defeat Armagh on 22 June 1975. Over the next couple of years, the club and county board worked to improve the ground, building new dressings rooms, seated accommodation, perimeter fencing and turnstiles. Their aim was to bring the facility up to provincial standard,

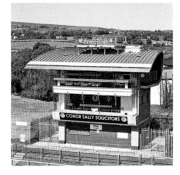

Healy Park's stylish media box, one of the best anywhere in the country, bustles with activity on big match days

which was quickly achieved. In 1984, under the stewardship of Declan O'Neill and Jack Martin, the club opened a new clubhouse and entertainment centre. The new millennium brought the opening of a 5,000-seater stand with an 18-metre cantilever roof in 2004, the building of a new press box and control tower and the installation of floodlights in 2006. The ground's facilities were added to in 2022 with a new ball wall and gymnasium.

1974
St Enda's Social Centre, the first of its kind in Tyrone, opens on St Patrick's night

1980
Park renamed in honour of Michael Healy on 19 October

1992
Former Tyrone captain and All-Ireland minor football medal winner Patsy Kerlin takes the first training session for St Enda's women's team, with '60 girls, one football and a whistle'

2021
'Caifé 32' is officially opened in the social centre at Healy Park by Omagh and Tyrone stalwart Thady Turbett, with décor celebrating Gaelic games' history in the town

Plunkett Park

LOCATION
Plunkett Park, Pomeroy

NAMED AFTER
**Saint Oliver Plunkett
(1625 – 1681)**
Archbishop of Armagh
**Joseph Mary Plunkett
(1887 – 1916)**
Easter Rising leader

OPENED
1948

CAPACITY
5,000

PITCH DIMENSIONS
145 x 88 m

COVERED ACCOMMODATION
Fr Peter Hughes Stand

FLOODLIGHTS
No

CLUB
Pomeroy Plunketts

Pomeroy's Frank Burns and Kieran McGeary manned the half-back line when Tyrone won the 2021 All-Ireland SFC title. The club won four county IFC titles between 1967 and 2016, and hopes its investment in underage talent will yield a SFC title before long.

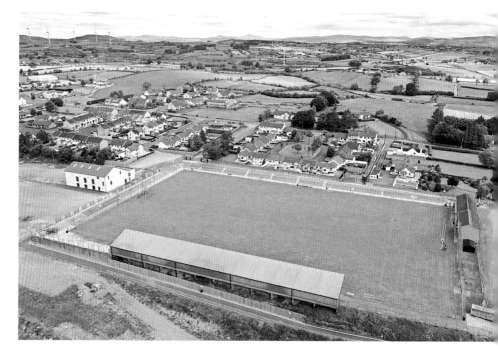

Plunkett Park sits some 170 metres above sea level among the fabled Mountains of Pomeroy. Gaelic football in the area can be traced back to Pomeroy Emmets football team, who played their first game on 8 November 1908 against Sixmilecross, which they won by 2–3 to 1–5. The Pomeroy Plunketts club replaced the Emmets in 1916 and over the next 30 years played their games in different fields, including Shamrock Park and Gaelic Park.

At the instigation of local curate Fr Peter Hughes, an Armagh-born priest who had served as Tyrone County Board chairman, the club decided in June 1946 to find a permanent home. Six acres on the Cavanakeeran Road was subsequently purchased for £726. 10s. A local appeal yielded £400, but capitalising on the euphoria of the recent All-Ireland triumph of the county minors, who had trained in Pomeroy, Fr Hughes set off for America and returned with twice that sum from friends of Tyrone in New York.

Plunkett Park is Ireland's highest county ground and has been the venue for National League, McKenna Cup, Lagan Cup and college games

KEY DATES

1935
Pomeroy Plunketts win their first trophy in a 7-a-side tournament organised by St Patrick's and also win the Tyrone JFC title

1946
The club buys Dalmidge's Field on the Cavanakeeran Road

1967
Plunketts win the Intermediate Football Championship, League and the McElduff Cup

1981
Club opens a new sports centre that includes an indoor handball alley

PLUNKETT

Plunkett Park honours Joseph Mary Plunkett, executed for his part in the 1916 Rising, and the inspiration for the Pomeroy club's name, while the club was also formed under the patronage of St Oliver Plunkett, the Catholic Archbishop of Armagh martyred in 1681.

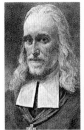

Although separated by over 200 years both men were executed for having been involved in a 'conspiracy with His Majesty's enemies'

FAITH IS A SPIRITUAL THING

The overall bill to develop the ground amounted to £1,500. Contributions from the Ulster Council and Central Council helped to defray the costs, but the greatest contribution came from local volunteers. The programme for the official opening attributed their efforts to a combination of nationalism and creed: *'Outsiders who are qualified to know have estimated the value of their services as many thousands of pounds. But we who are of the GAA set a higher value on that service because they gave us something that money could not buy. Faith is a spiritual thing, and it was their belief in the cause of a Gaelic Ireland that called them to the building of a milestone on their road to freedom.'*

THE HEART OF ULSTER

Plunkett Park was opened by senior political figure and Armagh man Frank Aiken on 8 August 1948 and granted county ground status that December. Although Pomeroy lies at the geographical heart of Ulster, the rugged terrain and poor road network militated against the ground obtaining Ulster championship fixtures even though it was a favoured venue for county finals.

Development over the years was gradual. Minor improvements were carried out during the 1950s and '60s, and in the 1970s the pavilion on the north side of the ground was replaced with a new building that included dressing rooms, opening on 14 May 1972.

NEW COMPLEX AND 50th BIRTHDAY

The amalgamation of St Mary's Handball Club with Plunketts in 1980 spawned an ambitious business plan to construct a new club complex under their new name, Pomeroy Plunketts Gaelic Athletic Club. The Community Employment Programme approved the plan – the first application from a northern GAA club to succeed. A team of 16 employees built an indoor handball court, changing-rooms, a kitchen and referee's room, and a recreation centre over the next six years. The club later purchased 4.5 acres of adjacent land to develop a training pitch in 1994.

A Golden Jubilee development project launched in 1995 led to the extension and resurfacing of the pitch, terracing around three sides, the installation of a stand dedicated to Fr Peter Hughes, as well as new toilet blocks and entrances with turnstiles. The grand opening of the redeveloped park on 9 August 1998, timed to mark its 50th anniversary, was performed by former GAA president Peter Quinn.

SCORING ON AND OFF THE FIELD

Major work was carried out in 2008 to replace a retaining wall that had collapsed and build terracing on the stand side of the ground. The Plunketts club celebrated their teams winning the intermediate Tyrone and Ulster football titles in 2004 and again in 2016. Work began on a new club facility in 2023 that will include dressing rooms, gym and meeting rooms overlooking the main pitch. The new development also has plans to include a new floodlit training pitch.

1998
Archbishop Seán Brady blesses vastly refurbished Plunkett Park on its reopening

2003
Plunkett Park stages its first NFL game in two decades, Tyrone vs Galway, with live television coverage on TG4

2005
Plunketts lose to Carbery Rangers (Cork) in the All-Ireland Intermediate Club final

2021
New floodlit walkway laid and opened around Plunkett Park

O'Neill Park

LOCATION
Lisnahull Road, Dungannon

NAMED AFTER
Ulster's O'Neill sept

OPENED
1947

CAPACITY
5,000

PITCH DIMENSIONS
139 x 80 m

COVERED ACCOMMODATION
Yes

FLOODLIGHTS
No

CLUB
Dungannon Thomas Clarkes

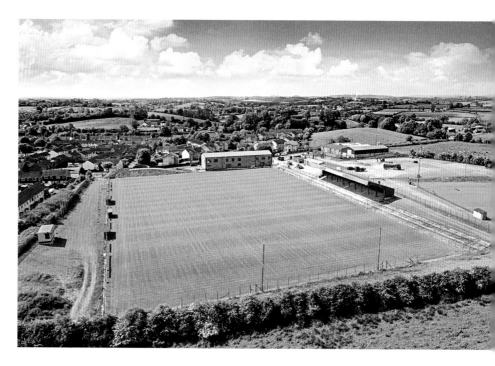

Building facilities fit for a chieftain – O'Neill Park pictured in summer 2023 as it undergoes a major upgrade

Dungannon Thomas Clarkes lie joint second in the league table of Tyrone senior club titles, having won the championship ten times. Two of club legend Iggy Jones' grandsons, Dalaigh and Ryan Jones, played on the team that took the honours in 2020, the first time since the Clarkes, with Iggy playing, won it in 1956.

The title O'Neill Park was first conferred on a pitch leased by Thomas Clarkes GAA Club on Dungannon's Donaghmore Road that opened officially in February 1927. Tyrone's identification as 'O'Neill's county' was a badge of pride for the GAA and the renowned Gaelic sept's symbol – the red hand – eventually became the crest on the county jersey.

Dungannon's first GAA club – Emmets – contested their first football match on 20 December 1903 against Tír na nÓg from Armagh on a pitch owned by the Bennett brothers. Tyrone met Armagh in the first Ulster SFC match played in the town, held in Emmet Park, Donaghmore Road, on 31 January 1904. The club made Springfield Park its base, as did its successor club, Craobh Ruadh, from 1907. Thomas Clarkes club, established in 1917, played initially at Lisnahull, but moved to Springfield after Craobh Ruadh folded two years later. The need for a bigger ground led Clarkes to invest in the first O'Neill Park in the mid-1920s. It was a timely development for Tyrone, having just entered the NFL.

KEY DATES

1927
The first O'Neill Park hosts Tyrone vs Kildare, All-Ireland champions, in an NFL game on 13 November

1929
O'Neill Park features on the oldest known film of Gaelic games in Ulster. The Gaumont Graphic newsreel catches some of a Tyrone vs Antrim game

1947
The second O'Neill Park opens with Armagh playing Tyrone in an Ulster SFC match

1950s
New dressing rooms and terrace improve facilities for players and spectators

THE O'NEILL

The park honours the historic role of Dungannon as a stronghold of the O'Neill clan, one of the historic dynasties of Gaelic Ireland, whose leader was styled 'The O'Neill.'

BODIES WANTED, TOOLS SUPPLIED

Dungannon Clarkes decided in 1937 to purchase their own grounds but suffered a string of disappointments until 1940 when the club, represented by Henry Madden, bought two fields in the Lisnahull area from James Donnelly for a total of £343. 14s. 9d. Now they had to develop the ground, with a seven-feet height difference between the fields, hampered by war-time rationing and a lack of machinery.

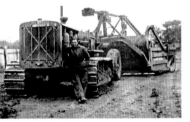

DUNGANNON THOMAS CLARKS

Initially the labour force comprised a very small band. Aloysius Kelly worked alone at times, before John McQuaid, Jimmy Casey and Vincent Fox joined in. A tractor arrived in 1943 and a bulldozer nicknamed 'Mooncoin' owned by Alex Hanlon came along at the end of the war. Early in 1946 the club issued an appeal to complete the project, announcing that 'There will be a pick, shovel, spade, barrow – or something – for every volunteer.' Their labours weren't helped by 'The Big Snow' of 1947 but the community rallied to ensure that everything would be ready for the opening on 29 June by Ulster Council Chairman Alf Murray. The club brought the old name to the new venue, which was a milestone for Tyrone GAA – the first vested ground in the county.

BOMBED BUT NOT BEATEN

The facilities at O'Neill Park, which had been improved through the 1950s and '60s, were destroyed in an instant by 30 lbs of explosives on St Patrick's Night

A club getting the use of earth-moving equipment was rare in the 1940s, so it was a major boon when Alex Hanlon and 'Mooncoin' joined the work crew

1971. The club later received £22,000 compensation, but now with only Nissen huts to act as changing rooms the park lost out to Omagh as the chief county ground after the latter's opening in 1972.

The Dungannon club opened a social centre in July 1981 in an effort to revive morale and generate income. The centre paid its way for several years but was forced to close in 1989. Meanwhile, the dressing rooms were extended and toilet facilities were improved. The embankment on the Lisnahull side was built up to increase capacity and a spectator stand was erected in 1989 at a cost of £35,115, with two new dressing rooms built in 1992. Tyrone teams played most of their NFL games at the park through the 1990s.

GAA NOSTALGIA

PAYING TRIBUTE TO IGGY

O'Neill Park's heritage was underlined in the 1990s with the opening of the Iggy Jones Room. The exhibition space paid tribute to the nifty little forward renowned for his dazzling solo runs and scores, and arguably one of the greatest Tyrone footballers of all time.

NOSTALGIA AND HOPE

From the early 2000s the park's use as a county ground declined as Tyrone's resources were concentrated on Healy Park, but for many people the former remains the spiritual home of football in the county.

Dungannon hopes to see the ground return as a venue for major county and provincial matches, launching a development plan in partnership with the local council in September 2022 which will bring a resurfaced playing pitch and fitness facilities, clubrooms and a community hub.

1972
The last Ulster SFC game at O'Neill Park takes place on 9 July, when Tyrone beat Derry in the semi-final

1986
Dedicated club man Art McRory receives Special Merit Award from Tyrone GAA

2011
Club names ground adjacent to park Cian's Field in memory of 11-year-old Cian Corrigan

2020
Dungannon bridge a 64-year gap winning their 11th Tyrone SFC title after penalties

2023
New Community Hub in train to cater for Dungannon Clarkes GAA and Aodh Ruadh Ladies

Fr Peter Campbell Park

LOCATION
Annagher Road, Coalisland

NAMED AFTER
**Fr Peter Campbell
(1915–1987)**
Missionary, footballer

OPENED
1949

CAPACITY
4,500

PITCH DIMENSIONS
138 x 81 m

COVERED ACCOMMODATION
Yes

FLOODLIGHTS
Yes

CLUB
Coalisland Fianna

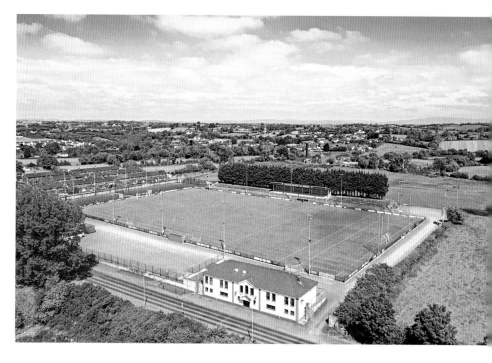

Since 1903, Coalisland Fianna has been the most enduring club name in Tyrone Gaelic games. Na Fianna won their first Tyrone SFC title in 1905, and a tenth in 2018. The club can also boast of having Tyrone's All-Ireland winners Johnny Curran (1998), and Pádraig Hampsey (captain) and Michael McKernan (2021) as club members.

A number of teams played out of the Coalisland area up to the 1920s, including Mitchels, Emmet Tones, Owen Roe's and the Fianna. The origins of Coalisland Fianna can be traced to a meeting in the cellar of St Patrick's Hall in 1903. The club affiliated to the newly formed Tyrone County Board in February 1904 and played their home games in Fianna Park. This was the venue for the first Ulster SFC game in Coalisland – the 1903 semi-final between Tyrone and Armagh played on 19 February 1905.

So good they named it thrice – Na Fianna's ground had two other names before they rededicated it in 1988 to a member of a family steeped in club history

From 1923 the club played at Annagher Hill – the location of one of the collieries that gave Coalisland its name – on the outskirts of the town. The land belonged to Henry Campbell, who rotated his crops so that the Fianna always had suitable ground to play on. This arrangement lasted until November 1946, when the club bought a five-acre plot known as McDaniel's Fields, also at Annagher Hill, for £1,100 as a place to establish a permanent home.

KEY DATES

1904
Club captures the first ever Tyrone SFC title in November by defeating Strabane

1932
The ground at Annagher Hill hosts several notable football matches, from the headline game between Kerry and Wexford in 1932 to three Ulster SFC matches up to 1941

1949
Ulster Council President Alf Murray opens MacRory Park before a crowd of 7,000

1959
MacRory Park reopens after the pitch is extended, ploughed and re-seeded

FR PETER CAMPBELL

Born at Clonoe, Coalisland, in 1915, Peter Campbell was ordained a missionary priest in 1941. His work included stints in England, China, the USA and the Philippines. After his return to Ireland in 1971 he was hospital chaplain in Drogheda and then assisted the Archdiocese of Armagh from 1976.

Peter was a star player for St Patrick's College, Armagh, and Tyrone minors, and graduated to the county senior team at the age of 18, also gaining selection for Ulster. Strict rules regarding priests taking part in games put paid to his promising career. Like his father, Henry, who had given the Fianna a playing pitch at Annagher Hill, Peter remained a dedicated club supporter. He was enrolled in the Tyrone GAA Hall of Fame in 1987.

COLUMBAN MISSIONARY SOCIETY

VOLUNTEERS GET DUG IN

The ground, initially named Annagher Park, was developed under the guidance of Frank O'Neill, Alf Daly and Joe Henry Campbell. Volunteers carried out most of the work in the evenings, pulling hedges up by the roots and levelling the earth, though one tree that couldn't be budged had to be burned out. The park was distinctive for the pitch level being four feet higher than the base of the spectators' embankment. The grass on the pitch refused to grow to begin with, but when it was re-seeded and spread with turf mould that dramatically helped the process. Walls were built on the two sides of the park, wire fencing was installed around the playing area, and the dressing rooms featured a sub-terranean passageway leading to the pitch.

RENAMING I

Renamed on 19 June 1949 in honour of Cardinal Joseph MacRory, the first Catholic primate from Tyrone, Coalisland may be the only county ground in Ireland that has been dedicated to two clerical figures. It was Tyrone's third county ground, along with Dungannon and Pomeroy, when there had been none before 1947. However, after hosting a couple of Ulster SFC games in the early 1950s the Coalisland venue was overlooked, largely due to its proximity to O'Neill Park five miles away in Dungannon.

MAKING A SHOW OF THEMSELVES

The Fianna club launched a novel fundraising scheme in the 1950s: the MacRory Dramatic Group. The variety troupe toured the province, performing singing, dancing and comedy sketches produced by Frank O'Neill, a teacher who later became Ulster Council president.

RENAMING II AND REDEVELOPMENT

The ground was closed for a year in 1987 and following drainage, re-sowing and extensive work on terracing reopened as Fr Peter Campbell Park on 28 August 1988, with Cardinal Tomás Ó Fiaich as special guest. Further redevelopment ensued with the construction of four new dressing rooms and referee's amenities, which were opened in August 1995.

With these upgraded facilities, its mid-Ulster location and a pitch that stayed playable throughout the winter, Fr Campbell Park staged a series of MacRory Cup finals in the 1990s. NFL games were also fixed for Coalisland occasionally, such as the Tyrone vs Donegal match of 2003 which attracted some 7,000 spectators. The club installed a new state-of-the-art digital scoreboard in 2022.

1966
20,000 people attend 1916 Golden Jubilee commemoration ceremony at ground

1977
Club builds a new social centre which opens in March

2010
New stand is subject to arson attack a few weeks before its opening

2014
NI Sports Minister Carál Ní Chuilín opens club's two all-weather 4G pitches

2018
Coalisland Fianna win the Tyrone SFC title for the tenth time

ACKNOWLEDGEMENTS

I have been fortunate over the past ten years to come across some great GAA people, who were very supportive as I compiled this work.

Before pen was put to paper on *A Place to Play*, I had a chat with Dónal McAnallen, who had a similar idea about writing a book on this theme. We agreed to collaborate on the production. However, due to his many other commitments Dónal was unable to devote his time to this, though I was pleased that he later came on board as a contributing editor.

Adam Staunton of the Croke Park library was very helpful as I researched articles there, while Kathy Slattery, David Connellan and Stephen Lohan in the Finance Unit could not have been more accommodating when giving me access to important files.

I want especially to thank Liam O'Donoghue, Thurles; Jimmy Dunne, Arklow; Paul Anglim, Askeaton; Alex Stenson, Rathdowney; George Cartwright, Breffni Park; and Billy Phelan, Abbeyleix, who gave me valuable information about their grounds while they were busy writing their own books.

The support of the four GAA provincial councils was invaluable, and I am extremely grateful to Larry McCarthy, Uachtarán Cumann Lúthchleas Gael, who kindly agreed to write a foreword, as did award-winning sportswriter Michael Foley. Meeting Michael Berkery of FBD Trust was fortuitous for me and ensured that the work was completed; his support is very much appreciated.

A special word of thanks to Michael McGee, who gave me sound advice and direction on the administrative side of producing the book. Thanks to my childhood pal, Tony Burke, who accompanied me on my first 'drone shoot' to the Fraher Field, Dungarvan. Tony's role as lookout was taken over by Eoin Kelly, and together we travelled thousands of miles, criss-crossing the country to visit grounds. When the car's satnav led us astray, Eoin proved an equally good guide, and acted as liaison officer with the local groundsman or caretaker on

arrival. Ken Fitzgibbon and Redmond Walsh of Eirtrade Aviation were also very supportive.

Thanks to Ray McManus for the sound advice about drone photography and access to his outstanding Sportsfile image library.

I was delighted to have Merrion Press come on board and add their imprimatur to *A Place to Play*, as well as their expertise in printing, marketing and distribution. I want to thank publisher and managing director Conor Graham, commissioning editor Patrick O'Donoghue and marketing manager Maeve Convery for giving this work their vote of confidence.

It is hard to put into a few words the contribution Peadar Staunton and his Design Gang, and editor Peter Malone made from Kerry. To say their input was immense would be an understatement. They took my idea, developed the concept further, and blended their considerable skills to make this the book you have in your hands.

I don't know where I would be without the support of my wife Claire, sons Tony and Eamon, and Susan, my daughter. I have lost count of the number of times my children bailed me out when it came to computer technology. Even though they live busy lives and have their own families they always came up trumps – I can only thank them.

The following people supported me in different ways, often with valuable information, and I am very grateful to them. Thanks to Jarlath Cloonan, Athenry; Tony O'Keeffe, Tralee; Frank Burke, Galway; Áine and Mike Fitzgerald, Kilmallock; Andy O'Sullivan, Athlone; Pat Doherty, Mullingar; Barrie Henriques, Callan; Seamus O'Reilly, Clare; Bobby McIlhatton, Loughgiel; Brother Thomas, Marist Brothers Athlone; Ciarán McBrien, Charlestown; Tommy Murphy, Carlow; Collie Donnelly, Belfast; David Morgan, Semple Stadium; Martin Quigley, Wexford; Fergal McCormack and Róisín McCormack, Newry; Eugene Gallagher, Ballybofey;

Frankie McCloskey, Ballinascreen; Tim O'Neill, Patrickswell; Gerry Boland, Limerick; Gerry Kerley, Dowdallshill; Tommy Brennan, Kilmessan; Seán Kilbride, Kiltoom; Tim Floyd, Tipperary; Gerry McArdle, Inniskeen; James Lundon, Limerick; Jim Carney, Tuam; Stephen Stack, Listowel; Jimmy Smyth, Lurgan; Joe McGurn, Enniskillen; Paul Brewster, Enniskillen; John Keenan, Derry; Julianne McKeigue, Croke Park Museum; Kevin Bowes, Omagh; Liam Mulvihill, Longford/Ashbourne; Louie Walsh, Castlebar; Billy Field, Cork; Luke Kilcoyne, Tubbercurry; Myles Courtney, New Ross; Gerry Larkin, Galway; Mairead (Mud) Bourke, Waterford; Mark Quinn, Magherafelt; Michael Burns, Castleblayney; Páraic Duffy, Castleblayney/Scotstown; Michael Kavanagh, Freshford; Ned Kennedy, Freshford; Mick Hoban, Naas; Neal Farry, Ballymote; Declan Bohan, Leitrim; Brian Armitage, Lisnaskea; Ned Quinn, Kilkenny; Noel Murphy, Parnell Park; Paddy Galvin, Sligo; Basil Jones, Athleague; Pat Cassidy, Carrickmacross; Pat Kilcoyne, Tubbercurry; Pat Teehan, Offaly; Phil Fanning, Waterford; Dessie Donnelly, Ballycastle; Raymond McHugh, Castleblayney; Seamus Brennan, Trim; Seamus Finnerty, Galway; Pearse Murphy, Cork; Michael Verney, Birr; Seamus O'Doherty, Thurles; Donie Nestor, Askeaton; Dickie Murphy, Enniscorthy; Seamus O'Hanlon, Louth; Seán Nugent, Clonmel; Kevin Leahy, Clonmel; Seán Ó Súilleabháin, Ballinamore; Marty McEvoy, Athy; Seán Óg McAteer, Down; Adrian Taheny, Dublin; Tom Brewster, Enniskillen; Ger Ryan, Munster Council; Tom and Michael Daly, Ballyshannon; Michael Duffy, Irvinestown; Tom Hunt, Mullingar; George Cartwright, Cavan; Eugene O'Loughlin, Wicklow; Donal Sheridan, Dowdallshill; Tommy Kilcoyne, Tubbercurry; Denis O'Hara, Corrigan Park; Brian McAvoy, Ulster Council; Vincent Carmody, Listowel; John Horan, Dublin; Jimmy Gray (RIP), Dublin; Johnny Haughey (RIP), Athleague; Bosco Creed, Fermoy; Brendan Keane, Fermoy; Tom Kenny, Kenny's Bookshop, Galway; Michael Hennessey, Miltown Malbay; Raymond Doherty, Ballybofey; Pat Flynn, Waterford; Liam Ross, Armagh; Brian McCabe, Lisnaskea; Seán Murray, Leitrim; Tony Conboy, Roscommon; Seán Carney, Cootehill; Phil Smith, Kingscourt; Chris Murphy, Tullow; Liam McManus, Naas; Tony and Bernadette McGovern, Leitrim and London; Catherine McGourty, Ballycran; David Murray, Wicklow; Noel Treacy (RIP), Galway; Tony Kenny, Portmarnock and Roscommon; John Reidy (RIP), Miltown Malbay; Donal Garvey, Cork and Clare; Micheál McDonald, Ardee; Tony Ryan, Dungarvan; Barry Molloy, Roscommon; Brian Melinn, Athlone; Seán McKenna, Derry; Noel Minogue, Dublin and Tulla; Brendan Hayden, Carlow; P. J. Martin, Kiltoom; Bernie Mullan, Owenbeg; Liz Foley, Mallow; Joe and Fiona Carroll, Dundalk; Richard Melia, Ashford; Gerry Martin, Kingscourt; Pat Firth, Tulla; Jim Nagle, Nenagh; Willie Fraher, Waterford County Museum; Nicky Brennan, Kilkenny; Eddie Barrett, Tralee; Maureen Diffley, Carrick-on-Shannon; Diarmaid Carney, Cootehill; Damian Callan, Louth; Seamus O'Donovan, Dublin and Listowel; Tommy Moran, Leitrim; George Darcy, Bagenalstown; Noel Farrell, Kells; Seán Murray, Ballinamore; Liam McManus, Naas; Niall Ryan, Abbeyleix; Gerry Seale, Ballinasloe; Seamus Whelan (RIP), Mullingar; Frank Mulrennan, Celtic Media Group; Donncha Ó Caoimh, Cork; Tadg Hurley, Blarney; Alan Betson, Dublin; Emma Sweeney, PRO Kerry GAA; Brendan Crossan, *Irish News*; Olivia and Pearse Ferguson, Kells; Carol Thornton, Kells; Eugene Reilly, Dublin and Ballyhaise; Ian Hannigan, Waterford; Matt Loughrey, Mayo; Tommy Moran, Leitrim; Róisín Bennett, Armagh; Kevin Cummins, Cork; Kevin McStay, Mayo; John Maughan, Mayo; Mark Egan, Ballycran; Tommy Callaghan, *Leinster Leader*; Anthony Loughman, Castleblayney; Pat Joyce, Fermoy; John Prenty, Connacht Council; Michael Reynolds, Leinster Council and Liam O'Neill, Trumera.

SELECT BIBLIOGRAPHY

Paul Anglim, *Askeaton–Ballysteen, GAA Story 1884–2020*, Ballysteen GAA Club, 2021

Frank Burke, *All-Ireland Glory: A Pictorial History of the Senior Football Championship 1887–2005*, 2006

Jarlath Cloonan (ed.), *Athenry GAA Story: A History of Gaelic Games in Athenry*, St Mary's GAA Club, 2003

Eoghan Corry, *Kildare GAA: A Centenary History*, Kildare County Board, 1984

Eoghan Corry, *An Illustrated History of the GAA*, Gill and Macmillan, 2006

Joe Crawford and **Dan McCool**, *Golden Memories: A History of Gaelic Games around the Twin Towns 1916–1966*, Seán Mac Cumhaill Club, 1999

Jim Cronin, *Munster GAA Story*, 1986

Mike Cronin, **Mark Duncan** and **Paul Rouse**, *The GAA: A People's History*, Collins Press, 2009

Mike Cronin and **Roisín Higgins**, *Places we Play: Ireland's Sporting Heritage*, Collins Press, 2011

Paddy Donnelly, **Alex Campbell**, **Aidan Boyle**, **Karen Coyles** and **Una Kelly**, *McQuillan GAC Ballycastle: A Century With Honour*, McQuillan GAC, 2007

Jimmy Dunne, *From The Sea To The Summit: History of Arklow GAA*, 2021

Marcus de Búrca, *The GAA: A History*, Cumann Lúthchleas Gael, 1980

Dónal McAnallen, 'The Greatest Amateur Association in the World?' in **Mike Cronin**, **William Murphy** and **Paul Rouse** (eds), *The Gaelic Athletic Association 1884–2009*, Irish Academic Press, 2009

Tommy Moran, *History of Connacht GAA*, 1902–2002, Connacht Council, 2002

Donal A. Murphy, **P. J. Maxwell** and **Nancy Murphy**, *Gaelic Sport in Nenagh*, Relay Books, 2014

Michael O'Brien, *The Struggle for Páirc Tailteann: A History of Meath's & Leinster's Premier GAA Grounds*, 1994

John Reidy, *Miltown St Joseph's GAA Club: The Story of St Joseph's GAA Club*, 2013

Liam Ó Donnchú, *Semple Stadium: Field of Legends*, O'Brien Press, 2021

John O'Neill, *The Complete All-Ireland Senior Football Championship 1887–2019*, Litter Press, 2019

Report of the Commission on the GAA, Cumann Lúthchleas Gael, 1971

Alex Stenson, *Rathdowney and Errill GAA: The Story So Far*, 2022

Irish newspaper archives

British newspaper archives

GAA Library and Archive, Croke Park

National Club and Infrastructure Finance Unit, Croke Park